Museum Worlds
Advances in Research

———■———

Contents
Volume 1 ■ 2013

Museum Worlds

Museum Worlds
Advances in Research

———————■———————

Museum Worlds

Advances in Research

Volume 1 - 2013

■ EDITORS ■

Sandra Dudley and Kylie Message

berghahn
NEW YORK · OXFORD
www.berghahnbooks.com

Responding to the need for a rigorous, in-depth review of current work in the broad field of Museum Studies, *Museum Worlds: Advances in Research* contributes to the ongoing formation of Museum Studies as an academic and practical field of research, the expansion of which parallels the rapid growth of museums in just about every part of the world. *Museum Worlds* aims to trace and comment on major regional, theoretical, methodological and topical themes and debates, and encourage comparison of museum theories, practices, and developments in different global settings. Each issue includes a conversation piece on a current topic, as well as peer-reviewed scholarly articles and review articles, book and exhibition reviews, and news on developments in Museum Studies and related curricula in different parts of the world. Drawing on the expertise and networks of a global Editorial Board of senior scholars and museum practitioners, the journal will both challenge and develop the core concepts that link different disciplinary perspectives on museums by bringing new voices into ongoing debates and discussions.

COPYRIGHT

ONLINE

Museum Worlds: Advances in Research is available online at www.berghahnbooks.com/journals/airmw, where you can browse online tables of contents and abstracts, purchase individual articles, order a sample copy, or recommend the journal to your library. Also visit the *Museum Worlds* website for details on the journal, including full contact information for the editors and instructions for contributors.

ADVERTISING

▉ V. BOOK REVIEWS

Editorial

Sandra Dudley and Kylie Message

Museum Worlds: Advances in Research represents trends in museum-related research and practice. It builds a profile of various approaches to the expanding discipline of museum studies and to work in the growing number of museums throughout the world. It traces major regional, theoretical, methodological, and topical themes and debates, and encourages comparison of museum theories, practices, and developments in different global settings.

Museums, as well as the work within them and the studies that concern them, are neither self-contained nor static. Museums are not simply institutions, nor even are they merely institutional agglomerations of collections, people, and buildings. They are better envisaged as dynamic clusters of multiple relationships that connect present and past individuals, communities, and organizations at different levels within and beyond the museum, together with material and more ephemeral objects and the formal and informal networks that produce, use, and attribute meaning to collections and their related infrastructures. Contrary, perhaps, to the initial implications of the idea of the museum as a place for preserving things as they are in perpetuity, the character of some or all of those relationships change over time. Which relationships hold most power and influence and which ones are deemed to matter most, can demonstrate surprising fluidity. Museums engage with and are embedded within the societies and histories of which they are a part, and in doing so they are not only influenced by, but also impact upon, wider social and cultural patterns. Studies of museums, in their increasing range of disciplinary influences and subject focus, reflect this embeddedness and dynamism. Museums, and the ever developing field of museum studies, are variously concerned, on different levels and in a diversity of ways, with institutions, nations, people, communities, governments, exhibitions, displays, public programs, collections, material culture, audiences, public memory, and concepts and experiences of place, identity, and belonging. The articles in this inaugural issue of *Museum Worlds* touch in some way upon all of these.

Rather than working to consolidate a picture or singular overview of what the field of museum studies is, we have, as editors, sought articles, reports and reviews that analyze and engage critically, broadly, and dynamically with trends in museum-related research and practice. This editorial decision has formed a structure for our contributions, which have, in turn, encouraged us to consider that the most appropriate and relevant question is not one of definition but of purpose—about whom and what museums are for. As such, the research articles, reviews, and conversations contained within this volume contribute substantively to contemporary museum studies as a core scholarly field of research. The contributions also engage with investigations concerned with museums in other disciplines, and those conducted through interdisciplinary methods across a broad range of humanities and social sciences, as well as the natural sciences.

Museum Worlds: Advances in Research 1 (2013): 1–6 © Berghahn Books
doi:10.3167/armw.2013.010101

One purpose of *Museum Worlds* is to present an annual review or update of current work in the field, yet we certainly do not aim to provide a final word or neat summary on this continually evolving field of research. Rather, we intend the journal to contribute to the ongoing trajectory of the field by bringing together scholarly researchers, museum practitioners, and others to challenge, extend, and strengthen ways of understanding museums in a complex contemporary world. We aim to provide insight into cutting-edge research and into the principal concerns and practices pertinent to each year of publication, and to offer a vehicle for rigorous debate on current themes. To extend our current focus on museum dialogues and the networks of effect that radiate outward from them, a central element of the journal is the 'conversation', or roundtable feature. In this issue, the roundtable took as its topic 'Museums and a Global World', and generated a lively debate amongst participants at the inaugural international Association of Critical Heritage Studies conference in Gothenburg, Sweden, in 2012. We anticipate that the roundtable feature of future editions of *Museum Worlds* may also include responses to articles included in this and subsequent issues.

Editorial board members for the journal were sought for their potential to contribute to these conversations, and because they represent diversity in the field, geographically, institutionally, and also in terms of disciplinary affiliation. They were invited because of their individual contributions to scholarship and the profession, but also because if *Museum Worlds* is to act as a kind of discursive hub, the editorial board members provide the spokes and networks that can bring new voices into these discussions, thereby helping the debate resist becoming homogenous, insular, or singular in content or in the form or style in which it is recounted.

All of the contributions featured in this inaugural volume in some way ask questions about the public functions, obligations, debates around power and authority, and values of museums, with many exploring how museums in different countries are attempting to square the challenges of nation with ideas about local and community identity. They also and with equal rigor intersect productively and critically, directly or indirectly, with aspects of the field of museum studies. Each contributor has probed the current intellectual and practical landscape occupied by museum studies today and each represents particular views on directions in which the research field is heading. In addition, each article combines a range of insights and practices to actively engage with museums, collections, and the worlds within which these are located, in order to generate new understandings and innovations.

The journal

The research articles follow on from the editorial. The important scholarly dialogue they exhibit is also demonstrated in the interactions occurring more spontaneously in our roundtable conversation feature (we provide a transcript of a real time exchange of ideas). The research articles represent a range of views and case study sites and, taken together, they exemplify a diversity of literature, viewpoints, and stakeholders to be considered in studies of museums and society. This is a question not of combination but of negotiation across public and private spheres, and of communicating across borders, be they international, regional, or interpersonal. Rather than being used to demonstrate a singular point or homogenous ideal, when the ideas and arguments are taken together, the articles (and the dialogues they represent) in this volume also make the important point that museums are not just neutral reflections of the social politics and dynamics of the context in which they have been produced, but active contributors to debates on social order and justice, as well as governmentality.

Museums and museum studies scholarship are similarly affected by national, historical and topical trends of the moment, and anthologies and annual reviews such as *Museum Worlds* show the conversation that we see emerging in and across museums themselves at particular times. In this we agree with Preziosi and Farago's contention (from *Grasping the World: the Idea of the Museum,* Ashgate 2004) that a central element to consider in approaching any analysis of museums is the 'when' of the museum; and that by extension, understanding when a museum was produced, and its relationship to a given social and political era helps to unpack its meaning because the time of production provides crucial clues about power structures and priorities. This means, of course, that studies of museums are, or should be, also understood as studies of society, politics, economics, and other matters of structural, psychological, and emotional importance. Moreover, a collection of contemplations, interactions, and sound bites such as is provided by this volume of research articles, 'roundtables', and reviews, is itself an analogy of sorts with a museum of material cultural heritage: both at heart are collections of ideas and political agenda. While the research articles provide a formal and academic type of exchange, they are followed by the roundtable conversation, reports into current affairs or events in the museological sector, and then reviews of recent exhibitions and books.

Development and change, be it in disciplinary and museum studies forums, in the social contexts giving rise to (or levelling criticism at) museums, or in the particular museum forms or settings that aim to respond to and converse with each of these, are themes that all the research articles in this first issue could be said in some way to address, implicitly or explicitly. This begins with the changes in intellectual perspective, definition, and analytical approach suggested by two critical (re)positionings: the first article's stance on the scholarship of museums generally, and the second's on both 'the digital' in museums and the study of it. Anthony Shelton's article draws a distinction between what he identifies as three different museologies (critical, praxiological, and operational), and then focuses in on critical museology, and its development and precepts. Many readers will already identify with much of his manifesto, but they will bring to it distinct viewpoints and histories of their own and may find these valuably enriched through careful attention to the theoretical, historical, and practice-based genealogies and trajectories that Shelton traces. The article demonstrates the period- and culture-dependent specificities in these patterns that too often are overgeneralized, and ultimately raises some usefully provocative areas for inquiry and debate in future directions of both museum practice and museum studies. Ross Parry's piece on museums in the postdigital age also considers the trajectory of future work, focusing particularly on what Parry sees as a need to "reset our relationship" with digital media now that it is a normalized part of the museum (and other parts of the) world. In other words, it is time we ceased thinking of 'new' technology, digital revolutions, and the digital versus the nondigital worlds, and recognized instead the now normalized, mutual embeddedness of the digital and the nondigital. Parry does not reject change or represent the situation now as static; rather, he deals with it subtly and demonstrates that to continue treating digital technology as radically transformative and as 'other' is largely inappropriate in the contemporary setting.

A subtle and questioning approach to development and change continues in the next four articles, all of which, in diverse ways, address the relationships between museums, identities, and wider cultural dynamics—broadly defined, contexts of globalization, colonialism, heritage, and urban development, respectively. The first two articles in this group both deal with questions of museums and national identities, although in distinct settings and over rather different timescales. Rhiannon Mason explores whether or not Europe's national museums now essentially comprise something that properly belongs in an earlier era, given their associations with nationhood and place-bound identity on the one hand and the apparent rise of cosmo-

politanism and globalization on the other. Her conclusion is that, rather than globalization suggesting the demise of national museums, in fact such museums—and indeed other sorts of museums too—have an important role to play in articulating the tensions between globalization and national (and other) identities, precisely because in reality it is such tensions that appear to define contemporary cultural dynamics. She argues that museums should "cosmopolitanize from within" and that a "cosmopolitan museology" needs to be developed to guide future practice. Also looking at issues of national identity and political change, Christina Riggs takes a long view of the Museum of Egyptian Antiquities in Cairo, taking as her starting point an analysis of interpretations of governmental claims regarding looting of the museum during mass protests in January 2011. She moves on from this to examine both the history of her case study museum and wider entanglements between museums, (ancient) historical representations, and European colonial endeavors in Egypt and beyond. Her article ends with a return to the contemporary postcolonial contexts in which the museum now finds itself, and a consideration of not only current dynamics but also future possibilities.

The second two articles in this cluster are concerned with relationships between museums, identities, and wider cultural dynamics, and focus on heritage, culture, and urban development. Mary Bouquet examines some major recent development and revitalization projects at Dutch museums. She situates them within a wider debate about the relationship between museums and "heritage," and argues that they, and the increasing trend for their ilk, constitute a process she terms "reheritaging." Effects of this include enhancing public sensibilities both locally and in communities far beyond where the museum is based, and reshaping of both the institution and its audiences. Through her case studies, she demonstrates how museums have become actively part of, and impacted by, these ongoing heritaging processes with global reach and are, as a result, being turned "inside out." Lisanne Gibson's article also concentrates on museum developments, in her case particularly those that form a part of wider, culture-led urban regeneration projects. She situates her examination within a juxtaposition of two different literatures, bringing together an exploration of extant work on museums' roles in urban development on the one hand with scrutiny of museum studies discussions of the 'postmuseum' on the other. Concluding that these approaches are dichotomous and do not allow full account to be taken of both the technical and symbolic aspects of new museum developments, Gibson proposes instead consideration of the phenomenotechnics of these projects.

The final three research articles in this issue of *Museum Worlds: Advances in Research* take us inside the walls of the museum, focusing on questions pertaining to changing curatorial and exhibitionary practice, shifting relationships between museums and originating communities, and altered approaches to objects and interpretations. Anita Herle reflects, from the curatorial point of view, on the making of an exhibition. Most particularly, she asks if curatorial techniques can themselves comprise a form of anthropological research. This is especially pertinent given that the curatorial techniques in question center on sustained engagement with objects, and that the exhibition under discussion is the University of Cambridge Museum of Archaeology and Anthropology's *Assembling Bodies: Art, Science and Imagination,* which explicitly "attempted to transcend" subject-object and person-thing dualisms. Herle's discussion of the exhibitionary process is illuminating, and makes a powerful case for the significance of not only shifting considerations of exhibition making specifically but also of more general people-object relationships in and beyond the museum. A second anthropological article follows, this time focusing on changing relationships between museums and indigenous groups, through objects in the museum collections. In this article, Laura Peers explores the sensory and affective engagement of Blackfoot visitors with five historic Blackfoot shirts in the University of Oxford's Pitt Rivers Museum. Ranging over issues of colonial trauma, heritage, memory, kin, and community, Peers

analyzes the role of objects and the senses, including touch, in healing "ceremonies of renewal," and how such ceremonies can enable the strengthening of contemporary knowledge, identity, and well-being in the present. She examines the implications of such a project for museums' shifting sense of their obligations to enable indigenous communities to gain culturally, sensorially appropriate access to the objects with which they identify. Finally, Janet Marstine's article considers socially engaged artistic practice within the museum space. Focusing on a detailed case study of the work of artist Theaster Gates in the 2010 *To Speculate Darkly* project at the Milwaukee Art Museum, she explores how the mobilization of fluctuating postcolonial hybridities enables the museum to make symbolically reparative steps toward equality and inclusivity that might not otherwise have been feasible. Like Peers's article, Marstine's article is underpinned by an acute awareness of the fluidity of identity and the continually shifting relationships between museums, communities, and individuals, especially in postcolonial contexts; but where Peers provides us with a detailed case study of the importance, in such an atmosphere, of working with originating communities and utilizing the power of original objects and sensory experience, Marstine gives us a convincing example of the impact of bringing a socially and politically engaged artistic practice into the museum space. Both, like Herle's article too, constitute instances of changing forms of practice and reflection by and within museums that augment and complement more established curatorial processes.

Change and development generally, in museum practices, representations, and scholarship, are, as we have already observed, themes running through all the research articles in this issue, touched on in various ways and at different museum levels. As an unsurprising corollary to this, also common to all the articles, though in varied ways, are questions about time, history, and changing perspectives. Such issues are raised explicitly by Shelton, Riggs, and Mason, for example, and they are also very clearly present not only in the thematic or institutional repositioning narratives by Parry, Bouquet, and Gibson, but also in the articles focused on newer forms of, and reflections on, practice by Herle, Peers, and Marstine.

These themes are also central to the two 'reports' included in this issue. The first of these gives an account of a workshop held at the Smithsonian Institution in 2012. Focused on issues of digital repatriation and the circulation of indigenous knowledge, the challenges and changing nature of the relationships between museums, communities, and individuals that are addressed in this report have synergy with many of the main themes of the research articles included within this volume. The second report describes a seminar held in Leh, Ladakh, India, also in 2012. Organized by the Department of Museology at the New Delhi National Museum Institute of History of Art, Conservation and Museology, in collaboration with the Ladakh Autonomous Hill Development Council (LAHDC), this seminar brought together Ladakhi and international speakers. It aimed both to explore the museum's potential as a vehicle for the documentation, representation, and communication of sociocultural change, and to help initiate the process of planning a museum for Ladakh.

In summary, each of the contributions to this inaugural issue of *Museum Worlds: Advances in Research* stands independently, and it follows that the articles are quite distinct from one another. Furthermore, the issue does not claim to be a comprehensive review of current trends in museum studies research; indeed, to attempt to create such a review would be unfeasible. Nonetheless, this volume represents a wide number of current trends in museum-related research and practice, includes discussion of examples drawn from five different continents, and, importantly, because of the common threads of change, development, and time, gives an overall sense of dynamism in the field. Museum studies, as an academic and practical field of research that is rapidly expanding and alive with potential, presents an opportunity and challenge that parallels the explosive growth of museums throughout the world. We note that dynamism, development,

and diversity are crucial keywords that mark the trajectory of disciplinary innovation and transformation in our field globally. With a range of articles and reflections that capture breadth as well as depth in the compelling processes of change presently underway in different places and parts of the world, and that also offer the potential for comparison across case studies and contexts, *Museum Worlds: Advances in Research* is critical and responsive, and important now.

ARTICLES

Critical Museology
A Manifesto

Anthony Shelton

■ **ABSTRACT:** Synthesizing work carried out by the author over the past twenty-five years, this article proposes a tentative disciplinary definition of critical museology, distinguishing its related methodological interdictions and describing its distinctiveness from what is here defined as operational museology. The article acknowledges the diverse intellectual sources that have informed the subject and calls for a reorientation and separation of critical museology from the operational museologies that form part of its area of study.

Critical museology, it is argued, is not only an essential intellectual tool for better understanding museums, related exhibitionary institutions, fields of patrimony and counter patrimonies, and the global and local flows and conditions in which they are embedded, but is also crucial for developing new exhibitionary genres, telling untold stories, rearticulating knowledge systems for public dissemination, reimagining organizational and management structures, and repurposing museums and galleries in line with multicultural and intercultural states and communities.

■ **KEYWORDS:** complexity theory, critical museology, deconstructionism, heritage, museum anthropology, museum studies, museum theory

There is not one but three museologies, critical, praxiological, and operational, each defined by a particular epistemological position, method or technique, communicative media, and practice. Critical and praxiological museologies are focused on the study and exploration of operational museology—critical museology from a narrative multidisciplinary perspective, and praxiological museology through visual and performative media.

Praxiological museology is closely related to 'institutional critique' and the work of artists like Marcel Broodthaers, Lothar Baumgarten, Andrea Fraser, Jimmie Durham, Fred Wilson, Hans Haacke, and Joseph Kosuth; it is also closely related to new realism through the work of Edward Paolozzi and Martial Raysse, as well as other artists as diverse as Peter Greenaway, Hiroshi Sugimoto, Gabriel Orozco, Rirkrit Tiravanija, and Mark Dion, particularly his archaeological digs (Fribourg 1995; Umbertide 1976; Venice 1997–1998; London 1999) aimed at ques-

Museum Worlds: Advances in Research 1 (2013): 7–23 © Berghahn Books
doi:10.3167/armw.2013.010102

tioning established classificatory systems and the relation between empirical knowledge and 'amateur' fictions. Since these three museologies have been discussed in earlier publications (Shelton 1997, 2001a), I will focus for the purpose of the manifesto only on critical museology and its relationship to operational museology.

Operational museology is that body of knowledge, rules of application, procedural and ethical protocols, organizational structures and regulatory interdictions, and their products (exhibitions and programs) that constitute the field of 'practical' museology. In addition, it comprises the related professional organizations; accredited courses; systems of internship; mentorship and peer review; conference cycles; and seminars and publications by which it regulates and reproduces its institutionalized narratives and discourses. Operational museology combines, rationalizes, and essentializes different discourses derived from epistemologically distinct systems of knowledge and ethical interdictions into a seemingly discrete and coherent subject that over the past half century has been increasingly taught in universities, credited by professional associations, and applied in museums and galleries internationally. In the past twelve years operational museology has stimulated an avalanche of professional and academic conferences, books, papers, and readers in English, French, Portuguese, and Spanish. However, with few exceptions (Ames 1986, 1992; Macdonald and Silverstone 1991; Macdonald 1998; Hainard and Gonseth 2002; Handler and Gable 1997; Porto 2009; Guasch and Zulaika 2005), the disciplinary architecture and institutional cultures of operational museology have escaped sustained analysis or deconstruction (Hainard and Gonseth 2002: 15; Padró 2003: 51; Díaz Balerdi 2008: 15).

Critical museology has as its subject the study of operational museology. As a field of study it interrogates the imaginaries, narratives, discourses, agencies, visual and optical regimes, and their articulations and integrations within diverse organizational structures that taken together constitute a field of cultural and artistic production, articulated through public and private museums; heritage sites; gardens; memorials; exhibition halls; cultural centers; and art galleries (Bennett 1995; Canclini 1995). These fields are clearly related to competing subfields of power relations and economic regimes that are made partially visible through ideas and counter ideas of patrimony and social identity (Bourdieu 1993: 30; Canclini 1995: 108).

Critical museology is distinct from Peter Vergo's (1989) *The New Museology* (cf Lorente 2003: 15, 2012: 70), which never defined a distinct field or method of study, or subjected the 'old' museology to sustained critical evaluation. Given the title's promise, it is curious that the theoretical apparatus, previous critiques formulated against the 'old' museology, or organizational reorientations implemented or discussed by protagonists like Georges-Henri Rivière, Pierre Mayrand, André Desvallées, Jan Jelínek, or Vinos Sofka were largely unacknowledged (Gómez Martínez 2006: 274–275; Lorente 2012: 50–51). In Britain, it was the contributors to a different volume, Robert Lumley's *The Museum Time Machine*, which appeared the year prior to Vergo's work, who better expressed the growing disquiet about traditional museological presuppositions and operations. The volume's critical trajectory was anticipated by the conference organized by Brian Durrans, Making Exhibitions of Ourselves: The Limits of Objectivity in the Representation of Other Cultures (British Museum, 1986), and through the questions raised by Malcolm McLeod and Edward Paolozzi in their *Lost Magic Kingdoms* exhibition (Museum of Mankind, 1985), as well as the curatorial practices of Charles Hunt, undertaken just a little after Jacques Hainard's experiments at the Museum of Ethnography in Neuchâtel. In his useful synopsis of the international development of museological thinking, Pedro Lorente (2012: 80) rightly confirms anthropology's importance to the emergence of critical museology in the English-speaking world. Nevertheless, the discipline's cross-fertilization with critical theory, sociology, history, historiography, and cultural studies, and the influence of Hainard's own work, which was openly discussed at the Museum of Mankind during this period, should not be underestimated.

Critical museology is predicated on four general epistemological positions that stand in sharp contrast to those endemic to operational museology, and seven basic methodological interdictions that might initially guide its application.

Epistemological Positions

1. History does not exist independent of human perception and cognition, and is constructed by society. It is governed neither by revelation or laws, and is neither spiritually nor materially transcendent of humanity. Furthermore, history is not unitary or unified, but is constructed in distinct ways by different societies. Neither is history necessarily linear nor cumulative. History is composed through the articulation of structures of events that orchestrate causal relations between different conditions, actions, and mentalities to create explanatory frameworks of the past. These frameworks exist as distinct event structures, which are sorted and rationalized to constitute national, minority, or universal histories, each legitimated by supposed truth criteria, which impute it conviction and ensure its reproduction and dissemination through museums, galleries, archives, print and electronic media, and the educational system. Certeau (1988) argues for the absolute incommensurability between the alterity of the past and the 'operations' of historical discourses to capture it, 'operations' that inevitably conclude by being overwhelmed themselves by the enormity of such alterity. This has led the historian Ged Martin to conclude that history is "[s]ocially necessary, but intellectually impossible" (2004: 14), a position not unlike that espoused by Michael Ames (1992: 110) for museums of anthropology.

In *The Savage Mind* (1966), Claude Lévi-Strauss, anticipating part of Certeau's later critique, had already argued that 'history' does not possess a uniform or homogeneous consistency, but is constituted through different 'densities' of events. Some historical periods have left rich documental legacies that provide materials with which causal relations can be constructed, and the resulting interpretations compared to others assembled from like documentation to test the original causal hypothesis. Other periods, however, with a paucity of documentation and their consequent 'lighter' temporal density, are only able to support a thinner and more fragile structure of events. All such structures may be supplemented by archaeological or art historical 'evidence', but in so doing become epistemologically heterogeneous. 'History' then brings these causally inflicted event structures together in a linear projection to compose master narratives, which are appropriated and manipulated by specific interest groups or national and global communities.

History is not only internally differentiated and made up of different densities of time, which determine the conditions and possibilities for the establishment of causal relationships, but every event structure is also made up of different, often competing, structurations of time. Georges Gurvitch, in *The Social Spectrum of Time* (1964), distinguishes between distinct social groups and 'sociabilities' to which he attributes specific historical orientations. Groups experience time differently and consequently structure it in different ways. Furthermore, before the collapse and reduction of the category of time to indices of mechanical movement, and the imposition of the clock to measure such movement, time was marked in different ways, each of which imparted it with a distinctive qualitative character. The fragmentary and unevenly articulated event structures that we describe as constituting history are therefore neither uniform nor unitary; they constitute a heterogeneity of structures that obscure the multiple ways time is experienced and articulated within them.

Universal history is a 'representation' of representations, though as Belting (2003: 66) has noted in the case of art history, one that has internal limitations in its efficacy to encode and transmit a collective memory and that after all is the product of a specific civilization and his-

tory. In exhibitions and textual works, Fernando Estévez González (2004, 2010) has resolutely argued that the past is irrecoverable and can only be grasped through its relationships to a socially constructed present, which is always mediated differentially through unequal power relations. Archives, including museums, never protect or ensure authentic pasts, but, as explored in his exhibition *El Pasado en el Presente* (Tenerife, 2001), reconstitute them within the terms of the present; this process of essentialization involves a series of 'operations' not unlike those employed to create normative landscapes formulated from the freezing of time that Bender identifies with the construction of heritage sites (1998: 26). Museums have been legitimated in operational museology as embodiments of a long genealogy of institutions—the heirs of the library of Alexandria, church treasuries, cabinets of curiosities, and Enlightenment collections (Bazin 1967; Pearce 1989)—that implicitly accept an empirical, cumulative, and noncritical attitude to history fundamentally opposed to the 'archaeological' view essential to critical scholarship. The foundation and operational narratives with which museums legitimate themselves must always be subjected to skeptical scrutiny. Every history is a constructed fiction and every fiction has its own history.

2. The figure of the collector has long been prioritized to give operational museology historical continuity and impart it an objective legitimacy. Collecting, it has been argued (Cabanne 1963; Pearce 1989), has characterized every society and every period in the history of human development and, as I have argued elsewhere, has been naturalized in the work of these authors to become a fundamental psychological predisposition common to the whole of humanity (Shelton 2006: 481–482). Even our species identity (materialist, acquisitive, and competitive) has been defined by our universal propensity to collect. The justification of such activity however, in operational museology, is not attributed to its origin in history but to a transcendental psychological drive (Baudrillard 1981; Muensterberger 1994; Belk 1995). The legitimation of human materialism, acquisitiveness, and competitiveness is, in operational museology, guaranteed by supposed transcendental laws that exist and govern behavior independent of society, but whose effects can be demonstrated and 'proven' by museums asserting a 'truth effect' disseminated through the underlying presuppositions upon which exhibitions and programs are based. Museums legitimate their own 'stories' and activities by reference to transcendental criteria.

Operational museology further accepts that collecting is conditioned by well-defined and explicit ideal modalities. Susan Stewart ([1984] 1993) and Susan Pearce (1989) distinguished three modalities of collecting: fetishistic, souvenir, and systematic. Fetishistic collections are those that have been amassed through a pathological fixation that substitutes a specific type or order of objects in place of the 'normative' sexual impulse. Souvenir collecting is likewise centered on the ego. Here, following Stewart, the individual condenses personal experience of a time and space within an object that then contains his or her subjective memories. Only the systematic collection escapes the confines of the ego, they argue, by subordinating itself to the fulfillment of the rules of a transcendental objectivist taxonomic science. Here, accumulation is regulated by its focus on specific, systematically defined classes of objects, which share a supposed common ('natural') affinity. Only this latter modality, because collecting is regulated by natural taxonomy, is considered 'scientific' and therefore deemed useful for museum-based research and exhibition. In her 1989 book, Pearce used this typology to distinguish between legitimate (systematic) and illegitimate (fetishistic and souvenir) collecting to delineate the division between ethically responsible and irresponsible acquisition. By focusing collecting on the acquisition of systematically constituted object classes, museums are confirmed as scientific institutions and their work relegitimated according to what Lyotard (1984) refers to as a Humboldtian metanarrative that values science for its emancipatory propensity.

Collecting, however, does not fall so neatly into typologies, as many collectors themselves have insisted when discussing their personal or group motivations (Blom 2002; Miller 2008; Shelton 2006, 2011), and in a later work Pearce (1991) herself revises her position to acknowledge that motivations probably draw and combine together all three criteria that she and Stewart had earlier defined. Nevertheless, by reducing the motivations behind collecting to a tripartite psychologically based typology, operational museology has been able to construct and objectify a history through which museum practice was effectively legitimated (Shelton 2001b, 2006). This reduction of history to the play of psychological processes obfuscates the heterogeneous and conflicted contexts in which many collections were made (Fabian 2000; Gosden and Knowles 2001), the political and social contexts of how they were used (Coombes 1994; Levell 2000; O'Hanlon and Welsch 2000; Henare 2005; Elliott and Shambaugh 2005), and their role in defining personal identity (Bann 1994; Miller 2008: 293). Moreover, in some societies where individualism is subordinated to collective identity, psychological explanations may be entirely invalid. Álvaro Armero (2009: 27) is one of few scholars who, while suspecting that biological drives might motivate the propensity to collect nevertheless acknowledges the heterogeneous and nonessentialized directions in which collecting can develop. More fruitful still is the phenomenological approach that sees objects as inseparable from the subject perceiving them. In this formulation, objects seduce and fascinate us without ever imparting us any of their intrinsic identity—the only meaning we can know is that which we ourselves invest in them. Objects are experienced as close and comforting, but nevertheless, existentially, are always distant and alien (Schwenger 2006).

Studies of collecting should not forget what is uncollected and the relation and interpenetration between different regimes of value to better understand how systems of desire are personally mediated (cf. Miller 2008). Such foci may reveal synergies between collectors and what Leah Dilworth has called "meta museums," museums that disrupt and lay bare established rhetoric and celebrate "epistemological dilemmas" (2003: 5), or what Jacques Hainard has called a museology of rupture. A critical museology would aim to rescue museology from both the dead hands of an objectivist history and from psychological reductionism or "cold passion" (Armero 2009), in order to restore a critical and reflexive historical approach to understanding the assemblage of collections and the development of collection-based institutions (Shelton 1997, 2006, 2007b).

3. It will by now be clear that operational museology has constructed the museum's institutional authority on an uncritical acceptance of empirical methodologies anchored in theories of objectivity. The institution of curatorship, based on the privilege it accords material or visual culture as its source of knowledge, is one of the essential guarantors of this self-same authority. Museums reproduce a teleological circle in which curatorship guarantees the knowledge-value of material culture, while the knowledge-value of material culture reciprocally guarantees the curatorial authority on which museums are based. Jacques Hainard has explored this operation extensively in a series of exhibitions at the Museum of Ethnography, Neuchâtel, that culminated in *Le musée cannaibale* (2002), In Hainard and Gonseth's view,

> to feed the visitors of their exhibitions, museologists take from their reserves pieces of the world's material cultures. To prepare these objects they use recipes meant to bring to light the contrasts and similarities existing between the worlds of here and there. To do this, they have more or less agreed on a rhetoric which remains poorly analyzed and put into practice without method or system, wherein they mix juxtaposition, aestheticization, sacralization, mimesis, changes of scale and hybridization, logical relations and poetic associations, exhibiting their items either simply in showcases or in complex three-dimensional ways. (2002: 15)

Díaz Balerdi (2008: 67) reiterates the unquenchable appetite of museums for increasing their collections and transforming objects into exhibitions, publications, and programs, while at the same time concealing them in stores and warehouses to ensure their public face at least appears slim, slender and cool. For him, following the digestive metaphor, museums show all the symptoms of bulimia.

Objects, in the context of museum displays, not only act as signifiers but signifieds too. Their presence is not only a condition of their existence, but also a guarantor therefore of their meaning. They are performed as if they contain within them both form (optical evidence) and meaning (authority), which the curator traditionally had responsibility to unfold and make explicit to the wider public (Padró 2002: 54). For this reason authenticity, and the knowledges, technologies, and certifications that guarantee the object's 'purity' or 'sanitization', assume overwhelming importance in much curatorial work, while the proliferation of replicas, imitations material, and virtual copies (Estévez González 2010: 36) and the mutual 'impingements' of the authentic and the restored (Eco 1986), issues that raise fundamental questions, are only at best reluctantly acknowledged by operational museology. What is 'authentic', it needs be asked, in an increasingly hybrid world in which technology has the capacity to intervene through diverse operations to preserve, conserve, restore, and repair and reverse the effect of historical decay to mediate cultural and natural extinction? Is such obfuscation an effect of the museum's intention to always create order where none necessarily exists, not dissimilar from the operations of scientific laboratories, where the social and technical are intermingled and alternative scientific hypotheses are limited and restrained by the imposition of frameworks (Latour and Woolgar 1986: 36–37)? The application of the sciences of preservation is likewise culturally mediated (Clavir 2002: 54). The idea that objects have significance independent of their mediation through consciousness is, given the arguments of Barthes (1972, 1994), Baudrillard (1981, 1983), Certeau (1988), Appadurai (1986), and Kopytoff (1986), difficult to uphold, as is evidenced by the sustained criticism positivist material culture studies have received both by processual archaeologists and exponents of "new material culture studies" (Tilley et al. 2006). If objects and meanings are not held together by any 'naturalized' binding relationship—except that arbitrarily attributed to them—not only can an object's meaning change and differ at specific stages in its 'life history', but the nature of the simulacra through which it becomes imminent might itself change. Kopytoff (1986) and Baudrillard (1981) introduced a paradigmatic shift in material culture studies whose implications for curatorial work and the status of museum authority continue to be poorly appreciated within the profession. The move from an objectivist to a subjectivist concept of knowledge, as Jacques Hainard, Fernando Estévez González, Mary Bouquet, Bruno Latour, and Nuno Porto, among others, have repeatedly demonstrated in their curatorial strategies, retain enormous potential to generate new heterologies and explode the limited range of existing exhibition genres.

4. Related to these critiques of objectivist interpretations of the object is the precept that signifiers themselves have no common 'valency' in their relation to signifieds. Baudrillard (1983: 83) returned repeatedly to distinguish four different reality effects or simulacra that are created as a result of the distinct and irreductive relations constructed between signifiers and signifieds and among different categories of signifiers themselves. Baudrillard first isolated three simulacra as a typology that appeared to succeed each other chronologically. Later a fourth, viral simulacra, was identified which appeared to be specific to the contemporary world. Nevertheless, no such tidy chronological order exists in a society that is now nearly totally globalized and in which specific groups and ethnicities operate within and between different simulacra that coexist and sometimes overlap at the same time. Such simulacra are no longer restricted to

particular ethnicities and geographical spaces but may be specific ways of thinking that stretch between distinct cultures and geographies, as in Eco's (1986) and Baudrillard's (1989) hyper-realities. Under these conditions, increasing complexities and ambiguities within and between cultures and societies are exacerbated to the extent that any simple correspondence between object and meaning in museum displays hides, at best, a crass disequivalence that obfuscates our wider experience of existence. Operational museology develops within a field whose reality is constantly manipulated and attested through its own operations where politics are inseparably embroiled in its 'truth' (cf. Latour and Woolgar 1986: 237). Museums, however, no matter how deeply obfuscated, are fundamentally more heterotopic than the societies in which they operate and are therefore potentially disruptive of them.

Methodological Interdictions

1. Agency, while a key area of anthropological research and radical pedagogy, was almost entirely ignored by operational museology. Not only the agency of the institutions themselves, but also the agency implicit in the construction and institutionalization of collections, exhibitions, and related pedagogic work, was effectively eluded in the institution's public presentation. Critical museology needs to uncover these occulted relations, and also examine the intersections and struggles between different types of agencies represented by distinct groups and cultures (Ames 1992: 78). The museum, no more than the expression of an official patrimony, does not expend agency in a vacuum. It elicits resistance, contestation, counterprojects, and even violent reactions that seek its destruction, such as the large-scale cultural looting performed by Napoleon, Hitler, and Stalin; the destruction of patrimony after the fall of the Soviet Union and its satellites; or, more recently, the looting and bombardment of Iraq and Syria and the destruction of the Bamiyan Buddhas. The agency of patrimony and museums can be redirected into projects of reconciliation and cultural healing, as in the case of Holocaust museums, the Tuol Sleng Genocide Museum in Phnom Penh, commemorating those executed by the Khmer Rough, or the exhibition *Yuyanapaq: Para Recordar* (Museo de la Nacion, Lima, 2009), documenting the violence during the Peruvian state's struggle with Sendero Luminoso. Agencies and counter-agencies gain special visibility in the transfer of cultural property, such as in the repatriation of Ts'elxweyaqw from the Burke Museum in Seattle to the Sto:lo First Nation in British Columbia (2006), or the G'psgolox Pole from the National Museum of Ethnography in Stockholm to the Haisla First Nation (2006).

In 2010, the Reina Sofia hosted the exhibition *El Principio Potosi*, intended as a collaborative enterprise between German, Spanish and Bolivian museologists. The exhibition concept was intended to juxtapose seventeenth- and eighteenth-century Andean Catholic images with contemporary art works to draw parallel histories between the iconography and symbolic violence inherent to historical and current capitalist economic and ideological strategies. However, the project was severely critiqued by the Bolivian curators because of the lack of acknowledgment given to the historical and continuing role of indigenous agency in the appropriation and incorporation of these 'foreign' images into a uniquely Andean worldview.

Examples such as these emphasize the analytical importance of cross-cultural collaborative methodologies, which, even in a world characterized by increasing intercultural relations and hybrid cultures, better explicate the specificities and nuances of unique and irreducible cultural processes, epistemologies, and ontological understandings. Moreover, it is through such culturally diverse collaborations, of whose power operational museology is well aware, that critical museology can help perpetuate its own critical efficacy while ensuring that the so-called democ-

ratization and decolonization of museums, here taken as labels that denote continuous processes rather than completed conditions, remain an important goal.

2. Every theoretical intervention within museology occurs within an already constituted intellectual field made up of competing subject positions. Bourdieu defines a field as "a separate social universe having its own laws of functioning independent of those of politics and the economy" (1993: 162). The field includes the social conditions that determine the possibilities of specific functions. It is both conditioned and conditioning and includes the mechanisms that regulate its attendant power relations and define the limits of struggle between the different subject positions within it. Museological practices should be understood in relation to the field in which they unfold. This reflexivity is a necessary precondition for establishing a theory of practice, from which a practice of theory can emerge. Only by theorizing museum practices do we become conscious of the presuppositions that we apply to our everyday work, and only through a rigorous deconstruction and reflexivity of that work can we develop fresh insights and innovations necessary to ensure the future development of museums, such as in the example that follows.

As a precondition for the major gallery projects undertaken at the Horniman Museum, London, and the Royal Pavilion, Art Gallery and Museum, Brighton, it was thought necessary to understand the broader history of ethnographic curatorship in the United Kingdom (Shelton 1992, 2003). After comparing the chronology around the implementation and use of particular anthropological paradigms within museums and universities, it became apparent that for most of the twentieth century there had been a lag between the dismissal and adoption of each paradigm within the two institutions. This had resulted in some outdated and sometimes racist ethnographic exhibitions in the UK's provincial museums that had out lived perspectives already discredited within the university system. This preliminary study steered the adaptation, at Brighton, in two adjoining galleries, of radically different approaches, intended to capture the tensions and contradictions implicit to intercultural communication. The first gallery used categories including exchange, worship, work, association, secret societies, gender, etc., to present a comparative perspective on Western and non-Western aspects of culture; the second gallery examined the motivations behind various collectors who had donated substantial collections to the museum. The effects, conditions, and themes derived from the tensions generated between these two gallery approaches provided the subject for a series of small temporary exhibitions curated in a third space. Such an approach was generated in response to the theorization of some of the practices disclosed by the deconstruction of the history of ethnographic exhibitions in the United Kingdom.

3. The distinction between museology and museography, as discussed by Desvallées and Mairesse (2010: 52–54), is fundamentally incompatible with the methods of critical museology. To distinguish between museology as the study of museums and museography as a configuration of scientific, technical, and managerial knowledges (architecture, environmental controls, lighting, conservation, visitor studies, management) eludes the essential and dependent relations between the two systems of knowledges and obscures their points of articulation, relations of dependency, common epistemological origins, and political linkages and functions. By distinguishing between applied and intellectual knowledge we obscure the close relations between them and the way they are mediated through social relations. This only reinforces their appearances as closed, systematic, and coherent fields devoid of social and cultural operations (Latour and Woolgar 1986: 21). As Miriam Clavir demonstrates in *Preserving What Is Valued* (2002), science, in this case conservation, is always mediated and applied following social values and ethics fundamental to the very structure of museums and the various professional bodies that

buttress them. On a different level even the presentation of science in museums has itself repeatedly been argued to be socially and ethically mediated and to take place within specific social arenas, which are usually eluded from public view (Macdonald 1998; Vackimes 2008: 17).

More obviously, management, another core component of operational museology, is also based on cultural value and social-structural models governing the distribution of resources to achieve set functions. Functions, levels and application of resources, values attributed to such institutions, and the optimal organizational structure of power and authority are 'operations' all determined by political and socioeconomic considerations (Strathern 2000: 2). By comparing management models, which represent the ideal distribution of power and authority within an institution, to their practical implementation it is possible to locate the contradictions and areas of tensions and contestations that play a fundamental role in institutional change and transformation, and that form an essential part of critical museology.

The distinction between museology and museography, in the work of some of its expounders, divides the study of the publicly visible side of museums, exhibitions and programs, from that of its largely invisible organization and support structures, reproducing a division that easily occults the source of an important determinant of public policy. It is not, I believe, possible to distinguish between technical or applied knowledges on the one hand and interpretive methods on the other without privileging the site of museography as a theoretical 'no-go zone' and eluding the political determinants and epistemological presuppositions to which public programs respond. Like the laboratory described by Latour and Woogar, museum activity is deeply complicit in "the organization of persuasion through literary inscription" (1986: 88).

4. Museums, along with museology itself, are part of wider fields of social, political, and economic relations and cannot be understood when segregated from other museums and galleries, heritage sites, monuments, and formulations and counterformulations of 'patrimony' and national or regional identities. James Clifford's groundbreaking work "Four Northwest Coast Museums: Travel Reflections" ([1991] 1997) effectively shifted the study of museums away from individual institutions to the field of museological operations, in which individual museums and cultural centers are compared and interpreted. Not only did he distinguish similarities and differences in the institutional poetics of their displays, but he also related their innovations to a specific experience of indigenous/settler politics in British Columbia.

In a different context, Estévez González (2006: 151–152) draws attention to the growth of networks of museums, warning of their political tutelage and their involvement in new projects related to identity formation; the 'McDonald's-ization' of museums to become part of the tourist industry and the 'New Economy'; and the homogenization of museums under the direction of a hegemonic operational museology.

Operational museology itself is not a unified or coherent field, despite, as Estéves González (ibid.) observes, its claim to scientific status through which it aspires to claim universality. Its fractures and differences are evidenced in the two movements that Gómez Martínez (2006: 12–13) distinguishes as dividing the Anglo-Saxon and Mediterranean museum worlds. These differences, he argues, were determined by religious orientation and their associated sentiments and distinguished by their different foci on family, community, and society; the idea of service; and the love and celebration of beauty (ibid.: 19). Such a distinction is similar, in some regards, to Lyotard's (1984) description of what he refers to as the Humboldtian and classical paradigms, the dominant metanarratives underlying the legitimation of science and art and their respective museological institutionalizations.

It is no longer possible to distinguish between local, regional, and national museums (Shelton 2005, 2007a). Regardless of the nature of the state and its relation to the regional polities

within it, or its connections to neighboring states, there now exist multiple networks that link museums and other agencies more closely together than ever before. Critical museology must therefore distinguish between different fields that, depending on geographic proximity, political integrations, or shared subject positions, will be marked by variations in the intensity of their interactions and influences. Assuredly such fields cut across disciplines, sometimes creating repetitive but different scales of representational effects. Writing itself, as is clearly attested in nineteenth- and early twentieth-century travel narratives, contains strategies to fix and naturalize the materiality of the world in ethically charged spaces and times and to organize our visual and nonvisual experience of them. Such operations reaffirm the curatorial designs implicit within related media, including international exhibitions and museums.

5. Crucial to critical museology is the proposition that in defining any aspect of the society or regional civilization of which that society is part, we implicitly define or reproduce its opposite (cf. Preziosi 2003: 98–99; Said 2002: 202, 301–302). The institutionalization by museums of, for example, collections therefore needs to be critically assessed and the analysis of its effects examined for their political implications.

It is usual for museums to elide the presence and agency of Western institutions and individuals, including themselves, in the history of assembling collections and imputing them meaning. The circulation between different cultures of 'works' and the construction of their specific arenas or fields of political and cultural meaning are broken and obscured by the geographical separation of collections from one part of the world from those from another (Henare 2005). Trade, exchange, collecting, and looting are seldom elaborated upon in museum displays, partly because Euro-American material culture and art are institutionalized differently from their non-Euro-American counterparts, as if there had never been any historical contact between them.

Difference is created by the imposition of a limit, which draws a boundary around one category while at the same time delineating what becomes an absence. Limits are constructed by linguistic discrimination—the differentiation of signs that intervene between the undifferentiated experience of the world and its conceptualization through language. The separation between the condition of being and the act of experience constitutes a fundamental alienation between the world and consciousness, casting all signs, even within the same language, as 'foreign' to each other. Either way, there is no exterior to the everyday/exotic worlds imagined by the technologies that reproduce differential equations between them.

Language articulates and sometimes assists visualization of elaborate structures of otherness. The 'we' and the 'other' has been expressed in the past through the supposition of distinct mentalities, associated with specific cognitive mechanisms, operations, and ways of experiencing the world, as well as different ensuing histories (and nonhistories) and nonlinguistic cultural forms of expression. Further limits were and are constructed to equate these differences with geographical boundaries or psychological states and dispositions. Differences have been argued to have been created by species, race, gender, age, or form. These operations underlying the construction of difference produce the normative, familiar, and self-identifiable at the same time they lay out the space and raw material for the articulation of their opposites. Moreover, these phenomenological, linguistic, and philosophical operations, once concretely expressed, receive embodiment through their institutionalization, an institutionalization that is usually legitimated by historical objectification and essentialized to endow its authority transcendental value. The ongoing reorganization of the French museum system demonstrates well the changing political effects of institutionalization and reinstitutionalization on collections.

In 1996, the Chirac government announced it would move the ethnographic collections from the Musée de l'Homme and amalgamate them with those from the Musée National des Arts

d'Afrique et d'Océanie (MNAAO) to create the much discussed Musée du quai Branly (Clifford 2007; Price 2007; Shelton 2009). Not all the collections of the Musée de l'Homme were sent to the quai Branly. One hundred and fourteen 'masterpieces' were taken to be exhibited in the Pavilion des Sessions in the Louvre; works representing Asian civilizations were sent to the Musée Guimet; and just as significant, European ethnographic collections were set aside to be amalgamated with others from the Musée National des Arts et Traditions to form a reserve that is intended to provide the basis for the new Musée de l'Europe et de la Méditerranée, to be opened in Marseille in 2013.

By separating European from non-European collections, France reinforced an older and much criticized binary division between Europe and the 'other'. This difference, it is reported, has been smudged in the Marseille project by the unavoidable acknowledgment that the growth of Europe has always been intimately connected to the development of neighboring civilizations. It would be implausible to present European knowledge systems; science, cartography, medicine, and astrology; and Christianity, Judaism, and Islam independent of discussion of the wider region. Here, therefore, at least, the essentialization and purification of European material and intellectual culture might be mitigated. The quai Branly, however, in its permanent exhibitions, is unable to avoid the essentialization of the non-European cultures that it exhibits. Although there are soft transitions from one continental area to another, objects are abstracted and exposed as indices of specific cultural essences. Detached from history, collections have been purified and essentialized within a Western-generated grammar of difference that is mute to all and any process, transformation, or intercultural relationship that might have created links between Europe and elsewhere. Here, the West has effectively edited itself out of the process of the formation of these collections, and with it, even the mention of the circulation of ideas, technologies, and people between different worlds on which our own identity as well as that of those we 'other' has been constructed. The French museum system has proven itself an effective technology for distilling different grades of otherness and placing them in various historical, modern, and contemporary conjunctions with the 'we'.

The radical separation of European and non-European works institutionalized in the Musée du quai Branly is mirrored by that of people in the Cité National de l'Histoire de l'immigration. This is not a museum of immigration and emigration, which would have presented the mutual relationship between France and the world, but instead focuses only on the one-way movement of non-French people into France, a magnet with only one pole. It would appear therefore that whether intentionally or not, French museums have redoubled their efforts to maintain the separation between domestic and 'foreign' cultures and have thereby remained silent, in their permanent exhibition galleries at least, on the changing relations between Europe and the rest of the world. Ethnic cleansing, political and economic colonialism and dependency, Arab expansionism, colonialism and slavery, US counterhegemonic dependency and military projections, and, more recently, the effects of Asian economic development on Europe are all absent. We Euro-Americans have found it difficult to escape our own epistemologies and have articulated the 'other'—the reconstruction of archaeological sites or the historic centers of cities—through our own imagination of an 'other' using a Western gaze and framework. In short: The construction of the 'other' follows the same syntax as the construction of the 'we' (Preziosi 2003: 120).

6. Critical museology is never exhausted by the act of deconstruction. "Incredulity towards metanarratives," the skeptical attitude toward knowledge and the masquerading of information as knowledge (Lyotard 1984), is an essential attitude toward museum and gallery institutions, which must be sustained to ensure the continuity of self-critical and reflexive practices. It would be naïve not to expect that the insights derived from critical museology might be incorpo-

rated, undoubtedly for sincere reasons, into the operation, policy, or programming of museums and art galleries, rather like galleries have used artists associated with institutional critique to inform their own values, programming, and operations, though not, it needs to be acknowledged, without consequent dilution of their critical strategies (Crimp 1993: 155). The purpose of critical museology is not, however, to reform institutions or to claim a privileged position for its own practice, but to sustain an ongoing critical and dialectical dialogue that engenders a constant self-reflexive attitude toward museum practices and their wider constituencies. As theoretical knowledges move from intellectual to museum fields, they inevitably undergo a process of mediation, and reintegration within museum practices, objectives, vision, and values. Within this process, adopted perspectives become relationally and sometimes epistemologically transformed within new determinate fields. Oscar Navarro Rojas's exhortation that critical museology should aim to confront the museum visitor with "the dilemmas of contemporary society through the eyes of history and critical memory and ethics" (quoted in Lorente 2012: 81) should, like the provocative museological experiments of Hainard, equally never escape critical scrutiny. Neither should it be ignored that critical museology itself has grown in the shadow of the emergent master narrative of the 'New Economy', which predicates a major rearticulation of the arts, cultural and knowledge organizations, and their commodification within a knowledge and experience economy (Löfgren and Willim 2005: 2). Critical museology must, therefore, always maintain a sustained incredulity to itself as well as its field of application. It follows that critical museology could never be an operational tool or provide an alternative strategic mission for museums, though it needs to encourage institutions to adopt more experimental practices, champion openness and transparency, and support critical community engagement.

Such an unflinching attitude is not easy to sustain and can be expected to meet institutional as well as external resistance. Providing support for one party or another in situations of contestation over museum authority, and its ideological underpinnings, might merely result in the exchange of one static and hegemonic discourse for a counterhegemony that itself might do no more than nourish new hegemonies. Unlike operational museology, which implicitly is always politically situated, critical museology must remain politically skeptical if it is to ensure it remains reflexive, open, and critical. Failure to maintain distance between institutional and critical thought casts critical museology back into the mold of an operational subject position.

7. The epistemological critique of dominant models of museum operations, and the necessity to broaden the field of study to include adjacent institutions and national and international organizations suggests we should revise the lens through which we view museums. Since Clifford (1997) and Pratt (1992) formulated the concept of the contact zone, museums have moved beyond easily definable, geographically circumscribed arenas of interaction. Globalization, the formation of extraterritorial political and economic federations, and interterritorial organizations, together with the growth of the Internet and social networking sites, have contributed to phenomenal increases in connectivity between institutions. It is no longer adequate to define a museum solely by its physical plant and 'real' space exhibitions, programs, and projects. More now than at any time in their existence, museums perform as hubs within expansive international, national, and regional networks, and in so doing have lost more of their privileged singularity and uniqueness.

Such networks connect museums, the subject positions represented within them, professional organizations, and management structures. They also connect museums with diverse client communities, including those from where their collections originated. Geographical distance is no longer sufficient to ensure the separation of object and subject, as evidenced by the growing and rightful refusal of communities, artists, and individuals to remain silenced

on issues of institutional objectification and ownership rights. These networks, both virtual and physical, carry technical information, development campaigns, and managerial directives; they host research projects and lobbies; they project exhibitions and programs regionally and internationally; and they connect museums and communities, funding, and political sources, providing access to collections and archives and conduits for critical engagement. Networks are interactive and carry multidirectional flows of information. In short, they integrate institutions to the world, establishing a hypercomplexity that museum theory has been slow to appreciate (Cameron and Mengler 2009: 191).

It is individuals that create specific networks, even if institutional policy attempts to define their foci, a condition which results in a diffusion and broader spread of institutional authority and opens the prospect of its manipulation through network lobbying between groups within and external to museums. Critical museology needs to develop the analytical tools to enable museums to be better understood as hubs within hypercomplex, though not necessarily cohesive, networked fields. Hubs are both virtual and material, although their coexistence within or between fields does not necessarily imply similarity or correspondence between them. The epistemological foundations of the nodal institutions that make up a network can be radically separate, while at the same time intimately implicated in each other's operations. The virtual erases spatial difference—an exhibition or program on one side of the world can intervene in the subject or condition about which it is focused in places far removed from it; the instantaneousness of the moment of diffusion blinds temporal succession and denies the discreteness, even if it was only an appearance, of event structures; spatial and temporal boundaries, 'self' and 'other', being and nothingness which all dissolve under the operational world conjured by the virtual (Virilio 1991: 13). The paradox of contemporary existence is that while the virtual suffuses material institutions and threatens their discrete existence (solid walls, mission statements, institutional values, and political and ideological fields) at the same time it depends on them for its own existence and reproduction. Estévez González compares social and mechanical time, with "instantaneous time, the time of virtual reality", noting each conception has its own mode of regulating society and nature (2004: 17), which repeatedly brings nostalgia into collision with postmodernist pastiche (ibid.: 14). The museum and archive are perhaps frozen between this binary. "The past is everywhere," writes Estévez González; "[i]t is fashionable" (ibid.: 13); an impossible condition, that never the less envelopes our existence.

Instead of conceiving museums as the latest manifestation of a long line of collection-based institutions beginning with the Library of Alexandria, or Noah's Ark, we need to understand them as part of distinctive exhibitionary complexes (Bennett 1995), situated within particular historical periods and geographical principalities or fields. We need to exchange generalities about the historical development of collecting and exhibiting institutions (they are not always the same) for particularities of their function within set geographies and histories. Instead of reducing the subject of collecting to specific typologies, we need to examine the way collections have been used in self-fashioning social and personal identities (Bann 1994; Henare 2005; Elliott and Shambaugh 2005). Museums must recognize more generally that they no longer possess a monopoly over the meaning and significance of the material or visual cultures they institutionalize, and that objects have different meanings depending on their positionality in regard to distinct ethnic groups, classes, institutions, and exhibitionary strategies, which imply mutual rights and obligations (Hainard and Gonseth 2002; Shelton 2000). Following the already well-established application of the cannibalistic trope to museums, the question that needs to be asked is whether the coexistence of virtual and material realities leads to museum's autodigesting themselves. After severing the mechanical relationship between objects and meaning previously fixed by positivist sciences and developing a genre theory that might do for exhibitions

what literary theory has done for literary criticism, we can begin to develop new practices and new types of exhibitions that can be disseminated both materially and virtually. New challenges and expectations surrounding museums, and their implications for their traditional operations, have created major ruptures within operational museology that now demand a new disciplinary response to demystify them and assist in liberating and reharnessing their full creative and explosive potentialities. Rather than reduce possible museum futures to a simple choice between them being 'temples' or 'forums', let us reimagine them as laboratories redolent with possibilities. It is a worthy enough aspiration that a critical museology might strive to constantly help renew such quixotic and such essentially dialectical institutions as museums and galleries.

ANTHONY SHELTON is the director of the Museum of Anthropology and professor of Anthropology at the University of British Columbia in Vancouver. He has published extensively on critical museology, collection's history, the anthropology of art and indigenous Latin American and material culture and cosmology. His most recent work is *Luminescence: The Silver of Perú* (2012), which accompanied a major exhibition hosted both by the University of British Columbia and the University of Toronto.

REFERENCES

Ames, Michael. 1986. *Museums, the Public and Anthropology. A Study in the Anthropology of Anthropology.* New Delhi: Concept Publishing Company and Vancouver: University of British Columbia Press

Ames, Michael. 1992. *Cannibal Tours and Glass Boxes: The Anthropology of Museums.* Vancouver: University of British Columbia Press.

Appadurai, Arjun. 1986. "Introduction: Commodities and the Politics of Value." Pp. 3–63 in *The Social Life of Things, Commodities in Cultural Perspective,* ed. A. Appadurai. Cambridge: Cambridge University Press.

Armero, Álvaro. 2009. *Por eso coleccionamos: Sensaciones de una passion fría.* Seville: Los Cuatro Vientos/Renacimiento.

Bann, Stephen. 1994. *Under the Sign: John Bargrave as Collector, Traveller and Witness.* Ann Arbor: University of Michigan Press.

Barthes, Roland. 1972. *Critical Essays.* Evanston: Northwestern University Press.

Barthes, Roland. 1994. *The Semiotic Challenge.* Berkley and Los Angeles: University of California Press.

Baudrillard, Jean. 1981. *For a Critique of the Political Economy of the Sign.* St. Louis, Telos.

Baudrillard, Jean. 1983. *Simulations.* New York: Semiotext (e), Inc.

Baudrillard, Jean. 1989. *America.* London and New York: Verso.

Bazin, Germain. 1967. *The Museum Age.* Brussels: Deoer.

Belk, Russel. W. 1995. *Collecting in a Consumer Society.* London: Routledge.

Belting, Hans. 2003. *Art History After Modernism.* Chicago: University of Chicago Press.

Bender, Barbara. 1998: *Stonehenge: Making Space.* Oxford: Oxford International Publishing.

Bennett, Tony. 1995. *The Birth of the Museum: History, Theory, Politics.* London: Routledge.

Blom, Phillip. 2002. *To Have and to Hold: An Intimate History of Collectors and Collecting.* London: Allen Lane.

Bourdieu, Pierre. 1993. *The Field of Cultural Production.* New York: Columbia University Press.

Cabanne, Pierre. 1963. *The Great Collectors.* London: Cassell.

Canclini, Nestor Garcia. 1995. *Hybrid Cultures: Strategies for Entering and Leaving Modernity.* Minneapolis: University of Minnesota Press.

Cameron, Fiona and Mengler, Sarah. 2009. "Complexity, Transdisciplinarity and Museum Collections Documentation: Emergent Metaphors for a Complex World." *Journal of Material Culture* 14 (2): 189–219.

Certeau, Michel de. 1988. *The Writing of History.* New York: University of Columbia Press.

Clavir, Miriam. 2002. *Preserving What Is Valued: Museums, Conservation and First Nations.* Vancouver: University of British Columbia Press.

Clifford, James. [1991] 1997. "Four Northwest Coast Museums: Travel Reflections." Pp. 107–146 in *Routes: Travel and Translation in the Late Twentieth Century,* by J. Clifford. Cambridge, MA: Harvard University Press.

Clifford, James. 2007. "The Quai Branly in Process." *October* 120 (Spring): 3–23.

Coombes, Annie. 1994. *Reinventing Africa: Museums, Material Culture and Popular Imagination in Late Victorian and Edwardian England.* New Haven, CT: Yale University Press.

Crimp, Douglas. 1993. *On the Museum's Ruins.* Cambridge, MA: MIT Press.

Desvallées, André and Mairesse, François. 2010. *Key Concepts of Museology.* Paris: ICOM with Armand Colin.

Díaz Balerdi, Ignacio. 2008. *La memoria fragmentada: El museo y sus paradojas.* Gijón, Spain: Ediciones Trea, S.L.

Dilworth, Leah, ed. 2003. *Acts of Possession: Collecting in America.* New Brunswick, NJ: Rutgers University Press.

Eco, Umberto. 1986. *Travels in Hypereality.* New York: Harcourt Brace Jovanovich.

Elliott, Jeanette S. and Shambaugh, David. 2005. *The Odyssey of China's Imperial Art Treasures.* Seattle: University of Washington Press.

Estévez González, Fernando. 2006. "Redes de museos: Conexiones y enredos." *Museo: Revista de la Asociación Profesional de Museólogos de España* 11: 151–157.

Estévez González, Fernando. 2010. "Archivo y memoria en el reino de los replicantes." Pp. 31–45 in *Memorias y olvidos del archive,* ed. F. Estévez González and M. de Santa Ana. Tenerife: Museo de Historia y Antropologia de Tenerife.

Estévez González, Fernando, ed. 2004. *El pasado en el presente.* Tenerife: Museo de Antropología de Tenerife.

Fabian, Johannes. 2000. *Out of Our Minds: Reason and Madness in the Exploration of Central Africa.* Berkeley: University of California Press.

Hainard, Jacques and Gonseth, Marc-Olivier. 2002. *Le musée cannibal.* Neuchâtel, Switzerland: Musée d' Ethnographie.

Handler, Richard and Gable, Eric. 1997. *The New History in an Old Museum: Creating the Past at Colonial Williamsburg.* Durham, NC: Duke University Press.

Henare, Amiria. 2005. *Museum Anthropology and Imperial Exchange.* Cambridge: Cambridge University Press.

Gómez Martínez, Javier. 2006. *Dos museologías: Las tradiciones anglosajona y mediterránea: diferencias y contactos.* Gijón, Spain: Ediciones Trea, S.L.

Gosden, Christopher and Knowles, Chantal. 2001. *Collecting Colonialism: Material Culture and Colonial Change.* Oxford: Berg.

Guasch, Ana María and Zulaika, Joseba, eds.2005. *Learning from the Bilbao Guggenheim.* Reno: Center for Basque Studies, University of Nevada.

Gurvitch, Georges. 1964. *The Spectrum of Social Time.* Dordrecht, Netherlands: Reidel.

Kopytoff, Igor. 1986. "The Cultural Biography of Things: Commoditization as Process." Pp. 64–94 in *The Social Life of Things, Commodities in Cultural Perspective,* ed. A. Appadurai. Cambridge: Cambridge University Press.

Latour, Bruno and Woolgar, Stève. 1986. *Laboratory Life: The Construction of Scientific Facts.* Princeton, NJ: Princeton University Press.

Levell, Nicola. 2000. *Oriental Visions: Exhibitions, Travel, and Collecting in the Victorian Age.* London: Horniman Museum; Coimbra, Portugal: Museu Antropológico da Universidade de Coimbra.

Lévi-Strauss, Claude. 1966. *The Savage Mind.* London: Weidennfeld and Nicolson.

Löfgren, Ovar and Willim, Robert, eds. 2005. *Magic, Culture and the New Economy.* Oxford: Berg

Lorente, Pedro. 2003. *Museología crítica y Arte contemporáneo.* Zaragoza, Spain: Prensas Universitarias de Zaragoza.

Lorente, Pedro. 2012. *Manuel de historia de la museología*. Gijón, Spain: Ediciones Trea.

Lumley, Robert. 1988. *The Museum Time Machine: Putting Cultures on Display*. London and New York: Routledge.

Lyotard, Jean-François. 1984. *The Postmodern Condition: A Report on Knowledge*. Manchester: Manchester University Press.

Macdonald, Sharon, ed. 1998. *The Politics of Display: Museums, Science, Culture*. London: Routledge.

Macdonald, Sharon and Silverstone, Roger. 1991. "Rewriting the Museum's Fictions: Taxonomies, Stories and Readers." *Cultural Studies* 4 (2): 176–191.

Martin, Ged. 2004. *Past Futures: The Impossible Necessity of History*. Toronto: Toronto University Press.

Miller, Daniel. 2008. *The Comfort of Things*. Cambridge: Polity Press.

Muensterberger, Werner. 1994. *Collecting: An Unruly Passion: Psychological Perspectives*. Princeton, NJ: Princeton University Press.

O'Hanlon, Michael and Welsch, Robert. 2000. *Hunting the Gatherers: Ethnographic Collectors, Agents and Agency in Melanesia, 1870s–1930s*. New York: Berghahn Books.

Padró, Carla. 2003. "La museología crítica como una forma de reflexionar sobre los museos como zonas de conflict e intercambio." Pp. 51–70 in *Museología crítica y Arte contemporaneo*, ed. J. P. Lorente and D. Almazán. Zaragoza, Spain: Prensas Universitariasde Zaragoza.

Pearce, Susan. 1989. *Museum Studies in Material Culture*. Leicester, UK: Leicester University Press.

Pearce, Susan. 1991. "Collecting Reconsidered." Pp. 143–151 in *Museum Languages: Objects and Texts*, ed. G. Kavanagh. Leicester, UK: Leicester University Press.

Porto, Nuno. 2009. *Modos de objectificação da dominação colonial: O caso do Museu do Dundo, 1940–1970*. Lisbon: Fundação Calouste Gulbenkian.

Pratt, Mary Louise. 1992. *Imperial Eyes: Travel Writing and Transculturation*. London and New York: Routledge.

Preziosi, Donald. 2003. *Brain of the Earth's Body: Art, Museums, and the Phantasms of Modernity*. Minneapolis: University of Minnesota Press.

Price, Sally. 2007. *Paris Primitive: Jacques Chirac's Museum on the Quai Branly*. Chicago: Chicago University Press.

Said, Edward. 2002. *Reflections on Exile and Other Essays*. Cambridge, MA: Harvard University Press.

Schwenger, Peter. 2006. *The Tears of Things: Melancholy and Physical Objects*. Minneapolis: University of Minnesota Press.

Shelton, Anthony. 1992. "The Recontextualisation of Culture in UK Museums." *Anthropology Today* 8 (5): 11–16.

Shelton, Anthony. 1997. "The Future of Museum Ethnography." *Journal of Museum Ethnography* 9: 33–49.

Shelton, Anthony. 2000. "Museum Ethnography: An Imperial Science." Pp. 155–193 in *Cultural Encounters: Representing 'Otherness'*, ed. E. Hallam and B. Street. London: Routledge.

Shelton, Anthony. 2001a. "Unsettling the Meaning: Critical Museology, Art and Anthropological Discourse." Pp. 142–161 in *Academic Anthropology and the Museum: Back to the Future*, ed. M. Bouquet. New York: Berghahn Books.

Shelton, Anthony. 2001b. "Museums in an Age of Cultural Hybridity." *Folk: Journal of the Danish Ethnographic Society* 43: 221–249.

Shelton, Anthony. 2003. "Curating African Worlds." Pp. 181–193 in *Museums and Source Communities*, ed. L. Peers and A. Brown. London: Routledge.

Shelton, Anthony. 2005. "The Imaginary Southwest: Commodity Disavowal in an American Orient." Pp. 75–96 in *Les cultures à l'ouvre Recontres en art*, ed. M. Coquet, B. Derlon, and M. Jeudy-Ballini. Paris: Biro Éditeur.

Shelton, Anthony. 2006. "Museum and Displays." Pp. 480–499 in *Handbook of Material Culture*, ed. C. Tilley, W. Keane, S. Küchler, M. Rowlands and P. Spyer. London: Sage.

Shelton, Anthony. 2007a. "Questioning Locality: UBC Museum of Anthropology and its Hinterlands." *Efnografica* 11 (2): 387–406.

Shelton, Anthony. 2007b. "The Collectors Zeal: Towards an Anthropology of Intentionality, Instrumentality and Desire." Pp. 16–44 in *Colonial Collections Revisited*, ed. P. ter Keurs. Leiden, Netherlands: CNWS.

Shelton, Anthony. 2009. "The Public Sphere as Wildness: Le Musée du quai Branly." *Museum Anthropology*. 23 (1): 1–16.

Shelton, Anthony. 2011. "42, Rue Fontaine." Pp. 210–217 in *The Colour of My Dreams: The Surrealist Revolution in Art*, ed. D. Ades. Vancouver: Vancouver Art Gallery.

Stewart, Susan. [1984] 1993. *On Longing: Narratives of the Miniature, the Gigantic and the Souvenir*. Durham, NC: Duke University Press.

Strathern, Marilyn. ed. 2000. *Audit Cultures: Anthropological Studies in Accountability, Ethics and the Academy*. London: Routledge.

Tilley, Chris, Keane, Webb, Kuchler, Susanne, Rowlands, Mike, and Spyer, Patricia, eds. 2006. *Handbook of Material Culture*. Thousand Oaks, CA: Sage.

Vackimes, Sophia. 2008. *Science Museums: Magic or Ideology?* Mexico City: Albedrio/Sinc, S.A. de C.V.

Vergo, Peter., ed. 1989. *The New Museology*. London: Reaktion Books.

Virilio, Paul. 1991. *The Lost Dimension*. New York: Semiotext(e).

The End of the Beginning

Normativity in the Postdigital Museum

Ross Parry

ABSTRACT: This article is an attempt to frame a way of seeing museums after the digital revolution. By introducing the concept of the 'postdigital', its aim is to evidence a tipping point in the adoption of new media in the museum—a moment where technology has become normative. The intention is not to suggest that digital media today is (or, indeed, should be) universally and equally adopted and assimilated by all museums, but rather to use the experience of several (national) museums to illustrate the normative presence digital media is having within some organizational strategies and structures. Having traced this perceived normativity of technology in these localized institutional settings, the article then attempts to reflect upon the consequences that the postdigital and the normative management of new media have for our approach to museological research.

KEYWORDS: change, digital, museum, normativity, organization, postdigital, technology

Introduction

This article is an attempt to frame a way of seeing museums after the digital revolution. By introducing the concept of the 'postdigital', the aim here is to evidence a tipping point in the adoption of new media in the museum—a moment when technology has become normative and an "instrumental ought" (Barham 2012: 93). The intention is not to suggest that digital media today is (or, indeed, should be) universally and equally adopted and assimilated by all museums, but rather to use the experience of several (national) museums in the UK to illustrate the normative presence digital media is having within some organizational strategies and structures. Drawing upon the concept of technological 'capture' from Friedel (2012), what we will see in these museums are traces of this 'normativity' (a term used advisedly in this context) in their preparedness for a postdigital organizational structure, in their blended approaches to media and production, in their multiplatform vision and brand, and in the influence of digital thinking on (in some cases) nondigital activity in the institution. Having traced this perceived normativity of technology in these localized institutional settings, the article then attempts to reflect upon some of the consequences that the postdigital and the normative management of new media have for our approach to museological research. It will be suggested that digital heritage research (in this postdigital condition) can be characterized by an alternative set of starting points and theoreti-

cal frameworks, in particular how acknowledging blended and embedded new media negates neat distinctions between 'digital' and 'nondigital' and how overcoming a discourse of 'technological revolution' can situate our research inquiry, as well as our theoretical reference points, outside a paradigm of 'change' and 'progress'. This article may also stand as a response to the challenge for more theorized readings of museum institutional change with digital technology. Peacock (2008: 345) calls for an extension of the "cultural turn" (Parry 2005) in museum computing research to include a theorization of "change": "What is also needed in the discussion of technology-related change in museums," he explains, "is theory which explores how organisations themselves mediate, shape and create the effects of technology." In its consideration of the organizational capture and normative management of digital technology there is a conscious attempt in this article to contribute to what Peacock (2008: 346–347) calls the "missing links" (as well as the need for more "critical scrutiny") of our understanding of museums' relationship with new media.

The discussion here is informed partly by a series of in-depth semistructured interviews carried out over a two-month period by the author with senior managers of new media in six different national museums in the UK: Carolyn Royston (Head of Digital Media, Imperial War Museums); Dave Patten (Head of New Media, The Science Museum); John Stack (Head of Tate Online, Tate); Fiona Romeo (Head of Design and Digital Media, National Maritime Museum); Matthew Cock (Head of Web, British Museum); and Andrew Lewis (Digital Content Delivery Manager, Victoria and Albert Museum). The work also stems from three two-day residential 'sandpits', convened and led by the author, at which participants from over twenty cultural heritage organizations, academic institutions, and commercial organizations reflected upon their experience of integrated and embedded digital media in museums. Furthermore, as well as looking at its subject through the prism of the history of technology, philosophy, and the philosophy of social sciences literature, the research also crucially draws upon a substantial body of archival and documentary evidence from the institutions themselves (including formal annual reviews, strategy documents, and minutes of board meetings), both published and unpublished.

Visions of Digital Normativity

From the moment first adopters began to use computers in museums, there have been visions and projections of a future profession in which the digital is naturalized. In the late 1960s academics such as William J. Paisley (from Stanford University's Institute for Communications Research) were imagining the experience of future visitors to museums:

> Sometime in 1980 a scholar will enter a major museum, set himself at a computer terminal in the research room, and ask to review all works depicting, say, sailing vessels … He will expect to see works from all significant collections around the world, including works currently in storage in the museum, and those out in travelling exhibitions … At another terminal in the research room, an art student is reviewing treatments of the running human figure from several cultures … At a terminal in the museum lobby, a visitor scans the daily notices of special exhibits and events. When he encounters an unfamiliar term, he queries the computer. An explanatory footnote is slipped into the text as it pages across his scope. When he is finishing reading, the computer prompts him to stop at the terminal again on his way out, to answer a few questions about exhibits he enjoyed and other exhibits he would like to see in the future. (Paisley 1968: 195–197)

Paisley's vision extended further, to terminals underpinning administrative systems, acquisitions, and accounts, and embedded within the learning opportunities of the museum: "In the Children's Gallery one grade-school visitor is completing an instructional program on colour relationships," he explained, "[a]nother is playing a quiz-game with the computer on the names of famous statues. A third is creating a composition." Paisley, though only at the early dawn of museum computing, nonetheless envisaged a museum utterly automated and digitized, where digital technology is pervasive and embedded. Paisley's contemporary Edmund A. Bowles (from the Department of Educational Affairs at the IBM Corporation) poignantly referred to the way the computer would one day be embodied in a "new physiognomy" of the museum (Bowles 1968: xix). For practitioners and writers such as these, as indeed for Everett Ellin (from the then newly formed Museum Computer Network), it was "not ... outrageous to dream of the day when museum information may be delivered electronically from a computer centre directly to the home or classroom," and when "we might hope to orient and serve the museum visitor in a variety of modes keyed, under computer control, to ... individual requirements" (Ellin 1968: 332). This reverie became a recurring motif in the museum computing literature that followed over the subsequent ten years. Manuals looked to "forecast" a future where uses of computing in museums would be "commonplace," where computers would be used by staff "routinely" (Chenhall 1975: 2–5). In 1976 the team at the University of Kansas Museum of Natural History (keen to share with the sector their "exciting but often frustrating" process of implementing the automated cataloguing for collections) were sustained by "visions of trouble-free instant access to the data associated with the collections of the world," with curator-researchers "in constant communication" via "digital technology." "Perhaps someday," they mused, "this vision will become a reality" (Humphrey and Clausen 1976: 4). Even a generation later we find writers such as Julian Spalding anticipating a future in which the digital is integrated into all aspects of the visitor's experience and the institution's public engagement offer. Writing in 2002, he plays with the possibilities for a family group visiting the British Museum a decade later, in the year 2012. From the decision to visit the museum to the different pathways and experiences that each visitor chooses, to leaving the museum (completely satisfied and inspired by their visit), the family group's experience is utterly enmeshed, enhanced, and enveloped by responsive, personalized, and ambient digital interpretive media (Spalding 2002: 156–167).

In each of these visions of a heritage sector within an "increasingly digital life" (McKenzie and Poole 2010: 4), the description is of digital technology that has become more than just widely adopted and commonplace. These, in fact, are visions of digital technologies that "pervade" the operations and strategies of museums (Peacock 2008: 333), where digital media has become part of the body of the museum—expected, routine, integral. These are imagined scenarios of not just adoption and widespread use, but of what Chatterjee, Grewal, and Sambamurthy (2002: 66) call "assimilation"—where new technology "diffuses across organizational work processes and becomes routinized in the activities associated with those processes." What the authors attempt to chart and measure in their research (and what our past museum computing visionaries, before them, were attempting to predict), is a condition in which digital media has become normative within the institution.

The Concept of Normativity

The term 'normative' is used advisedly and deliberately here in our discussion, mindful of how it is considered and debated within the history of technology (Harbers 2005), philosophy (Barham 2012), the philosophy of social sciences (Turner 2007), the philosophy of language (Wikforss

2001), and analytical philosophy (De Caro and Macarthur 2010). *Normative* is a term with an important (if not always straightforward) set of referents and implications that are of use to us in this context. To say that digital media is *normative* (or is being managed *normatively*) within the museum is to imply more than just *adoption* and *acceptance*. First, normativity is situated; something that is *normative* is a localized construction (a representation in one context), and not a universal reality (Turner 2007: 72). In other words, to say that digital media is normative is to comment on how it is perceived to be the norm in one situation, and not how it is the global standard. Second, the normative is constructed; as Hans Harbers (2005: 268) has shown in his study of the politics of technology, *normativity* speaks to a set of values that are "actively created, constructed-in-practice." To say digital media is, therefore, *normative* in a particular context such as a museum (rather than *adopted,* or *assimilated*), is to acknowledge that a set of judgments have been made by a particular community. It infers the presence of values. Third, the normative is instrumental; to evoke the term *normative* is (to many writers on normativity, if sometime problematically) to imply an "ought," and that there is a "right" (Wikforss 2001: 203). The philosopher James Barham (2012: 93) alerts us to how "[t]he paradigm case of 'normativity' is undoubtedly moral prescription and proscription, expressed through the terms 'ought,' 'should,' 'must,' and related locutions." To use the terminology of *norms, normative practice,* and *normativity* is, therefore, to invoke "what we should or ought to do" (De Caro and Macarthur 2010: 1). In other words, 'norms' are, as Barham (2012: 93) puts it, "instrumental in character":

> They seem to be essentially involved with furthering the actualization of ends by specifying actions conducive to such actualization. That is, norms connect ends to the appropriate means, and wherever there is a means-end relationship, there is normativity in this sense. (ibid.: 93)

Therefore, to say that the digital is being treated *normatively* in the museums in question here means (in philosophical terms) much more than just implying the digital is accepted or assimilated. Rather, it is to signal that the normative digital is knowingly (in this local context) an agent to something good. Or, to follow Barham's formation, the presence of digital media (the norm) connects the museum's goals (the ends) to the museum's activity (the means). The presence of digital as a *norm* furthers the actualization of the museum's ends. In essence, arguing that the digital has become *normative* (and specifically to use that word) in the museum is not to say that it is widespread or accepted (even though both of these may or may not be true); it is rather to say that digital has become logically wired into the reasoning of the museum—what Barham (2012: 93) would call the "instrumental ought." In other words, it is understood that the museum (the agent) should use digital in order to meet its goals. Our discussion here, therefore, advisedly uses the term *normative* to describe the presence of digital media in these museums to evoke the philosophical connotations that the digital is not only typical and standard, but indeed perceived to be how things ought to be, while also recognizing that these arrangements might also be situated (local) and constructed (a value judgment).

Evidencing Normativity in the Museum

How, therefore, might the normative management of the digital manifest itself in museums? If normativity is present, where do we look in organizations for evidence of it, especially in regard to digital technology? In this respect technology assimilation theory provides a useful apparatus to give us direction and clarity (Chatterjee et al. 2002; Hossain et al. 2011). Building upon the earlier work of Wanda Orlikowski (produced in the School of Management at MIT),

these approaches from business studies offer a structurational model with a (largely) common nomenclature and differentiation that is particularly helpful and persuasive in conceptualizing how and where technology becomes assimilated into organizations. Informed by the sociology of Anthony Giddens, the structuration of Orlikowski (1992: 404) sensitizes us to what she calls "the reciprocal interaction of human actors and structural features of organizations," and the assumption that human actions are both "enabled and constrained by structures." Practically, it is the distinction between the structures of *signification, legitimization,* and *domination* that are of particular use to our study of normative digital media in the museum. Within this model, each of these institutional 'metastructures' are seen to influence the behavior of individuals inside the organization (Hossain et al. 2011: 580). In the case of the museum, the *structures of domination* could include the rules that regulate actions in the institution as manifest, for instance, in the museum's organizational shape or its mission; these are structures that might reveal how digital is part of what the museum considers itself to be. Distinct from these are the *structures of legitimization* in the museum, which might be seen as those that validate behaviors, such as the allocation of resources to particular digital projects or value given to digital skills or to working in a digital way; in other words, these are structures that might reveal how digital is embedded in how the museum functions. Finally, the *structures of signification* are those visible and meaningful directions captured in the museum's strategy; structures, in other words, that indicate how the digital is critical to how the museum wants to develop. Together these metastructures not only help to explain the assimilation of technology into organizations, but also provide the tools by which we can begin to evidence the normative management of digital media within museums.

Normativity Through Structures of Domination

Let us consider, therefore, the first of our three metastructures—*domination*—and, specifically, the concepts of mission and organizational structure. Acknowledging, as McKenzie and Poole (2010: 58) do, that "it seems more the case that heritage organisations have evolved to deliver their content and operations using digital technologies," it is not too difficult to find evidence today of digital being naturalized within museums' visions and articulations of themselves. This is sometimes an overt acceptance of digital normativity. For instance, on receiving the results of its institutional digital review, the board of trustees of the Victoria and Albert Museum (V&A) concluded that "the physical success of the Museum" was now "linked to its successes in digital spaces" (V&A 2012: item 5). This digital review, undertaken internally by the museum and discussed at its board of trustees meeting in March 2012, was unequivocal in underscoring how "[p]roviding access to the V&A's collections is central to the Museum's mission" (ibid.). Yet elsewhere, digital normativity is perhaps played out more subtlety. It is revealing, for instance, to consider the language within the succession of annual reports of another national museum (the British Museum) over the last decade and trace the change in prominence and expression around digitality. The British Museum's review of 2004–2006 gave a short passage (part of one paragraph within a seventy-eight-page document) to the challenge to "transform the website into a public space for multifaceted cross-cultural enquiry, to make it not merely a source of information about the collection and the Museum, but a natural extension of its core purpose to be a laboratory of comparative cultural investigation" (British Museum 2006: 9). For the 2006–2007 review, digital then became a full paragraph (entitled "Website") emphasizing its importance in "allowing the public much greater access to the BM's intellectual resources" (British Museum 2007: 53). But subsequently, in the following two years, we can see the prominence of digital in

the museum's annual public self-reflection growing to a whole section, in 2008 celebrating how the "BM's digital presence extends to many projects internationally" (British Museum 2008: 55) and in 2009—with reference to its 6.5 million website visits—describing how online access had become for the museum an "increasingly significant doorway to the BM collection" (British Museum 2009: 40). Yet, significantly, just as digital begins to rise in visibility in these institutional statements (gaining its own sections and chapters), so then in subsequent years do we see these references beginning to become more pervasive. Just as the 2010–2011 review makes separate reports on its "engagement online" and "Apps and downloads" (British Museum 2011: 37), so the following year, in 2012, digital is spread right across the review. Indeed, part of the key message conveyed in the foreword by the chairman of trustees (British Museum 2012a: 5) is a reflection on the institution's social media presence (ibid: 40), and its "Digital Campaigns" (ibid: 41). In other words, across these reviews by the British Museum (from a passage, to a chapter, to multiple separate references) we see digital gaining prominence in the institution's expression of itself, but significantly (latterly), we also see this prominence becoming more diffuse and less differentiated—expressed more in terms of the museum's core activity rather than as just siloed digital activity in itself. This idea of digital now "often brought into the articulation of the museum's vision" (Cock 2012) is evident in other national museums as well. For Tate (at least from the perspective of the head of Tate Online) "digital is becoming a dimension of everything that happens" (Stack 2012). Tate recognizes today that its mission "will be played out in many platforms" and that "the digital space" is part of that (ibid.). More explicitly still, the head of digital media at the Imperial War Museums (IWM) goes further in expressing the normative function of digital within the institution's articulation of what it does and what it is for: "We do not mention digital anymore. It is taken that there will be some digital activity even if people are not quite sure what that is" (Royston 2012). We note here a senior manager of the museum acknowledging how digital is implicit in the way the museum is "more open and participatory with audiences," as well as its "brand reputation and global reach" (ibid.). In each of these prominent examples we find evidence of digital becoming normative within the museum's vision of itself, of digitality entering the essential grammar and logic of these institutions.

Organizational shape is also revealing when considering the extent to which digital is being managed normatively within museums today. In the museums considered here we can evidence recent changes to where digital sits within the organogram. An institution such as the National Maritime Museum has seen its digital team move from IT to within a division concerned principally with public engagement. This is a relocation that signals a shift away (according to its head of digital media) from digital "being defined solely in terms of the materials rather than the processes and the outcomes" (Romeo 2012). To her, it marks "the normalisation or naturalisation of digital" within the organization, to a condition where digital "just becomes a part of all the products that you are delivering" (ibid.). The movement of the Web Team at the British Museum is equally revealing. In 2000 the members of the museum's digital team were largely to be found within the parameters of a specific project (COMPASS—tied to the opening of the museum's Great Court and the refurbishment of its Reading Room), and managed by the Department of Scientific Research. In time this migrated to a New Media Unit (made up of a Multimedia Projects Team and an Educational Multimedia Unit), within what was then called the museum's Learning and Information Department; while corporate elements of the institution's website were managed by the museum's marketing department. In 2007 all of these teams were brought together into a new Web Team, with a remit that extended in time to multimedia guides, gallery interactives, and mobile media (Cock 2012). By 2012 the British Museum was framing a new department entitled Digital Media and Publishing, in which the Web Team would sit. Its proposed new home not only facilitates a new era of 'cross-platform' thinking in the museum

(producing content and products across different formats), but, significantly, marks a point at which digital has—in organizational terms—moved up a level in the institution's hierarchical structure. In this regard, the language and principles within the job description of this new post are noteworthy, describing as they do how "[f]or the first time, digital media will be at the centre of the organisation's thinking about how visitors can access information about the collection within the museum as well as on-line" (British Museum 2012b). In short, in 2012, about to enter its two hundred and sixtieth year, the British Museum prepared for the word 'digital' to appear for the first time in its history at the departmental level. From IT and marketing, to a learning and audience focus, to ultimately publishing, the journey of the Web Team is perhaps testimony to a changing relationship with digital at the British Museum.

Elsewhere, we see a restructured National Maritime Museum, with a new head of design and digital media and with all of the museum's creative teams pulled together in one department. To the new head, Fiona Romeo (2012), this is "a sign of maturity for digital in [the] museum," of the institution being prepared to have "digital in the heart of its whole public offer." This is a sentiment echoed by the head of digital media at IWM. Before establishing its digital media department, digital was found across marketing, IT, and publishing. According to its head, by establishing the department the museum "was making a statement that this is a significant direction of travel for the organisation, and that digital is important" (Royston 2012). But whereas at these museums the prominence at a senior level of the word 'digital' might be seen to be indicative of normative digitality, at other institutions it is the revision—if not the actual removal—of the term and the tying of its advocacy to one single role that is significant. At Tate, for instance, we hear senior digital managers in the institution questioning whether "digital itself needs a director"; "in five years' time the leadership of the digital space needs to be a group leadership cutting across all kinds of different areas of activity" (Stack 2012). We see heads of new media (for instance, at the Science Museum, London) suggesting today that having a director of all things digital in the organization might be seen as a "short term thing"; "having a director of digital would almost stop that embedding happening, because actually you set something up that is protecting itself, when what we should be doing is embedding digital right across our practice and looking at the best ways of doing that" (Patten 2012). It is a challenge identified by other heads of new media:

> We are in the centre of everything. Our department is involved in every single bit of public facing activity that the museum does. Something to be thinking about as the museum moves forward … Digital is in a different place now. It is in a maturing place now in organisations. It is an interesting time now to think about where we sit. (Royston 2012)

Either way—whether these are institutions that are working hard to establish new senior managers with digital portfolios, or whether they are planning in the longer term to spread and embed digital activity—what we witness in these changing organizational shapes (as well as, previously, in vision statements and self-reviews) is digital being defined confidently and clearly as a core and essential function of the museum. And it is in this way that these structures of domination provide us with our first examples of digital normativity.

Normativity Through Structures of Legitimization

Assimilation theory's second metastructure, the *structures of legitimization*, provides an atlas for our second exploration into digital normativity in the museum. Hossain et al. (2011: 580) explain to us that *legitimization* is "established by those meta-structures that validate behaviours

as desirable and congruent with the goals and values of the organization." With respect to digital normativity, it is the ways in which blended roles, blended media, and (what is referred to in this discussion as) 'digital thinking' are validated in each of the museums under consideration here that is of particular interest. First, we see these museums "actively recruiting blended roles" (Romeo 2012); in other words, positions in the institution where an individual has a responsibility for digital, but within the context of another portfolio. Consider, for instance, the National Maritime Museum's introduction of a digital participation officer in its learning and interpretation team, or its digital marketing officer (ibid.). Likewise, we might reference here Tate's online shop manager (in Tate Enterprises, a separate company), its digital communications manager (within its marketing department), its digital learning curator (in its learning department), and its online research editor (in its research department) (Stack 2012). Yet, we see the legitimization of digital not just through the formality of these new roles and job titles, but also through the growing validation given to digital workflows and production processes. Personal testimonies of heads of new media at several of these national museums are particularly instructive here. On one level we hear these managers point toward the ways in which digital has gained legitimacy by practically driving particular types of changes in the organization:

> We have moved from being very risk aware. Through the website and the new collections search project we have moved the organisation to relook at copyright and digital rights, and to think about being more permissive with our audiences and opening up collections. That was a seismic shift for the organisation, particularly around the sensitivities with our collections, and the fear of opening them up and losing authority around them. (Royston 2012)

Alongside this is the legitimacy that digital gains by reconceptualizing how and where the museum operates:

> In the way we have implemented technology, we have often done it to fulfil department aims. We have a ticketing system, and an online shop, and a fundraising system, a bulk mailing system, that have all been implemented at a departmental level to meet needs of departments at particular times. So now we are wondering why we haven't got a single view of the customer across all of our technologies, why do we not have a single view of the customer in the digital space? Digital is forcing the organisation to take a more overarching view of all kinds of activities and saying that because they are going to play out in the digital space, we are going to need to join these up … The way that all kinds of activity collide in the digital space requires us to think differently as an organisation. (Stack 2012)

Yet, significantly, we also see in some of these institutions evidence of "digital thinking and values" (Romeo 2012) being adopted and legitimized by the organization. This 'digital thinking' might manifest itself, for instance, in more open and collaborative relationships with visitors, or in a more iterative approach to projects—even perhaps in areas where it will not necessarily be delivered digitally:

> This is the idea of things permanently being in beta, and the fact that you don't just open something and then it's finished, but you are constantly monitoring how it's used and adapting to its use and improving it … By having an in-house operational team with a mix of engineering and design skills we can go back in and be much more iterative in our approach to galleries and exhibitions. What you launch might not be what you have in six to twelve months. So when you are designing a gallery you are thinking about its whole life, not just in terms of robustness and maintenance, but in terms of how you will continue to activate that space and keep it relevant and live. (ibid.)

The fact that these workflows and principles of agile production from the digital realm are being adopted in the institution (even outside of exclusively digital projects) not only evidences the influence of new technologies on the very rhythms and patterns of work in some of these museums, but (in terms of our discussion here) signals the currency and legitimacy that digital carries—part of its normative function.

Yet digital appears to carry further legitimacy not just in its role as an assumed a priori category for production and communication, but also from the blended and multiplatform nature of many of the museums' outputs. The Science Museum's head of new media is typical in stipulating that digital "just forms parts of the interpretation strategy ... just one of the series of tools we can apply" (Patten 2012). Consequently, it has become routine to expect a consideration of digital at the start of the production process:

> In the museum, digital has been embedded for a long time, and has grown up with our practice over the last twenty years. What we have succeeded in doing increasingly is to make that a core part of what we do. [The digital team] are now working on projects as they are set up, so they work on the scoping, they are working on the bid process, and they work on the project right at the beginning. Digital is not thought about later, it is thought about as a project is conceived. (ibid.)

What we see is what one head of new media calls "an expectation" that when the institution plans its exhibitions the digital department will be involved (Royston 2012). Moreover, at these ideation moments, traditional distinctions between a 'digital' and a 'nondigital' approach can become increasingly fallacious. After all, the emerging media that museums are able to use are characterized by their blending of the actually (presently) real and the virtually (ideally) real. As mobile media becomes "pervasive in everyday life" (Johnson et al. 2011: 7), museums might choose to push content to users' personal devices (or, more likely, users may wish to pull such content to their devices), so the importance of location and physical context of the remote (and possibly itinerant) audience will become more important. In those instances, the interpretation is as much about the nondigital environment as it is the digital content. Likewise, as augmented reality continues to gain traction in museums and beyond (as streaming, calibration, and pattern recognition improve, and GPS becomes more standard in mobile devices) (Merritt and Katz 2012: 21), it comes to epitomize the blend between the physical and the digital that is likely to characterize more of our new media experiences. Similarly, the "world of interconnected items" that will make up the "Internet of Things" will, again, blur the simple distinctions we have carried between physical object and digital information (Johnson et al. 2011: 30). The National Maritime Museum is an example of one such organization where this blendedness of physical and digital is today being understood and confronted:

> It has now been recognised organisationally that actually it does not make sense to have a team that does 2D and 3D design and a team that does design and media that is digital. Actually, we are in this postdigital phase where it is much more mixed. Design has changed, all of these things are now one ... the opportunities being in the links between physical and the digital rather than having them as distinct realms. (Romeo 2012)

One of the 'future indicators' included by the National Maritime Museum at the end of its 2012 digital strategy review is 'postdigital design'. Speaking to that heading, the report states that "we have reached a point where screens are getting boring and the way we interact with them is increasingly seen as limited. Designers are looking for opportunities in tangible interaction, connected objects and printing. Museums are incredibly well placed to respond to this trend" (Romeo and Lawrence 2012: 11). The fact that heads of new media in these museums are com-

ing to admire interactive designers who are 'agnostic' to the materials they use (Maillard 2011) alerts us, yet again, to the extent to which digital is being not just assimilated into the organization's approach to production, but is being normativized—becoming Barham's (2012) "instrumental ought."

Normativity Through Structures of Signification

Our third—and final—metastructure of assimilation (signposting us toward evidence of digital normativity) is *signification*. Assimilation theory proposes that these are the structures in an organization that "promote understanding, thereby serving as cognitive guides for individual action and behaviour" (Hossain et al. 2011: 580). In the context of the museum we can be usefully directed to the position, language, and aspirations around the institution's strategy (particularly the references to digital therein), as well as the role of any digital strategy. Orthodoxy states today the critical importance of "a comprehensive digital strategy" to the long-term sustainability of any museum institution (Johnson et al. 2011: 5). And certainly we see organizations today, such as the British Museum and Tate, actively attempting to articulate a digital strategy. Consider, for instance, Tate's practical reasoning on the need for a single strategy:

> A lot of digital ideas are bubbling up all over the organisation. There is a need to have this all documented in one place, so it can be subject to discussion, and priorities can be set. Logistically, there is more work being initiated in the digital space than can possibly be done, so it has to be prioritised … There is a risk that if you don't have a joined up digital strategy you may end up with a fragmented offer. (Stack 2012)

In its 2010 digital and new media strategy report, IWM was clear in the strategic importance of digital to the museum, with its intention of "connecting digital activity across the museum to ensure that it was joining up and co-ordinating content, resource, commercial activity and technology strategically and effectively," and "making the digital agenda pivotal to the IWM's future success" (Royston and Sexton 2012). But the museum was equally clear on the commitment the organization (particularly its senior management team) would need to offer in implementing this strategy:

> Our aspiration is that the new website and other digital services will be world class, innovative, 'fit for the future', reflect our new brand values, build new audiences by providing a range of interactions, demonstrate the breadth and depth of our collections, and maximise our existing and emerging e-Commerce opportunities. Its implementation will require involvement from the whole Museum, a commitment from senior management to an ongoing Digital Agenda and transformation in the way we work as an organisation. (Royston 2010: 2)

What we see in the IWM strategy, therefore, is a specific and direct challenge for digital leadership. It states how the "Digital Agenda" needs to be "prioritised and championed by senior management and extend down to all staff," and that this would include appreciating and understanding "the importance that digital activity has on the way we work now and in the future" (ibid.: 4). At IWM (as at institutions such as the National Gallery in London) the overall goal in drafting these new digital strategies was (as their respective heads of new media put it) to make "digital central to organisational thinking and planning" (Royston and Sexton 2012). The presence and content of these digital strategies signal very strongly the significance of digital within their respective organizations—particularly when such concerted effort is effected to integrate them across the organization's provision (Chatterjee et al. 2002: 66; McKenzie and Poole 2010: 5).

However, we detect in some of these institutions a preparedness for a postdigital future—a future where digital does not need to be recognized and championed separately in its own strategy, but where digital becomes a feature (a given) in all of the institution's strategies. Indeed, for some of our museums considered here the assimilation of digital has reached such a state of maturity that the writing of an individual digital strategy is counter to the normative function it has assumed within the organization; the Science Museum's head of new media remarks on the "real challenge" of formulating an "overarching digital strategy" for this very reason (Patten 2012). Consider the reflections of the head of Tate Online:

> I increasingly find myself asked to go to meetings and review documents in their draft state. Whereas previously I was aware departments had strategies, now I get sent strategies from departments in draft form for me to input into, and I am invited to go to discussions. So my role now has become much more about the overarching direction of travel of the activity of all kinds of departments in the organisation in a way that it was not before. (Stack 2012)

Here digital is emerging as a dimension of all of the institution's strategies, with the digital team involved in all of these strategic discussions. This sense of maturing beyond the need for a single digital strategy (and instead recognizing the pervasive and normative management of digital throughout the institution) is perhaps most evident in the strategic language of the National Maritime Museum (NMM). The NMM's corporate plan from 2009 was adjusted by the museum's executive in 2011 to "better reflect the Museum's increasing focus on digital futures and social media" (NMM 2011: 25). Yet, rather than seeing a dedicated digital strategy in the plan, what we see instead is a dimension of digitality throughout the plan's four overarching aims: to stimulate curiosity; to provide stakeholders with a sense of ownership; to ensure inspired curatorship; and to build an organization that responds to the challenges ahead and makes the most of its opportunities (ibid.: 24–26). Rather than a single digital strategy, the plan instead calls for "an integrated suite of digital strategies across the museum in order to improve efficient access to collections and expertise" (ibid.: 26). "This document," the head of digital media and design explains, "is the first time we were able to … embed so many of our working practices" (Romeo 2012). Ironically, with so much digitality reflected and embedded in the corporate plan, the museum struggled with the challenge of producing a separate and distinct digital strategy (Romeo and Chiles 2012):

> We actually found that a difficult thing to write, as we felt it was a little bit like asking for a 'paper strategy'. In the end we talked about a series of catalyst projects that were planned, that were primarily digital and that brought in new infrastructure and new ways of interacting with audiences. Because we didn't feel we could set out an abstracted separate digital strategy we just focused on the projects that were more recognisably digital. But it would have been difficult to try and capture all that the museum was doing digitally. It just didn't seem to make sense anymore. (Romeo 2012)

What we see evidenced in the NMM's experience, and in Romeo's reflections, are what historian of technology and science Robert Friedel might call a point of 'capture'. In his attempt to frame a new set of questions and hypotheses of the history of technology that are beyond any fixed or rigid models or theories (Friedel 2007: 6), Friedel presents a series of principles on which his study is based. Alongside a concept that "improvement is contingent" and the idea that "an improvement is determined by individuals (who may or may not work in concert with others) with specific goals at specific times," and that technological improvement may also be ephemeral (ibid.: 3–4), he also introduces the concept of 'capture'—particularly useful with respect to evidencing the normalization of digital media. Capture is "the means by which an improvement

becomes not simply an ephemeral, contingent act or product, but part of a sustained series of changes":

> Capture may consist simply of telling other practitioners, writing down methods and dis-
> coveries, organizing distinct crafts or professions, distributing or maintaining products, or
> constructing legal or economic instruments. Capture does not consist simply in means of
> recording techniques, but also includes the processes by which a technical change is social-
> ized, by which the case is made that an improvement is, in fact, not only better for its origina-
> tor but is better, at least in some contexts, for others, and not only for the present but also for
> some time in the future. (ibid.: 4–5)

For his thesis, Friedel's historical interest is ultimately about tracing the control of technological capture in society, and what this can tell us, as he puts it, about "how the winners and losers are determined as technology changes" (ibid.: 5). Yet, from his work this concept of 'capture' (as a process that is not consistent, is historical and culturally contingent) sensitizes us to the ways in which a technology such as digital media comes to be managed normatively within an insti-tution such as the NMM. In struggling to conceive digital as something other—as something distinct—the museum is demonstrating how the technology has been 'captured'.

Indeed, stepping back from all three of our metastructures of assimilation, we can see how in these institutions digital has been 'captured' in the language and logic of the organization's mission, built into the organizational shape, organized into new blended roles and means of production, and socialized and argued for deep into their strategies. Together what we can evi-dence here is not a universal change for the museum sector as a whole, but rather illustrations of a range of (in this case British national) museums where digital appears to have become captured and assimilated to such an extent that we can term its use 'normative'—with all the connotations that word brings with it, not least that this, in the context of those institutions, is how things ought to be.

The Museological Consequences of Digital Normativity

Friedel's concept of 'improvement' also reminds us of some of the presuppositions that can be routinely made by those of us who reflect upon the history of technology—including the recent history of digital technology in the museum. He suggests that over the past thousand years there has developed (specifically in the West) a "culture of improvement." This is an environment, Friedel (2007: 6) suggests, in which "significant, widely shared value has come to be attached to technical improvement and conditions have been cultivated to encourage and sustain the pursuit of improvement." We certainly do not need to look far to find examples of new media writers setting out their research within this "culture of improvement"—particularly a preoc-cupation with 'the new'. After all, this is the "kind of spell" and "enchantment" to which Charles Gere (2002: 15) refers, describing how "beguiled" we are by "the effects of new technologies and media, and what they seem to promise." To Gere, this is a culture of "priest engineers, soft-ware wizards, technogurus, charismatic leaders and futurologist soothsayers" (ibid.). This is the "cult of the new" (Flew 2002: 54), the "shiny dazzle of novelty" (Lister et al. 2009: 44), that the esteemed historian of technology Lewis Mumford characterized as an "addiction to scientific and technological innovation" (Mumford and Theobald 1972: 11). Digital media (labeled, tell-ingly, our *new* media) has all too often been positioned in museological (and digital heritage) research within this framework of 'newness', encouraging what Mark Tribe (2001: xii) calls "a beginners mind"—and approached as "a constantly shifting frontier for experimentation and

exploration." And yet, crucially, our evidence set out here of digital being managed normatively within our case museums runs exactly counter to this discourse of 'the new'. What we have seen in our discussion of normative ('postdigital') constructions of digital in some example museums is a set of assumptions (in strategy, in vision, in workflow, in organizational shape) where this technology is characterized by this very breaking of Gere's "spell." This alerts us to the museological consequences of the normative digitality; it prompts us to question how, intellectually, our researching of the museum changes when digital is normative.

First, it opens the opportunity, now, for the recognition of new starting points for research and writing around digital media. Postdigitality in the museum necessitates a rethinking of upon what museological and digital heritage research is predicated, and on how its inquiry progresses. Plainly put, we have space now (a duty, even) to reframe our intellectual inquiry of digital in the museum to accommodate this postdigital condition. It appears to be inquiry, after all, that in some contexts can work from the assumption that digital is no longer new, that it is present, and that consequently the lines of investigation and study can be detached from traditional questions of *adoption* and *uptake*—with all their associated codas on *risk, opportunity,* and *change.* The researching of digital in the museum no longer has to be an inquiry into 'newness', but can in some instances, instead, work from the assumption that digital is already present—if not normative. This is a school of museological (and digital heritage) research and writing that can see change as "on-going" and "continuous" (Peacock 2008: 338–339). It is a research trajectory that frees itself from digitality as 'revolutionary' in the museum, and that sees digital in a less teleological (progressive, directional) way—allowing itself, instead, to situate it more genealogically (full of remediations, convergences) (Lister et al. 2009).

Second, as well as this reappraisal of (perhaps even a new wariness toward) 'newness' within our research discourse, the presence of normative digitality also affects the language and classifications of our inquiries—particularly with respect to the blended nature and embeddedness of digital media. Our research will benefit from blurring (if not entirely removing) previous distinction between 'digital' and 'nondigital'. What we see (at least from the evidence presented in the museums in this study) is a move away from such differences. We can trace in these museums preparations (and, in many cases, preparedness) for a postdigital condition. Postdigital (like the term *poststructuralism*), is a layering over, not a chronological next step, and is not a rejection of the previous state, but an acknowledgment that the situation has progressed into something recognizably different—an augmentation. To be 'postdigital', like Nicholas Negroponte's (1995) notion of 'postinformation', is not to be without digital—indeed, quite the opposite. Nor is it to suggest that digital has been fully adopted and universally accepted. Rather, it is to indicate a state in which digital is no longer societally emergent and technologically nascent, and in which even where it is not being used (for instance, the museum that cannot resource hardware procurement, or the maintenance of digital services) it is, nonetheless, in a society and part of a culture where digital has become normative. The postdigital museum is that in which the case can be seen for, the visitor acceptance is established for, and the best practice and evidence are available for the normative use and management of digital. It is suggested here that the primary questions, presuppositions, and nomenclature of our museological (and digital heritage) research ought, now, to acknowledge the postdigital.

Conclusion: The Postdigital Museum

This article has attempted to recognize a key moment for museums in their relationship with digital media, and what this means not just for our practice, but also for our research. It is

suggested that it is perhaps time, finally, to acknowledge the extent of normative digital media in the museum. Our discussion here has presented cases where digital media is essential to policy making and strategy, where digitality has naturalized itself into the grammar of communication, and where digital production has eased itself into the organizational shape— become embedded where once it was marginal, permeating where once it was discrete. This is joined by an in-gallery aesthetic where technology (though present) is ever more ambient, and where a new contract between the connected institution and the connected visitor allows digital media to no longer be the interloper but rather the familiar and expected. This is public engagement and programming that no longer makes a reductive choice between 'digital' and 'nondigital', but instead anticipates a blend of the two, an embodied augmentation of one with the other.

Once digital media is no longer 'new technology', we can use a different set of assumptions, a different lexicon of terms, and free ourselves from discursive set pieces around uptake and advocacy. We can be free to reach for alternative sets of theoretical reference points, and break away from the gravitational pull of dominant theories of technological adoption. With digital media normative (naturalized, ambient, and augmented) in the museum, we are now ready to reset our relationship with it.

▪ **ACKNOWLEDGMENTS**

I am grateful to the Arts and Humanities Research Council (AHRC) and BT plc for funding me as principal investigator on the LIVE!Museum Research Network Pilot project, from which this article emerged. I am also grateful to the many participants (from museums, academic institutions, and commercial organizations) of the 'sandpits', reflecting on their experience of managing and designing digital media in museums, that were such a key part of that project, and that had such an informative role in generating the evidence and shaping the thesis at the center of this article. I also offer my thanks to the organizers of the Transformative Museum event (23–25 May 2012, convened by the DREAM project at the University of Southern Denmark and University of Roskilde), who allowed me to air an earlier version of this article as a keynote address to that inspiring international conference, and for the opportunity to explore the ideas further during a visiting professorship at the same institutions in the summer of 2012.

▪ **ROSS PARRY** is Senior Lecturer in the School of Museum Studies at the University of Leicester. From 2009–2012 he was a Tate Research Fellow and is Chair of Trustees of the Jodi Mattes Trust (for accessible digital culture). He sits on the national JISC Content Advisory Group, and is also currently a member of the International Scientific Advisory Board for the research project 'Learning 2.0' managed by DREAM (the Danish Research Centre on Education and Advanced Media Materials) at the University of Southern Denmark. From 2008 to 2011 he was elected chair of the national Museums Computer Group. In 2005 he was made a HIRF Innovations Fellow for his work on developing in-gallery digital media, and from 2004 to 2010 co-convened the annual 'UK Museums on the Web' (UKMW) conferences. He is the author of *Recoding the Museum* (Routledge 2007), the first major history of museum computing, and in 2010 published *Museums in a Digital Age* (Routledge).

,ò-Sút

■ REFERENCES

Barham, James. 2012. "Normativity, Agency, and Life." *Studies in History and Philosophy of Science, Part C: Studies in History and Philosophy of Biological and Biomedical Sciences* 43 (1): 92–103.

Bowles, Edmund A. 1968. "Introduction to the Work of the Conference." Pp. xv–xx in *Computers and Their Potential Applications in Museums,* ed. Metropolitan Museum of Art. New York: Arno Press.

British Museum. 2006. *Museum of the World for the World: London, United Kingdom and beyond: British Museum Review April 2004–March 2006.* London: British Museum.

British Museum. 2007. *Review 2006/7.* London: British Museum.

British Museum. 2008. *Review 2007/8.* London: British Museum.

British Museum. 2009. *A Museum for the World: British Museum Review 2008/9.* London: British Museum.

British Museum. 2011. *2010–2011 Review.* London: British Museum.

British Museum. 2012a. *2011–2012 Review.* London: British Museum.

British Museum. 2012b. "Job Details: Head of Digital Media and Publishing." *The Guardian,* 17 May. http://m.jobs.guardian.co.uk/job/4458624/ (accessed 20 September 2012).

Chatterjee, Debabroto., Rajdeep. Grewal, and Vallabh Sambamurthy. 2002. "Shaping Up for E-Commerce: Institutional Enablers of the Organizational Assimilation of Web Technologies." *MIS Quarterly* 26 (2): 65–89.

Chenhall, Robert. 1975. *Museum Cataloging in the Computer Age.* Nashville, TN: American Association for State and Local History.

Cock, Matthew. 2012. Head of Web (British Museum). Interview with author, 13 July.

De Caro, Mario, and David Macarthur, eds. 2010. *Naturalism and Normativity.* New York: Columbia University Press.

Ellin, Everett. 1968. "Information Systems and the Humanities: A New Renaissance." Pp. 323–335 in *Computers and Their Potential Applications in Museums,* ed. Metropolitan Museum of Art. New York: Arno Press.

Flew, Terry. 2002. *New Media: An Introduction.* Oxford: Oxford University Press.

Friedel, Robert. 2007. *A Culture of Improvement: Technology and the Western Millennium.* Cambridge, MA: MIT Press.

Gere, Charles. 2002. *Digital Culture.* London: Reaktion Books.

Harbers, Hans, ed. 2005. *Inside the Politics of Technology: Agency and Normativity in the Co-Production of Technology and Society.* Amsterdam: Amsterdam University Press.

Hossain, Md. Dulal, Junghoon Moon, Jin Ki Kim, and Young Chan Choe. 2011. "Impacts of Organizational Assimilation of E-Government Systems on Business Value Creation: A Structuration Theory Approach." *Electronic Commerce Research and Applications* 10: 576–594.

Humphrey, Philip S., and Ann C. Clausen. 1976. *Automated Cataloging for Museum Collections: A Model for Decision and a Guide to Implementation.* Lawrence, KS: Association of Systematics Collections.

Johnson, Larry, Samantha Adams, and Holly Witchey. 2011. *The NMC Horizon Report: 2011 Museum Edition.* Austin, TX: The New Media Consortium.

Lister, Martin, Jon Dovey, Seth Giddings, Iain Grant, and Kieran Kelly. 2009. *New Media: A Critical Introduction.* London: Routledge.

Maillard, Chris. 2011. "Case Studies from Chris Maillard's Article 'The Far Side'." *Eye* 81. http://www.eyemagazine.com/feature/article/case-studies (accessed 20 September 2012).

McKenzie, Bridget, and Nicholas Poole. 2010. "Mapping the Use of Digital Technologies in the Heritage Sector." Flow Associates and the Collections Trust for the Heritage Lottery Fund. http://www.hlf.org.uk/aboutus/howwework/Documents/HLF_digital_review.pdf (accessed 20 September 2012).

Merritt, Elizabeth E., and Philip M. Katz. 2012. *TrendsWatch 2012: Museums and the Pulse of the Future.* American Association of Museums' Center for the Future of the Museums. http://www.aam-us.org/docs/center-for-the-future-of-museums/2012_trends_watch_final.pdf (accessed 20 September 2012).

Mumford, Lewis, and Robert Theobald. 1972. "Two Views on Technology and Man." Pp. 1–27 in *Technology, Power and Social Change*, ed. Charles A. Thrall and Jerold M. Starr. Lexington, MA: Lexington Books.

National Maritime Museum. 2011. *National Maritime Museum Annual Report and Accounts 2010–2011: Presented to Parliament Pursuant to Section 9 (8) of the Museums and Galleries Act 1992*. London: Stationery Office.

Negroponte, Nicholas. 1995. *Being Digital*. London: Hodder & Stoughton.

Orlikowski, Wanda J. 1992. "The Duality of Technology: Rethinking the Concept of Technology in Organizations." *Organization Science* 3 (3): 398–427.

Paisley, William J. 1968. "The Museum Computer and the Analysis of Artistic Content." Pp. 195–216 in *Computers and Their Potential Applications in Museums*, ed. Metropolitan Museum of Art. New York: Arno Press.

Parry, Ross. 2005. "Digital Heritage and the Rise of Theory in Museum Computing." *Museum Management and Curatorship* 20 (4): 333–348.

Patten, Dave. 2012. Head of New Media (Science Museum, London). Interview with author, 30 July.

Peacock, Darren. 2008. "Making Ways for Change: Museums, Disruptive Technologies and Organisational Change." *Museum Management and Curatorship* 23 (4): 333–351.

Romeo, Fiona. 2012. Head of Digital Media (National Maritime Museum, London). Interview with author, 24 July.

Romeo, Fiona, and Lawrence Chiles. 2012. *Digital Strategy: Implementation Plan*. London: National Maritime Museum.

Royston, Carolyn. 2010. *Making Connections: IWM Digital and New Media Strategy*. Internal strategy document. London: Imperial War Museums.

Royston, Carolyn. 2012. Head of Digital Media (Imperial War Museums, London). Interview with author, 11 July.

Royston, Carolyn, and Charlotte Sexton. 2012. "Navigating The Bumpy Road: A Tactical Approach To Delivering A Digital Strategy." Paper presented to Museums and the Web 2012, San Diego, CA. http://www.museumsandtheweb.com/mw2012/papers/navigating_the_bumpy_road_a_tactical_approach_ (accessed 20 September 2012).

Spalding, Julian. 2002. *The Poetic Museum: Reviving Historic Collections*. Munich: Prestel.

Stack, John. 2012. Head of Tate Online (Tate, London). Interview with author, 25 July.

Tribe, Mark. 2001. "Foreword." Pp. x–xiii in *The Language of New Media*, ed. Lev Manovich. Cambridge, MA: MIT Press.

Turner, Stephen P. 2007. "Explaining Normativity." *Philosophy of the Social Sciences* 37: 57–73.

Victoria and Albert Museum. 2012. Minutes of the Board of Trustees, 21 March 2012. http://media.vam.ac.uk/media/documents/board-of-trustees/BoT_Minutes_21.03.2012_WEB.pdf (accessed 20 September 2012).

Wikforss, Åsa Maria. 2001. "Semantic Normativity." *Philosophical Studies: An International Journal for Philosophy in the Analytic Tradition* 102 (2): 203–226.

National Museums, Globalization, and Postnationalism
Imagining a Cosmopolitan Museology

Rhiannon Mason

ABSTRACT: In recent years it has been asked whether it is time to move 'beyond the national museum'. This article takes issue with this assertion on the grounds that it misunderstands not only museums as cultural phenomenon but also the ways in which globalization, nationalism, and localism are always enmeshed and co-constitutive. The article begins by considering theories of globalization, postnationalism, and cosmopolitanism and their relevance for national museums in the European context. Specific theories of cosmopolitanism are subsequently further explored in relation to two museum examples drawn from the National Museum of Scotland in Edinburgh and the Museum of European Cultures in Berlin. In different ways both examples demonstrate the potential for museums to engage visitors with ideas of cosmopolitanism, globalization, and postnationalism by revisiting, reframing, and reinterpreting existing national collections and displays. In the process the article makes the case for the merits of a nationally situated approach to cosmopolitanism in European museums. At the same time it acknowledges some of the potential limits to such endeavors. The article concludes by imagining what a 'cosmopolitan museology' would offer in terms of practice, politics, and ethics.

KEYWORDS: cosmopolitan museology, globalization, national museums, postnationalism, Europe

If the nation-state and the kind of 'public' with which it was associated are on the brink of obsolescence, then what future is there for museums? Are museums perhaps too intimately linked up with material- and place-rooted, homogeneous and bounded, conceptions of identity to be able to address some of the emerging identity dilemmas of the 'second modern age' or 'late modernity'? (Macdonald 2003: 1)

In today's global, postcolonial and cosmopolitan context, right-wing groups, religious extremists and extreme political parties are appropriating heritage and criticizing museum displays. Indigenous people, local groups and organizations are claiming rights to the past. The nation-state is at the same time deeply questioned…. In a global, postcolonial and cosmopolitan context, contrary to a colonial and nation-based context, museums have to rethink their stories, the place as such and the people to whom they aim: What stories are told and why? Who is the audience? … Lastly: Is there a future for the museum as we know it? ("The Museum Beyond the Nation?" 2011)

Museum Worlds: Advances in Research 1 (2013): 40–64 © Berghahn Books
doi:10.3167/armw.2013.010104

Beyond the National Museum?

A decade ago Sharon Macdonald was already questioning the future for museums in the context of late modernity and contemporary social theory. Macdonald's own assessment was that the answer was far from straightforward because of the inherently adaptive qualities of museums, their "fuzzy logic," and arguably because of the *"failure* of the nineteenth-century museum project" (2003: 11). However, as demonstrated by the second quotation above and other publications, this question continues to trouble those who study museums (Rogan 2004a, 2004b; Daugbjerg 2009a; Monash University 2011).

This article sets out to answer the important questions posed in the above quotations. It refutes the suggestion that Europe's national museums are made redundant by societal changes brought about by globalization, postnationalism, and cosmopolitanism. While there is considerable value in these theoretical approaches for reassessing the position of national museums in European societies, there is a problem in the assumption that national museums have somehow become 'out of step' with contemporary globalized societies. This assumption oversimplifies national museums as cultural phenomena and overlooks three key points.

First, globalization is not automatically antithetical to the national but can be seen to coexist with it. Aspects of globalization have been integral to the histories of national museums as they developed in the European context (Prosler 1996). Second, many of the individual objects and collections that have found their way into today's national museums predate modern European nineteenth-century nationalism. Despite being retrospectively conscripted into overarching and unifying national histories, these individual objects continue to have the potential to illuminate global, postnational, and cosmopolitan stories. Failure to recognize this arises from a conflation of nationalizing impulses deriving from the institutional discourses of national museums with what may be discerned at the scale of the collections and individual objects; they are intimately connected but not the same. Third, nations have never been without their own internal heterogeneity and diversity. Nationalism comes in many different forms and combinations, such as ethnic, civic, cultural, and political. The more homogenizing discourses of ethnic nationalism work hard to try to elide and unify or disavow these differences. However, Europe's national museums hold the evidence of this difference within and, in many cases, combine contradictory and competing discourses of nationalism in different parts of their displays and collections. Given their heterogeneity, national museums therefore have the potential to demonstrate the contingent and constructed nature of contemporary nations, *if* they are reframed and reinterpreted through a reflexive and cosmopolitan perspective and *if* the visitor is inclined, enabled, and encouraged to 'read for' such an account.

Instead of categorizing museums as either national, supranational, transnational, or universal at an institutional level or alternatively calling for a move 'beyond the museum', I propose therefore that it is more fruitful to recognize that national museums operate as clusters of cultural practices and constellations of material culture comprising many different intersecting ontological scales. In this respect, I draw parallels with Daugbjerg and Fibiger's work on tensions between local, national, and global heritage and their assertion that

> heritage has not *simply* gone global. There is no neat epochal chronology in place in which older local or national meanings are unanimously overridden or rendered obsolete as the global agendas simply take over. (2011: 137)

I also argue that it is more useful to recognize difference and diversity by problematizing settled notions of 'the nation' in order to deconstruct the distinction between a nation and its 'others'. Rather than positing accounts of diversity, migration, and cosmopolitanism as somehow out-

side of national representations, the point is precisely to find ways to shine a light on the difference that already exists within all nations and is evident in national museums.

The ensuing challenge for Europe's national museums (and with which many of them are already engaged) is how to recognize, display, and interpret the contemporary complexities of identities, cultures, and histories in ways that are intelligible, engaging, and resonant with contemporary museum audiences. This is particularly so because European museum audiences may themselves become increasingly internally heterogeneous, differentiated, and, in some cases, cosmopolitan in terms of their values, experiences, and expectations precisely because of the same pressures arising from current forms of globalization and postnationalism.

This article employs some of the many theories of cosmopolitanism that have been extensively debated in the humanities and social sciences literature since the 1990s but that have, as yet, made only limited incursions into the fields of heritage, museum, and material culture studies (Appiah 2006; Cuno 2008, 2011; Meskell 2009; Daugbjerg 2009a, 2009b; Delanty 2010; Daugbjerg and Fibiger 2011; Dibley 2011). Cosmopolitanism offers a theoretical vantage point from which to think through the political, ethical, and practical challenges facing contemporary national museums. It presents an alternative to the way that recent museological debates have been organized in terms of the merits of the 'universal' versus the 'national' or versus identity politics based around ideas of ethnicity. In particular, I draw upon Delanty's (2010) ideas of "critical cosmopolitanism," Held's (2002) "cultural cosmopolitanism," and Beck and Grande's (2007) "nationally rooted cosmopolitanism" to understand how heritage and museums might respond to contemporary societal change in the European context.

These theoretical frameworks are brought to bear on two museum examples, the *Kingdom of the Scots* gallery in the National Museum of Scotland, Edinburgh, and the *Cultural Encounters* gallery in the Museum of European Cultures, Berlin. In both cases I argue that the museums contain the potential for what I term a 'cosmopolitan museology', although the coordinates within which this potential is framed are configured differently in both examples according to their own institutional and national histories and present-day contexts. The article concludes by considering the possibilities, practicalities, and limits of a 'cosmopolitan museology' that might enable visitors to see the world through the 'other's' eyes. At the same time, it acknowledges the significant challenges in aligning this with visitor expectations and many visitors' understandable desire for a visit experience that might be more affirming of existing identities than disruptive of them.

Globalization and Postnationalism

The suggestion that it might be time to move beyond the national museum references a whole host of societal shifts and intellectual debates that have taken place since the 1970s and 1980s. It is widely argued, for example, that one of the effects of contemporary globalization has been to reconfigure the former relationships of societies and territorial spaces by moving power and influence away from national governments and nation-states as actors (Appadurai 1996; Beck 1999; Young 1999; Habermas 2001; Hedetoft and Hjort 2002; Held 2002, 2010; Held and McGrew 2003). In terms of business, finance, travel, environment, migration, communication technology, and media, the volume and intensity of exchange and movement on a global scale is described as historically unprecedented (Young 1999; Held and McGrew 2003; Assayag and Fuller 2005; Castles and Miller 2009; Isar et al. 2011).

Concomitantly, the ability of nation-states to command the allegiances and commitment of the populations within their own borders is alleged to be weakened (Ang 2011). Appadurai

(1996), for example, has argued that the international media of our time have contributed to shaping new deterritorialized, overlapping, and heterogeneous points of reference and attachment, introducing greater possibility for diasporic groups to maintain contact and a sense of cultural identity across geopolitical borders.

In Europe specifically, the fall of the Berlin Wall (1989), the reunification of Germany (1990), and the collapse of the USSR (1991) problematized the future of nations and prompted some to ask whether European societies should now be understood as 'postnational' and 'beyond the nation' (Appadurai 1996; Habermas 2001; Paul et al. 2003; Breen and O'Neill 2010). The recent Eurozone crisis has again called into question the economic, political, and cultural relations between national, supranational, and global interests in the European context.

As has been well documented, there are several problems with both this 'accelerated globalization' thesis and the view of postnationalism that sees the global as superseding the national (Vertovec and Cohen 2002: 1–24; Calhoun 2004; Kymlicka 2004). Aspects of globalization can be identified at many points throughout history, depending on how it is defined (Young 1999). Moreover, despite all the talk of mobility, migration, and cosmopolitan lifestyles, geographic and economic mobility remain finite for many people (Assayag and Fuller 2005; Kockel 2010). Ethnicity and national identity also remain powerful points of reference and self-organization (Held 2002; Jenkins 2002). Kymlicka, for example, argues that "ideas of nationhood are still central to our collective political imaginary" (2004: 228). Indeed, in some cases, traditional and conservative forms of nationalism appear to be on the rise rather than on the wane (Taras 2009; Paul et al. 2003; Auer 2010). On the cultural front, museums, galleries, and heritage sites continue to be largely administered, financed, and organized at the national scale (Bennett 2006; Daugbjerg 2009a).

One way to reconcile these divergent trends is to recognize that globalization is always experienced locally. As Assayag and Fuller explain:

> the local and the global—and, *a fortiori*, the national, regional or other spatial levels—are always enmeshed or entangled, not separate and preformed, because they are always mutually constituted vis-a-vis each other through social relationships and cultural patterns. (2005: 2)

Similarly, Hernández-Durán argues that we should not be thinking of the national and the postnational as discrete states where the national is superseded by the postnational but "as coeval tendencies in a larger historical process" (2011: 14).

Cosmopolitanism

Theories of cosmopolitanism are similarly interested in the implications arising from globalization's challenge to the nation-state, namely, the proposal to move beyond the nation (Cheah and Robbins 1998; Vertovec and Cohen 2002; Appiah 2006; Fine 2007; Beck and Grande 2007; Brown and Held 2010; Held 2010). The literature on cosmopolitanism generally refers back to two traditions of moral philosophy. First, as Held explains, the Stoics, who argued for the universalist perspective of the 'cosmos' as opposed to the more narrowly defined sphere of the 'polis', and second, Kant's Enlightenment ideas of the 'world citizen' and cosmopolitan right, which "connotes the capacity to present oneself and be heard within and across political communities" (Held 2010: 68). While supporting this account, Delanty cautions against Eurocentricism and points out that ancient Chinese, Hindu, Islamic, and Christian civilizations also "gave rise to ways of thinking that promoted an inclusive version of human community" (2009: 19–20). However, it is since the 1990s that there has been a significant return to these ideas and

a proliferation of theoretical permutations. Yuval-Davis (2011), for example, notes the existence of 'rootless', 'rooted', 'visceral', 'vernacular', 'banal', and 'convivial' cosmopolitanism. While all these variations are noteworthy, I will focus here on three works: those by Delanty, Beck and Grande, and Held, theorists whose ideas, I suggest, hold particular resonance for thinking about museums and heritage more broadly.

Delanty's 2006 article provides an overview of the burgeoning field of cosmopolitanism divided into four categories: moral, political, cultural, and critical. Moral cosmopolitanism follows the approach of the classical writers, arguing for a universal view of humanity and morality. Delanty sees this underpinning "liberal communitarian approaches to multiculturalism as in the idea of the universal recognition of the moral integrity of all people" (2006: 28). Political cosmopolitanism concerns itself with questions of citizenship, democracy, and international human rights in a globalized and transnational world where nation-states and place-based identities may no longer hold the same sway. Cultural cosmopolitanism concerns itself with "major changes in the cultural fabric of society leading to the erosion of the very notion of a bounded conception of the social" (2006: 31). Thus, cultural cosmopolitanism argues that people's patterns of identification and sense of identity have been reconfigured by the effects of greater mobility, migration, multiculturalism, and a globalized mediascape to become pluralized and discontinuous. Consequently, it is argued that the local and global have become enmeshed in unprecedented ways so that an awareness of being simultaneously implicated both 'here' and 'there' is intensified (Rosenau 2003).

As with the globalization and postnationalism theses, there are several limitations with each approach, and it is not always self-evident how such theories can be usefully brought to bear directly on questions of museums and material culture. However, Delanty also proposes his theory of critical cosmopolitanism, which he has applied to ideas of European heritage and identity and which is applicable to questions of interpretation, representation, and cultural encounters:

> A critical cosmopolitan approach with respect to cultural phenomena, in brief, concerns a methodological emphasis on: (1) the identification of openness to the world, (2) self-transformation in light of the encounter with the other, (3) the exploration of otherness within the self, (4) critical responses to globality, and (5) critical spaces between globality and locality. (2010: 17)

Delanty's focus on the encounter with the other and self-reflexivity echoes the work of Held, who advocates cosmopolitanism as a way to see things from a perspective outside of one's own "location" (Held 2002: 58; Held 2010). Adoption of this "expanded horizon," Held (2002) argues, is necessary to deal with the precisely global nature of present and future challenges facing humanity, such as the environment, war, terrorism, economic crises, religious diversity, and multicultural societies. Translating this idea of an expanded horizon into the sphere of culture, Held proposes his model of cultural cosmopolitanism as follows:

> [C]ultural cosmopolitanism should be understood as the capacity to mediate between national cultures, communities of fate and alternative styles of life. It encompasses the possibility of dialogue with the traditions and discourses of others with the aim of expanding the horizons of one's own framework of meaning and prejudice (Gadamer 1975). Political agents who can 'reason from the point of view of others' are better equipped to resolve, and resolve fairly, the challenging transboundary issues that create overlapping communities of fate. (Held 2002: 58)

Although neither Held nor Delanty discuss museums explicitly in these writings, it is not difficult to imagine how museum displays and collections might offer such opportunities for encounters

beyond the self. Since their inception museums have seen it as their raison-d'être to collect the 'other' defined by time or geography or both (Sherman 2008). Yet, having an interest in the 'other' is not the same as being able to see the world 'from the point of view of the other' or to value it on its own terms. To qualify as properly cosmopolitan in orientation that interest would necessitate a capacity for empathy and self-identification with the other as oneself. It would need to be transformative in the sense that it has the effect of relativizing one's own position. Delanty defines it thus: "In the encounter with the Other the self or native culture undergoes a process of learning or self-discovery.... [it entails t]he capacity for a mutual evaluation of cultures or identities" (2009: 87).

This cosmopolitan approach to otherness has certainly not always been the case in museums. Given the colonial histories of many museums, it has been quite the opposite. However, there are indications that this philosophy is now evident in some areas of contemporary practice. The Museum of World Culture in Gothenburg, Sweden, for example, adopts an explicitly cosmopolitan, postcolonial, and globalist philosophical stance in its institutional statements:

> In dialogue with the society in which it exists, the Museum of World Culture seeks to serve as a meeting place where sensitive, intellectual experiences will enable people to feel comfortable at home and abroad, trusting in and taking responsibility for a shared global future in a constantly changing world. (Museum of World Culture: 2012a)

> The museum wants to be an arena for discussion and reflection in which many and different voices will be heard, where the controversial and conflict-filled topics can be addressed, as well as a place where people can feel at home across borders.(Museum of World Culture: 2012b)

Accordingly, the museum has staged displays based on transnational topics such as people trafficking, AIDS, mobility, and travel. Similar efforts can be found at a supranational level; for example, UNESCO has initiated a project with partner museums of "culture and civilization" entitled Museums of Intercultural Dialogue, focused on Common Heritage: A Museological and Educational Approach to the Dialogue of Cultures and Civilizations. (UNESCO: 2012).

A core idea of cosmopolitanism is therefore to facilitate encounters beyond the known and the self in order to take one outside of, and to encourage reflexive awareness of, one's 'own location'. At the same time, much of the recent writing about cosmopolitanism stresses the importance of simultaneously holding onto a notion of the local and particular (Vertovec and Cohen 2002: 4; Daugbjerg 2009a, 2009b; Appiah 1998). While there is a tendency in some writings to conflate cosmopolitanism with globalization and transnationalism, several writers argue strongly that it should not be understood as antithetical to national, rooted, situated, or patriotic affiliations (Appiah 1998; Delanty 2009; Daugbjerg 2009b).

Beck and Grande, for example, argue for a radical rethinking of nationalism but at the same time assert that nationalism "represents the historically most successful way of underpinning and stabilizing collective difference with universalistic norms" (2007: 16). For some writers, the nation-state remains the only serious legal and political framework within which the rights of individual citizens can be realized and addressed (Kymlicka 2004). Beck and Grande's proposal for a nationally rooted cosmopolitanism offers a useful way of thinking about the challenge for national museums, specifically in Europe. Based on a logic of *both/and* rather than *either/or*, they argue:

> Cosmopolitan Europe is not only the antithesis of, but also presupposes, a national Europe, i.e., a Europe of nations. It cannot simply abolish national Europe but must cosmopolitanize it from within. In this sense, we speak of a nationally rooted cosmopolitanism. ... the

cosmopolitan must be conceived as the *integral* of the national and must be developed and empirically investigated as such. (2007: 16)

National museums are particularly appropriate for such contemplations precisely because they are situated at the conjuncture of global flows of ideas, objects, and peoples while simultaneously being enrolled in regional and national politics. They are also subject to local economic pressures and the material legacies associated with specific places in the form of particular collections and articulations of identity.

Close-Up: Not Either/Or but Both/And

Switching to a close-up view of specific institutions, I now want to consider how two individual national museums might be related to the kind of societal changes and theoretical concerns outlined above. Do they seek to foreground cosmopolitan ideas of pluralistic, internally diverse, and heterogeneous societies? Do they go beyond simply celebrating pluralism as a form of cultural enrichment to encourage self-reflexivity, both positive and negative? Or do they domesticate such differences by subsuming them back into a traditional national story, and if so, why?

A salient point here is that a nation's 'historical consciousness' (Macdonald 2006; Seixas 2006) is deeply shaped by what is imagined to be at stake in presenting the nation's 'constitutive story' (Smith 2003) at any given moment. Risse (2010), for example, argues that discourses of national identity differ markedly depending on whether the nation has had to construct its own historical past as a negative other to its present and future, as with Germany and Spain's fascist pasts.

At the same time, it would be wrong to overdetermine the relationship between nation-states, governments, and museums. Museums cannot be reduced to mere instruments of nation-states or individual governments; the relationships are too complicated and the agencies involved too multifaceted (Mason 2007; Mackenzie 2009: 9; Whitehead et al. 2012). Institutional identities, the histories of individual collections, and the materiality of museums as display spaces all determine what museums come to mean. Museum professionals bring their own disciplinary, cultural, and intellectual perspectives to work, just as visitors come through the museum door with their own motivations, expectations, and habitus (Macdonald 2002). Museum objects and spaces too have their own biographies and social lives (Alberti 2005; Appadurai 1986) that intersect with, but are not fully overwritten, by the museum's technologies of display and interpretation. As Tony Bennett puts it,

> a point I take from Latour's account of the ways in which technologies fold into and accumulate within themselves powers and capacities derived from different times and places (Latour 2002a), objects carry with them a part of the operative logic characterizing earlier aspects of their history as they are relocated into reconfigured networks. (2005: 537)

It is precisely this accumulation of multiple logics and the resulting polysemy of objects and spaces in museums that makes them amenable to so many reinterpretations. However, it is equally important to explore the limits of the museum's multivalency and—with the earlier theoretical discussion in mind—to consider the following questions:

- Is it possible to make an object or a display that was previously created, designed, and intended to communicate notions of distinctiveness and, in some cases, the national supremacy of one nation over another now resignify in a cosmopolitan way?

- National museums of the nineteenth century typically sought to marshal their collections to tell unifying national stories. By contrast, many of the individual objects that make up national collections predate conceptions of modern nationalism as developed in many European countries. What kinds of insights do these kinds of objects provide into the longer histories of globalization and cosmopolitanism and the organization generally of societies prior to nineteenth-century nationalism?

- How far can objects and spaces be rescripted through new display and interpretation strategies to promote intercultural understanding and a sense of supranational European, postnational, or global identity? Should they be?

- How amenable are museums, their staff, and their collections to (re)discovering and emphasizing 'new' cosmopolitan stories of globalization, diversity, and the migration of ideas, objects, and people instead of presenting a settled nation?

This next section explores these questions through two different examples: the National Museum of Scotland, Edinburgh, and the Museum of European Cultures, Berlin, Germany. The purpose is to examine what two different museums pitched at contrasting scales (one national and the other transnational) and in two quite different national contexts may illuminate about the kinds of issues raised above. What kinds of different histories do they make available to visitors and what other potentials might they contain?

To understand the ways in which the museum representations make sense of—by which I mean organize, define, and value—the possible sets of relations afforded by their collections and spaces I employ Beck and Grande's (2007) theorization of the distinction between two different ways of conceptualizing cultural difference: (1) nationalism and (2) cosmopolitanism.

The National Museum of Scotland: Reconciling Diversity and Unity?

The National Museum of Scotland (NMS) in Edinburgh opened in 1998 on St. Andrew's day against a backdrop of political devolution that gave (or returned, depending on your perspective) political autonomy from the British parliament to a newly constituted Scottish parliament based in Edinburgh. As such, the new museum is heavily freighted with national significance and symbolism. The museum comprises six floors that begin with the formation of the land we now call 'Scotland' geologically and end with the present day. The museum project had a long history and the extant museum, known at the time as the Royal Museum, to which the new NMS adjoined, has been in existence since 1854 (Mason 2004). Objects from the Royal Museum's collection were relocated into the new museum. As is common with almost all ostensibly new museums, the collections and objects themselves have had a much longer life that precedes the new institutions, so that collections have often been relocated, parsed, scattered, and sometimes reconstituted several times in the service of various different institutional and political agendas. In 2011, the Royal Museum of Scotland was significantly refurbished and both parts were rebranded jointly under the single name of The National Museum of Scotland.

For present purposes, I am interested in what this museum's collections can tell us about many of the issues commonly identified with globalization, postnationalism, and cosmopolitanism—migration, diversity, mobility, exchange, and hybridity. Specifically, I am interested in what they tell us about the long-standing histories of cultural exchanges and interactions across borders and the ways in which the display and interpretation organizes the possible sets of relations, thereby creating particular kinds of accounts of cultural difference. My proposition

is that museums are full of objects that have the potential to draw our attention precisely to the long-standing mixing of cultures within and beyond national borders, to the movement of peoples, ideas, and material culture, and the fluctuation of national borders throughout history. Indeed, to the attentive eye the constructed nature of the nation is always just below the surface in museum representations. Every museum display about national unity and coherence also contains within it centrifugal forces that problematize a conventional national narrative if presented in a particular way. A 'close-up' perspective on an individual object enables us to examine this in further detail.

The example I have in mind can be found in the section of the National Museum of Scotland that focuses on telling the formative moment in Scotland's history, *Kingdom of the Scots*—the time when Scotland becomes a kingdom and "emerges as a nation" (National Museum Scotland: 2012a). It might be expected that this will be an overtly nation-building account, and ostensibly it is, but if one looks closely all sorts of artifacts can be found within the displays that complicate the picture. The particular object in question is the Lewis Chessmen exhibit described by the National Museum of Scotland as perhaps its most famous exhibit, fame enhanced by the appearance of replica pieces in the 2001 internationally successful film *Harry Potter and the Philosopher's Stone*. These chess pieces were found in 1831 on the Hebridean island of Lewis off the coast of what is now Scotland (figure 1). Carved from walrus ivory, the museum's website describes them as follows:

> The Lewis Chessmen have fascinated visitors and art historians alike. Believed to be Scandinavian in origin, it is possible they belonged to a merchant travelling from Norway to Ireland.
> They were probably made in Trondheim in Norway during the late 12th and early 13th centuries, when the area in which the chessmen were buried was part of the Kingdom of Norway, not Scotland. It seems likely they were buried for safe keeping on route to be traded in Ireland. (National Museums Scotland: 2012b.)

The original hoard is thought to contain four chess sets comprising ninety-three pieces (National Museums Scotland 2012b). After its discovery it was divided up and eighty-two pieces were acquired by the British Museum in London between 1831 and 1832, where they have remained until today (Robinson 2004: 7). Having failed to originally secure the other chess pieces, which passed into private hands for many years, the Society of Scottish Antiquaries worked with the British Museum to purchase eleven additional chess pieces in 1888; these are the chess pieces now on display in the National Museum of Scotland (Robinson 2004: 6–7). The retention of the lion's share of the hoard in the British Museum has been the source of contention for some campaigners in Scotland who have argued for the return of the Lewis Chessmen to the place of their discovery, the Isle of Lewis. The campaign has been supported recently by local councillors, members of the Scottish National Party, the ruling party of Scotland, and no less than the party leader and first minister of Scotland, Rt. Hon. Alex Salmond. One of the arguments made in favor of their return is for the potential economic benefit of heritage tourism to the local area of Lewis. The area has suffered considerable population losses in the last twenty years because of the decline in its traditional industries of tweed, fishing, and oil rig servicing (Macleod 2007).

In 2012 the British Museum finally agreed to return six chess pieces on semi-permanent loan to Lewis's newly refurbished Lews Castle Museum (BBC 2012). They will arrive in the year 2014, which has been designated a second year of the Scottish homecoming, the seven hundredth anniversary of the Battle of Bannockburn of 1314—a famous battle in which the Scottish defeated the English—and the year when a public referendum will be held to decide whether Scotland should separate from the UK after more than three hundred years of political union.

Figure 1. "The Lewis Chessmen". National Museum of Scotland. Copyright: NMS

The British Museum's Lewis Chessmen recently featured as one of the podcasts on the British Museum's hugely successful *History of the World in 100 Objects* project. In that broadcast the cultural history of the game of chess was discussed and the global heritage of the objects emphasized:

> Chess originated in India after 500 BC and had arrived in Christian Europe via the Islamic world by at least the AD 990s. The original Indian and Islamic game was adapted to reflect medieval European society, so that the Indian war elephant was replaced with the figure of the bishop. The rooks biting their shields resemble the Viking berserkers of Norse myth, while the pose of the queens is derived from depictions of the grieving Virgin Mary. The pawns, lacking any human features, reflect the abstract pieces used in the Islamic version of the game. (British Museum website)

The global heritage of the game of chess—the way it fuses transnational cultural influences and transcends political and geographical borders—is underscored by a related holding in the National Museum of Denmark. This museum holds similar European chess pieces discovered in medieval Danish forts and recently displayed them alongside several Muslim chess pieces also found in Denmark, identifiable by their nonfigurative form. A number of these chess pieces featured in a 2012 exhibition entitled *Europe Meets the World*, staged in the year Denmark held

the European Union (EU) presidency (figure 2). The writers of the museum catalogue for that exhibition explain that "[e]ven though figurative chess pieces were probably the most sought after, non-figurative pieces were also used in medieval Europe. Examples of the latter from Danish medieval forts show that Europeans were equally able to play chess in Arabic fashion if required" (Christensen et al. 2012: 143). Replica pieces of the National Museum of Scotland's and the British Museum's Lewis Chessmen were on sale in the National Museum of Denmark at the time of the exhibition, testifying to the transnational nature of today's museum retailing and the wide appeal of certain museum objects.

The Lewis Chessmen therefore illustrate the complex interweaving of local, national, and global heritages and identities that can be found in so many museums, particularly where collections concern trade, migration, colonization and empire. In this respect, it is clear that to describe a museum and all it comprises as simply 'national' is to oversimplify the situation. Certainly, at the institutional level expressions of traditional nation building can be discerned in the National Museum of Scotland, but at the level of individual objects there are innumerable examples that exceed and complicate the national story.

These chess pieces, for example, have the potential to signify in many directions. They can draw attention to the changing nature of borders and how the past differed from today's political arrangements. They can reorient visitors' view of Scotland today by emphasizing its Scandinavian heritage rather than its British connections. Moreover, when the history of chess is brought to the fore, these diminutive objects have an important story to tell about the long-standing interplay between East and West and how European cultures have been shaped through interactions with many other parts of the world. At the same time, these objects can also tell a story of local heritage focused on the place of discovery and present-day aspirations for culture and

Figure 2. "European figurative and non-figurative chesspieces of Muslim type: Archaeological finds from Denmark." National Museum of Denmark. Copenhagen. Copyright: Arnold Mikkelsen/National Museum of Denmark

tourism as new economic drivers. They may be equally mobilized into a nationalist, political narrative by those of the pro-independence persuasion, arguing that Scotland always has to fight for recognition from London-based institutions.

In actuality, the label in the object case attempts to balance a transnational story with a nod to local claims. Entitled "The Norse," it says the chess pieces "are a legacy of the times when the Norse ruled the Hebrides … They stayed as settlers and intermarried with the Gaelic-speaking inhabitants. … These marvellous chesspieces were probably made in Scandanavia, but belonged equally in the Gaelic world where they were clearly valued."

By contrast, at the top level of the textual interpretation in the National Museum of Scotland, these potential stories are mostly contained and constrained within the narrative of the formation of the Kingdom of Scotland. The dominant message from a display perspective is about how diversity is turned into national unity. This can be seen in the large text panel at the entrance of the gallery in which the Lewis Chessmen sit:

> LAND, PEOPLE, LANGUAGE AND BELIEF all helped to define Scotland. Gradually one kingdom and one name emerged from territories which were described by early writers as Dál Riata, Pictavia, Alba, Caledonia and Scotia.
>
> These were the lands of different peoples of different ethnic backgrounds who came together under a single dynasty of kings in the early 9th century.
>
> Look down to the floor below on your right to Scotland before history was written down. Look down to your left and there is the formation of the landscape. The entrance in front of you takes you into the *Kingdom of the Scots,* where the story of Scotland in history begins.
>
> The story opens with the shaping of a nation often invaded, but committed to the idea of independence.

This approach of presenting cultural difference as ultimately unified within the national paradigm matches Beck and Grande's (2007) account of how nationalism operates as a system of classifying and organizing the world. Unlike colonialism or caste and class systems, which are organized *vertically* into "a hierarchical relation of *superiority and subordination,*" they observe that:

> As a strategy for dealing with difference, … [nationalism] follows an either/or logic … Nationalism has two sides: one oriented inwards, the other outwards … nationalism dissolves differences internally while at the same time producing and stabilizing them towards the outside. (2007: 13)

With this in mind, the *Kingdom of the Scots* display can be understood in terms of the tension between stories of transnational cultural exchange and networks of global interaction that these premodern objects themselves offer up and the interpretive, overarching framework of the display that pulls the intended visitor toward a modern understanding of how the world is organized into nation-states.

The kinds of logics identified here are common to many museums and certainly to most national museums. Although the kinds of national narratives present can vary considerably from display to display—especially between more historical and contemporary galleries—overarching themes of migration, global interaction, and cultural exchange tend not to be strongly connected vertically between different floors and time periods. Visitors are not necessarily encouraged to consider the perennial push and pull of the twin poles of unity and diversity that always characterize processes of nation formation. Nor are they encouraged to reflect upon broader questions of how societies have dealt with long-standing issues of cultural difference and sameness in different ways throughout history.

While this is understandable in one sense and it is important to avoid anachronisms, it is also possible to imagine a more explicitly lateral and layered approach to interpretation that could make those connections across the different time periods, displays, disciplines, and collections not only in individual museums but in counterparts like the British Museum, the National Museum of Denmark, or the local museum in Lewis. This could be designed to encourage visitors to actively follow and investigate crosscutting transnational and global themes such as the histories of migration, trade, cultural exchange, and cultural difference, both past and present.

Following the logic of both/and rather than either/or, the interpretation could adopt a polyvocal approach and foreground the multiplicity and interconnectedness of histories and peoples. With new forms of digital interpretation and the ability to connect physically distinct collections by means of transnational digitized resources, new possibilities for realizing more pluralistic and self-reflexive, cosmopolitan approaches to interpretation are emerging all the time. In our present time, when relations between European and Islamic cultures are often characterized in the media and politics as irreconcilable, the Lewis Chessmen and their Arabic counterparts have a powerful story to tell.

The Museum of European Cultures, Berlin: Reframing the Nation?

My second example comes from a museum that has created a self-reflexive presentation of the nature of nationalism that both critiques a traditional view of the nation while using some material culture collected and produced for nineteenth-century nationalistic purposes. It is in the Museum of European Cultures in Berlin, one of the national museums of Berlin, rooted in the intellectual traditions of European ethnology, folklife studies, and social anthropology and thus premised upon a comparative approach to cultural difference. It is a smaller museum than the previous example and shares its location in the Berlin suburb of Dahlem with an Ethnological Museum and a Museum of Asian Art. Its website explains that

> [t]he Museum of European Cultures was called into being in 1999 and was created by merging the 110 year-old Museum of European Ethnology (Museum für Volkskunde) with the European collection of the Ethnological Museum. It focuses on lifeworlds in Europe and European cultural points of contact from the 18th century until today. Comprising some 275,000 original objects, the museum houses one of the largest European collections of everyday culture and popular art. The topics covered by the collection are as diverse as the cultures of Europe themselves: ranging from weddings to commemorating the dead, the cult of Napoleon to Halloween, music on Sardinia, the historically pagan 'Perchten' processions in the Alps … the list goes on and on (Museum of European Cultures 2012b).

Much of its collection was destroyed in the Second World War: an estimated 80 percent of its ethnographic holdings (Museum of European Cultures 2012a). Following the division of Berlin post World War II, other parallel museums and galleries were set up on the other side of the city. After the reunification of Germany, the collections from East and West Berlin were brought together in 1992 to create a single Museum of Folklore (Museum of European Cultures 2012a) In 1999 the move was consciously taken to abandon a German-specific focus and instead to adopt a European perspective. The curators explain: "As Europe became more united, it was no longer appropriate to have two institutions, one with an almost exclusive German ethnographic collection, the other with an analogous collection from the rest of Europe, located in a museum which exclusively concentrated on non-European cultures" (Vanja and Tietmeyer 2009: 129). Today, the museum describes its institutional mission as follows:

> Within the overall organization of the National Museums in Berlin, the Museum of European Cultures is the institution responsible for posing questions about the daily life and lifeworld of individuals, as seen within the wider context of the cultural and contemporary history of Europe.… Following on from the scholarly tradition of the then Museum for Folklore, the Museum of European Cultures also continues to engage itself with our own society's everyday culture, seen within a European context—posing such questions as who is part of our own society and who is not. The issue of migration thus also plays a foremost role in exhibitions and events. (Museum of European Cultures 2012b)

The museum's main display, *Cultural Contacts: Living in Europe,* opened in 2011 and juxtaposes material from different national cultures within an interpretive framework that actively draws attention to the way nations operate as discourses and are always interwoven with ideas of region, locality, and the global. The display takes the last two hundred and fifty years as its time period and is structured around the ways that cultures encounter and shape each other. The curator explains: "It examines cultural phenomenon in their specific local, regional, ethnic, and national forms, changes and hybridities based on the migration of people, things and knowledge" (Tietmeyer 2011: 11). Thematically organized, it focuses on topics such as "Encounters," "Borders," and "Religiosity" to explore what happens when different national cultures meet. "Encounters," for example, contains the subthemes "trade, travel, media and migration," while "Borders" looks at "local, regional, national and supranational sitings of culture."

In contrast to the National Museum of Scotland, the Museum of European Cultures explicitly makes links and comparisons between contemporary accelerated globalization and its earlier precedents. For example, the "Encounters" section opens with a display about the Silk Route and the European clothing and fashions enabled by this international trade. The text panel begins by discussing how silk weaving develops out of China in 600 AD and closes with a discussion of the continuing trade in silk today. Similarly, a Venetian gondola works as a centerpiece for the gallery to emphasize Venice's role as a long-standing trading hub for glass between the fifteenth and seventeenth centuries, but also to represent how global patterns of tourism have always commodified places through the promotion and circulation of national symbols for tourist consumption (Franke and Niedenthal 2011).

A more recent acquisition—a doner kebab sign from a Berlin trader—continues this theme of drawing parallels between contemporary and historic cultural contact. The gallery text panel makes explicit connections between the contemporary aspects of global culinary influences and earlier ones in order to problematize ideas of 'native culture':

> *Cultural Diversity Through Migration: Culinary Traditions*
> Hardly anything characterises a culture as much as its eating habits, diet, dishes and drinks—typical to the region or else modishly adapted. In new surroundings, people tend to stick to the culinary predilection of their native country, as a constant link to their origins.
> Greater mobility and growing migration have also helped to spread the unique culinary features of foreign cultures. While French cuisine decisively influenced the fare of the upper classes, at least in eighteenth and nineteenth century Europe, Italian, Oriental and ultimately globally adapted culinary influences have come to predominate in the twentieth century.
> This is clearly reflected in many European cities: Turkish doner restaurants, Italian pizzerias, Arabian tearooms and Chinese eateries are part of the townscape. Their authenticity, however, is only putative, when they are operated by Kurdish, Lebanese, and Vietnamese proprietors. But is this also applicable to 'native' foods and beverages such as potatoes or rice, tea or coffee? They came to Europe from other regions of the world centuries ago.

The "Borders" section similarly looks at cross-border influences both historical and contemporary through, for example, traditional costumes, uniforms, and, more recently, a soccer jersey of

a famous Turkish-German player—a particularly resonant object given the long-standing tensions over the status and treatment of Turkish immigrants to Germany. In a contemporary twist on the ethnographic tradition of collecting folk costume, the curators commissioned fashion designers to create two new hybrid costumes for 'the Europeans'. The text panel explains how "the garments serve as an invitation to reflect on the theoretical construct of a transnational European identity, and to discuss how this is influenced by local, regional and national identities" (figure 3). "Borders" also addresses issues of migration, immigration, conflict, stereotyp-

Figure 3. "The New Europeans", designed by Stephan Hann; Museum of European Cultures, Berlin. Copyright: Staatliche Museen zu Berlin, Ute Franz-Scarciglia.

ing, inclusion, and exclusion. The overall display ends by asking who is "at home in Europe or is there such a thing as European identity?" Juxtaposing the EU flag with an image of seaborne migrants in a fragile boat attempting to cross the Mediterranean into Europe, the exhibition questions what values and histories unite and divide individual Europeans today and in the past (figure 4).

Taken as a whole the display does conform closely to Beck and Grande's discussion of a nationally rooted cosmopolitanism:

> [U]nderstanding Europe in cosmopolitan terms means defining the European concept of society as a regionally and historically particular case of global interdependence ... *Cosmopolitanism* differs from all the previously mentioned forms in that here the recognition of difference becomes the maxim of thoughts, social life and practice, both internally and towards other societies. It neither orders differences hierarchically nor dissolves them, but accepts them as such, indeed invests them with a positive value.... Whereas universalism and nationalism (and premodern, essentialistic particularism) are based on the principle of 'either/or', cosmopolitanism rests of the 'both/and' principle. The foreign is not experienced and assessed as dangerous, disintegrating or fragmenting but as enriching. (2007: 12–14)

Of particular interest is the section of the museum dealing with "so-called national personifications." This section takes visual material produced in the nineteenth and early twentieth century to be explicitly nationalist, jingoistic, and in some cases xenophobic and reframes it through a postnational interpretive frame (figure 5). The result is that the objects signify in both directions simultaneously. We still recognize the unreconstructed national stereotypes visually represented

Figure 4. "At Home in Europe?" Text Panel, Museum of European Cultures, Berlin. Copyright: Rhiannon Mason

Figure 5. Illustrated broadsheet "Greek and Turks", around 1860; Mainz, Germany; Museum of European Cultures, Berlin. Copyright: Staatliche Museen zu Berlin, Ute Franz-Scarciglia.

on the collections of postcards, maps, games, souvenir tea towels, and tourist ephemera, but we are also invited to look at them simultaneously from the cosmopolitan viewpoint that the display organizes for its visitors (figure 6). The museum thereby sets up a double gaze that works with the multivalency of the objects and foregrounds the constructed nature of nations and identities.

The Museum of European Culture indicates how museums might address the societal changes being brought about by accelerated globalization and postnationalism. It differs from the Scottish example in that the Museum of European Cultures does not adopt an explicitly national framework. Instead it presents a mix of the effects of globalization both historic and contemporary (through trade and migration), ideas of transnationalism (cross-border influences), and examples of postnationalism and supranationalism (foregrounding the constructed and changing nature of nations and referencing the EU's rising importance). Throughout, it is infused with an ethos of cosmopolitanism in its nonhierarchical valuing of cultural difference. Along the way it makes a strong case for the long-standing evidence of different types of cultural diffusion, mixing, and hybridity and the continual interplay and blurring between the scales of local, regional, national, and global. It is, I would argue, cosmopolitan in approach because of its generally positive emphasis on the mutual influence of cultures and because its interpretive stance explicitly encourages the relativization of one's own position.

And yet, this museum is still rooted in its German context. Its avowedly transnational perspective can be seen as in keeping with a broader suspicion of overt nationalism borne out of Germany's own twentieth-century history of National Socialism. The conceptual framework of

Figure 6. Souvenir cloth "The ideal European should be …", 1990s; Strasbourg, France; Museum of European Cultures, Berlin. Copyright: Staatliche Museen zu Berlin, Ute Franz-Scarciglia.

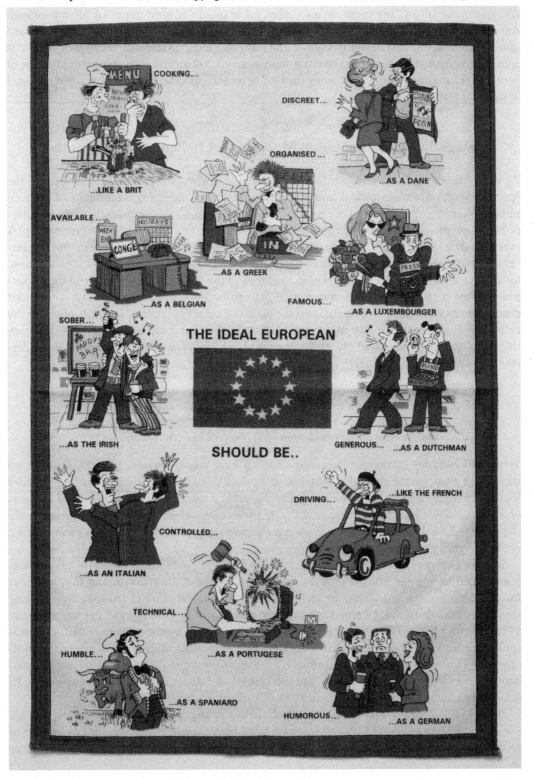

the display appears indebted to ongoing public and academic debates in Germany about how to present national history specifically as well as broader sociological ideas relating to mobilities and transnationalism. The museum also takes for granted the importance of regions—much more than would be usual in a UK national museum—which reflects the long-standing historical importance and political power of regions (*Länder*) in a federal Germany (Eckersley 2012). Its comparative approach speaks to its roots in European ethnology just as the National Museum of Scotland is a narrative history museum situated in its own specific, politically charged moment of national reaffirmation.

Imagining a Cosmopolitan Museology: Challenges and Potential

As these examples have attempted to demonstrate, it is always essential to acknowledge the specific social, cultural, historical, and political context when reflecting on the state of national museums and wider museological debates. Indeed, several authors have identified that cosmopolitan aspirations risk failure because they may seem too abstract and removed from people's everyday lives. Risse (2010), for example, concludes that any attempt to generate public conversations about the changing nature of national identities and Europeanization is much more likely to be successful if it is framed within the terms of the discourses appropriate to the respective national context, rather than in supranational terms. Similarly, Dibley (2011) has criticized cosmopolitan aspirations for museums on the basis that empirical studies seriously question the extent to which people are able and prepared to make the conceptual and ethical leap between their own situation and that of others they perceive to be far removed from themselves. Preferring the term 'cosmopolitical', Dibley concludes:

> Perhaps, the cosmopolitical museum might come to put forward proposals by which 'we' think of our decisions 'in the presence of' those others once disqualified by the borders of nation, species, and animation, not on the assumption that we nevertheless share a common world, but that we enter into the hard work of its composition. (Dibley 2011: 162)

While still considering the term 'cosmopolitan' to have value, I concur with Dibley that we should not presume the general acceptance or a priori existence of cosmopolitanism. In order for (what I would term) a 'cosmopolitan museology' to be successful it must be framed in terms of, and accessible through, a local scale that genuinely resonates with people. The coordinates of this scale will be determined by the discourses surrounding politics, culture, and identity that obtain within a given setting.

Bearing Dibley's critique in mind, we might also ask whether visitors would be not just able but inclined to respond positively to the framework offered. Conversely, would they filter out the cosmopolitan framing device by seeking objects and narratives that are 'identity-confirming' rather than disrupting? Large-scale research carried out by Doering and Pekarik since the 1990s into the relationship between visitor expectations and visitor responses to the Smithsonian Institution suggests that many visitors are predisposed more toward exhibition messages that concur with their own 'entrance narratives'. They argued that if a discrepancy existed between the two it was either simply not recognized (if minor) or a source of displeasure (if strongly marked) (Doering and Pekarik 1996; Pekarik and Schreiber 2012).

If this is the case, any attempt to encourage visitors to step outside of their location and see the world through the eyes of 'others' will have to be framed in ways that equally offer points of recognition for visitors and invite them to extend this perspective into new territory. It is essen-

tial to remember that people have chosen to spend their precious free time visiting museums and therefore any attempt to use museums to raise controversial or sensitive issues has to be thought of in the context of a leisure choice, and not in the way it might be addressed through the formal education system.

Encouragingly, Rounds (2006) argues that a key motivation for museum visitors is to engage in acts of identity-as-exploration. He argues that visitors use exhibition visiting as a low-risk means to temporarily try out other worldviews and see this as a source of pleasure, although he suggests that this rarely fundamentally calls into question the visitor's own identity except where topics might be particularly powerful, such as the Holocaust. This low-risk exploration falls short of Delanty's and Held's more transformative visions of the encounter with the other as prompting a full relativization of one's own position. However, the scenario Rounds describes is probably a more realistic account of what museum exhibitions might achieve for a majority of visitors and, I would argue, still has considerable value.

More broadly, thinking of museum visiting as an opportunity to see the world from another's perspective raises two important questions. First, what might be the scope of such exploration; are there any limits to the kinds of views and horizons that a museum might wish to present? Second, does a cosmopolitan approach lead to the overt instrumentalization and politicization of museums, and is this acceptable? To take the latter point first, the 'new museological' literature and museum practice of recent years has resolutely confirmed that museums are not and cannot be 'neutral' spaces or apolitical. Displays, interpretation, and collecting practices are all bound up with questions of politics and power. Moreover, a close relationship between museums and government is not particularly new in many countries and contexts where museums have been seen as useful tools for achieving social, patriotic, diplomatic, or economic goals (Ang 2010; Eckersley 2012).

However, what I am arguing for is not necessarily the same as being conscripted to particular cultural policy agendas emanating from specific governments. In fact, it could be argued that cosmopolitanism is less explicitly political in the sense that it advocates recognition of a heterogeneity of perspectives and acknowledges a plurality of worldviews rather than pursuing a singular policy agenda.

Cosmopolitanism's emphasis upon plurality of views—some of which may be in conflict with one another—leads us to the second question about limits. Would a cosmopolitan approach to museology therefore mean that all views should be equally welcome in the museum space, or even treated with parity? The wider literature on cosmopolitanism addresses this question of possible cultural relativism, and it is frequently advocated that a respect for difference must be tempered by a higher principle of respect for human rights, equality, and relevant legal frameworks. In a similar way, we might ask if there are lines to be drawn and judgments to be made on the limits of museums as spaces for public dialogue. In practice, most museums as institutions operate—whether explicitly or tacitly—with an ethical code that informs the kinds of views they are prepared or able to espouse. Sometimes this will result from legal obligations that attach to them as publicly funded bodies and prohibit the promotion of certain points of view, particularly around race and equality legislation. In some countries museums may also be subject to more direct political control by governments. Despite the seductive claim that museums can truly be an open forum for every different point of view, in practice some arguments are always treated as more equal than others. If museums pursue the logic of operating as dialogic spaces, they will need ultimately to address these questions of implicit political frameworks and the limits of public discourse as defined in that context. Some institutions, like the Museum of World Culture in Gothenburg, are already doing so (Grenill 2011).

Concluding Thoughts

This article has endeavored to identify issues that arise when theories developed in relation to economics, finance, or demographics are transferred into the realm of material culture and cultural history as embodied in museums. Throughout, the overriding intention has been to address this question of whether we should be moving 'beyond the national museum' because of its traditional association with concepts of the nation and place-bounded identities. My conclusion is that this is not necessary or advantageous. Museums are already more than capable of telling stories that resonate with new, contemporary, and cosmopolitan ways of being in the world. They are extremely flexible and adaptive forms of cultural practice because the objects and stories that they house can be re-presented and reinterpreted in a myriad of ways. As the Museum of European Cultures shows, it is possible to set up a deliberate tension between the museum's interpretation and the cultural objects to call ideas of nationalism into question. Within a museum like the National Museum of Scotland, which is focused on the national perspective, there is equally the opportunity to draw out powerful stories of global connections and intercultural exchange. As these examples illustrate, museums have the potential to play an important role in helping contemporary societies navigate the perennial questions of identity, belonging, sameness, and difference.

Rather than seeking to move beyond the national museum the imperative must be, in my view, to cosmopolitanize it from within. This is not just a philosophical issue but also a practical one. Few museums are able to transcend their national parameters in an operational sense. In the same way that citizenship is only legally realizable within the parameters of nation-states or regional blocs like the EU (you cannot have a passport of the world), in reality only in a very few cases will it be possible to construct entirely new museums and new collections in line with a more explicitly postnational or global outlook. Fully supranational museum projects will most likely always find it challenging to muster enough financial and political backing to survive long-term precisely because they fall outside any nation-state's vested interest. In most situations museums that wish to respond to the challenges of addressing contemporary topics of migration, diversity, and multiculturalism will be working with what they already have.

Moreover, there is a risk that by identifying some topics as transnational, such as migration and diaspora, and demarcating those aspects of history in distinct institutions, we reassert comfortable notions of what counts as core and peripheral histories. While there may certainly be times when this is justified, I would argue that it is generally better to pluralize nations' histories from within so as to bring to the fore the diversity that has always been there. After all, the nation's 'others' are perpetually reminded of their peripheral status; the challenge raised by globalization, postnationalism, and cosmopolitanism is therefore to question the certainty of the core of the national story. In this way, museums—national or otherwise—can help societies better understand the historical roots of contemporary societal change, in turn helping to make sense of present-day concerns.

Museums alone do not have the answer or carry the responsibility for these sociological, philosophical, or political problems. They must be seen in relation to the wider political and cultural sphere and this will be highly differentiated according to each national context. Not all museums are subject to repatriation claims or the high levels of international visitors experienced in major cities. However, it seems reasonable to imagine that many museums will encounter some aspects of the accounts of globalization, postnationalism, and cosmopolitanism outlined above. Many museums are already grappling with the changing nature of their 'local' population and seeking to understand the heterogeneous mix of reference points that their audiences bring. At the very least, many museum visitors may bring with them some awareness that things happen-

ing simultaneously in many other parts of the world have a connection to their lives, be that in terms of the environment, global security, or international economic crises. The challenge is to meaningfully connect the way that people experience such issues locally with their global, transnational, and cosmopolitan dimensions.

How best might this be achieved? A cosmopolitan approach to museology would seek to make intelligible both what is common and shared across societies and what is distinct and particular within groups and places. It would look for methods of polyvocal interpretation and display that can engage an increasingly heterogeneous audience base. It would encourage people to consider the world through the 'other's' eyes and from an 'other's location' while encouraging visitors to connect this back to their own lives and experiences. It would try to capture the sense of what it means to be implicated simultaneously in both 'here' and 'there', local and global, past and present. A cosmopolitan museology does not need to be restricted to national museums; it can occur at any scale, although it may be easier to achieve in temporary exhibitions with a clearly defined focus and narrative. Whatever the practical methods adopted, to paraphrase Appiah (2006), the challenge for a cosmopolitan museology is to help people find new ways to live together as neighbors 'in a world of strangers'.

▪ **RHIANNON MASON** is a senior lecturer in museum, gallery, and heritage studies at the International Centre for Cultural and Heritage Studies (ICCHS) at Newcastle University. Her research and teaching interests concern national museums and heritage, history curatorship, identity, memory, and new museology. Rhiannon is the author of the book *Museums, Nations, Identities: Wales and its National Museums* (University of Wales Press, 2007). She has been involved in several research projects that bring together museological research and museum practice and is currently coinvestigator on Work Package 1 of the European Commission–funded MeLa project European Museums in the Age of Migration (MeLa: n.d.).

▪ **ACKNOWLEDGMENTS**

This article is indebted to the insights afforded to me as a participant in the European Commission–funded project MeLa and has benefited from discussions with other members of the network, especially Chris Whitehead and Susannah Eckersley of Newcastle University. I would also like to thank Kat Lloyd, Alistair Robinson, and Joanne Sayner for their very useful comments and suggestions. This article also benefited from the opportunity to present at a eunamus conference in Athens (April 2012) and the Association of Critical Heritage Studies in Gothenburg, Sweden (June 2012). Any shortcomings remain my own responsibility.

▪ **REFERENCES**

Alberti, Sam. 2005. "Objects and the Museum." *Isis* 96: 559–571.

Appadurai, Arjun. 1996. *Modernity at Large: Cultural Dimensions of Globalization.* Minneapolis: University of Minnesota Press.

Appadurai, Arjun, ed. 1986. *The Social Life of Things: Commodities in Cultural Perspective.* Cambridge: Cambridge University Press.

Ang, Ien. 2011. "Unsettling the National: Heritage and Diaspora." Pp. 82–95 in *Heritage, Memory and Identity,* ed. Helmut Anheierand and Yudhishthir Raj Isar. London: Sage.

Appiah, Kwame Anthony. 1998. "Cosmopolitan Patriots." Pp. 91–116 in *Cosmopolitics: Thinking and Feeling Beyond the Nation,* ed. Pheng Cheah and Bruce Robbins. Minneapolis: University of Minnesota Press.

Appiah, Kwame Anthony. 2006. *Cosmopolitanism: Ethics in a World of Strangers.* London: Penguin.

Assayag, Jackie, and Christopher Fuller. 2005. *Globalising India: Perspectives from Below.* New York: Anthem Press.

Auer, Stefan. 2010. "'New Europe': Between Cosmopolitan Dreams and Nationalist Nightmares." *Journal of Common Market Studies* 48 (5): 1163–1184.

BBC 2012. News: Highlands and Islands. "Historic Lewis Chessmen returning to Western Isles" 13 June 2012. http://www.bbc.co.uk/news/uk-scotland-highlands-islands-18429790 (accessed 20 November 2012).

Beck, Ulrich. 1999. *World Risk Society.* Cambridge: Polity Press.

Beck, Ulrich, and Edgar Grande. 2007. *Cosmopolitan Europe.* Cambridge: Polity Press.

Bennett, Tony. 2005. "Civic Laboratories: Museums, Cultural Objecthood and the Governance of the Social," *Cultural Studies* 19 (5): 521–547.

Bennett, Tony. 2006. "Exhibition, Difference and the Logic of Culture." Pp. 46–69 in *Museum Frictions: Public Cultures/Global Transformations,* ed. Ivan Karp and Corinne Kratz. Durham, NC: Duke University Press.

Breen, Keith, and Shane O'Neill, eds. 2010. *After the Nation? Critical Reflections on Nationalism and Postnationalism.* Basingstoke, UK: Palgrave Macmillan.

British Museum. 2012. A History of the World in 100 Objects: Lewis Chessmen. http://www.bbc.co.uk/ahistoryoftheworld/objects/LcdERPxmQ_a2npYstOwVkA (accessed 20 November 2012).

Brown, Garrett Wallace, and David Held, eds. 2010. *The Cosmopolitanism Reader.* Cambridge: Polity.

Calhoun, Craig. 2004. "Is it Time to Be Postnational?" Pp. 231–256 in *Ethnicity, Nationalism and Minority Rights,* ed. Stephen May, Tariq Modood, and Judith Squires. Cambridge: Cambridge University Press.

Castles, Stephen, and Mark J. Miller. 2009. *The Age of Migration: International Population Movements in the Modern World.* London: Palgrave Macmillan.

Cheah, Pheng, and Bruce Robbins. 1998. *Cosmopolitics: Thinking and Feeling Beyond the Nation.* Minneapolis: University of Minnesota Press.

Christensen, Lars, Poul Grinder-Hansen, Esben Kjeldbaek, and Bodil Bundgaard Rasmussen. 2012. *Europe Meets the World.* Copenhagen: National Museum of Denmark.

Cuno, James. 2008. *Who Owns Antiquity: Museums and the Battle over our Ancient Heritage.* Princeton, NJ: Princeton University Press.

Cuno, James. 2011. *Museums Matter: In Praise of the Encyclopaedic Museum.* Chicago: University of Chicago Press.

Daugbjerg, Mads. 2009a. "Going Global, Staying National: Museums, Heritage and Tensions of Scale." Invited paper from London Debates seminar, 14–16 May 2009, published on the website of the School of Advanced Study, University of London. http://pure.au.dk/portal/files/18793825/Daugbjerg_2009_Going_global__staying_national#page=1&zoom=auto,0,842 (accessed 22 November 2012).

Daugbjerg, Mads. (2009b). "Pacifying War Heritage: Patterns of Cosmopolitan Nationalism at a Danish Battlefield Site." *International Journal of Heritage Studies* 15 (5): 431–446.

Daugbjerg, Mads, and Thomas Fibiger. 2011. "Introduction: Heritage Gone Global: Investigating the Production and Problematics of Globalized Pasts," *History and Anthropology* 22 (2): 135–147.

Delanty, Gerard. 2006. *The Cosmopolitan Imagination: The Renewal of Critical Social Theory.* Cambridge: Cambridge University Press.

Delanty, Gerard. 2010. "The European Heritage from a Critical Cosmopolitan Perspective." LSE Europe in Question Discussion Paper Series. LEQS. Paper No 19/2010: 1–21.

Dibley, Ben. 2011. "Museums and a Common World: Climate Change, Cosmopolitics, Museum Practice." *museum and society* 9 (2): 154–165.

Doering, Zahava D., and Andrew J. Pekarik. 1996. "Questioning the Entrance Narrative." *Journal of Museum Education* 21 (3): 20–25.

Eckersley, Susannah. 2012. "Opening the Doors to Hold the Fort: Museums and Instrumental Cultural Policy in 19th Century Britain and Germany." *Museum History Journal* 5 (1): 77–104.

Fine, Robert. 2007. *Cosmopolitanism.* London: Routledge.

Franke, Julia, and Clemens Niedenthal. 2011. "Ship as Cypher: On Siting the Venetian Gondola in History and Media." Pp. 18–25 in *Cultural Contacts: Living in Europe: Museum Europaischer Kulturen,* ed. Elisabeth Tietmeyer and Irene Ziehe Berlin: Koehler and Amelang.

Grenill, Klas. 2011. "When Legitimate Claims Collide: Dealing with Critiques of Dialogical Efforts in Museum Work." *museum and society* 9 (3): 227–243.

Habermas, Jürgen. 2001. *The Postnational Constellation: Political Essays.* Cambridge: Polity Press.

Hedetoft, Ulf, and Hjort Mette, eds. 2002. *The Postnational Self: Belonging and Identity.* Minneapolis: University of Minnesota Press.

Held, David. 2002. "Culture and Political Community: National, Global and Cosmopolitan." Pp. 48–60 in *Conceiving Cosmopolitanism: Theory, Context, and Practice,* ed. Steven Vertovec and Robin Cohen. Oxford: Oxford University Press.

Held, David. 2010. *Cosmopolitanism: Ideals and Realities.* Cambridge: Polity Press.

Held, David, and Anthony McGrew, eds. 2003. *The Global Transformations Reader: An Introduction to the Globalization Debate.* Cambridge: Polity Press.

Hernández-Durán, Ray. 2011. "Post-Nationalism." *Hemisphere: Visual Cultures of the Americas* 4: 13–15.

Jenkins, Richard. 2002. "Transnational Corporations? Perhaps. Global Identities? Probably Not!" Pp. 66–84 in *The Postnational Self: Belonging and Identity,* ed. Ulf Hedetoft and Hjort Mette. Minneapolis: University of Minnesota Press.

Kockel, Ulrich. 2010. *Re-visioning Europe: Frontiers, Place Identities and Journeys in Debatable Lands.* London: Palgrave Macmillan.

Kymlicka, Will. 2004. "Nationalism, Transnationalism and Postnationalism." Pp. 227–268 in *From Liberal Values to Democratic Transition: Essays in Honor of János Kis,* ed. János Kis and Ronald William Dworkin. Budapest: Central European University Press.

Levy, Daniel, and Natan Sznaider. 2002. "Memory Unbound The Holocaust and the Formation of Cosmopolitan Memory." *European Journal of Social Theory* 5 (1): 87–106.

Macdonald, Sharon. 2002. *Behind the Scenes at the Science Museum.* Oxford: Berg.

Macdonald, Sharon. 2003. "Museums, National, Postnational and Transcultural Identities." *museum and society* 1 (1): 1–16.

Macdonald, Sharon. 2006. "Undesirable Heritage: Historical Consciousness and Fascist Material Culture in Nuremberg." *International Journal of Heritage Research* 12 (1): 9–28.

Mackenzie, John M. 2009. *Museums and Empire: Natural History, Human Cultures and Colonial Identities.* Manchester, UK: Manchester University Press.

Macleod, Murdo. 2007. "Salmond Plots First Move in Scottish Battle to Win Back Lewis Chessmen." *Scotland on Sunday.* 23 December. http://www.elginism.com/20071224/salmonds-plans-for-the-return-of-the-lewis-chessmen/ (accessed 18 September 2012.)

Mason, Rhiannon. 2004. "Devolving Identities: Wales and Scotland and their National Museums." Pp. 312–329 in *History, Nationhood and the Question of Britain, ed.* Helen Brocklehurst and Rob Phillips. New York: Palgrave.

Mason, Rhiannon. 2007. *Museums, Nations, Identities: Wales and its National Museums.* Cardiff: University of Wales Press.

Meskell, Lynn. 2009. *Cosmopolitan Archaeologies.* Durham, NC: Duke University Press.

MeLa. n.d. European Museums in an Age of Migrations. http://www.mela-project.eu/ (accessed 20 November 2012).

Monash University. 2009. National Museums in a Transnational Age Conference. Prato, Italy. 1 November – 4 November 2009. http://www.globalmovements.monash.edu.au/events/documents/National%20Museums%20Abstracts%20and%20Pgm%20Nov%202009.pdf (accessed 18 November 2012).

Museum of European Cultures. 2012a. Collection – History. http://www.smb.museum/smb/sammlungen/details.php?objID=10&n=0&r=0&p=1 (accessed 20 November 2012).

Museum of European Cultures. 2012b. Collection. http://www.smb.museum/smb/sammlungen/details
.php?objID=10&n=0&r=0&p=0 (accessed 20 November 2012).

Museum of World Culture. 2012a. https://archive.org/details/varldskultur (accessed 25 September 2012).

Museum of World Culture. 2012b. http://www.varldskulturmuseerna.se/varldskulturmuseet/om-museet/
in-english/ (accessed 25 September 2012).

National Museums Scotland. 2012a. http://www.nms.ac.uk/our_museums/national_museum/explore_
the_galleries/scotland.aspx (accessed 20 November 2012).

National Museums Scotland. 2012b. http://www.nms.ac.uk/highlights/objects_in_focus/lewis_
chessmen.aspx (accessed 20 November 2012)

Paul, T.V. G., John Ikenberry, and John A. Hall, eds. 2003. *The Nation-State in Question.* Princeton, NJ:
Princeton University Press.

Pekarik, Andrew J., and James B. Schreiber. 2012. "The Power of Expectation: A Research Note." *Curator*
55 (4): 487–496.

Prosler, Martin. 1996. "Museums and Globalization." Pp. 21–44 in *Theorizing Museums,* ed. Sharon Mac-
donald and Gordon Fyfe. Oxford: Blackwell.

Risse, Thomas. 2010. *A Community of Europeans? Transnational Identities and Public Spheres.* New York:
Cornell University Press.

Robinson, James. 2004. *The Lewis Chessmen.* London: British Museum.

Rogan, Bjarne. 2004a. "The Emerging Museums of Europe." *Ethnologia Europaea* 33 (1): 51–60.

Rogan, Bjarne. 2004b. "Towards a Post-Colonial and a Post-National Museum: The Transformation of
the French Museum Landscape." *Ethnologia Europaea* 33 (1): 37–50.

Rosenau, James. 2003. *Distant Proximities: Dynamics Beyond Globalization.* Princeton, NJ: Princeton
University Press.

Rounds, Jay. 2006. "Doing Identity Work in Museums." *Curator* 49 (2): 133–150.

Seixas, P., ed. 2006. *Theorizing Historical Consiousness.* London: University of Toronto Press.

Sherman, Daniel, ed. 2008. *Museums and Difference.* Bloomington: Indiana University Press.

Smith, Rogers. 2003. *Stories of Peoplehood: The Politics and Morals of Political Membership.* Cambridge:
Cambridge University Press.

Taras, Ray. 2009. *Europe Old and New: Transnationalism, Belonging, Xenophobia.* Plymouth, UK: Row-
man and Littlefield.

"The Museum Beyond the Nation?" 2011. Panel Discussion at *Places, People, Stories* an interdisciplinary
& international conference. Linnaeus University, Kalmar 28–30 September 2011. http://lnu.se/
polopoly_fs/1.50474!The%20museum%20beyond%20the%20nation%5B2%5D.pdf (accessed 18
November 2012).

Tietmeyer, Elisabeth. (2011). "Cultural Contacts and Localizations in Europe—From the Collections of
the Museum of European Cultures." Pp. 11–17 in *Cultural Contacts: Living in Europe,* ed. Elisabeth
Tietmeyer and Irene Ziehe. Berlin: Koehler and Amelang: Berlin.

UNESCO. 2012. http://www.unesco.org/culture/museum-for-dialogue/museums-for-intercultural-
dialog/en/ (accessed 20 November 2012).

Vanya, Konrad, and Elisabeth Tietmeyer. 2009. "The Staatliche Museen Zu Berlin's Museum of Euro-
pean Cultures as a Platform for Intercultural Dialogue." *Journal of Ethnology and Folkloristics* 3 (1):
129–133.

Vertovec, Steven, and Robin Cohen. 2002. "Introduction: Conceiving Cosmopolitanism." Pp. 1–24 in
Conceiving Cosmopolitanism: Theory, Context, and Practice, ed. Steven Vertovec and Robin Cohen.
Oxford: Oxford University Press.

Whitehead, Christopher, Susannah Eckersley, and Rhiannon Mason. 2012. *Placing Migration in Euro-
pean Museums: Theoretical, Contextual and Methodological foundations.* Milan: MeLa Books. http://
www.mela-blog.net/archives/2315 (accessed 05 January 2013).

Young, Linda. 1999. "Globalization, Culture and Museums: A Review of Theory." *International Journal of
Heritage Studies* 5 (1): 6–15.

Yuval-Davis, Nira. 2011. *The Politics of Belonging: Intersectional Contestations.* London: Sage.

Colonial Visions

Egyptian Antiquities and Contested Histories in the Cairo Museum

Christina Riggs

■ ABSTRACT: During the Egyptian revolution in January 2011, the antiquities museum in Tahrir Square became the focus of press attention amid claims of looting and theft, leading Western organizations and media outlets to call for the protection of Egypt's 'global cultural heritage'. What passed without remark, however, was the colonial history of the Cairo museum and its collections, which has shaped their postcolonial trajectory. In the late nineteenth and early twentieth centuries, the Cairo museum was a pivotal site for demonstrating control of Egypt on the world stage through its antiquities. More than a century later, these colonial visions of ancient Egypt, and its place in museums, continue to exert their legacy, not only in the challenges faced by the Egyptian Antiquities Museum at a crucial stage of redevelopment, but also in terms of museological practice in the West.

■ KEYWORDS: ancient Egypt, colonialism, Egyptian Antiquities Museum, Grand Egyptian Museum, heritage studies, postcolonial museums, representation of museums

On the night of 28 January 2011, the 'Friday of Anger', protests throughout Egypt escalated as the rebellion against the Mubarak regime rapidly gathered pace. The center of the revolution was Tahrir Square, an awkward, traffic-congested public space left over from Khedive Ismail's Hausmannian development of Cairo in the 1870s, known until Nasser's revolution in the 1950s as Ismailiya Square. Buildings around Tahrir told the story of twentieth-century Egypt: the late 1940s government administration block called the Mogamma; the former Nile Hilton and the headquarters of the Arab League, both of which stand on the site of the military barracks occupied by the British army from 1882 until after World War II; the offices of Mubarak's ruling National Democratic Party (NDP); and the Museum of Egyptian Antiquities (commonly known as the Egyptian Museum or Cairo Museum), a 1902 Beaux Arts building dwarfed by its modern neighbors, but immediately recognizable by its salmon pink stucco façade.

When the building housing the NDP offices was set alight that Friday evening, fears grew for the security of the Egyptian Antiquities Museum adjacent to it, and over the next two days, a flood of news stories and activity on blogs and Facebook reported alleged break-ins, thefts, and vandalism in the museum, which had been closed to the public during the protests.[1] The suggestion of looting drew comparisons with the ransacking of the National Museum in Baghdad

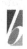

during the US-led invasion of Iraq. In Cairo, filming inside the museum showed a few smashed vitrines, several splintered statues, including finds from the tomb of Tutankhamen, and the jumbled heads and bones of mummified bodies, which Egyptology sites speculated were the grandparents of Tutankhamen (an assertion that specialists soon countered). The Egyptian antiquities minister, Dr. Zahi Hawass, posed with heavily armed soldiers to demonstrate that the museum had been secured. Few news outlets followed up their initial stories to report subsequent, well-founded suspicions that the looting had been staged by the secret police in a bid to turn Western powers against the protesters. Moreover, the military are alleged to have used the Egyptian Antiquities Museum as a detention and interrogation center during further protests in March 2011, earning it the soubriquet *salakhana,* 'torture chamber' (Elshahed 2011; Mohsen 2011).

The threat to antiquities in the museum succeeded in grabbing the attention of archaeological and cultural heritage organizations based in Europe and the United States. The International Council of Museums (ICOM), United Nations Educational, Scientific and Cultural Organization (UNESCO), the International Committee of the Blue Shield (ICBS), and the Archaeological Institute of America (AIA), jointly with the American Anthropological Association (AAA) and the World Archaeological Congress (WAC), issued statements or appeals in the ensuing days calling for the protection of cultural heritage in Egypt.[2] According to the ICOM statement, no less than the "collective memory of mankind" was at stake in safeguarding the collections of Egyptian museums and archaeological storerooms. A handful of academics took issue with such an emphasis on objects over people, as violence erupted around Egypt, but most commentators insisted that politics and heritage were separate, and that the protection of Egyptian artifacts transcended such concerns.[3]

Like many heritage institutions, however, the Egyptian Antiquities Museum in Cairo is steeped in politics, even if this was only notable by its absence in media coverage of the revolution. The museum has its origins in nineteenth-century colonialism, as far back as Mohammed Ali's post-Napoleonic ventures with European powers (Colla 2007: 116–120), and the doors of its current building opened at the height of the British 'veiled protectorate' overseen by Evelyn Baring, later Lord Cromer (Reid 1996, 2006). A European institution, aimed primarily at European audiences (whether residents or visitors), the museum was a stage on which to act out Europe's command over the antiquities of Egypt, even as events of the twentieth century gave the country its political autonomy, and changed the face and name of Tahrir Square.

From the 1970s, when Anwar Sadat realigned Egyptian markets and foreign policy with the United States and Western Europe, and approved an international tour of the Tutankhamen finds, the number of foreign tourists visiting the museum steadily swelled, outnumbering indigenous visitors. In terms of audience numbers, the Egyptian Antiquities Museum far outstrips other museums in Cairo: before the revolution, it received more than 1.7 million visitors per year, compared to fewer than 50,000 visitors per annum for the Museum of Islamic Art (Doyon 2008). Throughout Egypt, museums housing pharaonic, classical, and Byzantine ('Coptic') antiquities have been buoyed by foreign tourists, who are far less likely to visit museums of fine art, ethnography, or natural history. Many of these museums, whatever their focus, are products of European imperialism, part of a surge in museum building in Cairo and Alexandria in the late nineteenth and early twentieth centuries. The Museum of Islamic Art began as a museum of Arab art in 1884 (and moved to its present location in 1903), an ethnographic museum opened in 1895, and geology and entomology museums opened in 1904 and 1907 respectively; a museum for Coptic antiquities was established in Old Cairo in 1908, and the Graeco-Roman Museum, located in Alexandria, opened in 1892 (Doyon 2008: 6). Yet the Egyptian Antiquities Museum was, and remains, the most prominent in Western consciousness, which is why it is almost always referred to simply as the Egyptian Museum or the Cairo Museum, eliding the

pharaonic past with the city of Cairo and the nation-state of Egypt. Had the Egyptian revolution witnessed the violation of the Museum of Islamic Art, for instance, one imagines that responses from Western media and organizations would have had a different, and almost certainly more subdued, tone. It was the violation not simply of a museum, but of a museum concerned with ancient Egypt, that aroused a pained and fervent outcry ('devastating', 'shameful', 'sad' were frequent comments), as if the West itself were under attack.

And in a sense, it was, or could feel itself to be, for the museological partition of Egyptian culture into pharaonic, classical, and Byzantine pasts on the one hand, and Islamic pasts on the other, is part of a larger discursive strategy laying claim to ancient Egypt as the intellectual— and often actual—property of the West. But the situation is made more complex by competing claims both within and beyond Egypt, such as Islamic and Coptic Christian identity formations, and in Europe and North America in particular, the varied interests of academic Egyptology, Afrocentrism (a more diverse range of perspectives than the single word implies), and the broader public at whom press coverage of the Cairo Museum looting seemed to be aimed—a public used to consuming ancient Egypt through popular culture, tourism, amateur societies, and museum visits.

Where the West's cultural memory of ancient Egypt is concerned, processes of musealization remain essential to the project of placing, and keeping, Egyptian antiquities in the archive from which Western culture forms itself—and whether that formation takes place through opposition or alignment (Other or Self, if one employs the bipartite analysis of Said's Orientalism, discussed further below), cultural patrimony is its prerequisite. Contemporary instances that threaten to rupture this archive—claims for repatriation, for instance, or the attack on the museum in Cairo—may seem to be recent phenomena, but their roots lie in histories that are a century old, and more. Thus, my approach to understanding the impact and implications of rupture, such as the looting of the Egyptian Antiquities Museum, looks to the disciplines of history, archaeology, and art history as well as museum, literary, and cultural studies. The effects of colonialism, including the evolving relationship between the ruling Ottoman khedives and European powers, and the diplomatic machinations of France and Britain in particular, were directly responsible for the development of museums and the antiquities service in Egypt as well as the growth of European and North American museum collections and academic Egyptology (Reid 2006; Colla 2007). But colonialism shaped imaginations, not just institutions. For instance, literary scholars have made the case that the British entanglement in Egypt, which dated from the purchase of an interest in the Suez Canal in 1875 and was confirmed by the military occupation of 1882, was the impetus for the 'mummy's curse' genre of fictional output in the late nineteenth and early twentieth centuries. The instability of the political situation, and the threat modern Egypt posed to the British Empire, were transmuted through tales of supernatural aggression, whereby mummies and antiquities wreaked havoc on Western interlopers (Luckhurst 2012; Bulfin 2011; Deane 2008). Many of these stories incorporated museum settings, adducing a 'museal aura' in which past and present collapsed (Hoberman 2003).

Images likewise played a crucial, but often underestimated, role in limning how the museum and its antiquities related to the imperialist endeavor in Egypt, which coincided with the heyday of museum building not only in Egypt but also in European and North American cities. Through such imaginative representations, museums were acknowledged as the site where antiquities were estranged from their point of origin and incorporated, somewhat uneasily, into the modern world. In what follows, I use representations of the Egyptian Antiquities Museum at the height of the colonial enterprise to show how visual as well as literary accounts of the museum captured the exhibitionary and experiential imagination of a much larger Western audience than could visit Egypt in person—and that these imaginations from afar remain influential in

museological practice and heritage discourse. Filtered through the press, such representations helped to create and sustain a series of interrelated tropes: the superiority of European modernity, the disinterest of contemporary Egyptians in the ancient past, and the availability of the ancient Egyptian body for the European gaze. In the context of a museum based in Egypt, these tropes were especially potent, and have informed subsequent redactions of the Egyptian Antiquities Museum in the Western imaginary, which persist in viewing the museum as 'ours' and not 'theirs'—a tension evident in contemporary Egyptian perspectives as well (Colla 2007; Haikal 2003; Ikram 2011; Naguib 1990). The contested histories that the museum embodies require both acknowledgment and critique if institutions in either Egypt or the West are to develop alternative strategies and reimagine the heritage of ancient Egypt.

Other Egypts

Ancient Egypt is freighted with multivalent meanings, nowhere more evident than in the practice of collecting and displaying its antiquities (Riggs 2010). On the one hand, the pharaonic past was, and remains, familiar to the West, reinforced through ancient sources like the Bible and classical authors, and latterly vested with national interests and identities through the "artifaction" (Colla 2007) and musealization of its remains. Its historical longevity, cultural accomplishments, and enduring materiality (pyramids, hieroglyphs, mummies) helped mark ancient Egypt as a 'civilization' ripe for appropriation and worthy of inclusion in universalist narratives, including institutions like the Louvre, the British Museum, and the Metropolitan Museum of Art. On the other hand, ancient Egypt has been exoticized by difference (race, religion), making it available as a rod against which the West could measure its distance from the East. In this, ancient Egypt would be comparable to the timeless 'medieval' or 'Islamic' Egypt that has also provided a foil to the Western Self—with the result that, depending on specific contexts, both ancient and modern Egypt could qualify as the Orientalist Other of Said's formulation (Said 1978).

The evidence I consider here, however, warns against placing too much emphasis on the 'Other'-ness of ancient Egypt without framing such an analysis within colonial discourse. Rather than 'othering' ancient Egypt, colonial visions such as the paintings in figure 1 and figure 3, by French Salon artists, assert that Egyptian antiquities, and the institution of the museum, are rightfully the purview of European specialists, and in fact require the intervention of Europeans to care for and understand them. The Orientalist exclusion or subsidiary position of contemporary Egyptians supports the authoritative stance of Europeans toward the museum and its objects and, in this case, specifically French claims to the legacy of ancient Egypt. Literary evocations of the Egyptian Antiquities Museum likewise exclude contemporary Egyptians, and may ascribe to ancient Egyptian objects, especially mummies, such Orientalist tropes as sexual allure or magical powers. But the operation and impact of Orientalism must be analyzed through historical specificity (Burke and Prochaska 2008): in the context of the late nineteenth and early twentieth centuries, the antiquities museum in Cairo was a point of conflict between French and British interests, against a backdrop of weakened Ottoman rule and nascent Egyptian nationalism. That the antiquities themselves belonged—figuratively, if not literally—to the West was, and arguably remains, a discursive strategy situated within shifting geopolitical parameters. The case studies discussed below demonstrate that the Egyptian Antiquities Museum and its objects were points of intellectual anxiety at a moment of changing relations between European powers; in the uprising of 2011, they were points of anxiety again, but this time between the Europe and the United States on one side, and an Egypt at risk (to Western eyes) of becoming an Islamist state on the other.

The perception of Egypt's ancient accomplishments had enabled its inclusion in a narrative of Western progress. In Renaissance Europe, the recovery of the classical past included the recovery of ancient Egypt, which classical thought directly linked to the Hermetic literature of Egyptian late antiquity (Assmann 2006: 178–189). Ancient Egyptian wisdom (as glimpsed through classical authors) underpinned the Deistic, Enlightenment thought encapsulated in Freemasonry and Rosicrucianism, which appealed to cultivated male elites and coincided with the rise of the nation-state and the national museum. Napoleon's invasion of Egypt in 1798 was informed by this legacy, and hence combined a political and military endeavor—control of Egyptian territory and trade routes to the East—with a scientific effort to record the country and acquire its antiquities, destined for the Louvre (Cole 2007; Godlewska 1995). Although Napoleon was thwarted in this aim, the decoration of the Louvre mapped ancient Egypt onto French and European history, depicting it alongside Greece, France, and Italy as one of the great 'schools' of art (Duncan 1995: 26–27). The end of the Napoleonic wars saw Europeans trickle, then flood, into Egypt to 'rescue' antiquities from perceived Ottoman neglect, a condition that in part reflected Islamic or Christian ambivalence to irreligious images. Encountered in museums back home, Egyptian antiquities compared unfavorably to those of Greece and Rome, proving to be "wondrous curiosities" (Moser 2006) rather than works for uplifting aesthetic contemplation. Similarly, the decipherment of hieroglyphs in the 1820s opened the way for philological and archaeological studies, but also demonstrated that the secret wisdom hidden in the hieroglyphs was more prosaic than anticipated. The 'decline' of ancient Egypt, the failings of its art, and the disappointments of its writings only proved the point that Egypt was a basis for Western civilization, but had not fully realized the potential of human progress.

The trajectory traced above is inevitably a simplification. Moreover, there was (and is) no single, modern Egypt: in the colonial era, the Egyptian populace comprised an Ottoman elite, an ascendant but stymied Egyptian middle class, and the large peasant class that supplied agricultural labor, in addition to indigenous minority and immigrant communities (Greek, Italian, Jewish, and Coptic and Levantine Christians) often associated with specific trades or specialties, like banking (see Cole 1993). All these groups had differing aims and interests, as did the European powers with political and financial stakes in Egypt, especially Britain and France. In the twentieth century, the changing fortunes of pharaonism in Egyptian politics (Colla 2007), or the recent rise of the Salafi movement, which has grabbed headlines for decrying pharaonic statues as idolatrous (Sheffer 2011; Metwaly 2012), exemplify the polarizing potential of ancient Egypt in its own homeland.

Minority groups in the West have also availed themselves of ancient Egypt as a foundation myth, linking Judaism to the pharaoh Akhenaten, for instance (Montserrat 2000: 95–108), or African American slaves to ancient Egyptian ancestors (Trafton 2004). The Afrocentric arguments developed by Senegalese scholar Cheikh Antah Diop in the 1960s (first presented in English in 1974), and embraced in West Africa and among the African diaspora (Howe 1998), posit an ancient Egyptian, pan-African identity, disrupting both Western and Egyptian imaginings of Egypt. Yet Afrocentrism has been ignored or rejected by museums and by academic Egyptology, with very few exceptions (Roth 1998; Exell 2011); the often heated reaction to the first volume of Martin Bernal's *Black Athena* (Bernal 1987) focused on the empirical aspects of his work (Lefkowitz and Rogers 1996; Lefkowitz 1996; Bernal 2001), and hence failed to engage with the wider resonance of his argument, namely, that Western scholarship was a product of an imperial age and its attendant imbalances and bias (Young 1993, 1995; Colla 2007: 17).

It is by now customary to consider the 'birth' of the museum as a phenomenon of the modern age (Bennett 1995; McClellan 1994), with the attendant task of problematizing the institution on its home ground and in the colonial contact zones to which it was exported (Clifford 1997;

Karp and Lavine 1991; Karp et al. 2006). However, older paradigms persist in public perception and professional practice, as MacDonald (2003) elucidates for late twentieth-century London, and as Beverley Butler (2001, 2007) has discussed in relation to the UNESCO-backed millennium project to rebuild the library and museum (Museion) of Alexandria, known today as the Bibliotheca Alexandrina. Alexandria's legendary foundation as a Greek city brought it under the purview of classical heritage, which nineteenth-century thought cleaved from Africa and the Middle East. Emblematic of this separation, the destruction of the ancient Museion enabled a mythology of revival and return, as if the West's fraught relationship with Egypt could be healed by rebuilding the institutions in contemporary Alexandria. In Butler's terminology, the Alexandrina is a 'homecoming' for the museum concept, whose odyssey has seen it travel around the world and back again.

Given the range of ancient Egypts available, it is significant that museums today favor a presentation that avoids making temporal or geographic links with modernity. But it is also significant that ancient Egypt maintains a prominent place in a range of museums, from 'universal survey' museums to university, natural history, and local authority institutions. That prominence is due not to ancient Egypt's 'Other'-ness per se, but to its role in the Enlightenment narrative of progress. Historically, with its French pedigree and primarily, though not exclusively, non-Egyptian staff and audience, the Egyptian Antiquities Museum in Cairo could be lumped together with other Western museums and their burgeoning collections of coffins, mummies, and statues—but to do so overlooks the distinctive status it held by virtue of its location in colonial Egypt. The museum was set apart by the size and caliber of its collection, since the antiquities service received a division of finds discovered by archaeological missions, but more importantly, by its symbolic potential as a Western institution successfully inserted into Ottoman Egypt, an 'improvement' that made the country more European while ensuring that Europe's purported forebears, the ancient Egyptians, were in safe hands.

Vision 1: Modernity and Antiquity

The antiquities museum in Cairo had several homes before French architect Michel Dourgnon won an international competition to design the current building in 1895 (Reid 1996). 'International' meant that most entrants were British, French, and Italian, and all five finalists were French. The first attempt to form something like a national collection of antiquities for Egypt stemmed from the Albanian-born, Ottoman viceroy Mohammed Ali, who issued a decree in 1835 banning the export of antiquities and establishing a museum in Cairo to collect and display them (Khater 1960; Colla 2007: 116–120, 126–129). The decree made explicit reference to European models, and posited foreign visitors, rather than Egyptians, as the audience; it had little effect, however, and Europeans continued to criticize Mohammed Ali harshly for the destruction of archaeological monuments (Reid 2006: 54–58; Gliddon 1841). By the 1840s, the museum had clearly failed, and Mohammed Ali's successor, Abbas I, gifted the collection to the sultan in Istanbul and to Archduke Maximilian of Austria. In the 1850s, French Egyptologist Auguste Mariette, who had trained at the Louvre, established both a permit-based system for archaeological work in Egypt and a permanent, purpose-built museum on the banks of the Nile at Bulaq in Cairo, north of the current museum and convenient for offloading objects shipped from sites throughout the country (Reid 2006: 103–107). The Bulaq Museum was opened by Khedive Ismail in 1863 and within fifteen years was running out of space and threatened by the annual Nile floods. Mariette died in 1881, having been succeeded as director of the antiquities and museum service by another Frenchman, Gaston Maspero. When Maspero retired to France

in 1886, his countryman Eugène Grebaut, an experienced archaeologist, took on the role and oversaw the museum's move to a neo-Islamic khedival palace at Giza in 1890, where it remained until the Dourgnon building was ready (Reid 2006: 192–195).

The Bulaq and Giza incarnations of the antiquities museum witnessed the British takeover of Egyptian state affairs in 1882 and the ensuing, protracted negotiations between French and British officials concerning the cultural capital of the museum and its collections. The French retained control of the archaeological service and the museum, but the British held the purse strings. As director, Maspero ably balanced his dealings with the French government and the British authorities in Egypt, all the while promoting the museum's work and keeping close tabs on archaeologists and the antiquities trade. In the spring of 1882, just months before the British invaded to put down the Egyptian general Urabi's revolt, Maspero made headline news around the world when the mummified bodies of some two dozen Egyptian pharaohs and other high-ranking individuals were discovered in a cache at Deir el-Bahri, near the Valley of the Kings. The mummies and their coffins were shipped immediately to the Bulaq Museum, and in 1886, before his retirement, Maspero used a gallery of the museum to stage the unwrapping of several of the mummies (Maspero 1886a, 1886b). The international press avidly reported the results, cementing the reputation of the Egyptian Antiquities Museum as an institution whose collections were unrivaled, and whose position within the colonial administration, and among its peers in the West, was secure.

With the move to the Giza palace in 1890, however, the museum entered a challenging phase in its history. Relations between the archaeological service and British interests were strained: French scholars continued to run the museum, but were under pressure from Britain to employ more British Egyptologists in the archaeological service. The Society for Preservation of the Monuments of Ancient Egypt, chaired by no less than the president of the Royal Academy of Arts, Sir Edward Poynter, pressed for closer British involvement and for a new museum building, which was threatened by financial constraints (Reid 2006: 182–183). The Egyptian Antiquities Museum and its collections were openly discussed in the letters page of the London *Times*, lamenting the parlous environmental conditions of the Giza site. The mummy of king Seti I, reported one archaeologist involved with the Society, was white with moldy growth just a few short years after its triumphalist unwrapping (Poynter and Naville 1890).

Accusations of incompetence or backwardness stung museum officials not only because of internal politics in Egypt, but also because of the international museological and archaeological arena. As employees of the still nominally Ottoman government, the French (and some Armenian, Greek, and Egyptian) staff of the museum resisted suggestions that conditions in Cairo in any way lagged behind museum and academic practice elsewhere—an Orientalizing of the institution. In the boom years of the 1860s and 1870s, Mariette had promoted the antiquities service and the museum at international exhibitions like the 1867 Exposition Universelle at Paris, where objects shipped from Cairo were displayed in a mocked-up temple that formed part of Egypt's pavilion (Delamaire 2003; Mitchell 1988). The British regime was unwilling to sponsor an Egyptian entry at world's fairs, however, in part due to lack of funds and in part due to the 'veiled' nature of the protectorate (Reid 2006: 190–192). Promoting the French contribution to Egyptian archaeology, and keeping the Egyptian Antiquities Museum in international esteem, had to be accomplished by other means.

It was against this background that the French Salon painter Marius Michel submitted his painting *Photograph of a Mummy* (French title perhaps *Photographie d'un momie*) to the Columbian Exposition held in Chicago in 1893 (figure 1). The current location and exact date and dimensions of this painting are presently unknown, but it proved popular enough to be included in an album of engravings of paintings shown at the exposition. The original painting

Figure 1. Engraving of Marius Michel, *Photograph of a Mummy* (c. 1891), leaf removed from the bound volume *World's Best Art*, publisher unknown, 1894.

PHOTOGRAPH OF A MUMMY, by Marius Michel (*French Section World's Columbian Exposition*).—It would be impossible to put antiquity and the present into more striking juxtaposition than in this picture. A lot of Egyptian mummies and mummy cases have been opened and set around, and an artist, or at least a photographer, has come in with his camera to make a picture of these extinct subjects of the Pharoah. Suppose that these effigies out of a dead world could have seen the future four thousand years ago ! Suppose they could have seen a new world beyond the Western Ocean ! Suppose they could have seen themselves raised from the repose of their burial chambers and set against the marble walls to be photographed with a three-legged camera, while a modern adventurer holds the watch to count off the seconds of the sitting ! To what uses may we come ! The Shakespearian imagination which fancied Cæsar's lordly dust converted into a mud-plug for a bunghole was not equal to the grotesque and instinctive juxtaposition of dead and living things illustrated in this quaint conceit of Michel. Certainly it may be alleged that this is the most silent, if not the most orderly, photographic chamber in the world. This picture is reproduced in this work by special permission of the artist.

cannot date much earlier than the 1893 fair, for it is set in the museum at Giza, and it may form a pair with another painting discussed below, Paul-Dominique Philippoteaux's *Examen d'un momie* of 1891. The likely source of both commissions was either the khedival government (perhaps to commemorate the museum's new location in the Giza palace) or the Institut d'Égypte, the oldest and most prestigious French cultural and scientific body in Egypt. The caption of the published engraving indicates that *Photograph of a Mummy* was shown in the "French Section" of the Columbian Exhibition, one of two oil paintings by Michel that were displayed in the Palace of Fine Arts building, later to become the Museum of Science and Industry (Handy 1893: 943).

Michel used the setting of the Egyptian Antiquities Museum to show the deployment of novel technologies, as he depicted long-serving, German-born curator Émile Brugsch at work photographing an Egyptian coffin lid whose base lies in the foreground, still holding its wrapped-up mummy. Intrinsically aged, yet marvellously new in terms of what could be done to them and with them, objects like the coffin and mummy operated between the poles of antiquity and modernity, and Michel's painting encapsulates this convergence of old and new, East and West (terms I use here and throughout with the caveat that both are reductive constructions). A number of coffins and other antiquities fill the floor space of the high-ceilinged gallery, whose only visible entrance is a doorway at the far left, through which another room filled with ancient objects can be glimpsed. The dimensions of the gallery that is the focus of Michel's painting are

hinted at by the frieze at the top left and by the Oriental-style lamp that hangs from what is presumably the center of the ceiling. The objects distributed around the room also indicate the vastness of the space: a large, carved limestone false door from an Old Kingdom tomb dominates the back wall, and a fragment from the side of a Late Period coffin hangs next to it, over head height. The coffin at the far, rear right, lying on the floor like the others, is the one in which the mummy of king Ramses II had been found by Brugsch and Maspero just over a decade earlier in the Deir el-Bahri cache. Other Egyptian artifacts add to the funereal theme of the display: small *shabti* figures on a mat in the foreground, animal-headed canopic jars, and a square box with a jackal figure reclining on top. In the rear left corner of the space, the two coffin lids leaning against the wall suggest a display in the course of installation, or the secure but haphazard array of a busy museum work-in-progress.

Work certainly lies at the center of the scene, where a camera angles down on the coffin lid that has been propped on an upturned crate positioned on a chair seat. The slender legs of the camera tripod embrace the object, and off to the left stands Brugsch, a moustachioed man in a relaxed, almost rumpled suit, intently studying his pocket watch to time the camera exposure. His tarboosh (or fez) identifies him as an official in Ottoman employ. Like the lamp hanging just above the camera, the tarboosh inserts a certain note of the exotic and the 'timeless' Orient into the picture, yet in the historical context of colonial Egypt, its meanings were more complex. In the mid-nineteenth century, this headgear had been a sign of modern reform enforced by the Ottoman Porte, and adopted by both Muslim and non-Muslim officials in the civil service, army, and police—hence its rejection in Turkey by Mustafa Kemal (Ataturk) and in Egypt, finally, by Nasser and the Free Officers' rebellion of 1952 (Nereid 2011). By the time of the British occupation, the tarboosh was becoming a sign of conservatism as well as status; on Brugsch, who held the rank of pasha, it emphasizes the French and Ottoman cultural alliance in Egyptian state affairs.

In the Michel painting, modernity is signaled by the camera itself, which the caption to the engraved reproduction makes explicit:

> It would be impossible to put antiquity and the present into more striking juxtaposition than in this picture. A lot of Egyptian mummies and mummy cases have been opened and set around…. Suppose they could have seen themselves raised from the repose of their burial chamber and set against the marble walls to be photographed with a three-legged camera, while a modern adventurer holds the watch to count off the seconds of the sitting!

The confrontation between antiquities and Western adventuring elides millennia, and almost removes contemporary Egypt from the picture, in a literal and figurative sense.

A similar elision of time characterized other representations of Egypt at the Columbian Exposition. As was typical for international exhibitions, the Columbian Exposition combined architecture, the arts, manufacturing, and entertainment to spectacular effect, all the while foregrounding the imperial enterprise (Greenhalgh 1988). The 1893 expo, which attracted twenty-seven million visitors, commemorated the four hundredth anniversary of Columbus's 'discovery' of America and capped the rebuilding of Chicago after the devastating fire of 1871 (Burg 1976; Rydell 1984: 38–71). On the Midway, the main attraction was Cairo Street, with its mosque, café, sixty-one shops, artisan displays, donkey boy, camel driver, and musicians. Inspired by the Rue du Caire at the Paris exposition of 1889 (also organized without official Egyptian sponsorship), the street—"a composite structure which combines the most beautiful architectural features of Cairo"—took shape after consultation with the Khedive, who permitted Egyptian government architect Max Herz to plan and oversee the construction (Anon. [W. J. H.] 1893: 2–3). It led to a mock-up of Luxor Temple, which displayed wax copies of the royal New Kingdom mum-

mies, including Ramses II, whose coffin features in the Michel painting. After passing through the eastern portal of the exhibition to enter Cairo Street, a guidebook assured visitors, "there is nothing to remind you of the 19th century, save the costumes of the visitors who are there, like yourself, and whom you might wish elsewhere that you might enjoy your dream" (Anon. [W. J. H.] 1893: 5). Egypt had entranced visitors already in childhood through the biblical tales of Moses, Joseph, and the flight into Egypt, the same guidebook observed, and the personal encounter between this ancient past and the present gripped the imagination. Although founded on object(ive) 'facts', this reverie of images and imaginings easily slipped free of them, so it did not matter, for instance, that the real Cairo and Luxor were more than four hundred miles rather than a street apart, or that the status of the Egyptian Antiquities Museum, commemorated in Michel's grand painting, was very much in flux.

The activities brought to bear upon antiquities were embedded in modern relationships of power, identity, and commoditization (one shop on Cairo Street 'sold' mummies), and always underlying these was the certainty that significant antiquities belonged in a museum, and hence to the West, which was uniquely able to care for, conserve, and study them. In the foreground of *Photograph of a Mummy*, the open coffins, loose mummy bandages, and overturned pail (*situla*), once used for a milk offering, mark one of the qualities that many ancient Egyptian objects shared: if not already emptied by time, like the *situla*, they could be opened, unpacked, and unwound. Knowing all meant seeing all, and the dark cover pulled back to show the camera box and lens emphasizes the power not only of technology, but of revelation. Once revealed, the object could be understood, and understanding could be confirmed and conveyed through representations, like a photograph, an exhibition, or a painting that captured both.

Brugsch's photography was an essential part of cataloguing and publishing the collections of the Egyptian Antiquities Museum, an effort in which the museum broke new ground. Positioning itself and its collection as crucial to Egyptological scholarship, the museum had ambitions to produce a complete *Catalogue général* of the collection, organized by type of object (*shabti* figures, Greek sculpture, etc.) and authored by museum staff as well as British, German, and American scholars, especially after 1900. Illustrated by copious plates featuring photographs by Brugsch, most of the volumes were published in Cairo by the French archaeological institute (Institut français d'archéologie orientale). Although the catalogue was a rarified publication of interest to specialists, the work of producing it was enmeshed in the museological practices of registering, ordering, and documenting objects. Making these techniques the subject of a high-status painting expressed the integral role of the museum in general, and of the Egyptian Antiquities Museum in particular, and showing modernity and technology at work on antiquities identified the museum (and the Egyptian Antiquities Museum) as the place where ancient objects, and bodies, were turned into knowledge and narratives for the benefit of the West.

Vision 2: Orient-ing the Egyptian Mummy

The museum context of the Michel painting, and even the identity of some of its objects, like the Ramses II coffin, would have been familiar to urban middle classes who read such publications as the *Illustrated London News, Le Petit Journal* in Paris, or the *New York Times* and other newspapers, for the Egyptian Antiquities Museum (then located at Bulaq) had been widely reported in conjunction with the unwrapping of the royal mummies discovered in 1882, just months before the British invasion. In staging the unwrapping of several of the royal mummies at the Bulaq Museum in 1886, Maspero had made a savvy public relations gesture, and a political one as well, for both the Khedive and General Stephenson, commander of the occupation army,

were invited to attended (Maspero 1886a, 1886b). The museum's move to Giza was reported in the international press as well: the London *Graphic* featured drawings of the new galleries, emphasizing the display of the royal mummies and the fact that some works were still being installed (figure 2; Anon. 1890).

A second painting set in the galleries of the Egyptian Antiquities Museum at Giza—and perhaps a pendant to the lost Michel—was executed in 1891 by Paul-Dominique Philippoteaux (figure 3).[4] Entitled *Examen d'un momie,* it too represents French control over the museum, its ancient objects, and the domain of Egyptology, but its use of Orientalist themes is more explicit than in Michel's work, and a significant comment on Western perceptions of who belonged in the museum. Executed in oil, and measuring a substantial 275.0 cm wide and 183.0 cm high, *Examen d'un momie* hints at what the original appearance and dimensions of Michel's *Photograph of a Mummy* might have been, given the projected relationship between the two works. Like his father Henri before him, Paul-Dominique Philippoteaux was a successful history painter, best known for his vast panoramic paintings, including several versions of the Crucifixion, which toured the United States and Canada, and of the Battle of Gettysburg, one of which has been reconstructed at the battlefield (Oettermann 1997: 164–165, 343–344). Philippoteaux maintained studios in the United States and Paris and spent two years in Egypt, from 1890 to 1892, where he painted a portrait of the Khedive (present location unknown) and executed a number of smaller-scale paintings and sketches, some of which illustrated the popular book *Present-Day Egypt* (Penfield 1899). During his stay in Egypt, Philippoteaux also painted *Exa-*

Figure 2. Images of the newly opened antiquities museum in the Giza palace, printed in the *Graphic,* 21 June 1890.

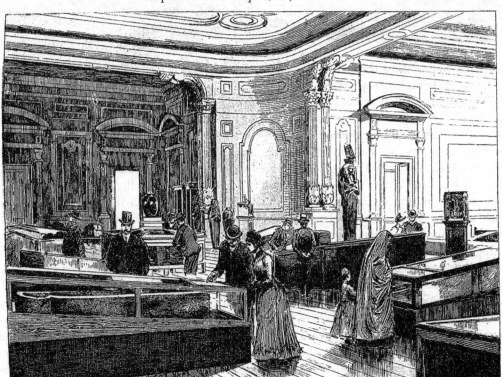

HALL OF ROYAL MUMMIES
Case containing the Mummy of Rameses the Great in the foreground

Figure 3. Paul-Dominique Philippoteaux, *Examen d'un momie* (1891), private collection. Photograph copyright the Bridgeman Art Library.

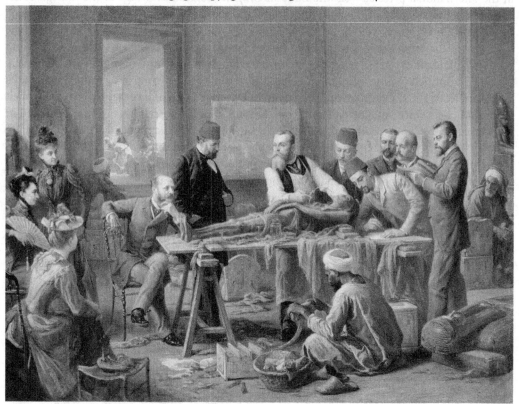

men d'un momie, using the same Orientalizing mode evident in some of his other output, not to mention his father's earlier work.

The painting is mounted in a gilt frame to which two brass plaques are fixed. One describes the event depicted, identifying the mummy and the date and place of its discovery, the name of its discoverer (Eugène Grebaut, then director of the antiquities service and the Eqyptian Antiquities Museum), and the unwrapping "by Dr Fouquet at the Museum of Ghizeh, 31 March 1891. Painted by Philippoteaux." The mummified body was that of a priestess named Ta-udja-re, from a group of twenty-first dynasty burials belonging to the High Priests of Amun that were found during continued work in the cliffs around Deir el-Bahri, the site that had yielded the earlier cache of royal mummies. The Khedive and the museum gifted a number of mummies and coffins from the priestly burials to Western museums like the British Museum, using the antiquities as a sort of diplomatic currency during the period of tension with British authorities. In the painting, the stiff body of the priestess Ta-udja-re reclines on a wooden plank propped on sawhorses, in an echo of the odalisque. Wisps of cloth trail over her thigh and hip to hang in swathes over the edge of the plank, and her hands curve modestly over her pubic area. At the far left of the scene, the corseted and covered bodies of three women (presumably French) in brightly coloured European dress form a contrast to the dull colour and near nudity of the mummy. As in the Michel painting, the setting of the scene in a museum gallery is prominent: there is an indistinct panel of tomb relief on the rear wall, a stone statue of a pharaoh at right, and an assortment of antiquities lying on the floor as if removed from recently opened crates.

The second brass plaque provides an outline sketch of the group of men who gather around the body of the priestess, their active gestures and serious expressions marking them out as the true subjects of the painting. The plaque makes no reference to either the European women or the Egyptian attendants. On the sketch, each figure is numbered to correspond to the plaque's list of identifications, where each man's name and office appear. The first man named is the gentleman seated at the feet of the mummy, the Marquis de Reversaux, French minister to Cairo, whose nonchalant, open posture indicates his high status among the company, even without the priority given to him in the list. The standing man next to him is Grebaut, wearing the tarboosh. In a white apron and shirtsleeves is Dr. Daniel Marie Fouquet, a French physician based in Cairo, who turns toward the seated European women as if explaining a point while his hands continue to work on the body of the priestess. Next to him are Brugsch (the plaque gives his rank as pasha) and another Eqyptian Antiquities Museum curator, Georges Daressy, both of whom also wear the tarboosh. The three bare-headed men clustered at right, around the head of the mummy, are Henri Bazil, a museum official; Jean Barois, from the Ministry of Public Works to which the antiquities service and museum belonged; and Urbain Bouriant, a former antiquities inspector who was then the director of the French archaeological institute.

Whereas the *Graphic* sketches from the opening of the Giza museum included a man, woman, and child in Oriental dress (the woman fully veiled) among the viewers in the galleries (see figure 2), the indigenous Egyptians depicted in the Philippoteaux painting are humbled by their role and positioning: an elderly man sits at the remote right edge of the painting, his view blocked by the backs of the Frenchmen and his placid, seated pose paralleled by the royal statue just behind him. Cross-legged on the floor, his back to the viewer, another man in Arab gown and turban rolls up the unwrapped mummy bandages to store in the basket on his right. He shows no interest in what is happening on the wooden plank, and by extension in the knowledge being generated and displayed there. Tidying away the ancient strips of linen, his work is the opposite of the Europeans' endeavor in every way. Framed through the ancient Egyptian-style doorway in the background, work taking place in the next gallery appears to show a man with a tarboosh directing two figures in Arab dress, leaning over as if to move a heavy object.

If the theme of Michel's *Photograph of a Mummy* was the dichotomy between modern technology and the remains of antiquity, which represented the superiority of European forms of knowledge, then the Philippoteaux counterpart *Examen d'un momie* expresses a similar but somewhat different take on the theme, contrasting Egyptians both ancient and contemporary—passive, languid, dull—with Europeans, who were active, lively, and bright. Both paintings aggrandize French achievements in Egypt, which had been crucial to French identity since Napoleon (see Porterfield 1998), and it is telling that they do this through the Egyptian Antiquities Museum, with which the antiquities service so closely identified itself, no more so than at a period of tension with British officials and archaeologists. But by placing Europeans in absolute control of an ancient body and of the museum space, both paintings also engage with the dominant discourse of colonialism. The shift to Giza from Bulaq did not shift existing colonial visions of the museum, which were well established and widely promulgated, nor would the next change in the museum's history, when it moved to its new home in the city's reconstructed center opposite the barracks of the occupying British force.

Vision 3: Attraction and Revulsion

As the British occupation continued, its 'temporary' nature clearly a long-term prospect, representations of the Egyptian Antiquities Museum, and of Egyptian antiquities in Western

museums, settled into a predictable pattern. If anything, the increased prominence of British archaeologists in the antiquities service augmented the Western identity of the museum, as did the new building that finally opened in Ismailiya Square in 1902, after a series of funding delays (figure 4). Travel writers greeted the opening of the new museum in mostly positive terms, since it met or exceeded their expectations of what a museum should be. One British writer claimed that its system of classifying the antiquities on display was so admirable that it should serve as a model to European institutions (Gregory 1999: 133).

In fiction of the time, female mummies (shades of Ta-udja-re) returned to life to lure stalwart British Egyptologists, a fantasy that frequently included scenes set in museums. Rider Haggard used both the British Museum and the Egyptian Antiquities Museum in Cairo (which he had visited) in his short story "Smith and the Pharaohs," published in installments in 1912 and 1913. The eponymous protagonist is locked in the Cairo Museum overnight and comes face-to-face with the spectral form of his mummified love interest, the ancient queen Ma-mee—whom he had first encountered at the beginning of the story in the British Museum (Deane 2008: 385–389). The illustration accompanying the Cairo episode in *The Strand Magazine* alluded to the museum by showing a statue or relief high on the wall, its details in shadow (reproduced in Deane 2008: 390, figure 3). Hoberman (2003) has argued that the museum setting of such stories was a response to the aura of the decommodified museum object, which viewers were meant to long for but could not possess. However, it is the space and identity of the museum as much as the objects it contains that are at stake. The concern with individual objects, whether a fictional mummy or the actual mummies feared damaged in the 2011 Egyptian uprising, conceivably masks concern for the museum itself as an institution of social, cultural, and political significance. Where Egyptian antiquities were involved, museum encounters were further laden with the freight of ancient Egypt's position in Western cultural memory.

The prolific and popular French writer Pierre Loti (the pen name of naval officer Julian Viaud) passed a harsh judgment on the new museum in his travel narrative, *Le Mort de Philae*, first published in 1908:

Figure 4. The Egyptian Antiquities Museum in Ismailiya (now Tahrir) Square, in a postcard dated 1907.

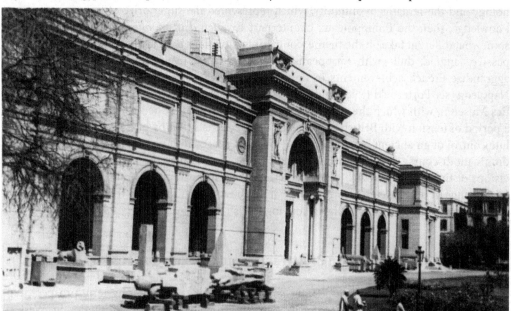

In the daytime this 'Museum of Egyptian Antiquities' is as vulgar a thing as you can conceive, filled though it is with priceless treasures. It is the most pompous, the most outrageous of those buildings, of no style at all, by which each year the new Cairo is enriched. (Loti [1908] 2006: chap. 4)

The European-style building epitomized the modernization of Cairo, and may not have pleased visitors seeking an 'authentic' Oriental experience. Tellingly, Loti's opinion of the place improved by night, when he was given a personal tour by no less than Maspero, who had returned from France to direct the museum in 1900. The royal mummies and other bodies that Maspero had been so instrumental in discovering, and unwrapping, occupied a gallery on the first floor, as they do today. By the light of a lantern, with the doors "doubly locked" behind them, Maspero and Loti made their way through the museum, which Loti described as "vast," "monumental," and occupied by "mysterious things that are ranged on every side and fill the place with shadows and hiding-places." When at last they reached the gallery, through air "heavy with the sickly odour of mummies," Loti passed from case to case, bending over with the lantern to see the faces of the pharaohs, which were arranged in chronological order and labeled with "common paper tickets." Their unwrapping of the mummies were fresh in the minds of both men, and in his description of viewing the mummy of Ramses II, Loti drew on details from the 1886 event, either relayed to him by Maspero or gathered through the several published accounts.

In its new home, the Egyptian Antiquities Museum continued to be a place of memory formation and accretion in the Western imaginary: the 1880s unwrapping was entwined with the fictive memory of ancient lives, and with Loti's own memory-making experience of visiting the building first by day, and then, dramatically, by night. Viewing the mummies in their vitrines stirred a range of emotive responses: curiosity, dread, calm, and, for one female mummy in particular, a spectral eroticism. Loti remarked on her "naked shoulders" and "dishevelled hair." His view was unobstructed, as the mummy lay revealed and still beneath his gaze: "[S]traightway I meet the sidelong glance of her enamelled pupils, shining out of half-closed eyelids, with lashes that are still almost perfect." As in the 'mummy's curse' genre of literature that flourished in the period of British occupation, Loti's account uses the mummy in the museum as a metonym for colonial dis-ease, the more so for taking place in Cairo. The experience of being in a European building but not in a European city appears, for Loti at least, to have been both attractive and repellent, an experience of the uncanny not unlike the mummy itself. Arguably, its location in the colonial contact zone made the Egyptian Antiquities Museum an especially potent symbol: physically and conceptually 'closer' to the ancient past, in possession of iconic objects like the royal mummies, and buffeted by competing European claims as well as nascent Egyptian nationalism, the space of the museum heightened Western responses to its objects—and the risk they posed should they fall into the 'wrong' hands.

Re-visions: Concluding Thoughts

Pictorial and literary visions of Egypt produced in a French and British milieu at the height of imperialism may seem a rather narrow lens through which to view the history of the Egyptian Antiquities Museum in Cairo and the laden symbolism of Egyptian antiquities in museums more generally. Yet it is in such focused glimpses that larger truths are met, for the familiarity of these images underscores the extent to which the musealization of Egypt was in place by the 1890s, and the role that museums in the West and, crucially, in Egypt played in the colonial project. The Eqyptian Antiquities Museum in Cairo maintains a special hold on the imagina-

tion of ancient Egypt as the birthright of the West, a hold that was painfully evident more than a century after Loti's visit when the fate of two mummified heads sparked an outcry amid fears that they were from those same mummies Loti had gazed on with lust and awe.

In the 2011 revolution, headlines about the Egyptian Antiquities Museum also focused on damage to objects from the tomb of Tutankhamen, an archaeological find kept intact for the museum in part through the efforts of Egyptian nationalists, marking a significant shift after World War I in how Egyptians were able to relate to the museum and claim the pharaonic past (Colla 2007; Hassan 1998). The museum continued to have French directors until after Nasser's coup in the 1950s, however, and since Sadat's controversial policies of liberalizing, and Westernizing, Egyptian markets in the 1970s, the museum has faced the challenge of balancing the demands of Western funding and foreign tourism against Egyptian interests and infrastructure, stretched by the growth of other museums as well as the sheer volume of the antiquities collections. In the past decade, further museum development in Cairo has focused on the National Museum of Egyptian Civilization (NMEC) at Fustat, a UNESCO-backed, Egyptian-designed project that incorporates all phases of the country's history in one institution, and the Grand Egyptian Museum (GEM), a mammoth development at the site of the Giza pyramids.[5] Designed by an Irish team of architects and funded to the tune of eight hundred million US dollars, chiefly from Japanese sources and loan guarantees, the GEM will house the Tutankhamen finds and thousands of other antiquities, relieving pressure on the Tahrir Square building—and potentially discouraging tourists from visiting central Cairo at all. The planned opening date is 2015, but at present, only the conservation facilities have been built. In spring 2011, plans were also announced for a USAID-sponsored museology institute in Cairo (el-Aref 2011).

The assertion that antiquities in Egypt belong to a 'global' heritage is a double-edged sword (Meskell 2002). On the one hand, foreign interest leads to foreign investment, but on the other, colonial legacies leave neocolonial hangovers. In both Egypt and the West, the contested histories of Egyptian antiquities and the museums that house them have yet to be brought into the open, challenged, and reimagined. Instead, the history of collecting and curating remains a history of Western effort from which the colonial narrative, and the colonized subjects, are absent, as in the biographies of British Egyptologists presented in the recently refurbished Egyptian galleries of the Ashmolean Museum. A Petrie Museum project to identify Egyptian archaeologists who worked on British excavations is a notable exception to this rule (Quirke 2010). As a colonial museum in a postcolonial nation-state, the Egyptian Antiquities Museum in Cairo remains caught in a discourse that subsumes ancient Egypt into the West, a discourse in which it has been embedded since its nineteenth-century foundation. Although beyond the scope of my discussion here, a backward glance invites a forward one: if it is emptied in whole or part of its antiquities when the Grand Egyptian Museum opens, the museum edifice in Tahrir Square may at last be free to re-vision ancient and modern Egypt alike, and to tell the story that lies on its own doorstep.

■ **CHRISTINA RIGGS** is a lecturer in ancient Egyptian art and director of the master of arts program in museum studies at the School of Art History and World Art Studies, University of East Anglia. She is the author of *The Beautiful Burial in Roman Egypt: Art, Identity, and Funerary Religion* (Oxford University Press, 2005) and editor of the *Oxford Handbook of Roman Egypt* (2012). She is currently completing a book entitled *Unwrapping Ancient Egypt* (Berg, forthcoming), which she presented as the Evans-Pritchard Lectures at All Souls College, Oxford, in 2012.

▪ ACKNOWLEDGMENTS

I thank the journal's anonymous referees for thought-provoking comments, and my colleague Ferdinand de Jong for invaluable discussion of the text and argument.

▪ NOTES

1. Al Jazeera television provided the first video footage of smashed cases and splintered antiquities inside the museum, followed by copious reports in US, European, and Arab news outlets, summarized in Bailey (2011), and on the Huffington Post, with embedded links, at http://www.huffington post.com/2011/01/30/looters-in-cairo-museum-a_n_816095.html. See also the "Looting Matters" blog by classicist David Gill at http://lootingmatters.blogspot.co.uk/, January and February 2011 archives, and coverage on the "Eloquent Peasant" blog by Egyptologist Margaret Maitland at http://www.eloquentpeasant.com/2011/01/29/statues-of-tutankhamun-damagedstolen-from-the-egyptian-museum/. Facebook groups included "Save + restore the Egyptian Museum" and "Egyptologists for Egypt" (accessed 17 July 2012).
2. ICOM: http://icom.museum/actualites/actualite/article/icom-urges-to-protect-egypts-cultural-heritage/L/2.html.html. UNESCO: http://www.unesco.org/new/en/media-services/single-view/news/unesco_director_general_launches_heritage_and_press_freedom_alert_for_egypt/. ICBS: http://www.ancbs.org/index.php?option=com_content&view=article&id=109:statement-egypt-31-01-2011&catid=10:statements&Itemid=20. AIA: http://www.archaeological.org/news/aianews/3934. AAA: http://www.aaanet.org/issues/policy-advocacy/Egypt-Letter.cfm. WAC: http://www.worldarchaeologicalcongress.org/component/content/article/63-press-releases/518-egypt-statement (accessed 10 May 2011).
3. Dissenting voices included archaeologist Neil Asher Silberman blogging at http://neilsilberman.wordpress.com/2011/01/28/archaeology-and-the-criminal-in-us/; anthropologist Rosemary Joyce at http://blogs.berkeley.edu/2011/02/04/of-people-and-things-egyptian-protest-and-cultural-properties/; and posts and comments on the Zero Anthropology blog at http://zeroanthropology.net/2011/02/05/the-american-anthropological-association-and-egypt-its-mostly-about-the-artifacts/ (accessed 10 May 2011).
4. For further details and images, see http://www.leicestergalleries.com/19th-20th-century-paintings/d/paul-dominique-philippoteaux/21387 (accessed 26 June 2012). The painting is in a private collection.
5. For the NMEC, whose interior fit-out is in progress, see http://portal.unesco.org/culture/en/ev.php-URL_ID=36838&URL_DO=DO_TOPIC&URL_SECTION=201.html (accessed 10 July 2012); for the GEM, see the architects' website, http://www.hparc.com/work/the-grand-egyptian-museum/ (accessed 25 July 2012).

▪ REFERENCES

Anon. 1890. "The Ghizeh Palace Museum, Cairo, Where the Art Treasures of Egypt are Preserved." *Graphic,* 21 June, issue 1073.
Anon. [W. J. H.] 1893. *Street in Cairo: World's Columbian Exposition.* Chicago: Egypt-Chicago Exposition Co.
el-Aref, Nevine. 2011. "An Institute of Museology." *Ahram Online,* 10 May. http://english.ahrma.org.eg/News/11810.aspx (accessed 10 July 2012).
Assmann, Jan. 2006. *Religion and Cultural Memory: Ten Studies.* Trans. Rodney Livingstone. Palo Alto, CA: Stanford University Press.

Bailey, Martin. 2011. "Details of Looting of Cairo and other Egyptian Museums." *The Art Newspaper,* 31 January. http://www.theartnewspaper.com/articles/Details-of-looting-of-Cairo-and-other-Egyptian-museums/23018. [last accessed 10 March 2013]

Bennett, Tony. 1995. *The Birth of the Museum: History, Theory, Politics.* London: Routledge.

Bernal, Martin. 1987. *Black Athena: The Afroasiatic Roots of Classical Civilization.* Vol. 1, The Fabrication of Ancient Greece, 1785–1985. New Brunswick, NJ: Rutgers University Press.

Bernal, Martin. 2001. *Black Athena Writes Back: Martin Bernal Responds to his Critics.* Ed. David Chioni Moore. Durham, NC: Duke University Press.

Bulfin, Ailise. 2011. "The Fiction of Gothic Egypt and British Imperial Paranoia: The Curse of the Suez Canal." *English Literature in Translation, 1880–1920* 54 (4): 411–443.

Burg, David F. 1976. *Chicago's White City of 1893.* Lexington: University Press of Kentucky.

Burke III, Edmund, and David Prochaska. 2008. "Introduction: Orientalism from Postcolonial Theory to World Theory." Pp. 1–74 in *Genealogies of Orientalism: History, Theory, Politics,* ed. Edmund Burke III and David Prochaska. Lincoln: University of Nebraska Press.

Butler, Beverley. 2001. "Egypt: Constructed Exiles of the Imagination." Pp. 303–318 in *Contested Landscapes: Movement, Exile and Place,* ed. Barbara Bender and Margot Winer. Oxford: Berg.

Butler, Beverley. 2007. *Return to Alexandria: An Ethnography of Cultural Heritage Revivalism and Museum Memory.* Walnut Creek, CA: Left Coast Press.

Clifford, James. 1997. *Routes: Travel and Translation in the Late Twentieth Century.* Cambridge, MA: Harvard University Press.

Cole, Juan R. I. 1993. *Colonialism and Revolution in the Middle East: Social and Cultural Origins of Egypt's Urabi Movement.* Princeton, NJ: Princeton University Press.

Cole, Juan R. I. 2007. *Napoleon's Egypt: Invading the Middle East.* New York: Palgrave Macmillan.

Colla, Elliott. 2007. *Conflicted Antiquities: Egyptology, Egyptomania, Egyptian Modernity.* Durham, NC: Duke University Press.

Deane, Bradley. 2008. "Mummy Fiction and the Occupation of Egypt: Imperial Striptease." *English Literature in Translation, 1880–1920* 51 (4): 381–410.

Delamaire, Marie-Stephanie. 2003. "Searching for Egypt: Egypt in 19th Century American World Exhibitions." Pp. 123–134 in *Imhotep Today: Egyptianizing Architecture,* ed. Jean-Marcel Humbert and Clifford Price. London: University College London.

Diop, Cheikh Antah. 1974. *The African Origin of Civlization: Myth or Reality.* Chicago: Laurence Hill Books.

Doyon, Wendy. 2008. "The Poetics of Egyptian Museum Practice." *British Museum Studies in Ancient Egypt and Sudan* 10: 1–37.

Duncan, Carol. 1995. *Civilizing Rituals: Inside Public Art Museums.* London: Routledge.

Elshahed, Mohamed. 2011. "The Case Against the Grand Egyptian Museum." *Jadaliyya* ezine, Arab Studies Institute, 16 July. http://www.jadaliyya.com/pages/index/2152/the-case-against-the-grand-egyptian-museum (accessed 17 July 2012).

Exell, Karen, ed. 2011. *Egypt in its African Context: Proceedings of the Conference Held at the Manchester Museum,* University of Manchester, 2–4 October 2009. Oxford: Archaeopress.

Gliddon, George R. 1841. *An Appeal to the Antiquaries of Europe on the Destruction of the Monuments of Egypt.* London: James Madden.

Godlewska, Anne. 1995. "Map, Text and Image: The Mentality of Enlightened Conquerors: A New Look at the Description de l'Egypte." *Transactions of the Institute of British Geographers NS* 20 (1): 5–28.

Greenhalgh, Paul. 1988. *Ephemeral Vistas: The Expositions Universelles, Great Exhibitions and World's Fairs, 1851–1939.* Manchester, UK: Manchester University Press.

Gregory, Derek. 1999. "Scripting Egypt: Orientalism and the Cultures of Travel." Pp. 114–150 in *Writes of Passage: Reading Tavel Writing,* ed. James Duncan and Derek Gregory. London: Routledge.

Haikal, Fayza. 2003. "Egypt's Past Regenerated by its Own People." Pp. 123–138 in *Consuming Ancient Egypt,* ed. Sally MacDonald and Michael Rice. London: University College London, Institute of Archaeology.

Handy, Moses P., ed. 1893. *The Official Directory of the World's Columbian Exposition, May 1st to October 30th, 1893.* Chicago: W. B. Conkey.

Hassan, Fekri. 1998. "Memorabilia: Archaeological Materiality and National Identity in Egypt." Pp. 200–216 in *Archaeology under Fire: Nationalism, Politics and Heritage in the Eastern Mediterranean and Middle East,* ed. Lynn Meskell. London: Routledge.

Hoberman, Ruth. 2003. "In Quest of a Museal Aura: Turn of the Century Narratives About Museum-Displayed Objects." *Victorian Literature and Culture* 31 (2): 467–482.

Howe, Stephen R. 1998. *Afrocentrism: Mythical Pasts and Imagined Homes.* London: Verso.

Ikram, Salima. 2011. "Collecting and Repatriating Egypt's Past: Towards a New Nationalism." Pp. 141–154 in *Contested Cultural Heritage: Religion, Nationalism, Erasure, and Exclusion in a Global World,* ed. Helaine Silverman. New York: Springer.

Karp, Ivan, and Steve D. Lavine, eds. 1991. *Exhibiting Cultures: The Poetics and Politics of Museum Display.* Washington DC: Smithsonian Institution Press.

Karp, Ivan, Corinne A. Kratz, Lynn Szwaja, and Tomás Ybarra-Frausto, eds. 2006. *Museum Frictions: Public Cultures/Global Transformations.* Durham, NC: Duke University Press.

Khater, Antoine. 1960. *Le regime juridique des fouilles et des antiquités en Égypte.* Cairo: Institut Français d'Archéologie Orientale.

Lefkowitz, Mary R. 1996. *Not Out of Africa: How Afrocentrism Became an Excuse to Teach Myth as History.* New York: Basic Books.

Lefkowitz, Mary R., and Guy MacLean Rogers, eds. 1996. *Black Athena Revisited.* Chapel Hill: University of North Carolina Press.

Loti, Pierre. [1908] 2006. *La Mort de Philae.* Trans. W. P. Baines. Project Gutenberg edition, http://www.gutenberg.org/ebooks/3685 (accessed 10 March 2013).

Luckhurst, Roger. 2012. *The Mummy's Curse: The True History of a Dark Fantasy.* Oxford: Oxford University Press.

MacDonald, Sally. 2003. "Lost in Time and Space: Ancient Egypt in Museums." Pp. 87–99 in *Consuming Ancient Egypt,* ed. Sally MacDonald and Michael Rice. London: University College London, Institute of Archaeology.

McClellan, Andrew. 1994. *Inventing the Louvre: Art, Politics, and the Origins of the Modern Museum in Eighteenth-century Paris.* New York: Cambridge University Press.

Maspero, Gaston. 1886a. "Procès verbal de l'ouverture des momies de Ramsès II et de Ramsès III." *Revue Archéologique* 8: 1–7.

Maspero, Gaston. 1886b. "Procès verbal de l'ouverture des momies de Seti I et Seqenenra Taâaqen." *American Journal of Archaeology* 2: 331–333.

Meskell, Lynn. 2002. "Negative Heritage and Past Mastering in Archaeology." *Anthropological Quarterly* 75 (3): 557–574.

Metwaly, Ati. 2012. "Islamists on Art: Egypt's Arts and Culture Scene Hanging in the Balance." *The Majalla Magazine,* 26 April. http://www.majalla.com/eng/2012/04/article55231343 (accessed 27 October 2012).

Mitchell, Timothy. 1988. *Colonising Egypt.* Cambridge: Cambridge University Press.

Mohsen, Ali Abdel. 2011. "Egypt's Museums: From Egyptian Museum to 'Torture Chamber.'" *Egypt Independent,* 20 April. http://www.egyptindependent.com/news/egypts-museums-egyptian-museum-torture-chamber (accessed 17 July 2012).

Montserrat, Dominic. 2000. *Akhenaten: History, Fantasy, Ancient Egypt.* London: Routledge.

Moser, Stephanie. 2006. *Wondrous Curiosities: Ancient Egypt at the British Museum.* Chicago: University of Chicago Press.

Naguib, Saphinaz-Amal. 1990. "Egyptian Collections: Myth-makers and Generators of Culture." *Göttinger Miszellen* 114: 81–89.

Nereid, Camilla T. 2011. "Kemalism on the Catwalk: The Turkish Hat Law of 1925." *Journal of Social History* 44 (3): 707–728.

Oettermann, Stephan. 1997. *The Panorama: History of a Mass Medium.* Trans. Deborah Lucas Schneider. New York: Zone Books.

Penfield, Frederic Courtland. 1899. *Present-Day Egypt.* New York: The Century Co.; London: Macmillan.

Porterfield, Todd. 1998. *The Allure of Empire: Art in the Service of French Imperialism, 1798–1836.* Princeton, NJ: Princeton University Press.

Poynter, Sir Edward, and Edouard Naville. 1890. "The New Museum at Cairo," letter to the editor. *The Times,* 29 May, 12.

Quirke, Stephen. 2010. *Hidden Hands: Egyptian Workforces in Petrie Excavation Archives, 1880–1924.* London: Duckworth.

Reid, Donald Malcolm. 1996. "French Egyptology and the Architecture of Orientalism: Decipherin the Facade of Cairo's Egyptian Museum." Pp. 35–69 in *Franco-Arab Encounters: Studies in Memory of David C. Gordon,* ed. L. Carl Brown and Matthew S. Gordon. Beirut: American University.

Reid, Donald Malcolm. 2006. *Whose Pharaohs? Archaeology, Museums, and Egyptian National Identity from Napoleon to World War I.* Berkeley: University of California Press.

Riggs, Christina. 2010. "Ancient Egypt in the Museum: Concepts and Constructions." Pp. 1129–1153 in *A Companion to Ancient Egypt,* vol. 2, ed. Alan B. Lloyd. Oxford: Wiley-Blackwell.

Roth, Ann Macy. 1998. "Ancient Egypt in America: Claiming the Riches." Pp. 217–229 in *Archaeology under Fire: Nationalism, Politics and Heritage in the Eastern Mediterranean and Middle East,* ed. Lynn Meskell. London: Routledge.

Rydell, Robert W. 1984. *All the World's a Fair: Visions of Empire at American International Expositions, 1876–1916.* Chicago: Chicago University Press.

Said, Edward. 1978. *Orientalism.* London: Vintage.

Sheffer, Sarah. 2011. "Salafi Group Reaffirms Call to Set Egypt's Pharaonic Relics in Wax." *Bikya Masr,* 6 December. http://www.bikyamasr.com/50394/salafi-group-reaffirms-call-for-setting-egypts-pharaonic-relics-in-wax/ (accessed 27 October 2012).

Trafton, Scott. 2004. *Egypt Land: Race and Nineteenth-century American Egyptomania.* Durham, NC: Duke University Press.

Young, Robert J. C. 1993. "Black Athena: The Politics of Scholarship." *Science as Culture* 4 (2): 274–281.

Young, Robert J. C. 1995. *Colonial Desire: Hybridity in Theory, Culture and Race.* London: Routledge.

Heritage

Renovation, Relocation, Remediation, and Repositioning Museums

Mary Bouquet

ABSTRACT: This article examines the changing relationship between museums and heritage using a number of Dutch cases. It argues that if heritage was once defined as being museological in character, this order of precedence is under revision as museums themselves are recursively transformed by heritage dynamics. Such dynamics include the display of renovation work-in-progress; the enhancement of historical collections by relocation to prominent new sites and buildings; the transformation of old industrial sites into new art and public spaces; and a mutual reinforcement between the urban landscape setting and the institutions that compose it by virtual means. Postcolonial heritage practices worldwide enfold museums in a further set of transformatory dynamics: these include claims on cultural property that was removed in colonial times, but also the strategic transformation of cultural property into heritage for didactic purposes. Museums are subject to the recursive dynamics of heritage, which are turning them inside out.

KEYWORDS: heritage, museums, reheritaging museums, renovation, replication, recursive dynamics

> With long histories sedimented in the very buildings many have occupied since their inception, museums must negotiate the competing expectancies of diverse constituencies.
> (Kirschenblatt-Gimblett, 1998: 138)

Introduction

The relationship between museums and heritage seems to be shifting—even though the long history of discovery, preservation, and reinvention of the past might make this seem a matter of continuity (see Alsop 1982). If museums were once places for conserving and displaying objects that had been removed from the everyday world, heritage by contrast is located in that very world (Kirschenblatt-Gimblett 2006a). However, the grounds of the distinction between the two no longer seem so clear-cut.[1] Many scholars refer to the ambivalent way that museums and heritage are connected and yet distinct through globalization. Museums are often mentioned

Museum Worlds: Advances in Research 1 (2013): 85–100 © Berghahn Books
doi:10.3167/armw.2013.010106

together with heritage sites, the heritage industry, the heritage scene, and heritage landscapes, indicating that heritage is something bigger than museums—that it somehow *includes* museums (Kratz and Karp 2006). When Butler writes that heritage and museums are "sites for the reorganization of cultural capital" (2006: 470), she maintains a comparable distinction while assuming that both fulfill the same purpose. Hoelscher's observation that heritage has a ubiquitous character that resides in a "deeply domestic realm" whose concerns are "central to the constitution of the museum, but that inevitably spill beyond its confines" (2006: 200) vividly articulates this nebulous duality. Macdonald (2002: 38) points to post-1970s new heritage as creating total environments: for example, when former industrial sites are turned into tourist attractions that may include museums.

If heritage is "a mode of cultural production that is essentially *museological* in character" (Kirschenblatt-Gimblett 2006: 39), this entails that museum dynamics precede those of heritage. However, if, as Fyfe (2006: 40) has put it, "[h]eritage and heritage museums constituted a leading edge of twentieth-century museums," then that order of precedence appears to have been reversed. So what has happened to the museum-heritage relationship? Is it a matter of scale—have the ever-increasing volumes of the past, and ever-increasing numbers of people who identify with (bits of) it, or contest its ownership or meanings, or want to use it for their own purposes, somehow overtaken the museum? Does this leave museums themselves among "the boundary stones of another age, the illusions of eternity": "sea shells on the shore when the sea of memory has receded" (Nora 1989: 12)? It would not seem so.

The trend among leading Dutch museums in the first decade of the present century was self-conscious renewal, redevelopment, renovation, enhancement, and accentuation of locations, sites, and buildings. The Rijksmuseum, which closed in December 2003 and is due to reopen in April 2013, is emblematic in this respect.[2] Such long-term transformations raise the questions of whether heritage, as a mode of cultural production that creates something new (Kirschenblatt-Gimblett 2006), has turned back upon museums themselves; and whether this is a broader global trend. If heritage was once defined as *museological* in character, are museums themselves now subject to a process that might be called *reheritaging*?

This article examines recursive heritage processes in a number of Dutch museums to ask what kind of broader trend they may be part of. These include satellite museums, megarenovations, and the renewal and redevelopment of historical museums. How do these processes stretch museums, both inward and outward—and by whom, and for what purposes? If spectacular museum architecture reinforces and adds value to destinations, what might be the recursive effect of the destination on the institution? How does virtual amplification of the site impact upon the exhibitions and the way that inalienable possessions are shown? Such questions point at how museums are subject to heritage processes in new ways. If museum practice is part of heritage-making processes (Smith 2011: 9), then what have museums become? Macdonald writes of a "heritage effect" that consists of a "sensibility grounded in particular visual and embodied practice prompted by certain kinds of spaces and modes of display" (2009: 4). What kinds of heritage effects can be seen in the spaces and modes of display in the Dutch museums discussed here? The last part of the article touches on the reshaping of such effects in the process of negotiating claims by postcolonial constituencies on collections, spaces, modes, and narratives of display.

Renovation as a Heritage Effect

Amsterdam was the destination for nearly ten million tourists in 2010 who stayed overnight, took canal trips, and visited a range of attractions—from diamond polishing to the Amsterdam

Figure 1. The Rijksmuseum seen from the Museumplein during renovation, 2010 (Photograph: author)

Arena (Federova and Meijer, 2011). What role do museums play in Amsterdam as a destination? The argument here is that museums and their sites are among the ingredients that make the city a place worth visiting. Travelers arriving at Amsterdam Schiphol Airport may pass by, and can visit, the Rijksmuseum Amsterdam Schiphol: a small golden cage where since 2002 travelers can dip into small thematic exhibitions of work from the Rijksmuseum's collection such as *Dutch Skies* or *Books in the Age of Rembrandt*. This satellite museum was born of the major refurbishment of the Rijksmuseum, Amsterdam (figure 1), which began when the museum closed in 2003 for what qualifies as a "blockbuster reinstallation" (see Kratz and Karp 2006: 12).

Renovation, renewal, and redevelopment are the first way that historical museums are implicated in the heritage process. In the case of the Rijksmuseum, fundamental reorganization of the exhibition space and public reception facilities involved a long process of reevaluating and indeed revaluing architect Pierre Cuypers's 1885 mixed-style building: its original inner courtyards, its central thoroughfare passageway, and its decorations, to mention just three features. Together with the Spanish architects Cruz y Ortiz, the Rijksmuseum decided to 'go ahead with Cuypers' (rather than going 'back to Cuypers') and create a spacious new reception area by opening up and connecting the two original courtyards of the museum.

The Rijksmuseum's megarenovation of its building could be seen as a "transvaluation of the obsolete … the outmoded" (Kirschenblatt-Gimblett 1998: 149). Certainly, the Rijksmuseum's late nineteenth-century building was stretched to its limits by increasing numbers of visitors by the end of the twentieth century. At the same time, the museum's somewhat forbidding appearance, combined with its awkward entrances and limited public facilities, made it uninviting to visit—despite its famous collections. The Rijksmuseum was in short no longer felt by manage-

ment and staff to be adequate to its national function. State financial support underlined the national significance attached to the project, while the architectural design that won the competition, by a Spanish bureau, emphasized its international character. The conscious decision to reinvent this historical museum involved casting back to recover the lost or obscured and imbuing it with new value. Reconfiguring the original in a manner attuned to the present and the future is often done in the name of something bigger than the museum itself. The scale and duration of the project, which ended up taking five years longer than anticipated, took its toll on museum staff.

The Rijksmuseum's renovation is clearly intended to cater to expanding visitor numbers, reinforcing—together with the Van Gogh and Stedelijk museums—the Museumplein area of Amsterdam. Partial closure of the museum gave rise to innovation: an interim Rijksmuseum with the masterpieces of the collection displayed in the Philips wing, which remained open; a number of satellite museums, in addition to the Schiphol museum; a program of traveling exhibitions; and a contemporary art program. Upgrading meant stretching the national museum in two directions: both inward, through its metamorphosis, and outward, through the novel ways found of both keeping while sharing its inalienable possessions (see Weiner 1992). It also comprised a well-publicized process of self-reflection, as portrayed in the documentary film *Het Nieuwe Rijksmuseum,* which followed the difficult negotiations and delays that dogged the renovation process (Hoogendijk 2008). Making the renewal process visible, both in real time and virtually, made the public party to the trials and tribulations of the metamorphosis. The museum expanded its visibility in novel ways during the years of closure: through its website, through the documentary made about the process, and through Hard Hat Tours of the decommissioned building. Dressed in builders' protective hats, boots, and fluorescent jackets, small parties of twenty-five people were able to take guided tours of the emptied and gutted building: to visit it in an unprecedented and desolate condition and see the painstaking work-in-progress. The complex metamorphosis was relayed through a range of media, on- and off-site, and generated news, discussion, and discourse that, although focused on the minutiae of the site, had effects far beyond its walls. The museum did not simply transform itself, but self-consciously presented itself as doing so—addressing its peers as well as its public. The international coordinates of renovation were thus an essential premise of this national project. The closure of the three major museums on Amsterdam's Museumplein and the delays and setbacks in the process (partly due to a local controversy surrounding the cycle path that runs through the central thoroughfare passage of the Rijksmuseum) ensured a sustained presence in the public sphere.

During the ten years of the Rijksmuseum's closure (2003–2013), the institution reinvented its public profile through strategic use of the site and architectural renovation process (Bouquet 2012). Consciously adding value to work-in-progress and using delay and public debate, the Rijksmuseum transformed its metamorphosis itself into an object of display. Thus, insofar as the renovation process itself has been used to enhance public sensibility, it is possible to identify a heritage effect at work in the museum.

Relocation, Branching, Culture, Industrial Aesthetic, and Performance Art

A second heritage effect can be seen when an existing institution is relocated and recreated in new premises. The Dutch Film Museum, now known as the EYE Film Institute Netherlands, moved from its old quarters on Amsterdam's Vondelpark (in the Old South of the city) to a prominent new building on the northern bank of the Ij in 2012. The EYE presents itself as "the Dutch Centre for film culture and heritage,"[3] thus claiming a new expanded importance for itself.

Figure 2. The newly opened EYE building on the northern bank of the Ij River in Amsterdam, May 2012 (Photograph: author)

In its striking building, designed by Delugan Meissl Associated Architects (Vienna), the museum's ambitions reach farther than housing, conserving, and exhibiting an important historical film collection (figure 2). The EYE aims to promote "a vigorous film culture" that will foster both the film industry and audience appreciation of film. The institution thus situates itself at the intersection between the production and enjoyment of film: the EYE wants to cultivate the public culture of film, thereby addressing its role in reproduction and transmission. This is reflected in its collection, which includes by-products such as photographs, posters, soundtracks, and equipment; and in its activities, which go beyond exhibiting film and making exhibitions about film. The building, with its four cinemas and six spaces, can also be used for a range of additional activities—from conferences to lectures, meetings, workshops, receptions, and even weddings. These multiple uses of the building will shape and remake both the institution and its public through time (see MacLeod 2005: 19). The prominent location of the building, on the northern, unfashionable, and poorer side of Amsterdam, is meant to help revitalize that area. People cross the river by ferry from Amsterdam Central Station to visit the new landmark, which resembles, in that respect, a more modest version of Frank Gehry's Guggenheim Bilbao, which was part of a major urban regeneration plan (Fraser 2006).

The EYE's public facilities, such as a spacious restaurant with a view over the water, encourage broader public use and perhaps attract a new kind of public. When the EYE refers to promoting "film culture and heritage," it chooses a bigger and more self-conscious presence in this new location when compared with its former incarnation as the Dutch Film Institute on the Vondelpark. The EYE clearly envisages itself as operating at a more global level of international

significance. The value of its collections is enhanced by encouraging a culture around them and recasting this combination as heritage: something widely recognized as valuable and supported by an active constituency. The added value of the EYE thus consists of its highly visible presence and practices of exhibiting film together with a range of facilities designed to capture the public's attention—and to sustain its operations on a daily basis. This maneuver corresponds with Kirschenblatt-Gimblett's conceptualization of heritage as "a mode of cultural production that creates something new, namely, a new relationship to what comes to be designated as heritage" (2006a: 40).

Relocation of existing institutions can involve renovation of an existing building, such as an industrial plant, for new purposes. The Battersea Power Station in central London, transformed by architects Herzog and De Meuron to house the Tate Gallery's branch of modern and international art, is such a case. This raises the question of what sort of heritage effect is produced through the reuse of industrial architecture and aesthetics to create what are considered to be appropriate spaces for exhibiting modern and contemporary art. Reuse, it has been observed, is one way of preserving industrial patrimony (see Berens 2011: 41), while transforming it into unprecedented forms and combinations. Rees Leahy (2010) contrasts the block of white cube galleries in the main Tate Modern building with the cavernous dimensions of the former Turbine Hall of the Battersea Power Station, which is now used to display the annual Unilever Series commission. This series has helped to transform art museum visiting from enactment of a solemn civic ritual to new ways of consuming art and appropriating art spaces. The Turbine Hall is officially classified as a street and the relational aesthetics of the space, the artwork, and the visitor—for example, in the Weather Project 2003–2004—have prompted the development of a new museum habitus.

In the Weather Project, visitors became self-conscious performers whose entire bodies were caught up in experiencing the artwork in the specific space of the Turbine Hall: climbing up installations, shooting down slides, lying on the floor to view the atmospheric effects, stepping into and across a confected floor crack. Tacita Dean's 2011 Unilever Series work, *FILM*, which used the space of the Turbine Hall as an improvised cinema to examine the endangered status of analog film, ran somewhat counter to this trend, since it immobilized the audience. But the 2012 Unilever Series commission, Tino Sehgal's performance piece *These Associations*, was a work with a group of actors moving as a throng through the space of the Turbine Hall, sometimes stopping, sometimes chanting (for example, the word 'electricity'), and periodically engaging members of the audience in brief conversational exchanges (fragments of stories, memories) before abruptly leaving to rejoin the group. These generic fragments of conversation, woven together by movement through the space, lighting effects, and chanting, constituted a collection of interactional exchanges (speech fragments combined with body movement) that the audience is then left to ponder, discussing the very nature of conversation and sociality that can take place under a set of site-specified conditions. The patterned interchange of unfocused and focused encounters between strangers, to use Goffman's (1966) terms, thereby elevates embodied conversational fragments to the status of art, indeed conversation piece, in the online age. The conversation pieces harnessed actors' personal recall in forms generic enough for strangers to be able to engage with them briefly through the conventions of such encounters in this site-specific setting. In so doing, participants could hold up conversation itself—not just words but bodily movement through space, eye contact, and disposition—for inspection, reflection, and perhaps for wonder as a form of intangible cultural heritage.[4]

Both the EYE and the Tate Modern constitute entirely new institutions, through shape shifting and reconversion respectively. The accumulated experience of inhabiting the Tate Modern's differentiated spaces, and reflection upon that process, has brought change over twelve years—

both in what is on offer and in public practice and sensibility. The self-consciousness of bodily awareness (propriocepsis), discussed by Rees Leahy (2010: 167) with respect to Doris Salcedo's *Shibboleth* commission for the Turbine Hall, is carried a step farther by *These Associations*. And it is this step farther, this elevation and magnification of conversational fragments through embodied performance, that underlines the museum's capacity to reappropriate the distracted attention and fragmented memories of its self-made audience, elevating them through a potent mix of contemporary art and reconfigured industrial heritage.

While we can only guess at how the location and space of the EYE will unfold through the practices of its visitors and other users over time, the Tate Modern shows how the newly created, differentiated spaces of industrial heritage dynamically interact with artworks and audiences, reshaping the institution and its publics in the process.

Inside Out and Outside In: Mutual Reinforcement as a Heritage Dynamic

The emerging urban landscapes include a variety of new, renovated, and connected sites that appear to turn certain museum dynamics inside out. Rather than the museum indoors affecting the museum outdoors in the form of heritage landscapes (see Bunn 2006), the disposition of certain museums in a given heritage complex may recondition what is on offer inside. The process of creating new spaces, views, and displays in the waterfront area around Amsterdam Central Station bears this out. The station was designed by architect Cuypers more or less at the same time as the Rijksmuseum, in a similar late Gothic/Dutch Renaissance style (figure 3).[5]

Figure 3. Amsterdam Central Station under renovation, 2011 (Photograph: author)

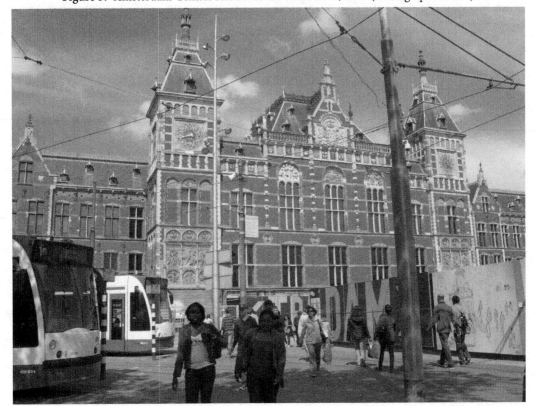

Its lengthy restoration is not unconnected with the renovation of the Rijksmuseum discussed earlier. Central Station is on the Amsterdam waterfront, which, like many other European cities, is in a process of redevelopment that involves several museums as well as housing and other projects. For example, the Tate Modern, located on the south bank of the Thames and connected by the new Millennium footbridge to St. Paul's on the other side, is an ancillary project to the London docklands redevelopment (Berens 2011: 213)—and situated near the renovated Waterloo Station.

The bridges connecting the various locations around the Amsterdam waterfront are part of the process of shaping it as a recreation area. They link a number of separate features that are displayed on this larger scale, almost as if they were exhibits in a "museum without walls" (Malraux 1967). In this case, however, the musealization process does not spill out through photographic reproduction: instead, the water and clouds reflected in it instill the locations they connect with a kind of open-air affect (see Dudley 2010). The bridges combine organized walking with a focused way of seeing (see Bennett 1995; Alpers 1991): yet the self-conscious walker is more than a roving Eye (Rees Leahy 2010: 164) taking in the constantly changing views of the city that unfold through locomotion. This setting affects the new or newly refurbished museums in several ways.

The Maritime Museum gradually appears as the walker, approaching from Central Station, skirts Renzo Piano's NEMO Science Centre building, which rises like a ship amidst the water of the Oosterdok (figure 4).[6] The roof of the building offers stunning views over the waterfront area and can be freely accessed, walked over, and picnicked on, without ever entering the "five floors

Figure 4. NEMO seen from one of the bridges leading from Amsterdam Central Station, with the Maritime Museum in the middle distance beyond it, 2012 (Photograph: author)

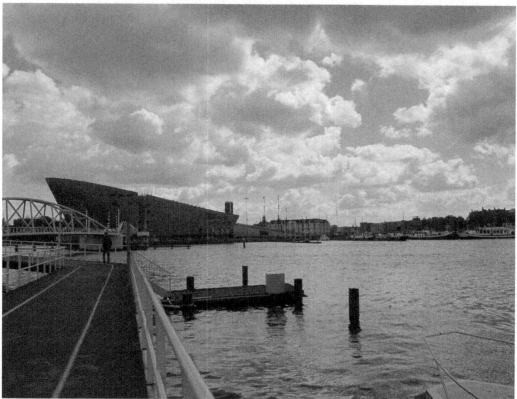

Figure 5. The Maritime Museum with the replica East Indiaman *Amsterdam* moored outside, 2012 (Photograph: author)

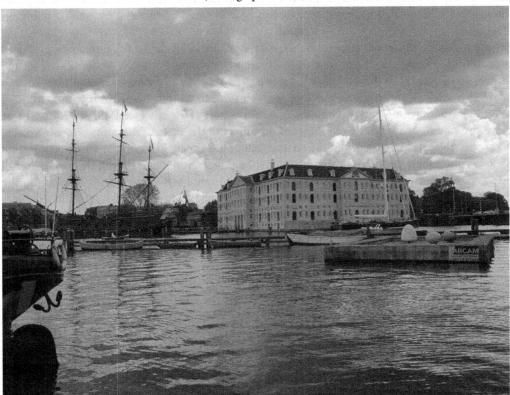

full of exciting things to do and to discover" (NEMO, n.d.b.). In a way, NEMO echoes the street dynamic of the Tate Modern Turbine Hall, but turned inside out. Even though NEMO may be "the perfect place for anyone with an inquiring mind" (NEMO, n.d.b.), the science center is highly conscious of its location and immediate surroundings.

The Maritime Museum (*Scheepvaartsmuseum*) is housed in the monumental seventeenth-century arsenal building (*'s Lands Magazijn*) designed by Daniel Stalpaert (1650–1656), which lies at the southeastern corner of the Oosterdok. The Maritime Museum underwent major refurbishment from 2007 to 2011, under the direction of Liesbeth v.d. Pol of Dok Architects. The project aimed at modernization by creating public spaces, reception rooms, a restaurant, and a library, while keeping the feeling of a seventeenth-century building (Maritime Museum n.d.). This included the removal of middle floors that had been introduced over time, the opening up of arches that had been covered, and the restoration of views (*zichtlijnen*). The replica East Indiaman *Amsterdam,* moored outside the building, adds to the interest and value of the site, which now claims to be breathing history. The replica allows people to *experience* history through the recreated spaces of the ship, without this needing to be the *original* ship.[7] Clambering aboard the *Amsterdam* is part of what Bennett (2006) has called the "transformatory logic of culture" in the post-1945 period, which he contends brought about a self-conscious, individuated relationship to inherited customs and material culture.

As a feature of the Amsterdam waterfront, the site of the original arsenal and the replica East Indiaman reinforce one another and add to the complexity of the museum. The arsenal's second life as heritage adds layers of value at different levels: to the bounded site of the Maritime

Museum, to the Amsterdam waterfront, and to Amsterdam in the broader sense as a destination culture (see Kirschenblatt-Gimblett 1998). We therefore need to examine what is going on inside the renovated museum to establish how it may be impacted by what is going on outside.

The Maritime Museum's structural metamorphosis includes the addition of a new glass and steel roof that spans the inner courtyard, echoing Foster and Partners' modernization of the British Museum's Great Court. This latter project reinvented a "long-lost" London place (Foster and Partners n.d.), creating new public space, accessible to nonmuseum visitors, and new flows of people—both within and through the museum as part of the city (see Williams 2004). These flows are said to break up the old imperial narratives of the British Museum, allowing visitors to choose their destinations from the central hub of the Great Court, in a manner comparable to an airport. Their destinations might include the Enlightenment Gallery in the former King's Library, or the ethnographic collections that were brought back to the British Museum in the late 1990s from the Museum of Mankind, where they had been for thirty years. These collections are now geographically organized into the Department of Africa, Oceania and the Americas, and are essential to the claims of the reconfigured universal museum to serve multicultural London. The monumental Haida memorial and house poles raised, in the presence of chiefs, in the modernized Great Court mark this reorientation in the British Museum's ambitions as a world heritage institution (see MacGregor 2007).

The Amsterdam Maritime Museum also signposts its North, South, East, and West wings from its covered inner courtyard. The exhibitions in these wings work like a series of discrete black boxes that, at a remove from the fabric of the building, open up new virtual worlds for our delectation. Every possible medium is engaged—from film to sound, motion, and replica—to amplify the fine historical collection and its site. For example, seventeenth-century navigational instruments are dramatized through installations that evoke the starry heavens; figureheads are artfully composed into a heroic group. New stories are told using the collection (ship models, maps, engravings, paintings) in combination with film—dramatized stories of seventeenth-century slavery give the image of domestic relations and affluence a new twist: Vermeer's milkmaid is reconfigured as a black slave worrying about her future in the household.

Although the restoration has created magnificent views from the building of its surroundings, the site is constantly remediated by virtual means—an effect that may be precipitated by the physical disjunction between the outer casement and the black boxes within. Here, the instruments of display are supposed to bring collection pieces 'to life' for visitors who have no living memory of them. This entails memories being manufactured on the spot: through sensation, replica, and virtuality, which situate the objects in the time and space of the visitor (cf. Hall 2006). It is the visitor who creates a memory through the experience facilitated by the museum, and it is the visitor who makes the connection with experiences outside—the interconnected places that together form a destination, and ultimately connect destinations farther afield. How does the museum facilitate this?

The Maritime Museum operates a virtual ride through the harbor area of Amsterdam, creating a sensation of moving at speed through the space already experienced by the visitor on their way to the museum. Sharing this simulated ride with others inside the museum objectifies and collectivizes individual memories brought in from the outside. The ship replica anchored outside further consolidates the formation of these experience-memories in a vessel that is an Amsterdam landmark, while evoking another time (the Dutch Golden Age) and another space (the Dutch East Indies) (figure 6). Such displays help to create a kind of 'cosmopolitan memory' loosened from the nation-state and transformed into the more generalized stories that belong to the realm of global heritage (Macdonald 2009: 12).

Figure 6. Visitors explore the replica East Indiaman at the Maritime Museum Amsterdam in 2012
(Photograph: author)

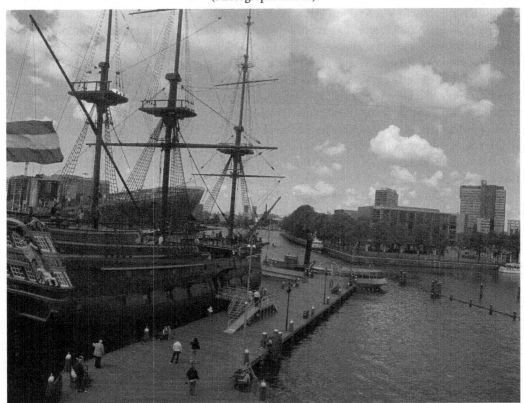

Inalienable Possessions, Return, and Giving While Keeping Heritage

Heritage dynamics have not only transformed existing museums in European cities such as Amsterdam, but have also given rise to new ones across the world. Heritage, as a set of rhetorical and material practices that create contemporary and future-oriented value out of selected resources identified with the past by sharing them, through display, with broader audiences, has been globalized. This development can in part be attributed to the expansion of global tourism and the creation of cosmopolitan memory. Since the Second World War heritage has become a global trend in which museums play key roles in different ways (see, e.g., Karp et al. 2006; Stanley 1998, 2007). The commemoration of the Holocaust through the creation of antimonuments, museums such as the Jewish Museum Berlin, and the preservation of death camps such as Auschwitz played a decisive role in this (e.g., Katriel 1997: 113–116; Macdonald 2009; Young 2000; Zelizer 2001). There are numerous ways that this can occur. In postconflict situations heritage may be used in the negotiation of trauma, such as in the aftermath of the Liberian civil war (Rowlands 2008). Archaeological and architectural heritage are being used strategically in disputes, such as the ongoing Israeli-Palestinian conflict (De Cesari 2010). Oppressed minorities and historically marginalized groups have come to define and use heritage in distinctive ways in Europe and also in settler colonies, such as in the United States, Canada, Australia, and New Zealand (Rowlands 2002a, 2002b). Repatriation claims to cultural property that was removed during the colonial period have become part of the emancipation struggles of First Peoples during the post-1945 period.

The case of the G'psgolox memorial pole, returned to the Haisla people of the northwest coast of Canada by the Swedish government in 2006, exemplifies the processes whereby selected items of cultural property in Western museums have acquired new meaning as postcolonial cultural heritage (Cardinal 2003, 2008). Two replicas of the G'psgolox pole were made in the course of the Haisla claim: one for reinstallation at the site from which the original pole had been removed at the instigation of the Swedish consul to British Columbia in 1927; and one flown to Stockholm as a gift from the Haisla people as part of their negotiations with the Ethnographic Museum, to which the pole had been presented. It is significant that this replica pole was raised *outside* the museum, where it will eventually be allowed to disintegrate, thereby displaying (and respecting) Haisla heritage values and practices to the Swedish public. The original G'psgolox pole, however, which was repatriated in 2006, is temporarily housed in a shopping mall to ensure that it does *not* disintegrate, hence respecting Swedish heritage values and practices, including the stipulation that the pole would only be returned to a museum-like facility.

Inalienable cultural possessions, to use Weiner's (1992) term, are not only being reclaimed, as in the Haisla case, but also used to educate and persuade fellow countrymen of the value of indigenous culture. It could, of course, be argued that the replica pole in Stockholm also serves a didactic purpose. Australian Aboriginal art and heritage have been crucial in contesting the European notion of Australia as *terra nullius,* with all the disastrous consequences that had (see Morphy 1998, 2006). Australians of Aboriginal descent, such as the Yolngu, have long understood the prestige and significance that art galleries and museums hold for Europeans, and become adept at using these institutions for their own purposes (Morphy 1998: 36). Indeed, it could be said that Aboriginal heritage has shifted from local to national to international public domains as a crucial part of the emancipation movement. This shift can be traced through three examples.

In creating the Elcho Island Memorial in 1957, when previously sacred painted and carved objects and bark paintings were made public, the Yolngu aimed at setting up an exchange relationship with Europeans by showing them their most valuable things. They hoped to gain more control over their own affairs as well as access to education and employment in the process (ibid.: 240). Morphy interprets this action as part of the remodeling of society after colonialism. The creation of the Aboriginal Memorial, composed of two hundred hollow-log coffins, thirty years later by Ramingining artists for the bicentennial celebrations, and later incorporated by the National Gallery of Australia (1987–1988), was more a countermonument in the context of the Australian state's invitation to contribute (ibid.: 413). It was a clear reference to the Aboriginal genocide in the setting of a prestigious national institution whose celebration had been cast in the framework of reconciliation. The *Yingapungapu* exhibit cocurated by Yolngu artists for the newly opened National Museum of Australia in 2001 was a collaborative work in which performances and artwork were nonetheless subject to the frictions of cooperating with multiple, global parties (Morphy 2006).

These last examples indicate how the strategic claims on and uses of heritage by First Peoples and Aboriginal Australians are shaping national as well as indigenous museums. Although that point is not developed here, it does situate the Amsterdam cases in a broader perspective.

Concluding Remarks

Heritage involves complex and subtle mechanisms whereby museums are co-opted into a range of social and political processes. Heritage amplifies the museum effect by producing new kinds of self-conscious attention for and sensibility to activities that would not have previously

qualified for it—such as the renovation process itself. The efforts to create a culture around a museum collection, such as film, and to designate it as heritage are closely allied with conquering a prominent place in the public domain. New forms of intangible cultural heritage—conversation pieces—are being created within the reinvented space of industrial heritage turned modern art museum. There are complex processes of mutual reinforcement taking place among neighboring institutions as part of newly configured waterfront complexes, where museums actively incorporate the outside—through views, replicas, or in remediated versions of their surroundings—collectivizing outdoor experience as an indoor ride. The use and the claims made on museums by new constituencies who make active use of these institutions as sites of civic persuasion are also reshaping both in the process. In these various ways museums have become subject to the recursive dynamics of heritage, which, globalized in scope, are turning the institution inside out.

▪ **MARY BOUQUET** is a fellow of University College Utrecht. With a PhD in anthropology from Cambridge, she worked in museums and at universities in Portugal, Norway, and the Netherlands. She has published many books and articles on museum collections and exhibition making, including: *Melanesian Artefacts/Postmodernist Reflections* (1988), *Pithecanthropus in Het Pesthuis, Leiden* (1993), *Bringing It All Back Home* (1996), *Academic Anthropology and the Museum* (2001), and *Science, Magic and Religion* (2005). Her most recent book is *Museums: A Visual Anthropology* (2012). She is series editor of Berghahn's *Museums and Collections* series. Her current research interests lie in heritage and contemporary art.

▪ ACKNOWLEDGMENTS

An earlier version of this article ("Corridors and Flying Buttresses: An Educational Round Trip") was presented at the ICTOP conference Bridges and Boundaries: Reframing Professional Education for Museums and Heritage? held at the Reinwardt Academy, Amsterdam, the Netherlands, 13–15 September 2012. I am grateful to ICTOP, to Lynne Teather and Hester Dibbits, and to participants at the conference for their comments and discussion; and to comments from three anonymous reviewers.

▪ NOTES

1. The vast literature on heritage has been reviewed many times and the authors referred to here are obviously a selection. Readers are also referred to Fairclough, Harrison, Jameson, and Schofield's *The Heritage Reader* (2008) and to Michael Rowlands (2002) for more on the subject.
2. Rijksmuseum director Wim Pijbes remarks: "As the museum is renovated, it is, so to speak, also being reinvented. The revamped museum will be completely in step with the 21st century" (Rijksmuseum n.d.).
3. Citation from the EYE film website (EYE n.d.). See also the Dutch Film Museum website at http://www.filmmuseum.nl/en (accessed 17 November 2012).
4. The Tate Modern Tanks, which opened in 2012, push the sensibility of the Turbine Hall still further in their darkened project rooms (see Tate Modern n.d.). The effect of a work such as *These Associations* can also extend into the white cube galleries where, in October 2012, I found myself involved in a brief conversation with two strangers who were standing before Luzio Fontana's *Spatial Concept*

Waiting (1960) discussing what this framed, vertically slit white canvas might mean. Would such a conversation have taken place without the prompts provided in the Turbine Hall? Or had it not been in the wake of the attack on Mark Rothko's *Maroon on Black,* which was tagged by a Yellowist a few days earlier? The Russian artist who inscribed Mark Rothko's 1958 painting 'Black on Maroon' with the words 'Vladimir Umanets A Potential Piece of Yellowism', claimed to be engaging in art and to have added value to the famous painting (Quinn 2012).

5. Beneath the station's glorious, renovated façade a banner proclaiming it as a heritage site used by thousands of people every day captured the self-conscious connection made with heritage discourse in May 2012.

6. NEMO is itself a location where scientific principles are made visible, put on display. The science center website refers to its collection of some seventeen thousand items as "Heritage" (NEMO n.d.a.). It is telling that this page shows an image of toasters from its collection in (the eloquently named) Café Renzo. For an image of the building, seen from the back, see NEMO (n.d.b.). There is also a NEMO presence at Amsterdam Schiphol Airport.

7. The Rosetta Stone replica in the King's Library of the British Museum allows people to touch, extending, by virtual means, the experience of the original in a glass case in the gallery on the other side of the Great Court.

REFERENCES

Alpers, Svetlana. 1991. "The Museum as a Way of Seeing." Pp. 25–32 in *Exhibiting Cultures: The Politics and Poetics of Museum Display,* ed. I. Karp and S. D. Lavine. Washington DC: Smithsonian Institution Press.

Alsop, Joseph. 1982. *The Rare Art Traditions: The History of Art Collecting and its Linked Phenomena Wherever These Have Appeared.* London: Thames & Hudson

Bennett, Tony. 1995. *The Birth of the Museum: History, Theory, Politics.* London: Routledge.

Bennett, Tony. 2006. "Exhibition, Difference, and the Logic of Culture." Pp. 46–69 in *Museum Frictions: Public Cultures/Global Transformations,* ed. I. Karp, C. Kratz, L. Szwaja, and T. Ybarra-Frausto. Durham, NC: Duke University Press.

Berens, Carol. 2011. *Redeveloping Industrial Sites: A Guide for Architects, Developers and Planners.* Hobokon, NJ: John Wiley & Sons, Inc.

Bouquet, Mary. 2012. *Museums: A Visual Anthropology.* London: Berg.

Bunn, David. 2006. "The Museum Outdoors: Heritage, Cattle and Permeable Borders." Pp. 357–391 in *Museum Frictions: Public Cultures/Global Transformations,* ed. I. Karp, C. Kratz, L. Szwaja, and T. Ybarra-Frausto. Durham, NC: Duke University Press.

Butler, Beverley. 2006. "Heritage and the Present Past." Pp. 463–479 in *Handbook of Material Culture,* ed. C. Tilley, W. Keane, S. Küchler, M. Rowlands, and S. Spyer. London: Sage.

Cardinal, Gil. 2003. *Totem: The Return of the G'psgolox Pole* [film]. National Film Board of Canada. http://www.nfb.ca/film/totem_the_return_of_the_gpsgolox_pole (accessed 3 December 2012).

Cardinal, Gil. 2008. *Totem: Return and Renewal* [film]. National Film Board of Canada. http://www.nfb.ca/film/totem_return_and_renewal (accessed 3 December 2012).

De Cesari, Chiara. 2010. "Creative Heritage: Palestinian NGOs and Defiant Arts of Government." *American Anthropologist* 112 (4): 625–637.

Dudley, Sandra., ed. 2010. *Museum Materialities: Objects, Engagements, Interpretations,* London: Routledge.

EYE. n.d. "About EYE." http://www.eyefilm.nl/en/about (accessed 17 November 2012).

Fairclough, Graham, Rodney Harrison, John H. Jameson Jr., and John Schofield, eds. 2008. *The Heritage Reader.* London: Routledge.

Federova, T., and R. Meijer. 2011. *Toerisme in Amsterdam en regio 2010/ 2011, Gasten en overnachtingen 2010 en hotels 2011.* Amsterdam: Gemeente Amsterdam.

Foster and Partners. n.d. "Projects." http://www.fosterandpartners.com/projects/0828/default.aspx (accessed June 2012).

Fraser, Andrea. 2006 "'Isn't This a Wonderful Place?' A Tour of the Guggenheim, Bilbao." Pp. 135–160 in *Museum Frictions: Public Cultures/Global Transformations*, ed. I. Karp, C. Kratz, L. Szwaja, and T. Ybarra-Frausto. Durham, NC: Duke University Press.

Fyfe, Gordon. "Sociology and the Social Aspects of Museums." Pp. 33–49 in *A Companion to Museum Studies*, ed. S. Macdonald. Malden MA: Blackwell Publishing.

Goffman, Erving. 1966. *Behaviour in Public Places: Notes on the Social Organization of Gatherings*. New York: Free Press.

Hall, Martin. 2006. "The Reappearance of the Authentic." Pp. 70–101 in *Museum Frictions: Public Cultures/Global Transformations*, ed. I. Karp, C. Kratz, L. Szwaja, and T. Ybarra-Frausto. Durham, NC: Duke University Press.

Hoelscher, Steven. 2006. "Heritage." Pp. 198–218 in *A Companion to Museum Studies*, ed. S. Macdonald. Oxford: Blackwell.

Hoogendijk, Oeke. 2008. *Het Nieuwe Rijksmuseum* [film]. The Netherlands: Pieter van Huystee Film & TV.

Karp, Ivan, Corinne Kratz, Lynn Szwaja, and Tomás Ybarra-Frausto, eds. 2006. *Museum Frictions: Public Cultures/Global Transformations*. Durham, NC: Duke University Press.

Katriel, Tamar. 1997. *Performing the Past: A Study of Israeli Settlement Museums*. Mahwah, NJ: Lawrence Erlbaum Associates.

Kirschenblatt-Gimblett, Barbara. 1998. *Destination Culture: Tourism, Museums, and Heritage*. Berkeley: University of California Press.

Kirschenblatt-Gimblett, Barbara. 2006a. "Exhibitionary Complexes." Pp. 35–45 in *Museum Frictions: Public Cultures/Global Transformations*, ed. I. Karp, C. Kratz, L. Szwaja, and T. Ybarra-Frausto. Durham, NC: Duke University Press.

Kirschenblatt-Gimblett, Barbara. 2006b. "World Heritage and Cultural Economies." Pp. 161–202 in *Museum Frictions: Public Cultures/Global Transformations*, ed. I. Karp, C. Kratz, L. Szwaja, and T. Ybarra-Frausto. Durham, NC: Duke University Press.

Kratz, Corinne, and Ivan Karp. 2006. "Introduction: Museum Frictions: Public Cultures/Global Transformations." Pp. 1–31 in *Museum Frictions: Public Cultures/Global Transformations*, ed. I. Karp, C. Kratz, L. Szwaja, and T. Ybarra-Frausto. Durham, NC: Duke University Press.

Macdonald, Sharon. 2002. *Behind the Scenes at the Science Museum*. Oxford: Berg.

Macdonald, Sharon. 2009. *Difficult Heritage: Negotiating the Nazi Past in Nuremberg and Beyond*. London: Routledge.

MacGregor, Neil. 2007. "Behind the Scenes at the British Museum." *Financial Guardian*, 14 September.

MacLeod, Suzanne. 2005. "Rethinking Museum Architecture: Towards a Site-specific History of Production and Use." Pp. 9–25 in *Reshaping Museum Space: Architecture, Design, Exhibitions*, ed. S. MacLeod. London: Routledge.

Malraux, André. 1967. *The Museum Without Walls*. London: Secker & Warburg.

Maritime Museum. n.d. "Monument." http://www.hetscheepvaartmuseum.nl/location/monument?t =English (accessed 18 November 2012).

Morphy, Howard. 1998. *Aboriginal Art*. London: Phaidon.

Morphy, Howard. 2006. "Sites of Persuasion: Yingapungapu at the National Museum of Australia." Pp. 469–499 in *Museum Frictions: Public Cultures/Global Transformations*, ed. I. Karp, C. Kratz, L. Szwaja, and T. Ybarra-Frausto. Durham, NC: Duke University Press.

NEMO. n.d.a. "Heritage." http://www.e-nemo.nl/en/?id=1&s=1125 (accessed 11 March 2013).

NEMO. n.d.b. "NEMO's Permanent Exhibitions." http://www.e-nemo.nl/en/?id=1 (accessed 11 March 2013).

Nora, Pierre. "Between Memory and History: Les Lieux de Memoire." *Representations*, 26: 7–24.

Quinn, Ben. 2012. "Man Who Defaced Tate Modern's Rothko Canvas Says He Added Value." *Guardian*, 8 October. http://www.guardian.co.uk/artanddesign/2012/oct/08/defaced-tate-modern-rothko (accessed 17 November 2012).

Rees Leahy, H. 2010. "Watch Your Step: Embodiment and Encounter at Tate Modern." Pp. 162–174 in *Museum Materialities: Objects, Engagements Interpretations*, ed. S. Dudley. London: Routledge.

Rijksmuseum. n.d. "The Future of the Rijksmuseum." https://www.rijksmuseum.nl/en/opening-and-renovation/the-renovation (accessed 1 December 2012).

Rowlands, Michael. 2002a. "Heritage and Cultural Property." Pp. 105–114 in *The Material Culture Reader*, ed. V. Buchli. Oxford: Berg.

Rowlands, Michael. 2002b. "The Power of Origins: Questions of Cultural Rights." Pp. 115–133 in *The Material Culture Reader*, ed. V. Buchli. Oxford: Berg.

Rowlands, Michael. 2008. "Civilization, Violence, and Heritage Healing in Liberia." *Journal of Material Culture* 13 (2): 135–152.

Smith, Laurajane. 2011. *All Heritage Is Intangible: Critical Heritage Studies and Museums*. Amsterdam: Reinwardt Academy.

Stanley, Nick. 1998. *Being Ourselves For You: The Global Display of Cultures*. London: Middlesex University Press.

Stanley, Nick. 2007. *The Future of Indigenous Museums: Perspectives from the Southwest Pacific*. Oxford: Berghahn Books.

Tate Modern. n.d. "The Tanks, Art in Action." http://www.tate.org.uk/whats-on/tanks-tate-modern/eventseries/tanks-art-action (accessed 2 December 2012).

Weiner, Annette. 1992. *Inalienable Possessions: The Paradox of Giving-While-Keeping*. Berkeley: University of California Press.

Williams, Richard J. 2004. *The Anxious City: English Urbanism in the Late Twentieth Century*. London: Routledge.

Young, James E. 2000. "Daniel Libeskind's Jewish Museum in Berlin: The Uncanny Arts of Memorial Architecture." *Jewish Social Studies* 6 (2): 1–23.

Zelizer, Barbie, ed. 2001. *Visual Culture and the Holocaust*. New Brunswick, NJ: Rutgers University Press.

Piazzas or Stadiums

Toward an Alternative Account of Museums in Cultural and Urban Development

Lisanne Gibson

ABSTRACT: Over the last twenty-five years or so there has been a 'cultural turn' in urban development strategies. An analysis of the academic literature over this period reveals that the role of new museums in such developments has often been viewed reductively as brands of cultural distinction with economic pump priming objectives. Over the same twenty-five year period there has also been what is termed here a 'libertarian turn' in museum studies and museology. Counterposing discussions of the museum's role within urban development with discussions from within the museum studies literature on the 'post-museum' reveals the dichotomous nature of these approaches to the museum. This article proposes instead a consideration of the phenomenotechnics of new museum developments. This approach presents a way of taking account of *both* technical *and* symbolic conditions and characteristics and in doing so, it is hoped, provides a way of analyzing the 'realpolitik' of the role of museums in urban development.

KEYWORDS: cultural development, culture-led regeneration, new museums, phenomenotechnics, post-museum, urban development

Introduction

Over the last twenty-five years there has been a 'cultural turn' in urban development strategies. Many such strategies have used museums[1] as a central focus for the development of inner-city cultural precincts[2] in which the museum is often a significant new capital development involving statement architecture, such as the Frank Gehry designed Guggenheim in Bilbao or the Daniel Libeskind designed Imperial War Museum North in Manchester. In other developments, such as Tate Modern, the museum is located in a piece of industrial heritage, reused and monumentalized, evoking a (romanticized) industrial past. In some cases, as in Newcastle/Gateshead—BALTIC Centre for Contemporary Art and The Sage Gateshead (the latter designed by Norman Foster)—both types of development, new and reused, sit side by side. These so-called culture-led urban development schemes are frequently cited and have, among some sectors, become almost shorthand for the multiplicity of benefits supposedly following such developments. This

Museum Worlds: Advances in Research 1 (2013): 101–112 © Berghahn Books
doi:10.3167/armw.2013.010107

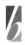

equivalence—culture-led development equals city 'transformation'—is characterized well by Anna Minton of the DEMOS consultancy, who makes the bold assertion that culture-led regeneration "has the power to transform the physical fabric of a city and to alter people's perceptions" (Minton 2003: 5). On the other hand, the same trend is cited by others as evidence that cultural policy is taking on a more instrumental character, driven by exogenous imperatives that are, it is argued, focused increasingly on economic rationales or social policy rationales such as 'inclusion', which such commentators describe as being to the detriment of cultural outcomes (see, e.g., Gray [2007, 2008], and for an alternative analysis of 'instrumentalization' see Gibson [2008]). Both approaches to culture and urban development, at least in relation to museums, tend to simplify the phenomenon they describe; museums and their effects are represented in purely symbolic terms—brands of cultural distinction with economic pump priming or social management objectives (see, e.g., Wilks-Heeg and North 2004; Yeoh 2005).

Surprisingly, the position of museums in urban development strategies has been subject to very few theoretically informed analyses that take account of the museum as a multidimensional institution made up of a variety of, sometimes competing, rationales and activities. In addition, and linked to this, few accounts of the museum's role in urban development take account of changes *internal* to the museum sector—within the profession, to practice, and to theory—over the same twenty-five year period as the 'cultural turn' in urban planning. This article proposes an alternative perspective for understanding the role of museums in urban development. Counterposing discussions of the museum's role within urban development as explored in the urban studies, cultural geography, and cultural policy and planning literatures with discussions from within the museum studies literature on the actual and potential roles of the 'post-museum' allows us to identify and analyze the key features of the discussion. This article does not aim to discuss actual museum developments or practice. Rather, it argues that analysis of the urban studies and cultural policy literatures, which is where most discussion of culture-led urban development, including museums, occurs, reveals a fundamentally different theoretical approach to understanding the museum than that which is found in contemporary museum studies literature. I will show in the following how in much of the literature on culture-led development new museums are analyzed primarily at the level of the symbolic. Instead, what will be proposed is an analysis of the phenomenotechnics[3] of the museum and its role in urban development. Such an account, which would analyze the technical as well as the symbolic multidimensionality of new museums in urban developments, would be better placed to understand the operation of the micropolitics of power in such spaces. This alternative approach to the discussion of culture and urban development will provide a way of analyzing the 'realpolitik' of museums and their roles in urban development.

Museums in Urban Precincts

Over the last quarter of a century there has been a significant increase in the numbers of new museums established. For instance, in Taiwan over five hundred new museums have been developed in the last twenty years (Lin 2010), and in the UK over six hundred museum capital build projects were funded by the Heritage Lottery Fund (HLF) over broadly the same period (HLF 2009).[4] So what is driving this 'multiplication of museums'? In many places (although not all), new museum developments (or significant refurbishments) have been part of urban development or redevelopment strategies where the museum is part of a suite of investments, alongside perhaps other cultural institutions, public art programs, investment in urban conservation, and so forth, which, as part of a cultural development package, aim to revitalize or rebrand a

particular place. There have been a number of strands to the discussion of this trend in the academic literature over the last, especially, twenty- five years. These discussions have taken place in particular within the cultural policy and cultural planning literatures (e.g., Bianchini 1993; Gibson and Stevenson 2004; Evans 2001, 2005, 2009; Mommaas 2004) and in urban studies and cultural geography (e.g., Jones and Wilks-Heeg 2004; M. Miles 2005; Miles and Paddison 2005; Zukin 1995). In reviewing the debates around culture's role in urban regeneration it is clear that museums have often been understood in quite limited ways. It is important to establish the precise nature of this characterization as, I argue, it is this view of the museum that dominates academic discourse when considering new or recently developed museums.

A review of the literature on culture and urban development reveals two main theoretical frames that are characteristic of much of the literature and that inform the consideration of museums. One framework establishes a dichotomy between investments in 'flagship' cultural programs versus 'community' cultural programs, where the 'flagship' is dismissed as a superficial visitor experience, part of a "single image and brand" (Evans 2003: 421) or merely as part of "property-led regeneration" (Wilks-Heeg and North 2004: 309), "targeting tourists and wealthier residents" (ibid.: 307).

The other dominant approach characteristic of the literature on urban development and cultural policy establishes a dichotomy between cultural programs described as encouraging 'consumption' versus those that are considered to support 'production'. Within this construction of consumption and production, consumption is cast as a passive activity (often with negative overtones) and production as having active identity and community forming effects. We can link these two sets of dichotomies. At play within this articulation of the 'flagship' institution versus the 'community' cultural program is the association of the former with passive consumption, instead of the preferred 'active' production; audiences are characterized as (mere) tourists or 'wealthier residents' as opposed to the 'local community'. Implied here is also a construction of the latter—the community-production-based program—as 'vernacular', organically developing and therefore 'authentic', whereas the 'flagship' is cast as an 'engineered' top-down incursion and therefore 'inauthentic' (Shorthose 2004). On this basis museum developments are understood as an incursion of regulatory control, anti-community and providing only a passive, single-dimension, consumption-based experience (Bianchini and Ghilardi 2004: 243–244). I want to argue here that such a de Certeauian (1994) opposition between 'free' and 'regulated' space is unhelpful to the consideration of the role of museums in urban developments. Before we consider what might be the basis of a different approach, it will be helpful to take a more detailed look at the assumptions that inform the framing of museums in many accounts of culture and urban development.

'Flagship' vs. Community

New museum developments are costly affairs, and it was already clear as early as the mid-1990s that, at least in the UK, regeneration centered around the capital development of cultural institutions was a strategy with many problems, not least the cost and an associated accusation that in such developments "the construction industry benefited much more than the arts sector" (Landry et al. 1996: ii). The key plank to this critique and a central concern in analyses of culture programs and the city more generally are that such developments do not connect with local people. There is no doubt that such a concern is an important consideration when planning for the longer-term sustainability of cultural investment. However, when reviewing a range of different types of arts-led regeneration, Landry and colleagues argue in relation to cultural programs involving significant capital development that

such large-scale projects produce mixed feelings among local people. They can absorb scarce resources from other proposals and their running costs can restrict future funds for cultural activities. In particular, the contrast between the favoured area, and those beyond its boundaries can seem very sharp, and may contribute to resentment and cynicism. (1996: 40)

In contrast, "participatory arts programs which are low-cost, flexible and responsive to local needs" (ibid.: i) are cited as likely to have a range of benefits, including "enhancing social cohesion, improving local image, reducing offending behaviour, [and] developing self confidence" (ibid.: ii–v). In this characterization, cultural programming involving "large-scale projects" are seen as *constitutively* static, unable to reach populations beyond their four walls, irrelevant to local communities, and a drain on other cultural resources. In contrast to this are posed activities such as small festivals and community arts activities, which are seen to be more "responsive to local needs."[5] Franco Bianchini and Lia Ghilardi further elaborate in relation to "flagship venues," where they describe favorably an "organic" approach to cultural regeneration, characterized as community-led cultural activities "where the cultural resources of the neighbourhood are mobilized in response to local aspirations, thus engendering participation and a sense of ownership" (2004: 243).[6] They contrast this with "flagship venues ... chosen as catalysts for development and increased consumption, these seem to have been largely unable to make their activities relevant to local people" (ibid.). Bianchini and Ghilardi acknowledge that this is not always the case, and there are instances where local people declare themselves proud of their local 'flagship' development; the example they cite in this regard is Bilbao (ibid.). This phenomenon of local pride in the development leading to a so-called 'trickle-down effect' has been one of the key tenets of the case made for culture-led regeneration in terms of significance to local communities.

There are a number of cases made *for* culture-led development; for our purposes here the most pertinent is the case made for developments structured around significant new build cultural institutions, such as museums, and the (hopefully) associated betterment of the city's image. The case for the existence of a 'trickle-down effect' posits that such developments can lead to an increase in pride in the local population, which leads to an increase in aspiration and following from this place vitality and prosperity. For this phenomenon to occur, Steven Miles argues that culture-led developments need to have a relationship with their local contexts and constituencies. For Miles, it is the *symbolic* impact of such developments that is powerful in this respect. In these terms, he considers the case of the Quayside development led by BALTIC Centre for Contemporary Art and The Sage Gateshead in Newcastle/Gateshead, an economically depressed industrial city in the northeast of the UK. For Miles, the success (measured through a series of interviews undertaken with local people) of the Quayside is due to the ways as a physical space it is able to articulate the distinctive identity of the northeast. While it is not clear from Miles's analysis quite how the Quayside development does this (perhaps because BALTIC is a reused industrial building?), nevertheless he concludes that this physical symbolism of the local enables the Quayside to "actually serve to revitalise the identities of the people ... it can reinvigorate the relationship between cultural, place and personal identity and offer a permanent legacy" (2005: 921). Ten years after the opening of BALTIC and The Sage Gateshead, and in the context of the northeast suffering the brunt of the UK government's austerity strategy through massive cuts in public services (the servicing of many of which were moved to the northeast in the late 1990s/early 2000s and arguably played a more central role in the area's relatively strong economic development throughout that decade), one can question whether this city rebranding has been enough to sustain the aspirations of those in the northeast who were not the immediate beneficiaries of the physical transformation of, at least, the inner-city environment (see more detailed discussion in Gibson [forthcoming]). I propose that to better understand the roles such

cultural institutions play in relation to their cultural, economic, and social environments, we need to analyze the effects of their programming and activities, some of which have little to do with their 'flagship' status and physical manifestation. I will argue in the section on cultural development and the 'new museology' that, at least in relation to the facilitation of local identity and interests, it is the *activities* of the museum that must be considered in order to understand the museum's role in urban development.

Consumption vs. Production

As we have already seen, integrally bound up with the representation of museums as 'flagships' incapable of responding to community/local or neighborhood needs is the notion of such museums as primarily constituted around a narrow form of consumption. Bianchini and Ghilardi argue that the key failing of such institutions is that they are manifestations of "mainly consumption-oriented urban cultural policies" (2004: 243). For Hans Mommaas, museums are places of "cultural consumption/presentation" that belong to an out-of-date mode of urban development based on presentation rather than production. In contrast, for Mommaas, are creative industries quarters described as "production spaces," "alternative working," and/or "breeding places," which Mommaas presents as offering the possibility of a cultural development strategy that is both economically generative and sustainable but at the same time supportive of local culture and identity (Mommaas 2004: 522).

This focus on balancing the economic and the cultural is at the heart of the definition of 'cultural development'. In the mid-1990s the UNESCO report of the World Commission on Culture and Development, *Our Creative Diversity*, argued that an exclusive focus on economic development had led to a range of social, cultural, and economic problems around the world, and had "given rise to cultural tensions in many societies" (1996: 7). The "cultural tensions" of particular concern were seen to be, in part, a result of the increasing dominance of certain cultural forms more able to survive in a free trade environment to the detriment of global cultural diversity and ultimately democracy. To address these pressing international policy issues the commission argued that "there was a need to transcend economics, without abandoning it" (ibid.). The idea of cultural development was introduced as a way of balancing cultural and economic policy objectives toward the achievement of democratic and convivial, culturally diverse societies (see Gibson 2001: chap. 7). It is in this context that 'flagship' museum developments, which are seen to have (passive) consumption and the attraction of tourists to the detriment of local communities as their focus, have been critiqued in terms that see them as commercially focused and therefore either politically passive, or worse, antidemocratic in their elitist and culturally homogenizing tendencies.

Given the focus on consumption in many new cultural developments in which museums feature, to what extent does this characterization, associating activities based on cultural production with cultural diversity and activities based on cultural consumption with homogeneity and 'inauthenticity', account for the roles of museums in urban developments? There is no doubt that such critiques identify a real risk for new museum developments. How though does this characterization of the museum compare with the theorization of the museum in contemporary museum studies and museology? The key challenge for cultural investment tasked with the regeneration, (re)development, or (re)imaging of a place is to balance the 'Janus faced' imperatives of economic development and cultural development—creative economy and civic participation—with the aim of facilitating not only economically stable but also democratic and convivial, culturally diverse societies (Gibson 2002). What is the potential for museums to respond to this challenge in ways that are productive of cultural citizenship and cultural democracy?

Cultural Development and 'New Museology'

The measure of a cultural development's sustainability over the longer term is the extent to which it is able to make a significant economic impact as well as a cultural impact, locally or on a larger scale. In this respect the development must reach a balance between economic impact, which might be achieved through increased tourist revenue or the facilitation and development of new cultural production and services,[7] and being productive and relevant for local people and communities. If the risks of such developments can include uneven development, gentrification, and the sanitization or homogenization of place (Gibson forthcoming), how can museum-led urban developments meet the cultural development goals of "stimulating cultural diversity and cultural democracy" (Mommaas 2004: 523)?

In parallel with the 'cultural turn' in urban development, there has also been a 'new museological' turn in museums over the same twenty-five year period. The term 'new museology' was discussed in Peter Vergo's *The New Museology* (1989), a collection of essays that, with Robert Lumley's *The Museum Time-Machine* (1988), were significant moments and are still much-referenced resources in the debate within museum studies and museology on the need for change. This paradigmatic shift was based on a challenge to the accepted position that the role of the museum was first and foremost to be a 'storehouse' of artifacts collected and conserved by experts who would present these 'objectively', according to singular historical narratives, to an audience of educated connoisseurs. Beyond this, where the audience was understood as the 'general public', the museum's goal was understood to be educative and 'improving'. Through mechanisms of communication based on the transmission of knowledge (rather than exchange) and its acceptance by an audience understood as passive (rather than playing an active role in their learning or meaning making), the purpose of the museum was understood as storing and presenting a narrowly defined version of 'enlightenment'. The last twenty years has seen a growing challenge to this understanding of the role of the museum; witness book titles such as *Re-Imagining the Museum: Beyond the Mausoleum* (Witcomb 2003) or *Reinventing the Museum: Historical and Contemporary Perspectives on the Paradigm Shift* (Anderson 2004). The initially radical vision of 'new museology' is now accepted as benchmark practice. There is no space here to undertake a detailed discussion of the history of this shift (see Anderson 2004; Weil 2002); rather, for our purposes I want to focus on two particular discussions of the role of the contemporary museum, Eilean Hooper-Greenhill's categorization and discussion of the 'post-museum' (2000) and Richard Sandell's consideration of an openly subjective and overtly political role for the museum around 'reframing difference' (2007).

In 2000 Hooper-Greenhill elucidated the trends at that time emerging in museum practice that she argued constituted a new model of museum—the 'post-museum'. She defined this as involving a shift from the "modernist museum as a site of authority to the post-museum as a site of mutuality" (xi). If the modernist museum, as I have characterized it above, was a 'storehouse' of artifacts, then, according to Hooper-Greenhill, the 'post-museum' "will hold and care for objects, but will concentrate more on their use rather than on further accumulation" (ibid.: 152). If the modernist museum presented information as the objective 'truth' and transmitted this information to an audience understood as passive, then in "the post-museum, the exhibition will become one among many other forms of communication … part of a nucleus of events … [which] might involve … community and organisational partnerships" (ibid.). In this way, rather than the museum representing a static or sanitary 'inauthentic' space, the

> production of events and exhibitions as conjoint dynamic processes enables the incorpora-
> tion into the museum of many voices and many perspectives. Knowledge is no longer uni-

fied and monolithic; it becomes fragmented and multi-vocal. There is no necessary unified perspective ... The voice of the museum is one among many. (ibid.)

Thirteen years ago Hooper-Greenhill identified these redefined museum rationales and associated practices as an *emerging* trend; they could be seen in particular benchmark institutions, Te Papa Tongarewa in New Zealand or in the *Indigenous Australians* exhibition in the Australian Museum (and it is notable that postcolonial contexts were at the forefront of this shift, due to the challenges to traditional museum forms of representation and visitor engagement coming from indigenous and multiethnic communities and audiences). Writing now in 2013 in England, there are few of even the most poorly funded local authority museums that, at least in some aspect of their management or annual program, do not have elements—community consultation committees, youth advisory boards, community-curated exhibitions and devoted community gallery spaces, off-site programming, audience development initiatives—that could be categorized as characteristic of the 'post-museum'. What is clear is that the characterization of the museum as static presentationism bears little relation to the museum discussed in contemporary museum studies or museology.

One of the key goals of cultural development as a rationality for cultural support is the production of active citizens. From this viewpoint one of the critiques of museums explored in the previous section was the accusation that they produce/encourage passively consuming audiences rather than actively engaged citizens. Sandell (2007) argues for an overtly active political role for the museum precisely by focusing on the processes of consumption involved in museum visitation. Rather than disregarding audiences as passive consumers, Sandell argues for an understanding of the museum visitor as a participant in the creation of meaning, and for the understanding of museum objects, exhibitions, and activities not just as texts but as resources for the active representation or *re*-presentation of information and narratives (2007: 24). He proposes a "rethinking [of] media-audience agency" that would recognize that audiences come to museums not as passive recipients but as performers with their own preexisting knowledges and capacities and from their own cultural, economic, and social contexts (ibid.: 97–104). In recognizing the particularity of the contexts and identity positions visitors bring to the museum, Sandell understands the visitor as an active participant in the meanings they produce in their interactions with museum objects, exhibitions, and activities. He argues that the exhibition-visitor relationship cannot be accurately characterized as one of passive consumption. Thus, far from being a 'static' entity operating only at the level of symbol, the museum becomes a 'resource'; in Sandell's terms,

> museums are increasingly deploying devices which invite audiences to participate in processes of cultural production, to 'perform' in ways which enable them not only to construct their own meanings but to present these viewpoints within the setting of the museum. In this way, exhibitions provide not only 'resources' for visitors to draw upon but also stages or platforms from which individual meanings can be articulated, shared and disseminated. (ibid.: 103)

In addition to the promotion of strategies to enable active visitor experiences, Sandell also argues for the role of the museum in providing a platform for debating questions of cultural difference (ibid.: 106). For Sandell, the museum has powerful potential as a political resource for the performance and representation of diverse identities due to its privileged position as an institution in which the general public has a high level of trust (ibid.: 106). Sandell allows that this vision of audience empowerment and the associated devices for achieving this participation can also result in constraining and limiting effects (ibid.: 108), not least because some visitors do not have the capacities to participate in the modes required by the museum. Nevertheless, the

key point here is that, again, the representation of the museum presented in the previous section as enabling only passive consumption and as counterposed to the facilitation of active citizenship is challenged when considered in light of discussions within contemporary museum studies and museology. It is important to note that these discussions are not limited to the academic literature; there are many (and multiplying) examples of museum exhibitions or activities that have sought to interrogate or intervene in, for instance, more traditional presentations of human identity through the positive presentation of cultural difference. Interesting examples of this trend in museum exhibition making include the Rethinking Disability Representation project (with which Sandell was involved), which included nine exhibitions at different museums, each focused on different ways of presenting the multivocal narratives and stories of people with disabilities using objects already in museum collections and through working with disabled people (Research Centre for Museums and Galleries 2008). The *Queering the Museum* exhibition at the Birmingham Museum and Art Gallery (BMAG) added to or changed the presentation of objects in BMAG's permanent display in order to draw attention to heteronormative assumptions in the ways in which objects are often displayed (BMAG 2011). Such exhibitions are not 'one-off' experimentations on the fringe of museum practice; one could also consider the attempts to present multiple voices and narratives that characterize new museums developed in the last ten years, such as the International Slavery Museum in Liverpool or the Museum of World Culture in Gothenburg. In addition, to re-presenting their subject matter, all of these museums are self-conscious about the ways they set out to achieve 'conversations' between the peoples associated with the narratives on display, the visitors, the objects, the exhibition, the museum staff, and the institution.

So we have by one reckoning the development of museums for commercial ends as symbols of cultural capital in large-scale rebranding of city space, and on the other hand, we have seen over the same twenty-five year period a radical paradigm shift in thinking and practice on the role of the museum. How can we draw on *both* these literatures in order to better account for the role of the museum in urban development?

The Phenomenotechnics of Museums in Urban Development

There is surprisingly little written about the role of museums within new urban developments from within the museum studies field (with notable exceptions; see, e.g., Witcomb [2003]). This means that there has been little to challenge the predominant notion within the literature of the new museum as a negative symptom or symbol of misguided culture-led urban development. But this critique of the new museum as elitist and non-participatory, when viewed in the light of the last twenty-five years of academic work in museum studies and contemporary museum practice, can be seen to be out-of-date. In this review of the literature on culture-led development, I have sought to show that the ways in which museums in such critiques are understood is primarily at the level of symbolic meaning. I have argued that such analyses, operating only or primarily at the level of the symbolic, miss the interventions and associated (positive and negative) effects produced by museums through their programming and activities. For instance, for Miles, the Quayside development in Newcastle/Gateshead works because it facilitates place identity at the level of the symbolic meaning of the physical buildings and space (S. Miles 2005). Yet his account takes no consideration of the direct action undertaken by BALTIC or The Sage Gateshead through their programming or activities. Miles is drawing on Sharon Zukin's influential study *The Cultures of Cities* in which she argues for an analytical framework that focuses on the symbolic importance of cultural developments and programs in understanding their effects and roles within urban space (1995; see also Zukin 1996). However, in these accounts

museums are primarily understood as icons. It is not my intention here to deny that over the last twenty years there has been a trend toward the development of cultural precincts within which an 'iconic' building, often an art gallery, more rarely a museum, is the main attraction. It is also true that in the development of such buildings there has been less attendance to the actual function of the museum, such that in some well-known cases the internal design of the building presents challenges for the museum professionals who work with it (see MacLeod's discussion of the 'ethics' of museum space [2011] and Bradburne [2004] and Janes [2009] for critiques of such developments from within the museum profession). So we can accept that the driving force behind many new museum developments is the wish to create, often through buying a high-status brand in the form of a well-known architect, a set of symbolic relations that are articulated to elite forms of cultural capital. What I want to add to this reading, however, is an understanding of the dynamism and the radical potential of the museum. The contemporary theorization of the museum within museum studies and contemporary recommendations for good museum practice from within the profession significantly challenge the static model and understanding of the role of the new museum as presented within much discussion of culture-led urban development. Engaging with the museum in terms of the programming and activities that define contemporary practice and their effects will allow us to take account of the institution and its effects as a dynamic force, with negative as well as positive effects. Such a view will add a significant dimension to analyses that seek to understand the extent to which these institutions are implicated in the reproduction of inequality; are they merely window dressing for the urban elite or are they capable of operating outside or indeed even subverting these tendencies in culture-led developments?

One way in which we might do this is to move away from the consideration of such spaces in dichotomous terms—dystopian and utopian, regulated and free, organic and engineered, authentic and inauthentic. Instead, drawing on Thomas Osbourne and Nikolas Rose (2004), I want to propose an approach that is grounded in an empirical (rather than postmodern) analysis of real space and would seek to understand the 'phenomenotechnics of spatialization' of the museum in urban developments. This "project … would be concerned with documenting the variety of ways in which space is actualised by various practices and techniques" (ibid.: 213). Consideration of the phenomenotechnics of such developments would engage with their operation not only at the level of symbol *but also* at a more contextual and material level, at the level of the actual techniques and practices that inform and enable the delivery of their activities and services. This would allow for analysis and understanding of the *actual* operation of the space through understanding the diversity of programs that construct and populate it and their effects both on the people with whom the museum is directly involved and also more broadly. Such an analysis, conducted at the level of the phenomenotechnics of museums in urban developments, would be able to encompass contradictory discourses and their effects, taking account both of the symbolism of the 'flagship' and its effects and the activities of the museum's audience development or museum education departments, for instance. In doing so, such an analysis would not seek to privilege one account over the other; instead, as Osbourne and Rose put it, an

> analysis of demarcation, however, is a matter not merely of describing these various zones and their definition and succession, but of trying to identify the problematisations within which these particular topoi have emerged … the way in which thought … comes to privilege particular territories or domains as a surface of application for the generation of problems, theories, hypotheses and paradigms. (ibid.: 214)

In other words, such an account, in analyzing the technical as well as the symbolic multidimensionality of museums in urban development, would be better placed to understand the operation of the micropolitics of power in such spaces.

Conclusion

Engaging with the detailed and grounded context of the museum in urban development does not mean we need to buy into the boosterism that has defined much discussion of the role of culture in urban development. Rather, attending to the detail helps us to understand the specific ways in which a museum has developed in relation to its context, an approach that allows for a multidimensional consideration of the museum's roles and operations, and the expectations and effects of these. Ultimately, and perhaps most importantly, it allows us to have some clear-eyed understanding of the possibilities for a particular museum, in both policy and political terms, in relation to its specific context. As Sandell argues, the question is not whether or not museums affect the ways in which the world is viewed or experienced, but rather, given the "particular and unique ways in which audiences view and make use of exhibitions mean that, *regardless of intent*, museums construct ways of seeing which have social and political effects" (2007: 195). The pressing requirement for research, therefore, is to seek to understand how museums, within their specific contexts, are affecting the creation of culturally diverse, convivial, and democratic societies. In undertaking such research our aim must be to ensure that the museum in urban development is more of a piazza—a forum for active and convivial meaning making—than a mere stadium for passive consumption.

▪ LISANNE GIBSON is a senior lecturer in the School of Museum Studies at the University of Leicester. She researches histories of cultural policy and politics especially in relation to spaces, places, landscapes, and environments. She is the author or editor of *Valuing Historic Environments* (edited with John Pendlebury, 2009); *Monumental Queensland: Signposts on a Cultural Landscape*, (coauthored with Joanna Besley, 2004); and *The Uses of Art* (2001), as well as a number of special journal issues and journal articles. She is currently working on a monograph entitled *Museums and the Politics of Urban Redevelopment* (Routledge, forthcoming).

▪ **ACKNOWLEDGMENTS**

Thanks to Richard Sandell and Suzanne MacLeod for commenting on earlier drafts of this article, which has benefited from their input; any errors or non sequiturs remain mine. I would like to acknowledge the British Academy for providing a small grant that assisted with some of the research for this project.

▪ **NOTES**

1. As is common in the field of museum studies, the term 'museum' is used in this context to refer to both museums and art galleries/art museums, whether or not they have a permanent collection or are a venue for touring exhibitions or internally initiated projects.
2. The term 'cultural precinct' is used in North America, whereas in most parts of Europe 'cultural quarter' is more common. In some countries both terms are used, such as Australia, Canada, and the UK.
3. The theory of phenomenotechnics was developed by Gaston Bachelard; in essence, it posits that theory and technique develop in tandem as each defines the possibility of the other: "phenomenotech-

nics challenges the 'false opposition' between theory and application by stressing how the creativity of scientific thinking is set to develop new possibilities and produces new realities" (Marechal 2009: 221).

4. While not all of these developments were new museums, the figure nevertheless gives an impression of the significant levels of museum capital development that have occurred over the last twenty-five years.

5. See Message (2011) for a discussion of a similar bias in favor of 'the arts' and its potential for effecting 'social inclusion' to the detriment of support for museums in recent Australian cultural policy.

6. Bianchini also describes initiatives such as ecomuseums as characteristic of what he terms "the 'age of participation'" (2006: 25–26).

7. However, see Evans (2009) for a detailed analysis that questions whether either of these is actually achievable without disproportionate public subsidy.

▪ REFERENCES

Anderson, Gail. 2004. *Reinventing the Museum: Historical and Contemporary Perspectives on the Paradigm Shift*. Walnut Creek, CA: AltaMira Press.

Bianchini, Franco. 1993. *Urban Cultural Policy in Britain and Europe: Towards Cultural Planning*. Brisbane, Australia: Institute for Cultural Policy Studies, Griffith University.

Bianchini, Franco. 2006. "Cultural Policies and Historic Urban Centres in Europe: An Overview of Some Key Issues for Cultural Managers and Policy-makers." Pp. 21–41 in *Agorá Di Pietra*, ed. A. Roncolini. Rome: Il Filo.

Bianchini, Franco and Lia Ghilardi. 2004. "The Culture of Neighbourhoods: A European Perspective." Pp. 236–248 in *City of Quarters: Urban Villages in the Contemporary City*, ed. David Bell and Mark Jayne. Aldershot, UK: Ashgate.

Birmingham Museum and Art Gallery. 2011. *Queering the Museum*. http://www.google.co.uk/url?q= http://www.bmag.org.uk/uploads/fck/file/Queeringbrochure-web.pdf&sa=U&ei=gsSeTrXWN4Oa8 gP8oZC1CQ&ved=0CBoQFjAD&usg=AFQjCNExoYAl0ByTnAi3FjBFMuYyYcAEKQ (accessed 19 October 2011).

Bradburne, James M. 2004. "The Museum Time Bomb: Overbuilt, Overtraded, Overdrawn." *Informal Learning Review*. http://www.informallearning.com/archive/Bradburne-65.htm (accessed 19 October 2011).

Certeau, Marcel de. 1994. *The Practice of Everyday Life*. Berkeley: University of California Press.

Evans, Graeme. 2001. *Cultural Planning: An Urban Renaissance?* London: Routledge.

Evans, Graeme. 2003. "Hard-Branding the Cultural City—From Prado to Prada." *International Journal of Urban and Regional Research* 27 (2): 417–440.

Evans, Graeme. 2005. "Measure for Measure: Evaluating the Evidence of Culture's Contribution to Regeneration." *Urban Studies* 42 (5–6): 959–983.

Evans, Graeme. 2009. "Creative Cities, Creative Spaces and Urban Policy." *Urban Studies* 46 (5–6): 1003–1040.

Gibson, Lisanne. 2001. *The Uses of Art: Constructing Australian Identities*. Brisbane, Australia: University of Queensland Press.

Gibson, Lisanne. 2002. "Creative Industries and Cultural Development: Still the Janus Face?" *Media International Australia incorporating Culture and Policy* 102 (February): 25–34. https://lra.le.ac.uk/ handle/2381/178 (accessed 6 March 2013).

Gibson, Lisanne. 2008. "In Defence of Instrumentality." *Cultural Trends* 17 (4): 247–257.

Gibson, Lisanne. Forthcoming. *Museums and the Politics of Urban Development*. London: Routledge.

Gibson, Lisanne and Deborah Stevenson. 2004. "Urban Space and the Uses of Culture." *International Journal of Cultural Policy* 10 (1): 1–4.

Gray, Clive. 2007. "Commodification and Instrumentality in Cultural Policy." *International Journal of Cultural Policy* 13 (2): 203–216.

Gray, Clive. 2008. "Instrumental Policies: Causes, Consequences, Museums and Galleries." *Cultural Trends* 17 (4): 209–222.

Heritage Lottery Fund. 2009, August. *HLF Policy and Strategic Development Department Data Briefing.* Unpublished.

Hooper-Greenhill, Eilean. 2000. *Museums and the Interpretation of Visual Culture.* London: Routledge.

Janes, Robert. 2009. *Museums in a Troubled World: Renewal, Irrelevance or Collapse?* London: Routledge.

Jones, Paul and Stuart Wilks-Heeg. 2004. "Capitalising Culture: Liverpool 2008." *Local Economy* 19 (4): 341–360.

Landry, Charles, Lesley Greene, François Matarasso and Franco Bianchini. 1996. *The Art of Regeneration: Urban Renewal through Cultural Activity.* Stroud, UK: Comedia.

Lin, Yung-Neng. 2010. "Towards Localization: The Development of Museums in Taiwan." *Bunkanken Report* 30: 5–6.

Lumley, Robert. 1988. *The Museum Time-Machine.* London: Routledge.

MacLeod, Suzanne. 2011. "Towards an Ethics of Museum Architecture." Pp. 379–392 in *Routledge Companion to Museum Ethics: Redefining Ethics for the Twenty-First Century Museum,* ed. Janet. Marstine. London: Routledge.

Marechal, Garance. 2009. "Constructivism." Pp. 220–225 in *Encyclopedia of Case Study Research,* ed. Albert J. Mills, Gabrielle Durepos, and Elden Wiebe. London: Sage.

Message, Kylie. 2011. "Slipping Through the Cracks: Museums and Social Inclusion in Australian Cultural Policy Development 2007–2010." *International Journal of Cultural Policy Studies* 19 (2): 201–221.

Miles, Malcolm. 2005. "Interruptions: Testing the Rhetoric of Cultural Led Urban Development." *Urban Studies* 42 (5–6): 889–911.

Miles, Steven. 2005. "'Our Tyne': Iconic Regeneration and the Revitalisation of Identity in Newcastle-Gateshead." *Urban Studies* 42 (5–6): 913–926.

Miles, Steven, and Ronan Paddison. 2005. "Introduction: The Rise and Rise of Culture-led Urban Regeneration." *Urban Studies* 42 (5–6): 833–839.

Minton, Anna 2003. *Northern Soul: Culture, Creativity and Quality of Place in Newcastle and Gateshead.* London: Demos.

Mommaas, Hans 2004. "Cultural Clusters and the Post-industrial City: Towards the Remapping of Urban Cultural Policy." *Urban Studies* 41 (3): 507–532.

Osbourne, Thomas, and Nikolas Rose. 2004. "Spatial Phenomenotechnics: Making Space with Charles Booth and Patrick Geddes." *Environment and Planning D: Society and Space* 22: 209–228.

Research Centre for Museums and Galleries. 2008. *Rethinking Disability Representation in Museums and Galleries.* http://www2.le.ac.uk/departments/museumstudies/rcmg/projects/rethinking-disability-representation-1 (accessed 19 October 2011).

Sandell, Richard 2007. *Museums, Prejudice and the Reframing of Difference.* London: Routledge.

Shorthose, Jim 2004. "The Engineered and the Vernacular in Cultural Quarter Development." *Capital & Class* 84: 159–178.

Vergo, Paul 1989. *The New Museology.* London: Reaktion Books.

Weil, Stephen 2002. *Making Museums Matter.* Washington DC: Smithsonian Books.

Wilks-Heeg, Stuart, and Peter North. 2004. "Cultural Policy and Urban Regeneration: A Special Edition of *Local Economy.*" *Local Economy* 19 (4): 305–311.

Witcomb, Andrea 2003. *Re-Imagining the Museum: Beyond the Mausoleum.* London: Routledge.

World Commission on Culture and Development. 1996. *Our Creative Diversity: Report of the World Commission on Culture and Development.* Paris: UNESCO.

Yeoh, Brenda 2005. "The Global Cultural City? Spatial Imagineering and Politics in the (Multi) cultural Marketplaces of South-east Asia." *Urban Studies* 42 (5–6): 945–958.

Zukin, Sharon 1995. *The Cultures of Cities.* Cambridge, MA: Blackwell.

Zukin, Sharon 1996. "Space and Symbols in an Age of Decline." Pp. 43–59 in *Re-presenting the City: Ethnicity, Capital and Culture in the 21st Century Metropolis,* ed. Anthony. D. King. London: Palgrave Macmillan.

Exhibitions as Research

Displaying the Technologies That Make Bodies Visible

Anita Herle

■ **ABSTRACT:** Drawing on a recent exhibition, *Assembling Bodies: Art, Science and Imagination,* at the University of Cambridge Museum of Archaeology and Anthropology (MAA), this article argues that curatorial techniques, involving a sustained engagement with objects, can play a vital role in anthropological research. Processes involved in the creation and reception of the exhibition facilitated the investigation of how bodies are composed, known, and acted upon in different times, places, and disciplinary contexts. *Assembling Bodies* attempted to transcend the dualism of subject and object, people and things, by demonstrating how different technologies for making bodies visible bring new and often unexpected forms into focus. Processes of exploration and experimentation continued after the exhibition opened in the discussions and activities that the displays stimulated, and in the reflections and ideas that visitors took away.

■ **KEYWORDS:** anthropology, art, assembly, exhibition, human body, museum, science

In recent years, museum anthropology has greatly strengthened its position as a specialist subject within both the discipline of anthropology and the broader interdisciplinary field of critical museology. Following the work of Michael Ames (1986), museums have been analyzed as important sites of cultural production within Western societies (Macdonald 2002) and as forums for complex cross-cultural negotiations and collaborations (Peers and Brown 2003; Herle 2003; Raymond and Salmond 2008). While museums are engaged in a wide variety of work behind the scenes and with communities around the world, as the public face of the museum, the exhibition is a powerful medium for making particular things (objects, people, ideas, disciplines, and activities) visible to large and diverse audiences (Herle and Moutu 2004; Latour and Weibal 2005; Weibel and Latour 2007). Drawing on a recent experimental exhibition *Assembling Bodies: Art, Science and Imagination,* (March 2009–November 2010) at the University of Cambridge Museum of Archaeology and Anthropology (MAA), this article reflexively explores the research potential of the exhibition process, a combination of curatorial, anthropological, and artistic insights and practices that actively engage with objects and theoretical ideas to generate new understandings.

All exhibitions involve background research that informs the selection of objects, themes, and methods of presentation. Often the research is substantive, incorporating original fieldwork, a detailed examination of relevant materials, and consultation and collaboration with

Museum Worlds: Advances in Research 1 (2013): 113–135 © Berghahn Books
doi:10.3167/armw.2013.010108

a range of specialists, including representatives of communities of origin. Yet, there remains a common assumption that the exhibitions can only passively present the results of research that is done elsewhere. In contrast, this article argues that curatorial techniques involved in the creation of exhibitions can themselves be a vital part of a larger research process. Exhibitions as research provide an opportunity to systematically investigate, develop, and demonstrate the fecundity of particular theoretical approaches. The work draws on the potential of discovery, a preparedness to encounter new things and consider them in new ways, identified as crucial to the "museum as method" (Thomas 2010: 7). The process of exploration and experimentation is not limited to a restricted academic discourse, nor does it stop once an exhibition opens to the public. It carries on, in the discussions and activities that the displays stimulate, and in the reflections and ideas that visitors take away.

With a few notable exceptions, there is a lacuna in critical accounts of curatorship from an anthropological perspective. How can anthropological expertise contribute to and benefit from exhibitionary practice in ways that go beyond the provision of informed ethnographic accounts? A number of recent exhibitions have demonstrated how theory can play a crucial role in the creation of public displays (Bouquet 2000; Herle and Moutu 2004; Latour and Weibel 2005; Breton et al. 2006; Macdonald and Basu 2007). This article aims to extend these discussions through analytical reflections on my own work as a curator, in conjunction with recent theoretical ideas about objects, materiality, and the body. Following a brief overview of *Assembling Bodies*, the potential of exhibitions as research will be explored. Central concerns are the relation between museum practice and theory, the mobilization of curatorial techniques of assembly and juxtaposition, the intersection between anthropological, curatorial, and artistic expertise, and the multiple resonances for diverse audiences.

Assembling Bodies: Art, Science and Imagination

Assembling Bodies: Art, Science and Imagination grew out of a cross-disciplinary Leverhulme research project entitled Changing Beliefs of the Human Body (2004–2009), involving colleagues in archaeology, social anthropology, classics, history, and the museum itself.[1] Each disciplinary subteam focused on a particular time period and topic within an overarching framework of change over millennia in European prehistory and history (Robb and Borić 2008; Robb and Harris 2013). The opening of the exhibition also marked the eight hundredth anniversary of the University of Cambridge and the one hundred and twenty-fifth anniversary of MAA. Building on curatorial expertise and the strengths of Cambridge collections, the museum initiative interacted with and extended the parameters of the Leverhulme project to develop and incorporate research in the history of science and medicine, genetics, brain imaging, and the visual arts, with additional funding from the Wellcome Trust and the Arts Council England East.

In addition to MAA's own collections, the exhibition included a broad range of objects and artworks from other Cambridge museums, colleges, and departments supplemented by a few key loans from national museums and contemporary artists. Drawing on the richness of the university's intellectual, artistic, and scientific resources, many of the displays highlighted innovations arising from Cambridge-based research—from early anthropological investigations, to archaeological excavations, innovations in surgery, the discovery of DNA, and the sequencing of the human genome. On display were a range of remarkable and distinctive objects, including early stone tools used by human ancestors, classical sculptures, medieval manuscripts, anatomical drawings, scientific instruments, Crick and Watson's model of the double helix, ancestral figures from the Pacific, South African body maps, and kinetic art.

Overall, the exhibition was not conceived nor arranged as a fixed or linear story. Rather than being didactic, we aimed to be provocative by challenging people to question preconceived ideas about the human body. The exhibition began with the question 'How do we know and experience our bodies?' There was no attempt to define 'the body'. Different bodies emerged as part of social relationships and technological practices. The displays were organized in overlapping thematic zones, each containing clusters of artwork, instruments, and ideas. While individual objects were situated within specific historical and cultural contexts, the exhibition did not attempt to provide detailed narratives of the body over time or in particular places. The open circular layout of the mezzanine gallery and intersecting sight lines encouraged visitors to create their own pathways through the displays.

A brief overview of the content and arrangement of the exhibition illustrates the interplay between ideas, objects, and the physical space of the gallery. The opening installation brought together a multitude of human forms originating from different times, places, and disciplinary perspectives. This "Assembly of Bodies" included a kinetic sculpture, a Bronze Age cremation urn, Pacific funerary effigies, a classical sculpture, a Mongolian shaman's costume, Crick and Watson's model of the double helix, an Auzoux anatomical figure, and a South African body map (figure 1). The juxtaposition of diverse materials provided insights into different ways that

Figure 1. Photographic montage of the introductory installation 'An Assembly of Bodies'. © MAA 2009.

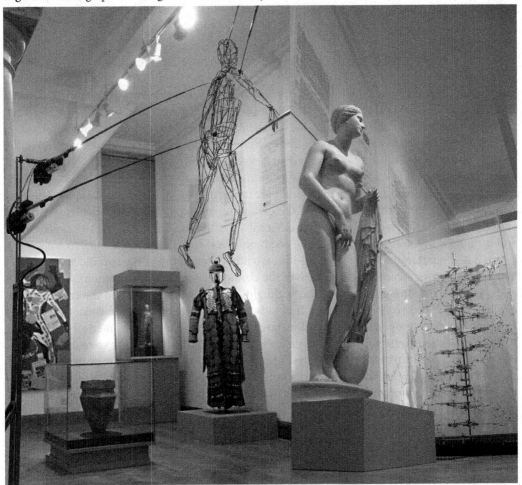

bodies are created, understood, and transformed. Specific objects also foreshadowed intersecting themes that were developed throughout the exhibition. Hovering over the figures were segments of British laws, acts, and guidelines originating over the last 250 years, from the 1751 Act for Better Preventing the Horrid Crime of Murder (which provided anatomists with the corpses of executed murderers), to more recent acts regulating organ transplants, identity cards, human fertilization, and embryology.

One side of the gallery focused on techniques of measurement and classification and pointed to the fertile and often uneasy relationship between anthropometric measurement, anatomy, and the arts. The other side of the gallery focused on relations between bodies, exploring how bodies are inextricably linked to landscapes and environments, mapped through genealogies and genomes, extended through various technologies, and distributed in different forms. Bridging the two sides of the gallery was "Multiple Bodies," exemplified by a series of life-sized South African body maps, originally produced in 2003 by members of the Bambanani Group as part of a project documenting the lives of women with HIV/AIDS who successfully fought for access to antiretroviral drug therapies (Morgan et al. 2003). Their self-portraits, each supported by a shadowy human form, were marked with individuating handprints and personal histories referencing physiology, religious belief, moral pollution, biomedical science, and political advocacy (figure 2). While 'the body' may be viewed from different perspectives, here multiple bodies were shown to coexist within a single corporeal form (cf. Mol 2002) extended through social relations.

Exploring the Technologies That Make Bodies Visible

The museum's contribution to Changing Beliefs of the Human Body was one of six distinct research components of the larger Leverhulme project, along with the Paleolithic/Mesolithic/Neolithic Body, the Bronze Age Body, the Classical Body, the Modern Body, and New Bodies. As curators, we compared empirical findings with the project members and participated in the broader theoretical discussions they generated. Recent work in the social and biomedical sciences has brought into question the composition and boundary of the human body. Starting from the anthropological premise that bodies are inherently social in their materiality (Lambert and McDonald 2009; Strathern 2009b),[2] the exhibition aimed to reveal and challenge preconceived notions of the body by exploring different ways that bodies are imagined, understood, and composed in the arts, social sciences, and biomedical sciences.

An initial curatorial concern was the mismatch between many of the specific areas investigated by the project teams, the expertise of the curators, and the rich collections within MAA and the university. This discrepancy also highlighted different approaches to the creation of an exhibition. Not surprisingly, academic methods tend to privilege textual forms of knowledge in which a well-developed storyline is illustrated by carefully chosen specimens. For the curators, the collections were a primary source for research and inspiration. We were committed to the potential of object-based research and keen to develop the visual and experiential aspects that the medium of an exhibition affords. Our self-imposed challenge was to take the agency of objects seriously and produce a dramatic effect that would demonstrate underlying theoretical propositions and encourage visitors to interact with the material on display.

As a particular form of expert practice and knowledge production, curating encompasses a close multisensory engagement with things. The museum provides an environment where curatorial knowledge and skill unfold in the practical and intellectual interaction with material objects (cf. Ingold 2000). Underpinned by an exploration of recent theoretical approaches to the

Figure 2. Body Map, Nomdumiso Hiwele, 2008.
Customised print from the original acrylic painting, 2003. ® MAA 2008.20.

body and materiality (see below), research was mobilized by the methodological potency of discovery. As a highly artificial and bounded assemblage, a museum exhibition is an ideal medium for experimentation (MacDonald and Basu 2007). The techniques involved in *Assembling Bodies* were intended to generate new insights about the body by revealing how different bodies are created and acted upon.

Underlying the methodological and theoretical considerations was the question of inclusion. A review of recent exhibitions on the human body, often framed within the context of 'world cultures', indicated a predominant emphasis on body decoration and personal identity, typically bolstered by contemporary fashion trends for tattooing and body piercing, with presentations oscillating between cultural relativism and exoticism.[3] Alternatively, science-oriented exhibitions tend to focus on medical discoveries and explanations of how the body works.[4] Yet, current work in the social sciences has shifted away from interests in identity to developing relational understandings of the human body that takes into account biological materiality, sociality, and technological innovation. Actively engaged in current discussions about the relations between people and things (Kopytoff 1986; Strathern 1999, 2005), art and agency (Gell 1991, 1998), materiality (Henare et al. 2007; Miller 2005), and actor network theory (Latour 2005b), as curators we were keen to explore and demonstrate certain theoretical propositions through a close engagement with the objects selected for display. The human body, encompassing subject and object, the corporeal and intangible, the individual and social, was a fertile topic for investigation.

As part of the process of exhibition making, the conceptual framework soon shifted from 'changing beliefs of the human body' to 'assembling bodies', disrupting the possibility of a progressive historical narrative. The idea of assembly, which started as a crucial curatorial technique, became a key theoretical concept. It was also the means by which we were able to activate the central goal expressed by our working subtitle for the exhibition: 'exploring the technologies that make bodies visible'. The process of assembling bodies facilitated our ability to trace associations between people, ideas, and things, thereby revealing obscure aspects of 'the social' in the ways that bodies are created and known (cf. Latour 2005b: 8).

Involving a direct physical interaction with diverse materials, the exhibition was constructed through an intensive process of discovery, juxtaposition, assembly, reflection, and reassembly. After several months of research and experimentation, a few hundred pieces were short-listed for display. The details of each candidate and their multiple potential associations were noted and brought together in numerous overlapping configurations, grouped and regrouped. The movement of an object in relation to another object cluster often sparked new insights. For example, a Palaeolithic hand axe alongside a prosthetic arm is a technology for extending the body, whereas if displayed with Mesolithic and Neolithic hand axes the emphasis shifts to a system of classification that defines different kinds of bodies and human capacities within a temporal sequence. The final layout of the exhibition was further refined as physical three-dimensional objects moved into the gallery and jostled for position. The background research leading to the content and nonlinear arrangement of *Assembling Bodies* directly addressed the central puzzle of how heterogeneous and hybrid bodies are composed and known.

The idea and practice of assembly evoked two distinct but overlapping themes that underlined the exhibition. Two kinetic sculptures by artist Jim Bond illuminated one notion of assembly—the process of putting something together, of creating something new from component parts. *Atomised* (2005), composed of an openwork human figure suspended from five external telescopic 'arms', was positioned at the entrance of the exhibition. The movement of visitors into the gallery triggered the arms to slowly pull the figure apart and put it together again, highlighting the point that the body is created by the different practices through which it is classified, taken apart, and (re)assembled. A second sculpture by Bond, *Anamorphic Man* (2009), over five meters in length, consisted of segments of the body suspended from the ceiling in the

central area of the exhibition. Apparently abstract fragments of twisted wire converged into a human figure from a singular vantage point (figure 3). The realization of the body's form was thus dependent on the viewer's perspective. Bond's two sculptures also elicited different types of physical engagements. With *Atomised*, visitors stood still and watched the body being taken apart and reassembled, whereas *Anamorphic Man* required people to move around the gallery to perceive the shifting relation between parts and wholes. This idea of assembly and the vari-

Figure 3. *Anamorphic Man* seen from the central viewing point in the gallery.
Jim Bond. 2009. © MAA.

ous technologies by which different bodies are made visible was revealed by other objects in the exhibition, from anatomical drawings to scientific models and genealogical charts.

The second notion of assembly referred to a gathering for a common purpose, such as a legislative 'body'. The placement of sections of British laws, acts, and guidelines above the introductory "Assembly of Bodies" was used to draw attention to the political implications of the ways that distinct bodies are defined, shaped, and regulated through various forms of legislation. Framed by the introductory installation, the displays were a tangible materialization of how the political is continually reconstituted by shifting and emergent assemblages of people and things (Latour 2005a).

Moving through the diverse gathering of objects brought together for the exhibition, one witnessed how different social and material technologies for making bodies visible brought new and often unexpected forms into focus. We were keen to present not simply a range of human forms, but the hidden processes involved in their production. In this sense the workings of the telescopic 'arms' that repeatedly took apart and reassembled the body of *Atomised* was what the exhibition aimed to reveal.

While the exhibition included diverse representations of the human body, displaying the technologies that make bodies visible also encompassed scientific instruments and models, kinship charts, genetic fingerprints, a Mongolian household chest, Papua New Guinean netbags, and ceramic 'hugs' (discussed below). The exhibition itself and the processes involved in its creation were a further attempt to transcend the dualism of subjects and objects, people and things. The materiality of artifacts is often associated with a kind of fixity or permanence, but the exhibition focused on diverse, changing, and emergent forms. The inclusion of kinetic art, distributed throughout the gallery, heightened the sense of dynamism. The material on display demonstrated that technologies through which humans make different bodies visible have a tangible, transformative effect on the body, both conceptually and materially. The creation of *Assembling Bodies*, requiring sustained engagement with a wealth of divergent materials, disciplines, and practitioners, was an illuminating and open-ended research project in itself. The question of what to include and how to contextualize the displays brought the core issue of how bodies are created and known into focus in unprecedented ways.

Assembly and Juxtaposition

Curatorial techniques of assembly and juxtaposition were crucial to the research process. The strategy of juxtaposing unlikely objects to create particular and often unexpected meanings has numerous antecedents within Euro-American traditions, each motivated by very different interests. The modern museum emerged from sixteenth- and seventeenth-century cabinets of curiosities, in which private collectors gathered and selectively displayed natural and artificial specimens. While the composition and arrangement of these cabinets were later seen by many as irrational, their creation was prompted by a desire to explore and demonstrate Renaissance ideas about similitude and universal order. Surrealists famously experimented with collage and juxtaposition as a means to probe the irrational and the subconscious, as well as to challenge orthodox artistic genres. The influential New York exhibition *ART/ARTEFACT* (1988) mobilized the potency of contrasting materials to challenge definitions of 'art', a move that inspired Gell's work on art and agency (Gell 1996, 1998). While the diversity and presentation of materials in *Assembling Bodies* also broke down problematic distinctions between art and artifact, our use of juxtaposition aimed to uncover the networks and processes from which distinct bodies emerged. Here, the exhibition drew on aspects of the comparative method, as developed in social anthropology, to throw differences into relief, to identify similarities between diverse materials, and to

make the familiar appear strange and open to investigation. The examination and comparison of distinctive types of bodies helped to reveal 'the social' in what may appear to be natural.

Co-curator Rebecca Empson has insightfully compared the exhibition's focus on assembly and juxtaposition to the techniques of montage pioneered by early filmmakers such as Eisenstein and Vertov. Exhibitions and montage both aim to generate knowledge by developing connections between disparate objects or fragments of film. The links are intended to go beyond what is visible to the human eye. According to Eisenstein, "The spectator not only sees the represented elements of the finished work, but also experiences the dynamic process of the emergence and assembly of the image (idea) just as it was experienced by the author" (Eisenstein 1942, quoted in Empson in press [2013]). This is very close to our goal of 'displaying the technologies that make bodies visible'. However, while montage is created by compiling fragments of film, the resulting composition is confined by its linear projection. With *Assembling Bodies,* audiences made their own pathways through the displays; there was no fixed beginning or end.

A closer look at particular juxtapositions will illuminate the efficacy of this technique. During the early planning stages, and as part of the conceptual pitch for the exhibition, we contrasted photographs of a nineteenth-century Malangan funerary figure from New Ireland, Papua New Guinea, with Crick and Watson's model of the double helix (figure 4). From the outset, this

Figure 4. Malangan funerary effigy, late 19th century, New Ireland, Papua New Guinea. © MAA 1890.177; Replica of Crick and Watson's model of the Double Helix. Claudio Villa and Roger Lucke, 2003. © Laboratory of Molecular Biology, Cambridge.

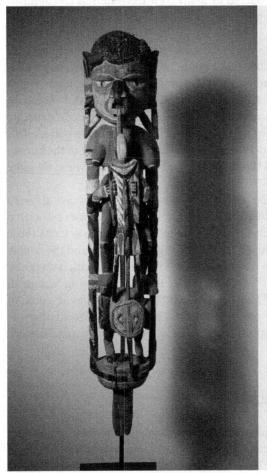

juxtaposition aroused curiosity and excitement. The impact of this movement was far-reaching, stimulating discussions about ways that the distinctive characteristics of individuals are represented, contained, and distributed.

Malangan sculptures are part of a rich and varied ceremonial complex for commemorating and regulating the dead that extends throughout the northern half of New Ireland, Papua New Guinea (Gunn and Peltier 2006). These unique works of art continue to be produced by specialist carvers from memory, several years after the death of the person they recall (Kuechler 2002). The form and design of Malangan sculptures temporarily recaptures the salient aspects of a person's life, most notably their relations with others, and is influenced by the rights of individuals and clans over particular designs.

A Malangan sculpture can be imagined as a second skin, a porous membrane that first contains and then releases the life force of the deceased after a long period of mourning. Alongside the model of the double helix, a Malangan sculpture draws attention to its ability to mark the particular characteristics of a person, which are selectively distributed to their descendants. As a genre, Malangan sculpture has also had a significant impact on the ways that bodies are envisaged in both anthropology and modern European art and literature. The sinuous openwork of complex interlocking images, combined with the intricate designs of their finely painted surfaces, created layers of visual ambiguity that fascinated German expressionists and French surrealists. Their visual appeal and elaborate ceremonial context have made them a highly desirable art form for Western collectors. Originally intended to be destroyed after ritual use, their removal through sale to outsiders has been considered by many New Irelanders as an appropriate (and profitable) means of disposal, resulting in hundreds of Malangans now preserved in museum and private collections.

Few models in the biological sciences have as much fame and immediate recognition as the double helix (de Chadarevian and Kamminga 2002). The image, through numerous manifestations, has become an icon of modern science and its understanding of inheritance. First created in 1953 by Cambridge scientists Francis Crick and James Watson at the Cavendish Laboratory, the model relied on powerful ways of imaging molecular structures. The double helix structure was striking because it showed how the protein bases that form DNA might be paired. This technology for making visible the molecular structure and subsequent sequencing of the human genome have suggested new ways of seeing and thinking about who we are and where we came from.

The Malangan sculpture and the model of the double helix powerfully encompass different understandings of ancestors, inheritance, sociality, and the distinctive characteristics associated with individuals. As models constructed by specialists, they are also intended to activate those understandings within particular contexts. In this sense the Malangan sculpture and the double helix are both formidable technologies for the transmission of knowledge, bodily substance, sociality, and property between generations. As Strathern pithily noted when using Malangan sculptures to think about patents: "Malanggan [sic] are not just like a technology in some of their effects but also like the very patents taken out to protect the application of technology, at once a description of transferable rights and a specification of how they are to be materialized" (Strathern 2001: 273).

Genealogies and Genomes

The significance of ongoing DNA research and ideas about the presence of ancestors was picked up in the cluster "Genealogies & Genomes," which displayed objects originating from different

cultural traditions. From a Raratongan staff god to a Maori cloak, Tibetan reincarnation murals, and biblical illustrations, genealogies are a powerful means of mapping social relations that produce, distinguish, and connect bodies. When compared these reveal diverse ideas about what is transmitted between bodies and suggest ways that different bodies are created in relation to each other. The power of many of these objects is not simply to serve as records that objectify social relations. They may also transform the bodies they describe. Many are believed to bring forth the power or capacity of the bodies depicted in their forms, instantiating rather than just representing relationships.

The efficacy of nuanced and unexpected juxtapositions can be aptly demonstrated by the selection and positioning of five objects originating from the European tradition. The focus on genealogical descriptions drew attention to shifting ideas about marriage protocols, rank, and succession, from biblical sources to more recent scientific notions concerning genetics, biological inheritance, and an individual's health or well-being. Two portraits hung over a table case containing three books (figure 5).

Figure 5. Top (l-r): Family Group. Abraham Willaerts. 1660. Fitzwilliam Museum 534; *Genomic Portrait*, Mark Quinn. 2001. Photograph and DNA sample of the geneticist John Sulston. © National Portrait Gallery 6591; 6592(1); bottom (l-r): Table of Consanguinity, *Etymologiae and Sententiae; De ortu Poncii Pilati; De ortu Jude Scarioht.* St Isidore of Seville, Archbishop of Seville, 12th century. ° St. John's College, Cambridge H.11; Biblical Genealogies from Noah's Ark, *The Genealogies Recorded in the Sacred Scriptures, According to Every Familie and Tribe. With the Line of Our Saviour Jesus Christ Observed from Adam to the Blessed Virgin Mary,* 1618. ° St. John's College, T.5.33 / U.15.13; Detail from a page of Volume 1, Chromosome 1, 'Library of the Human Genome', 2005. © Wellcome Collection.

The first book was a twelfth-century manuscript, *Etymologiae and Sententiae,* one of the first-known European encyclopedias. It contains charts that categorize people so that they may follow the celestial origins of marriage prohibition, based on the proximity of 'shared blood'. A full-page table of consanguinity maps relations bilaterally through seven generations, legitimized by the head of Christ at the top of the table. The second book, John Speed's compilation of *The Genealogies Recorded in the Sacred Scriptures …* (1618), contains diagrams that illustrate relations described in biblical stories such as Noah's Ark or the Tower of Babel. The third book was Volume 1 describing the first section of chromosome 1 from the *Library of the Human Genome* (2005), one of 119 thick volumes containing approximately 3,000 million letters referring to the sequence of base pairs that compose DNA. Above the table of consanguinity was an oil painting of a family group by Dutch artist Abraham Willaerts (1660), with a portrait of a mother and daughter standing in front of several overlapping paintings of absent or deceased kin.[5] The presentation of portraits within the painting, frames within frames, gives the painting a fractal quality. Positioned next to *The Family Group* and above Volume 1 of the *Library of the Human Genome* was Marc Quinn's *Genomic Portrait* (2001) of Cambridge geneticist John Sultson, director of the British side of the Human Genome Project (HGP), commissioned for the National Portrait Gallery. This double portrait is comprised of a hyperrealistic photograph of Sulston's face alongside a sample of his DNA in agar jelly mounted in a steel picture frame.[6]

While the three books and two portraits are individually remarkable objects, their juxtaposition opened numerous areas of investigation and discovery. The painting and framed DNA sample were intended to challenge the viewer to consider the accuracy of different forms of portraiture, underlining the complexity of shifting understandings of personal identity and descent. The table of consanguinity was configured as a simple A-shaped tree, a form greatly elaborated by the bountiful trees representing biblical genealogies in John Speed's compilation. These images became the foundation for many European family trees, whereby secular genealogies were grafted onto sacred ones in family Bibles. Tree imagery was also appropriated as a taxonomic device in nineteenth-century evolutionary theory, and later became an inspiration for the anthropological kinship diagram (Bouquet 1996). As a grouping, the books revealed technological shifts, from hand-painted manuscripts to woodcut prints and digital information, as well as profound changes in knowledge and belief, from biblical imagery to scientific data. Yet the human genome is often referred to as the 'book of life' or 'chemical code of life', drawing on scriptural and cybernetic antecedents and referencing previous technologies for recording genealogical information. While all of the books are weighty compilations, the materiality of the Volume 1 of Chromosome 1 demonstrated the vast amount of information generated by the HGP. The publication and display of the *Library of the Human Genome* was also a strong political statement, especially given that significant funding from the Wellcome Trust enabled the British side of the HGP to assume responsibility for approximately one-third of the project and effectively thwarted attempts by private American companies to privatize the results of their 'collaborative' research (Spufford 2003: 161–206). The volumes are kept in the *Medicine Now* gallery of the Wellcome Trust in London, where visitors can readily remove them from the shelves. While no one is likely to 'read' the human genome in this archaic printed form, the *Library of the Human Genome* continues to be a powerful assertion of public access to and ownership of scientific knowledge.

There were multiple links between the various objects on display and different thematic clusters within the exhibition. The ideas generated by "Genealogies & Genomes" were extended and reshaped in relation to other material in the exhibition. The impact of genetics on the way we understand the human body is strongly influenced by forms of legislation, as indicated by the laws displayed in the introductory section of the exhibition. For instance, the 2006 Identity

Cards Act stipulates that a National Identity Register of individuals should be available in the interests of national security, the detection of crime, immigration control, employment, and the provision of public services. The law regulates how the state can appropriate information about bodies for different means.

Genealogies and genomes are powerful models that individuate and define relations between people, a point accentuated by positioning the display opposite the cluster on "Measurement & Classification," which included one of the first DNA fingerprints (1985) and co-curator Mark Elliott's biometric identity card (now required for visitors entering the United States) alongside nineteenth-century instruments used to measure the body and its capacities. Technologies that identify and regulate bodies often challenge the extent to which we 'own' information about our own bodies, blurring boundaries between ourselves as subjects, objects, or citizens. While not explicitly stated in the exhibition, some visitors noted familiar aspects between some of the claims and debates around twenty-first-century genetics and those of various forms of nine-teenth-century anthropometrics.

The open design of the exhibition and the attention to sight lines encouraged visitors to make their own connections between the objects and ideas on display. This process was facilitated by the *Assembling Bodies* website, available in a central position within the exhibition, which included details for each of the two hundred objects on display and enabled people to create their own assemblies.[7] Over six hundred guided links were created between the objects on display, each opening a new path for investigation. For example, in the exhibition Newton's death mask was positioned alongside relics within the cluster "Extending & Distributing the Body." On loan from the Wren Library at Trinity College, it was originally used as a model for Roubillac's statues and later formed part of an assembly of relics and memorabilia of famous Trinity scholars, which became objects of veneration for subsequent scholars, reinforcing the close 'familial' bonds between the fellows and the students of the college (Fara 2002: 234–238). In the mid-nineteenth century Newton's death mask prompted much debate when the accuracy of phreno-logical readings was challenged by Newton's underdeveloped causality bump (ibid: 244). On the exhibition's website, one of the links to the death mask is the phrenology head, positioned in the exhibition opposite an interactive display on brain imaging as part of "Measurement & Classi-fication." It also links to the classical bust of the Roman emperor Augustus and the Rambaramp funerary effigy, each relationship raising different questions regarding memorialization and rel-ics, individual portraiture and ideal types, and heredity and rank. Visitors are encouraged to develop their own links and the site has remained popular after the closure of the exhibition.[7]

Curators, Artists, and Anthropologists

The process of exhibition making involves numerous contributors and stakeholders. As part of the research process we worked closely with other scholars, artists, and various 'community' representatives and responded to feedback from local focus groups. *Assembling Bodies* included historic and contemporary material originating from many parts of the world. While it was nei-ther appropriate nor feasible to attempt to consult with the many people who may have direct interests in the items we proposed to display, we were very conscious of ethical guidelines in anthropology, medical science, and museum practice. The recent family photographs that deco-rated the Mongolian household chest were collected during long-standing fieldwork by Empson and displayed according to the wishes of the family concerned (Empson 2009: 70–71). Along with the acquisition of the South African body maps, and in consultation with the Bambanani Group of artist-activists, we supported a project to record stories about the women's experiences

of living with a chronic disease, covering the crucial period when the fear of death was supplanted by the promise of life (MacGregor and Mills, 2009: 92–3).[8] These personal narratives, 'Mapping Change 2003–2008', were accessible in the gallery alongside the paintings, but following the wishes of the women involved, none of the details were published or available online. For people living with HIV, disclosure and the fear of social stigma are vital concerns. The Internet is immediate and omnipresent, whereas MAA was seen to be a safe distance from their homes Khayelitsha Township. More self-consciously, an early twentieth-century Rambaramp funerary effigy (containing a human skull) from Malakula, Vanuatu, was displayed near a panel outlining current UK guidelines for human remains in museums (Department of Culture, Media and Sport, 2005). Collected by Cambridge-based anthropologist Bernard Deacon in the 1920s, community approval and advice on the display of this body was obtained during my fieldwork in 2007 in consultation with the National Vanuatu Cultural Centre and indigenous fieldworkers on Malakula. As explicitly stated in the extended label, the public display of human remains was used as an exemplification of diverse cultural understandings of the body and the appropriate treatment of the dead as well as a reminder of the complex relations that exist between museums and members of communities of origin.

Artistic insights and practices were extremely fertile in revealing and mediating between different ways of knowing bodies. In the early planning stage we developed a partnership with the Kinetica Museum[9] that included loans and the commissioning of new works for the exhibition. This provided a special opportunity to work through and present complex conceptual ideas, such as the notion of assembly highlighted by Bond's sculptures, *Atomised* and *Anamorphic Man*. The selection of existing objects, the creation of new pieces, and the positioning of the artwork resulted from prolonged discussions with Kinetica and the artists about the theoretical interests and goals of the exhibition. With preexisting works, the artists' intentions overlapped with curatorial aims and were extended in different directions. For Bond, *Atomised* resulted from the creative and repetitive process of assembly but also addressed his fascination with "the concept that our bodies are made up of atoms which are not alive and once we die they disassemble and become part of something else, continuing to exist in another form" (2009: 12).

Another kinetic artwork, created especially for the exhibition, was Dianne Harris's *Head of the Blue Chip II* (2009), the bust of an interactive cyborg with a surveillance camera implanted in one of the eyes and a 'brain' that reflected what is seen on one side and revealed what it is thinking on the other side. Harris's background research included an examination of medical x-rays and prosthetic devices. Her intent was to mimic and suggest future human development through the infiltration of new technologies, while also evoking the silent and watchful gaze of our surveillance state. The *Head of the Blue Chip II* became the central object in "Extending & Distributing Bodies," looking toward the classical busts in "Art & Anatomy." Overall, the kinetic art that punctuated the gallery highlighted the body in motion and created a dynamic environment consistent with the theme of assembly. Tim Lewis's *The Mechanic* (2006), which simulated human bodies running around a wheel, explored notions of automation and perception, reminiscent of the photographic techniques pioneered by Muybridge in the late nineteenth century to show the body in motion.

More generally, the use of contemporary art provided an opportunity to co-develop other methods of interpretation. In some areas works of art were used as a riposte to regimes of power that were illuminated by some of the displays. For example, "Classification & Measurement" included two vivid photographic interventions. A large C-type *Untitled* (2005) by London-based Grenadian photographer Dave Lewis depicted a contemporary San warrior superimposed on drawers of glass lantern slides used for teaching and research in the Faculty of Archaeology and Anthropology at Cambridge. It was positioned above an installation of the original drawers,

which were organized and labeled according to racial and ethnic groups. Shigeyuki Kihara's compelling photographic triptych *Fa'a fafine: In the Manner of a Woman* (2005) was a powerful critique of European stereotypes of people and places. Transgendered and of mixed Japanese and Samoan descent, the artist posed in a semi reclined position on a Victorian chaise lounge in front of a misty tropical backdrop. In the first image she is wearing a scant hula skirt, in the second image her skirt is removed, and in the final image a penis protrudes from between her tightly closed legs. Responding to the voyeuristic and titillating expectations of the genre, her reenactment both highlighted and subverted the power of colonial photography to classify and subjugate. "The *Fa 'a fafine* work questions the western classification of races, gender and sexuality. I can never fit into them, but at the same time I ask myself—are they worth fitting into?" (Shigeyuki Kihara, excerpt from the exhibition label). The inclusion of quotes from artists, scientists, philosophers, and various forms of legislation in the exhibition texts was a means of expanding multiple narratives about the body.

Visitors were encouraged to explore different bodies through their own sensory capacities. *Sounding Bodies,* an installation on auscultation, encouraged the exploration of the body as a dynamic soundscape (Rice 2009: 46–47). Michael Market's kinetic artwork *Vox Theremin* enabled visitors to create varied speech sounds through the movement of their hands inside the theremin. An extremely popular display was the ceramic 'hugs' produced by artist Bonnie Kemske as part of her doctoral research at the Royal College of Art (Kemske 2007). These sculptural works of art were made by and for the embrace; the artist used her own body to cast the 'space' of a hug. Challenging the dominance of sight and drawing on Merleau-Ponty's premise that "what is given is not the thing on its own, but the experience of the thing," (Merleau-Ponty 1962: 379), Kemske's work captured the embrace as cast 'hugs' that engage the body's sense of touch as a way to merge the body as subject with the sculptural object.

The focus on assembly and juxtaposition assisted us in breaking down stereotypical contrasts between decontextualized art and ethnographic contextualization. Working closely with contemporary artists raised questions about the overlapping roles and specialist skills attributed to artists, curators, and anthropologists (cf. Schneider and Wright 2006). While a number of leading artists, including Dave Lewis,[10] have adopted ethnographic approaches as part of their practice, curatorial techniques of assembly and juxtaposition are strongly reminiscent of the genre of contemporary installation art. The approach of *Assembling Bodies,* to challenge people to think about what counts as a body rather than tell a didactic story of the human body, aligned more closely with conceptual art than museum pedagogy. Crucially, if we consider art as a distinctive form of technology intended to captivate its audiences in the aims of its creators (Gell 1991, 1998), then the combination of curatorial, artistic, and anthropological skills powerfully overlapped in the process of assembling and disassembling bodies.

A potent example was the unique installation imagined by the eminent Cambridge-based anthropologist Marilyn Strathern, guided by the curators and realized through the efforts of Cambridge MPhil students taking the course in 'Anthropology and Museums'. A unique composite object, a '*Bilum* Tree' or body, was created by carefully fastening a few dozen Papua New Guinean netbags (*bilum*) from a central pole (figure 6).

Made exclusively by women, the ubiquitous and elastic *bilum* is often likened to a womb. Used for carrying everything from garden food to babies, the *bilum* suggests female fecundity. Positioned beside a pair of pearlshells, competitively exchanged by men in the Papua New Guinean Highlands, the display highlighted the differential potential of gender and the body's capacity to produce and reproduce. The notion of production and exchange involving people, objects, and bodily substances pointed to the notion of the body not so much as an individual entity, but as part of a wider collectivity (Strathern 2009a: 64–65). On one level the display

Figure 6. *Bilum Tree*, 2007. Installation of netbags from Papua New Guinea. © MAA.

was a reification of Melanesian gender relations and Strathernian theories of relationality and personhood. A recent analysis has suggested that the '*Bilum* Tree' can also be understood as a kind of portrait of Marilyn Strathern as well as a portrait of relationships (Petrović-Šteger 2011), a conclusion based on a careful reading of Strathern and (I suggest) the positioning of the '*Bilum* Tree' within the cluster on "Genealogies & Genomes" and adjacent to the portraits and biblical representations of genealogical trees (described above). Initial attempts to write a label for the '*Bilum* Tree' and clarify its attribution highlighted the complexity and ambiguity of its composition, characteristic of the production and circulation of *bilums* within parts of Papua New Guinea (cf. MacKenzie 1991). While *bilum* are ubiquitous throughout Papua New Guinea, the '*Bilum* Tree' is not found sprouting throughout the highlands and islands. Yet attributing authorship to anthropological imagination risked negating the expertise of the women who created them and obscuring the collective labor that went into the assemblage. The installation was constructed of *bilum* made by (now) anonymous women throughout Papua New Guinea and collected by named colonial settlers, anthropologists, and travelers between 1922 and 2005, yet the intentionality of its distinctive form was a product of Strathern, in dialogue with the curators and the wider Changing Beliefs of the Human Body Project, brought into being with the support of curatorial and technical staff and students. Though now deconstructed, the '*Bilum* Tree' remains a unique entity in its own right, featuring on the cover of a recent book dedicated to Strathern (Edwards and Petrović-Šteger 2011). Unpicking the '*Bilum* Tree' is an illuminating example of how the focus on assembly worked.

Audiences and Resonances

It is difficult to measure the extent to which curatorial intentions overlap with visitor expectations and responses. Overall, *Assembling Bodies* attracted unprecedentedly large and varied audiences and received favorable reviews in regional newspapers and magazines, online sites, and specialist journals, including *Nature* (Ferry 2009: 1060–1061) and *Anthropology Today* (Geismar 2010: 25–26). The open-ended approach, range of exquisite objects, unexpected juxtapositions, and interactive displays was reported by a senior gallery attendant to "provide something for almost everyone" (Peter Roley, personal communication, 2009). An important corollary to this comment is that not everything was intended for everyone. Extensive visitor evaluation overseen by MAA's Outreach Organiser included audience surveys, questionnaires, and visitor mapping.[12] It provided valuable but very general information about visitors' experiences and indicated which sections of the exhibition were the most popular. Over 90 percent of the approximately six hundred people who filled out questionnaires (less than 1 percent of the total visitors) claimed that they found out something new during their visit, including 10 percent who noted this new knowledge was about 'perspectives'. Yet detailed comments were scarce and only provided glimpses of the ideas and experiences the exhibition prompted.

The most valuable feedback came through multiple interactions between museum staff and visitors during various outreach activities and as part of dozens of talks and activities within the gallery. For example, family activities for the University of Cambridge's "Festival of Ideas" included an "Anthropometric Laboratory" where museum staff wearing lab coats measured visitors' heads, produced composite photographs that mimicked Galton's approach of using facial characteristics to determine particular dispositions, and guided visitors through a series of physiological tests designed to measure capacities such as reaction time and visual acuity.[11] What was primarily seen as competitive fun became more serious for those participants who, realizing the implications of using such methods to determine particular 'types' of people, voiced their concerns.

Different aspects of the exhibition were targeted for particular audiences. Working in a university museum that is an integral part of a teaching and research department gave us the opportunity for relatively autonomous experimentation and provided a core academic audience. The exhibition was the setting for graduate workshops, specialist talks, and conference tours, which stimulated much thought and discussion. Questions were raised and various topics informally debated—the validity of 'race' as a biological category, ethical concerns related to advances in biomedicine, the use of human cadavers versus sophisticated anatomical models for surgical training, and the insights prompted by different approaches for defining and understanding 'the body', such as embodiment, relational theory, Actor Network Theory, and perspectivism. Yet it must be acknowledged that the vast majority of over one hundred thousand visitors to *Assembling Bodies* did not 'see' the exhibition as part of a dialogue with current theoretical debates within the social sciences, nor would they be likely to be interested in such an esoteric exercise. Our curatorial challenge was to bring together remarkable and diverse materials highlighting the strengths of (primarily) Cambridge collections and associated research, underpinned by theoretical ideas that provided an intellectual coherence, in ways that prompted engagement on multiple levels by diverse audiences.

The impact of exhibitions tends to be diffuse and far-reaching. Even the most straightforward didactic exhibitions cannot determine audiences' reactions and the multiple ideas, experiences, and events that will be generated. There is much work to be done on the diverse and multisensory ways that people engage with exhibitions and the longer-term effects. One of the shortcomings of the exhibition project was the limited resources for curatorial research staff after the exhibition opened. We were unable to develop a fully interactive website, directly engage with online visitors, or evaluate how they were using the site.

While the workshops, gallery talks, and public programs had particular targets that could be measured, we were delighted and astonished by some of the exhibition's more tangible results, which included a public performance in the gallery and two further exhibitions. Not surprisingly, the 'hot spots' in the exhibition included the kinetic art and some of the interactive displays, with children particularly attracted to *The Head of the Blue Chip II* and *The Mechanic*.[12] An unexpectedly large number of people were captivated by the textured ceramic 'hugs', presumably less by the exploration of philosophical existentialism that prompted their creation than by the tactile and experiential possibilities they offered. The two 'hugs' positioned beside a sofa were frequently held, caressed, and passed between visitors. Inspired by the 'hugs', a university dance group staged a public performance in the gallery entitled "Towards the Embrace: Movement and Communication," which involved carefully choreographed movements through the displays and enthusiastic audience participation.[13] National Diploma photography students at the Cambridge Regional College initiated their own photographic exhibition in direct response to *Assembling Bodies*. *The Bodies Exposed: Image and Identity* (March–April 2010), focused on "conflicting ways we represent ourselves," (exhibition text), exploring themes such as beauty, gender, and individuality. While *Assembling Bodies* did not focus on either individual identity or body decoration, these emerged as central concerns for the young student artists.

The most substantive spin-off has been a collaborative exhibition project *Unlimited Global Alchemy*, which was inspired by the chance encounter of London artist Rachel Gadsden with Nomdumiso Hlwele's body map in *Assembling Bodies* during my gallery talk for a Courtauld artists' symposium (Herle 2012: 11). Identifying with the portrayal of suffering and resilience in the face of chronic disease, Gadsden made contact with Hlwele and the Bambanini group in Khayelitsha Township and co-developed an exhibition project in association with MAA.[14] Over several weeks in 2011 they collectively produced an extraordinary body of artwork and a series of short autobiographical films of the participants, shot on location in the township.[15]

Sparked by *Assembling Bodies* and carried forward by Gadsden and the Bambanini group with the support of the British Council and the Unlimited funding programme for the 2012 Cultural Olympiad, *Unlimited Global Alchemy* was launched at MAA on 22 June 2012 and the London Southbank Centre on 31 August 2012 for the Paralympics, bringing Nomdumiso Hlwele, Thobani Ncapai, and Bongiwe Mba to the UK for the opening events. The exhibitions, film screenings, and associated performances resulted from personal reflections on the body's capacities and vulnerabilities and social action in the face of adversity (Mitchelson 2012). The powerful and empowering underlying message highlighted the political implications of the ways that bodies are defined and acted upon.

Conclusion

This article has attempted to explicate the potential of exhibition making for research, here framed by a strong anthropological focus. More broadly, the provision of a detailed reflexive case study aims to illuminate and promote more nuanced analyses of the links and gaps between museum practice and research. The process of *Assembling Bodies* involved intense engagement with a broad range of objects originating from different times, places, and disciplinary contexts. The waywardness of imaging and imagining, and the divergent character of objects and experiences that the exhibition presented, were mobilized as a potent curatorial resource. The provocative and open-ended approach challenged existing forms of knowledge and worked to prompt productive rather than reductive understandings. The introductory text panel encouraged people to temporarily join and reflect on the bodies that the exhibition assembled.

For the curators and some visitors, the specificity of particular bodies, the question of multiple bodies, and the efficacy of different theoretical approaches were topics that were explored within the gallery during the course of the exhibition. The visitors to the exhibition kept the research process dynamic even though the majority were not directly involved in 'research' as narrowly defined, either as subjects or in the sense of participating in a deliberate sustained investigation. As indicated by various forms of evaluation and direct observation, thousands of people closely interacted with aspects of the material and ideas on display. Overall, the main goal of the exhibition, to challenge preconceived ideas about the singularity or fixity of 'the body', appears to have been achieved. Displaying the technologies that make bodies visible revealed obscure aspects of 'the social' in the multiple ways that distinctive bodies are created and understood, while highlighting how the political is continually reconstituted by shifting assemblages of people and things. While this concept was only articulated by a relatively small number of visitors, it was explored, experienced, and expressed in diverse and unexpected ways by many more.

■ **ANITA HERLE** is senior curator for anthropology at the Museum of Archaeology and Anthropology, and an affiliated lecturer in the Department of Social Anthropology, University of Cambridge, where she coordinates a MPhil course in Social Anthropology and Museums. She is committed to the museum as an important site for scholarly and artistic research and expression, a place that brings together contemporary anthropological research with the concerns of originating communities and a range of specialist interests. Much of her work focuses on the theory, politics, and practice of exhibition making. She was the lead curator for *Assembling Bodies: Art, Science and Imagination* with co-curators Mark Elliott and Rebecca Empson.

■ **ACKNOWLEDGMENTS**

Assembling Bodies: Art, Science and Imagination was made possible by the generous support of the Leverhulme Trust, the Wellcome Trust, Arts Council England East, and the Crowther-Beynon Fund University of Cambridge. Exhibitions are collaborative projects that involve the creative input of numerous people. I particularly thank co-curators Mark Elliott and Rebecca Empson as well as members of the Leverhulme research project Changing Beliefs of the Human Body (2004–2009) led by John Robb, and the numerous specialists, artists, and museum staff who contributed to the exhibition and catalogue (see Herle et al. 2009; http://maa.cam.ac.uk/assemblingbodies/). Sarah Jane Harknett developed and oversaw extensive visitor evaluation. I am grateful to Mark Elliott, Rebecca Empson, Haidy Geismar, Nancy Hynes, and anonymous reviewers for their comments on earlier drafts of this article. I thank Jocelyne Dudding for photography and Deborah Wickham for assistance with the graphics. I am also grateful to colleagues for their valuable feedback following seminar presentations in the social anthropology departments at University College London and University of Manchester and at the Association of Art Historians 2010 annual conference, as part of a panel on "Exhibition as Research."

■ **NOTES**

1. The Leverhulme project Changing Beliefs of the Human Body was led by John Robb in the Department of Archaeology at the University of Cambridge and included six research groups. See details at http://www.arch.cam.ac.uk/lrp/intro.html.
2. This edited publication resulted from a workshop on "Social Bodies," organized by Maryon McDonald in 2005, which provided a strong anthropological framework for the project.
3. A recent popular exhibition is *The Body Adorned: Dressing London* at Horniman Museum (24 March 2012–6 January 2013). Notable exceptions to the numerous body exhibitions focused on body decoration and identity were *Spectacular Bodies: The Art and Science of the Human Body from Leonardo to Now* (October 2000–January 2001) and *Quest-ce Qu'un Corps?* (2006–2007), Musée du quai Branly, which compared the way that the body and the person are represented in Western Europe, West African, Papau New Guinea, and Amazonia.
4. Examples include many of the exhibitions at the Wellcome Gallery, London, and the exhibition currently touring the UK, *Inside DNA: A Genomic Revolution Liverpool,* developed by At-Bristol on behalf of the Association for Science & Discovery Centres with funding from the Wellcome Trust and support from the Sanger Institute.
5. Recent technical analysis conducted as part of cleaning this painting for loan to the exhibition revealed that some of the portrait frames were later additions, perhaps suggesting that these figures had become ancestors after the painting was first composed.
6. We were delighted that John Sulston agreed to formally open the exhibition on 6 March 2009.
7. The website can be found at http://maa.cam.ac.uk/assemblingbodies/.
8. This project was made possible by the assistance of medical anthropologist Hayley MacGregor (Institute of Development Studies, University of Sussex), Elizabeth Mills (AIDS and Society Research Unit, University of Cape Town), and Nondumiso Hwele (leader of the Bambanani Group).
9. The Kinetica Museum is a London-based organization that aims to actively encourage the convergence of art and technology. Initially established as a vibrant arts center in Spitalfields market (2006–2008), it now organizes an annual Kinetic Art Fair and is involved in a series of exhibitions and workshops around the world. The Kinetica Museum represents a number of leading international artists, coordinates activities between artists and institutions, and maintains a collection of kinetic, electronic, and experimental artwork dating from the 1950s to the present. For further information see http://www.kinetica-museum.org.

10. Lewis describes his artistic practice as combining photography with ethnographic research and he has worked closely with anthropologists, for example, as a visiting fellow in the Department of Social Anthropology at Goldsmiths University (2009–2010), where he produced the exhibition *Field Works* (Wright 2011).
11. A number of the physiological tests were based on those conducted by WHR Rivers as part of the 1898 Anthropological Expedition to the Torres Strait.
12. Visitor mapping was used to determine pathways in the gallery and the amount of time people spent looking at various displays.
13. Short sequences of the performance were posted on YouTube at http://www.youtube.com/watch?v=5RwgTICUBIs/.
14. For information about the project, see www.unlimitedglobalalchemy.com.
15. These intimate vignettes were made by Gadsden with filmmakers Cliff Bestall and Deborah May.

▪ REFERENCES

Ames, Michael. 1986. *Museums, the Public and Anthropology: A Study in the Anthropology of Anthropology*. Vancouver: Concept Publishing House in association with UBC Press.
Bond, Jim. 2009. "Atomised & Anamorphic Man." Pp. 12–13 in *Assembling Bodies: Art, Science, and Imagination*, ed. Anita Herle, Mark Elliott, and Rebecca Empson. Cambridge: Museum of Archaeology and Anthropology.
Bouquet, Mary. 1996. "Family Trees and Their Affinities: The Visual imperative of the Genealogical Diagram." *The Journal of the Royal Anthropological Institute* 2 (1): 43–66.
Bouquet, Mary. 2000. "Thinking and Doing Otherwise: Anthropological Theory in Exhibitionary Practice." *Ethnos* 65 (2): 217–236.
Breton, Stéphane, with Michele Coquet, Michael Houseman, Jean-Marie Schaeffer, Anne-Christine Taylor, and Eduardo Viveiros de Castro. 2006. *Quest-ce Qu'un Corps?* Paris: Flammarion.
de Chadarevian, Soraya, and Harmke Kamminga. 2002. *Representations of the Double Helix*. Cambridge: Whipple Museum of the History of Science.
Department of Culture, Media and Sport. 2005. *Guidelines for the Care of Human Remains in Museums*. London: DCMS.
Edwards and Petrović-Šteger. 2011. *Recasting Anthropological Knowledge: Inspiration and Social Science*. Cambridge: Cambridge University Press
Empson, Rebecca. Forthcoming [2013]. "Assembling Bodies: Cuts, Clusters and Juxtapositions." in *Transcultural Montage*, ed.. Christian Suhr and Rane Willerslev. Oxford: Berghahn Books.
Fara, Patricia. 2002. *Newton The Making of Genius*. New York: Columbia University Press.
Ferry, Georgina. 2009. "Our Changing Body Image." *Nature* 459: 1060–1061.
Geismar, Haidy. 2010. "Review: Assembling Bodies: Art, Science and Imagination." *Anthropology Today* 26 (5): 25–26.
Gell, Alfred. 1991. "The Technology of Enchantment and the Enchantment of Technology." Pp. 400–463 in *Anthropology, Art and Aesthetics*, ed. Jeremy Coote and Anthony Shelton. Oxford: Clarendon Press.
Gell, Alfred. 1996. "Vogel's Net: Traps as Artworks and Artworks as Traps." *Journal of Material Culture* 1: 14–38.
Gell, Alfred. 1998. *Art and Agency: An Anthropological Theory*. Oxford: Claredon.
Gunn, Michael, and Philippe Peltier, eds. 2006. *New Ireland: Art of the South Pacific*. Paris: Musée de quai Branly.
Henare, Amiria, Martin Holbraad, and Sari Wastell. 2007. "Introduction." Pp. 1–31 in *Thinking Through Things*, ed. Amiria Henare, Martin Holbraad, and Sari Wastell. London: Routledge.
Herle, Anita. 2003. "Objects, Agency and Museums: Continuing Dialogues Between the Torres Strait and Cambridge." Pp. 194–207 in *Museums and Source Communities*, ed. Laura Peers and Alison Brown. London: Routledge.

Herle, Anita. 2012. "Empowering Resilience." Pp. 11–13 in *Unlimited Global Alchemy*, ed. Andrew Mitchelson. London: Artsadmin.

Herle, Anita, Mark Elliott, and Rebecca Empson. 2009. *Assembling Bodies: Art, Science and Imagination*. Cambridge: Museum of Archaeology and Anthropology.

Herle, Anita, and Andrew Moutu. 2004. *Paired Brothers: Concealment and Revelation: Iatmul Ritual Art from the Sepil, Papua New Guinea*. Cambridge: University of Cambridge Museum of Archaeology and Anthropology.

Ingold, Timothy. 2000. *The Perception of the Environment: Essays on Livelihood, Dwelling and Skill*. London: Routledge.

Kemske, Bonnie. 2007. "Evoking Intimacy: Touch and the Thoughtful Body in Sculptural Ceramics." Unpublished DPhil diss., Royal College of Art.

Kopytoff, Igor. 1986. "The Cultural Biography of Things." Pp. 64–94 in *The Social Life of Things*, ed. Arjun Appadurai. Cambridge: Cambridge University Press.

Kuechler, Susanne. 2002. *Malanggan: Art, Memory and Sacrifice*. Oxford: Berg.

Lambert, Helen, and Maryon McDonald. 2009. "Introduction." Pp. 1–15 in *Social Bodies*, ed. Helen Lambert and Maryon McDonald. New York: Berghahn Books.

Latour, Bruno. 2005a. "From Realpolitick to Dingpolitik or How to Make Things Public." Pp. 14–43 in *Making Things Public: Atmospheres of Democracy*, ed. Bruno Latour and Peter Weibel. Cambridge, MA: The MIT Press.

Latour, Bruno. 2005b. *Reassembling the Social: an Introduction to Actor Network Theory*. Oxford: Oxford University Press.

Latour, Bruno, and Peter Weibel, eds. 2005. *Making Things Public: Atmospheres of Democracy*. Cambridge, MA: The MIT Press.

Macdonald, Sharon. 2002. *Behind the Scenes at the Science Museum*. Oxford: Berg.

Macdonald, Sharon, and Paul Basu. 2007. "Introduction: Experiments in Exhibition, Ethnography, Art and Science." Pp. 1–24 in *Exhibition Experiments*, ed. Sharon Macdonald and Paul Basu. Malden, MA: Blackwell Publishing.

MacGregor, Hailey, and Elizabeth Mills. 2009. "Mapping Change and Continuity: Living with HIV as a Chronic Illness in South Africa." Pp. 92–92 in *Assembling Bodies: Art, Science and Imagination*, eds. Anita Herle, Mark Elliott, and Rebecca Empson. Cambridge: Museum of Archaeology and Anthropology.

MacKenzie, Maureen. 1991. *Androgynous Objects: String Bags and Gender in Central New Guinea*. Chur, Switzerland: Harwood Academic Publishers.

Merleau-Ponty, Maurice. 1962. *The Phenomenology of Perception*. Colin Smith (trans.) London: Routledge.

Miller, Daniel, ed. 2005. *Materiality*. Durham, NC: Duke University Press.

Mitchelson, Andrew, ed. 2012. *Unlimited Global Alchemy*. London: Artsadmin.

Mol, Annemarie. 2002. *The Body Multiple: Ontology in Medical Practice*. Durham, NC: Duke University Press.

Morgan, Jonathon, and the Bambanani Women's Group. 2003. *Long Life: Positive HIV Stories*. Victoria, Australia: Spinifex Press.

Peers, Laura, and Alison Brown, eds. 2003. *Museums and Source Communities*. Routledge: London.

Petrović-Šteger, Maja. 2011. "Spools, Loops and Traces: On *Etoy* Encapsulation and Three Portraits of Marilyn Stratern." Pp. 145–160 in *Recasting Anthropological Knowledge: Inspiration and Social Science*, ed. Jeanette Edwards and Maja Petrović-Šteger. Cambridge: Cambridge University Press.

Raymond, Rosanne, and Amiria Salmond, eds. 2008. *Pasifika Styles: Artists inside the Museum*. Cambridge: Cambridge University Museum of Archaeology and Anthropology in association with Otago University Press.

Rice, Tom. 2009. "Sounding Bodies." Pp. 46–47 in *Assembling Bodies: Art, Science and Imagination*, ed. Anita Herle, Mark Elliott, and Rebecca Empson. Cambridge: Museum of Archaeology and Anthropology.

Robb, John, and Dusan Borić, eds. 2008. *Past Bodies: Body-Centred Research in Archaeology.* Oxford: Oxbow.

Robb, John, and Oliver Harris, eds. 2013. *The Body in History: Europe from the Paleolithic to the Future.* Cambridge: Cambridge University Press.

Schneider, Arnold, and Chris Wright. 2006. "The Challenge of Practice." Pp. 1–27 in *Contemporary Art and Anthropology,* ed. Arnold Schneider and Chris Wright. Oxford: Berg.

Spufford, Francis. 2003. "The Gift." Pp. 163–206 in *Backroom Boys: The Secret Return of the British Boffin,* ed. Francis Spufford. London: Faber and Faber Ltd.

Strathern, Marilyn. 1999. *Property, Substance and Effect, Anthropological Essays on Persons and Things.* London: Athlone Press.

Strathern, Marilyn. 2001. "The Patent and the Malanggan." Pp. 259–286 in *Beyond Aesthetics: Art and the Technologies of Enchantment,* ed. Christopher Pinney and Nicholas Thomas. Oxford: Berg.

Strathern, Marilyn. 2005. *Kinship, Law, and the Unexpected: Relatives are Always a Surprise.* Cambridge: Cambridge University Press.

Strathern, Marilyn. 2009a. "Bilums and Pearlshells: Production and Reproduction." Pp. 64–65 in *Assembling Bodies: Art, Science and Imagination,* ed. Anita Herle, Mark Elliott, and Rebecca Empson. Cambridge: Museum of Archaeology and Anthropology.

Strathern, Marilyn. 2009b. "Using Bodies to Communicate." Pp. 148–169 in *Social Bodies,* ed. Helen Lambert and Maryon McDonald. Oxford: Berghahn Books.

Thomas, Nick. 2010. "The Museum as Method." *Museum Anthropology* 33 (1): 6–10.

Weibel, Peter, and Bruno Latour. 2007. "Experimenting with Representation: Iconoclash and Making Things Public." Pp. 94–108 in *Exhibition Experiments,* ed. Sharon MacDonald and Paul Basu. Oxford: Blackwell Publishing.

Wright, Chris. 2011. *Field Work.* Goldsmiths University. www.gold.ac.uk/media/Chris%20Wright%20on%20Field%20Work.pdf (accessed 1 July 2012).

'Ceremonies of Renewal'

Visits, Relationships, and Healing in the Museum Space

Laura Peers

ABSTRACT: Access to heritage objects in museum collections can play an important role in healing from colonial trauma for indigenous groups by facilitating strengthened connections to heritage, to ancestors, to kin and community members in the present, and to identity. This article analyzes how touch and other forms of sensory engagement with five historic Blackfoot shirts enabled Blackfoot people to address historical traumas and to engage in 'ceremonies of renewal', in which knowledge, relationships, and identity are strengthened and made the basis of well-being in the present. The project, which was a museum loan and exhibition with handling sessions before the shirts were placed on displays, implies the obligation of museums to provide culturally relevant forms of access to heritage objects for indigenous communities.

KEYWORDS: Blackfoot, healing, indigenous communities, museums, touch

In 2010, the Pitt Rivers Museum at Oxford (PRM) loaned five historic Blackfoot shirts (figure 1) to the Glenbow and Galt museums in Alberta, Canada. The project team[1] held handling sessions at each museum, enabling over five hundred Blackfoot people to see and touch the shirts, unmediated by glass cases. Collected in 1841, and decorated with porcupine quillwork, paint, and human and horse hairlocks, the shirts are important heritage objects. For Blackfoot people,[2] they are also ancestors, embodying the spirits of those who made and used the shirts. Having been absent so long from their communities—along with nearly all hairlock shirts, which were collected during the colonial era—their presence and multisensory engagements with them provoked powerful responses.

The Blackfoot Shirts Project was intended to encourage the transmission of cultural knowledge within Blackfoot communities by using the provocation of touch to encourage participant discussions. The handling sessions went beyond this, addressing what Connerton (2011: 16) calls historical traumas, "those circumstances of mourning where the benefit of rituals and rules do not obtain." Connerton's definition of "routinised forms of suffering, against which certain categories of persons are relatively protected but to which others, the poor and the defeated, are especially exposed" (2011: 16) applies to Blackfoot experiences of colonialism. Globally, indigenous groups suffer poorer physical and mental health and lower income and education levels in relation to mainstream populations, as a result of assimilation pressures. One factor in the destabilization of indigenous communities has been the removal of heritage objects to museums. The

Museum Worlds: Advances in Research 1 (2013): 136–152 © Berghahn Books
doi:10.3167/armw.2013.010109

Figure 1. Blackfoot shirt with painted war honors, acquired 1841 by Sir George Simpson and Edward Hopkins. Elk or deer hide, sinew, human hair, horse hair, paint. Pitt Rivers Museum, University of Oxford, 1893.67.1.

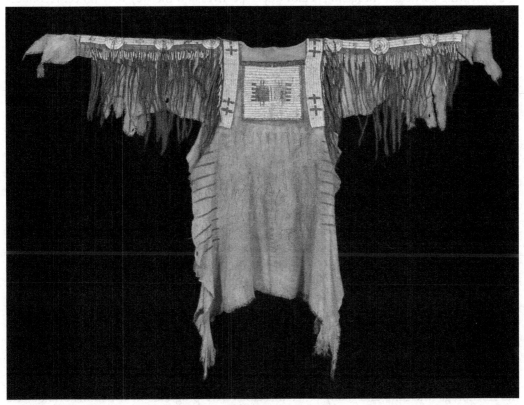

loss of symbols of identity and the interruption of social processes in which the making and use of material culture is embedded significantly weakened the transmission of cultural knowledge. Touching the shirts encouraged lively discussions, but went beyond this to strengthen participants' sense of connection to the past, to shared cultural knowledge and historical memory, and to each other. I argue that this process of strengthening relationships through multisensory engagements with historic museum 'objects' facilitated social healing for the Blackfoot people who engaged with the project. The restoration of relationships—with ancestors, with heritage, and with family and community members in the present—has been identified as crucial to healing after social loss (Miller and Parrott 2009) and historical trauma (Waldram 2008; Chandler and Lalonde 2008).

Transforming relationships is also an issue between museums and formerly colonized peoples. The Blackfoot Shirts Project is part of a movement to develop relationships of equality between museums and indigenous communities, and more broadly for museums to position themselves as ethical institutions, spaces of communication within which to foster awareness of social issues (Sandell 2007; Janes and Conaty 2005; Marstine 2011), and places of engagement between disparate groups where challenging conversations might occur (Clifford 1997). One strand of these processes of change has been the emergence of projects that seek to reconnect heritage objects in museums with indigenous communities of origin, or source communities (Peers and Brown 2003).

Explications of such developments are often set within postcolonial theory, which examines issues of power and voice within unequal relations of power. Such perspectives are valid, but risk obscuring particular indigenous cultural perspectives and the way they inflect reconnection projects. I agree with Elizabeth Edwards (2006: 28) that "it is necessary to destabilize those dominant theories and find other tools and methodologies that draw on indigenous categories and practices." As the Blackfoot Shirts Project unfolded, it became clear that Blackfoot people were aware of the power dynamics inherent in museum-based projects, and that they participated within these constraints to pursue their own goals. It also became clear that they saw the shirts, and engagements with them, through Blackfoot cultural perspectives rather than museological or postcolonial ones. The shirts, in Blackfoot thought, are potentially animate, associated with the spirits of those who made and wore them, and whose bodies were used to make them. Objects are not generically animate in Blackfoot thought: spirits associated with them might leave if treated disrespectfully, in which case they would become inanimate.[3] Respectful treatment involves particular forms of sociality: relationships, as Cynthia Chambers and Kainai scholar Narcisse Blood explain (2009: 267), are "nurtured through unimpeded access, continued exchange of knowledge, and ceremonies of renewal such as visiting and exchanging of gifts and stories." Chambers and Blood refer to such events as 'ceremonies of renewal'. Renewing relationships through visits, gifts, and the exchange of knowledge and stories provides a metaphor for museum-based reconnection projects. It also provides a culturally specific theoretical basis—one that goes beyond postcolonial theory—for understanding how engagements with heritage objects might be healing for indigenous peoples. The shirts are potentially animate; thus, they have powerful potential for strengthening relationships with heritage—and, through this, for strengthening identity in the present.

Making collections accessible to source communities has become a major emphasis in museums, and handling objects a standard methodology for reconnection projects. In North America, the School of American Research in Santa Fe, the Arctic Studies Center at the Smithsonian, the Anchorage Museum, and many other museums have programs in which historic objects are handled by tribal members. The U'Mista Cultural Centre, a tribally run facility in Alaska, cares for masks that are used in potlatches and then returned to the center; the Museum of Anthropology at the University of British Columbia and the National Museum of the American Indian have similar arrangements. In Britain, the National Museums of Scotland loaned objects to Tłįchǫ communities, which were used in handling sessions (Knowles 2008). There have been many delegations to UK museums for handling/study sessions (see Bolton et al. forthcoming; Herle 2003; Lincoln et al. 2010; Krmpotich and Peers forthcoming). The Blackfoot Shirts Project sits within these contexts.

Today, there are four nations within the Blackfoot Confederacy: Siksika, Piikani, and Kainai, in Alberta, and Blackfeet, in Montana (figure 2). The population of the confederacy is approximately forty-two thousand, divided between those who live on reserves and those who live in cities such as Calgary. In both countries, Blackfoot people have federally recognized treaty status, and their communities—governed by elected councils—receive some federal funding. Education and employment rates in these communities are lower than national averages, but are rising, and key positions in tribal administration, health, and education are now filled by Blackfoot people. Blackfoot language retention is uneven across generations. Many speak it fluently, and there are language classes in all four communities. However, people still feel that Blackfoot language and culture are in danger of being lost, and seek opportunities to strengthen them.

The Blackfoot Shirts Project was initiated by Blackfoot ceremonialists as such an opportunity. In 2004, Kainai ceremonial leaders Frank Weasel Head and Andy Blackwater were invited to

Figure 2. Blackfoot territory and communities today. Map by Jennifer Johnston, University of Aberdeen.

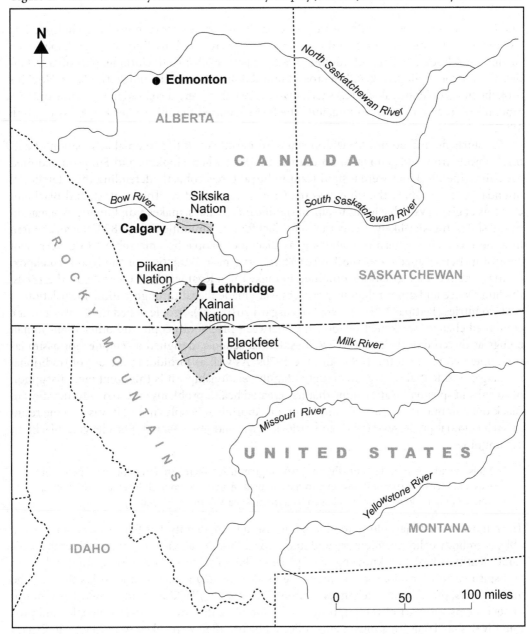

study the shirts at PRM. Following this, Weasel Head stated in a lecture to museum staff that he had never seen such things, that his children and grandchildren had never seen such things—and issued a challenge to "bring them home for a visit" so that Blackfoot people could learn from them. Arts and Humanities Research Council funding for the project was secured in 2009, and Blackfoot mentors titled the project "*Kaahsinnonniksi Ao'toksisawooyawa*: Our Ancestors Have Come to Visit."

"Mrs. Davis, why is our history so sad?"[4]

The Blackfoot shirts at the PRM were collected in 1841 by the governor of the Hudson's Bay Company, Sir George Simpson, and his secretary, Edward Hopkins. They were probably given by Blackfoot leaders at Fort Edmonton as a diplomatic exchange of clothing, part of an established protocol of gift giving within cross-cultural politics across the northern plains. Hopkins took the shirts to Montreal where, as tack marks attest, they were displayed in his home. In 1870, Hopkins retired and moved to England. The PRM acquired the shirts after Hopkins's death in 1893.

The shirts fit, and do not fit, within standard narratives of the colonial acquisition of cultural objects from indigenous communities. In 1841, when Hopkins and Simpson acquired the shirts, the Blackfoot were a significant political force, robustly defending their territorial boundaries. Simpson, at the time, was the Crown representative. This context, and Blackfoot customs of giving valuable items to affirm significant alliances, makes a diplomatic explanation of the shirts' transfer likely. Items that left Blackfoot communities after 1850, however, often fit a more coercive pattern of collecting, as Blackfoot people became subject to government control in both Canada and the United States. The near-extinction of the bison, smallpox, treaties, and federal legislation combined to make them legal wards of the state. In the 1880s, the Sun Dance and other religious practices were made illegal through national legislation in both countries (Pettipas 1994: 93–96; Lokensgard 2010: 122). People defied these laws, but the combined changes weakened relationships between Blackfoot people and other-than-human beings at the core of their worldview. Residential schools, designed as engines for assimilation, operated between the 1890s and the 1970s. As well as forbidding the use of traditional languages, residential schools interrupted family relationships. It is this combined disruption of social and spiritual relationships that has created health problems and social dysfunction in Blackfoot communities (Royal Commission on Aboriginal Peoples n.d.).[5] It was also the result of such colonial processes that led to hairlock shirts and other sacred items leaving Blackfoot communities:

> I talked with my friend about why they would give such a sacred item up, for some people it was a matter of survival. Being able to have a meal. And when your children are not eating, you're going to do whatever it takes to feed them. (Lea Whitford, Blackfeet)

The removal of material culture reinforced the assaults on identity. For Blackfoot people, sacred objects embody collective memory and knowledge: they are anchors for cultural identity. Cultural identity is based on knowing one's place in the universe and on participating in human and spiritual relationships. Sacred items are used to maintain such relationships through the visiting, gifts, prayers, and exchanges that form the core of Blackfoot ceremonies. The removal of such items was part of the imposition of colonial control over Blackfoot people, and profoundly destabilizing. That most items collected before 1850 were taken to museums in Britain and Europe compounds these effects, because they have been inaccessible to Blackfoot people. Many Blackfoot people have never seen early heritage items: as Treena Tallow (Kainai) said in an interview, "I have never seen quillwork in my life … I've never even seen pictures of quillwork." Mikkel Bille, Frida Hastrup and Tim Flohr Sorensen have written (2010: 4) of "the presence of absence" and its effects on people's lives, and the absence of heritage items has been a profound presence in the lives of Blackfoot people.

Despite the onslaught, Blackfoot culture did not vanish. As Herman Yellow Old Woman (Siksika) noted, "We still speak the language. We still call on our ancestors, where these shirts come from. We might have suffered some loss, but it's coming back strong." With great determi-

nation, individuals have preserved ceremonial knowledge and the Blackfoot worldview. Since the 1970s, Blackfoot people have repatriated ceremonial objects from museums and used these to revive ceremonies, engaging in what Archibald (1999: 133) calls "re-remembering": bringing knowledge back into play, restoring social processes such as the use of Blackfoot names, strengthening cultural identity. Some knowledge, however, is endangered: few people do porcupine quillwork. Blackfoot people want to regain cultural knowledge by learning from their ancestors, often through studying the things they made (Jerry Potts, Piikani, cited in Brown 2000: 191–192). It is in these tensions between the absence of heritage items, their presence in museums, and their needed presence in Blackfoot lives that the return of the shirts and engagements with them can be seen as social healing.

Objects and Healing

'Healing' is a concept much discussed regarding indigenous peoples, especially the healing of the social, mental, and physical pathologies caused by colonialism. Healing of Canadian Aboriginal people takes such forms as a Truth and Reconciliation Commission, an Aboriginal Healing Foundation, financial compensation to residential school survivors, and 'healing lodges' and clinical practitioners. However, as James Waldram, a medical anthropologist with the Canadian Aboriginal Healing Foundation, admits (2008: 4), the definition of healing used in relation to Aboriginal communities is "vague and fuzzy." Neither Aboriginal people nor the non-Aboriginal health professionals who work with them use it in a biomedical sense. It has a broader social meaning, resting on the link between changed social behaviors and improved mental and physical health. As Waldram states, the concept of 'healing' is

> about the reparation of damaged and disordered social relations. The individual, through outwardly and self-destructive behaviors, has become disconnected from family, friends, community, and even his or her heritage. The reason for undertaking healing is often found in the clients' desire to make amends and to be accepted back into the web of relationships. (2008: 6)

Heritage plays a key part in this process. Assimilation policies interrupted cultural knowledge and its social transmission: residential schools were all too often successful in teaching students that they must break with the past. As Frank Weasel Head said, "A lot of our young people are trying to identify themselves. They don't really know who they [are]. All they know is, I'm an Indian, and that's it. They don't know their history." For some, knowledge of specific community and family histories has become another of the absences in these communities.

Having access to heritage objects—making them present—is an important part of the healing process. Material culture has been described as "systems of recall for persons and social groups that have been threatened or traumatized by loss" (Hallam and Hockey 2001: 7; Parkin 1999); as facilitating relationships across generations (Miller and Parrott 2009: 502; Hallam and Hockey 2001); and as symbols of group identity that create "a profound sense of belonging" (Lyons 2002: 116). Reminiscence therapy with museum objects (Arigho 2008; Chatterjee et al. 2009) similarly underscores the potential of handling artifacts to provoke memories and improve well-being. Although Butler (2011: 355) is critical of "heritage healing" as a cure-all for the ills of modernity, access to symbols of collective identity is a powerful tool in the fight for survival for formerly colonized groups. The way that objects serve as a sensory link between the living and the dead facilitates the restoration of relationships—with ancestors, with heritage, and with community members in the present. As Gerald Conaty and Clifford Crane Bear note,

> Many of the objects in museum collections played an important role in maintaining connections between human beings and the rest of Creation. Other objects carry with them memories of historical events and the people who experienced those times.... *Access to these objects can help rebuild relationships which have been disrupted* and restore cultural memories which may be on the brink of being forgotten. (Conaty and Crane Bear 1998: 73; italics added)

Making heritage objects present within indigenous communities triggers learning about the past, even as it strengthens relationships. These processes are healing.

Handling historic artifacts is an especially powerful form of reconnection: in touching the object, one touches the ancestors who made and used it. The recent 'sensory turn' in anthropology (Edwards et al. 2006; Howes 2003; Classen 2005) has explored the provocation of touch, and the way this triggers memory and emotional response: "the sensible, physical characteristics of the thing trigger and thus contribute to the viewer's sensory perceptions, which in turn trigger emotional and cognitive associations" (Dudley 2009: 7; Tarlow 2012; Sennett 2008). Saunderson (2011: 164), citing experimental psychology, concludes that multisensory encounters enhance memory and learning, making encounters with objects more meaningful.

All of this is especially true for indigenous groups, for whom multisensory, emotional, and spiritual and social perceptions are as important as the visual in learning from objects (Phillips 2002: 62–63). Indigenous researchers often perform the objects' functions: lifting masks to faces, placing hats on heads, draping robes over elders to acknowledge kinship relations, social structure, clan rights—the objects are reabsorbed into social relationships. Being able to touch, stroke, kiss, hold, dance with, or weep over objects is simultaneously empowering, and a trigger for grief, anger, and joy. 'Healing' in these moments has to do with physical presence and the social meanings of touch.

These responses are muted if the encounter is purely visual. The primacy recently accorded to visual modes of engaging with museum objects has prompted Susan Stewart to claim (1999: 28) that museums are a set of "ritualized practice[s] of refraining from touch." Such is the expectation that visitors will look but not touch that, as Classen and Howes (2006: 216) note, "the issue of tactile access to collections is usually only raised as regards the visually impaired, the assumption being that those who can see have no need to touch" (see also Chatterjee 2008: 2; Saunderson 2011: 159–160). The emphasis on visual interaction with museum objects is a culturally, professionally, and historically informed set of values and ideals (Candlin 2008). For indigenous peoples, museum control over the nature of engagements with objects removed from their communities has been part of the colonial experience. Recently, museums have extended the 'right' to handle 'real' objects (as opposed to duplicates in educational handling collections) to indigenous researchers, as a mechanism for cultural learning as well as an acknowledgment of shifting relations of power.

On a more pragmatic basis, PRM staff were initially concerned about handling of the shirts because of the risks of physical damage and the widespread contamination of museum collections through historic pesticide use. Fortunately, XRF spectrometry testing revealed that PRM collections have only trace levels of arsenic and mercury, making handling feasible for this project if people either wore gloves or washed their hands after handling.[6] To balance the need for physical care of the shirts with the need of Blackfoot people for direct contact with them, Heather Richardson, head of conservation at PRM, traveled to Alberta to facilitate handling sessions.

The Ancestors Come Home

In spring 2010, the shirts were shipped to Alberta, where the team held forty-seven sessions with over five hundred Blackfoot people. Sessions were prebooked with elders, ceremonialists,

artists and craftspeople, teachers, and high school and college students from each of the four communities. At the request of elders, the project team also invited a group of Blackfoot people in a substance abuse rehabilitation program, in the hope that the experience would be a catalyst for healing for them.

In considering how engagements with the shirts were healing for Blackfoot people, it is important to understand the political dynamics within which these events occurred. While literature on museum collaborations has emphasized Clifford's (1997) idea of the 'contact zone', recent nuancing of this concept suggests that museums remain 'invited spaces' in which power remains with the museum (Lynch and Alberti 2010; Lynch 2011; Boast 2011). Looking carefully at local micropolitics, however, is key. At Glenbow, staff have developed long-term relations with Blackfoot people, who act as museum advisors. Glenbow staff helped to create the Alberta Repatriation Act, and work for Blackfoot communities on heritage issues (Conaty 2008). Galt staff have been mentored by Glenbow staff as well as directly by Blackfoot people. There was no simple insider/outsider dynamic in the sessions—some Blackfoot are regular consultants for these museums, while others assert forms of moral ownership over collections in these spaces. The project was initiated by Blackfoot ceremonialists to benefit Blackfoot people, who appropriated backroom spaces in which sessions occurred (the conservation lab at Glenbow; the archives room at Galt) for their own purposes. They also imposed Blackfoot perspectives and expectations on these spaces, taking ownership of them in key ways.

Rather than as controlled spaces, one might see these sessions as involving overlapping relationships: among Blackfoot people and ancestors, between the UK project team and Glenbow/ Galt museum staff, between museum/project staff and Blackfoot people. Each session began with Blackfoot protocol for interacting with sacred beings: with prayer and smudging. The ancestors' presence was acknowledged and their assistance was invoked, along with that of other beings. Blackfoot language, ontology, and the smell of sweetgrass framed the encounter, turning the space partially into a Blackfoot one.[7] Project team members then discussed the provenance of the shirts, engaging with Blackfoot concerns about whose shirts these might have been (and Blackfoot relationships with ancestors), and briefed participants on handling techniques, showing on a replica shirt where the hide could safely be touched. We also acknowledged our relationships with Blackfoot ceremonialists, whose support enabled the project by encouraging community participation, and noted their advice that according to cultural protocol, the hairlock shirts should not be touched by menstruating women. Having addressed these various relationships, we uncovered the first shirt.

Sessions began with an undecorated work garment (PRM 1893.67.5) that is poorly tanned, water damaged, and work-soiled. People gently stroked the shirt, sometimes leaning over and sniffing for the scent of home-tanned hide. We encouraged people to examine the stitching, construction, and signs of wear on the shirt, and to think about the gender roles involved in its making and use.

Following this, one of the decorated shirts (PRM 1893.67.1, 2, 3, 4) was uncovered. These are visually arresting, and uncovering them was always accompanied by exclamations. People paused to take in the power of the shirt and its associated spirits. The room filled with emotion: awe, joy at seeing the shirts, grief and anger at all that has been taken away from Blackfoot people, gratitude that the shirts were able to visit. Some wept, in pride and in sorrow; some sang honor songs or spoke to the ancestors. People looked intently at the shirts, counting painted lines, using magnifying glasses, taking photographs. Some felt for spiritual energies by holding their hands over the shirts. Many people touched them gently: traced painted lines with fingers, touched quillwork and sinew stitching to feel its texture, and stroked the hide. One shirt is painted with the artist's finger marks, and people put their fingers on these, touching the artist's hand through the paint.[8] In every workshop, participants wanted their pictures taken with

the ancestors in the manner of family photographs: these engagements were ways of renewing relationships.

This was a highly emotional part of the session. Fowles (2010: 26) has noted that "absences perform labor, frequently intensifying our emotional or cognitive engagement with that which is manifestly not present," and the uncovering of the powerful *presence* of the ancestors/shirts made manifest that which had been absent, provoking intense emotional responses. Ramona Big Head, who brought a group of students to see the shirts, remembers that "when the shirts were uncovered and we saw them for the first time, there was a breathless silence that overcame us. We were simply in awe. It was almost as though we could feel the presence of our ancestors who made those shirts." Touching the shirts, and the emotional responses that their presence generated, involved, as Eelco Runia (2006: 5) has expressed it, "being in touch—either literally or figuratively—with people, things, events, and feelings that made you into the person you are."

As with other projects exploring relations between material culture, touch, and emotion (Edwards 2006, 2010; Harris and Sorensen 2010; Seremetakis 1994), engaging with the shirts was also a social process. Caressing, weeping, singing honor songs, and expressing grief and anger are not responses to asocial, inanimate objects: these are things one does in the context of social relationships. Multisensory 'visits' are part of Blackfoot sociality and the means of maintaining relationships with the landscape, other-than-human beings, and ancestors. Relationships being renewed were not simply with heritage, however, but with the work that history does in the present. While encountering the past, Blackfoot people in these sessions were 'getting in touch with' identity in the present.

Presence, Absence, History, Identity

The shirts are from a distant, pretreaty past for Blackfoot people, and sensory engagements with them brought that past into the room. These historic object-persons were also clothing, an evocative "surface where collective norms, values and codes are deposited" (Seremetakis 1994: 133). As Darnell Rides at the Door, an educator and ceremonialist, said, "When I went and had the opportunity to see them at the museum, it was like holding a piece of my grandmother's teachings in my hands."

Within each session, initial observations about hide, stitching, dyes, quillwork, and decorative designs led to discussions about the people who made them, what they knew, and how they and their descendants had survived. If participants' embodied interactions with the shirts evoked social relationships with ancestors, these relationships were expressed as Blackfoot histories, either personal, family, or community—and these histories expressed an oppositional stance to mainstream society experiences of the past, thus affirming a distinct Blackfoot identity.

Historical relationships discussed ranged from the time of Morning Star and Mistaken Morning Star, ancestral beings whose images are quilled into one of the shirts' decorations, to recent family histories of participants. People invoked remembered ancestors painted by artists Karl Bodmer and George Catlin wearing similar shirts in the 1830s. Some mentioned ancestors who lived through events such as the Baker Massacre of 1870, while others recalled more recent kin, especially grandmothers who tanned hide in defiance of assimilation policies. That relationships between participants and ancestors were often mentioned is very much part of Blackfoot culture, in which history is often biographically narrated (Brown et al. 2006: 149–150). And, as Narcisse Blood, Kainai educator and ceremonialist, has said, "For us, relationship is our life— the relationship to the land, … to the cosmos, you know, the family relationship. Everything is about relationship" (quoted in Lokensgard 2010: 81).

Much of this discourse was about the shirts' function as material witnesses to Blackfoot experiences of history, which have been very different from dominant society narratives of the past.[9] In discussing why the project was important to Blackfoot people, Narcisse Blood said that "these shirts are about *our* history, written by us." Elders enjoyed explaining Blackfoot history to student groups. One high school teacher wore a replica shirt project staff had commissioned, and stood in front of the historic shirts telling students about the sacred history they embodied—and about the history of repatriation in the community, through which items had been brought home for ceremonial use. References to Blackfoot histories functioned as touchstones to evoke core values; as reminders of the strength of ancestors across difficult times; and as articulations of the oppositional nature of Blackfoot experiences of history (political and social marginalization) to mainstream narratives of progress—and thus of the oppositional nature of Blackfoot identity today. Blackfeet College student Debbie Gobert articulated this function of historical discourse when asked what she would do with the shirts:

> I would like to put them out on display for the world to see, not just the Blackfeet people. And I would want other people to know our history, that we just aren't here being drunks, that we did have meanings, and that our ways, as Blackfeet people, can actually be noticed, not just forgotten.

Debbie's response emphasizes the fact that many of the memories provoked by the presence of the shirts were difficult. Anger, grief, and frustration were as much a part of these narratives as admiration and reverence for ancestors. Articulating these emotions is part of the process of "being in touch … with people, things, events, and feelings that made you into the person you are" (Runia 2006: 5). Finding a place for emotion in narratives about the past is part of the healing process for indigenous peoples, whose experiences have been suppressed by mainstream narratives. Strong emotion also heightened the sense of opposition to mainstream narratives and strengthened the sense of a distinct Blackfoot identity in the present.

The Past in the Present

In 1992, Jonathan Hill wrote that in order to resist marginalization, "the first necessity of disempowered peoples, … is that of poetically constructing a shared understanding of the historical past" (Hill 1992: 811). Hill's comments resonate with Homi Bhabha's statement that history "is the necessary and sometimes hazardous bridge between colonialism and the question of cultural identity." Bhabha acknowledged that this process is sometimes "a painful re-membering, a putting together of the dismembered past to make sense of the trauma of the present" (cited in Gandhi 1998: 7). What Blackfoot people were doing with the shirts was re-membering: affirming shared understandings of the past, across the unevenness of knowledge within Blackfoot communities that colonialism has created. Diane Hafner noted similarly (2010: 269) that Lamalama Aboriginal people in an Australian research project, "read the objects discursively as a narrative about identity and history. They aim to make sense of the past and have it fulfil the needs of the present." Such uses of the past are universal, but have an especially powerful role within formerly colonized societies. Rosenzweig and Thelen's large-scale survey of American uses of the past (including Dakota Sioux respondents) found that people "interpreted and revised what experiences meant to them in order to create and pass on legacies of their own choosing" (1998: 39), actively using shared knowledge about the past to build community in the present.

Historic artifacts emerge in this context as technologies of collective memory and identity. Frank Weasel Head describes the shirts as codices of knowledge that can be unpacked to under-

stand identity: "These shirts are our curriculum; that's how we know who we are." With these meanings latent within museum objects, handling sessions can trigger "a resurgence of cultural pride and a reassessment of contemporary identity" (Hafner 2010: 272). For Blackfoot participants, this was not simply a sensory process, but a social one. It involved interaction with coparticipants and with ancestors: it involved the restoration of social relationships with the past, made present in the forms of the shirts after their long absence. The shirts/ancestors themselves became crucial links within social relationships among Blackfoot people, bringing them together, teaching them, strengthening identity: healing.

'Ceremonies of Renewal'

To understand the culturally specific perspectives that made the handling sessions efficacious, the Blackfoot concept of 'ceremonies of renewal' is useful. Cynthia Chambers and Narcisse Blood use this phrase (2009: 267) in the context of repatriating, or restoring, relationships with traditional Blackfoot lands:

> Repatriation, as an idea and a practice, acknowledges that like any reciprocal, interdependent relationship, the one between people and the places [or objects] which sustain them must be nurtured through unimpeded access, continued exchange of knowledge, and ceremonies of renewal such as visiting and exchanging of gifts and stories.

Within Blackfoot culture, such visits are occasions on which sacred knowledge—which underpins identity for traditionally oriented Blackfoot people—is transferred, and renewed, across generations. This process echoes Blackfoot ceremonial practices such as the ritual opening of sacred bundles, occasions on which knowledge and relationships are renewed between humans present in the ritual space and other-than-human beings associated with the bundles (Zedeño 2008; Lokensgard 2010). Blackfoot people who attend ceremonies are accustomed to using material items as mnemonics for collective history and identity, and as the focus for the renewal of relationships within Blackfoot society and between Blackfoot people and spiritual beings. Through such occasions of renewal, blessings are given to the people involved, including health, strength, and well-being. If things are understood in Blackfoot ontology as potentially animate, renewing relationships is the process by which they become so.

Across the project, this process of renewal was facilitated by visits with the shirts/ancestors: as Treena Tallow (Kainai) observed, "They're creating conversations just with their presence." These visits created shared experiences and triggered the transmission of knowledge, strengthening relationships among community members. This was seen very strongly within the Kainai community, where high school teachers initiated a project "to welcome our ancestors home," teaching students hide tanning and quillwork. At the same time, ceremonialists were considering how to revive a long-dormant ceremony to transfer the rights to own hairlock shirts. These projects raised many questions: about what was appropriate to teach students (quillwork is a sacred, initiated art), about how the ceremony should be conducted, about who had the knowledge necessary for such decisions. Ramona Big Head said that these dialogues

> became a kind of opening up of all these questions. The answers were already there and already within us. We just hadn't asked those questions yet. We hadn't had the voice to really articulate what we needed to know. … The way I see it, the knowledge was always there. But no one really opened that box, because we hadn't had the opportunity to think about it. And bringing the shirts here, all of a sudden these questions started coming up and we were being

led to people who knew what they were talking about.… And it's like we opened up a box of knowledge that we didn't realise we had.

These conversations link to Chambers and Blood's concept: they were "ceremonies of renewal such as visiting and exchanging of gifts and stories" (2009: 267).

Bringing the Past Into the Future: Implications for Blackfoot Communities

While discussions sparked by the visits with the shirts are still ongoing within Blackfoot communities, two sets of outcomes can already be seen. One involved high school and college students, and one involved ceremonial activity.

For many students, the effects of visiting with the shirts/ancestors were profound. One of the high school students who learned to do hide tanning and visited the shirts wrote that these projects affected his life "beyond any media influences. It was like a window into my original self. It showed me who I originated from. This program made me fill in that empty part of myself … These teachings are not outdated, they are skills that help my people be who they truly are."[10] Others began to think about heritage as a part of their futures. One college student changed his major, the day after his visit, to Blackfeet studies, and is now in a curatorial training program. Another, Alison Frank-Tailfeathers, reflected, "It was a life-changing event … We were here all of maybe an hour with them. And that made me want to further my education, and to research First Nations archives and maybe—you never know—I may someday be the head of a First Nations museum!"

The visit of the shirts sparked another set of outcomes when Kainai ceremonialists decided to revive a ceremony to transfer the rights to own hairlock shirts. This ceremony had become dormant as the result of assimilation pressures. They asked the project team if one of the historic shirts could be present in the ceremony so that the ancestors could act as a bridge from past to present to sanction this renewal. Conservator Heather Richardson folded one of the shirts into a laptop-sized bundle, and we took it into the museum boardroom for the ceremony. The shirt was passed reverently from the officiant to each of the men receiving the rights: there was a sense of awe that the ancestors themselves were present. It was a joyous occasion—something precious had been brought back, and that bringing back was a re-membering for those present. This was a kind of healing from the past, using the past to achieve it.

Although the shirts are now back in Oxford, they have a continued presence in Blackfoot communities. People use the project website, and Blackfoot teachers have contributed lesson plans to it; framed photographs of the shirts were given to college graduates; posters are up on classroom walls. Blackfoot people have made it clear that they have fulfilled their initial goals in respect to the project. They have also made it clear, through a formal request for another loan, that, as they said, "the work of the shirts is not finished in our communities."

Outcomes and Implications: Museums

If the 'work' of the shirts is healing, and if particular forms of presence of heritage objects provoke healing, then this project has serious implications for museums. One of these involves the obligation to provide culturally appropriate forms of access to heritage items, and the other involves the nature of relationships renewed between museums and indigenous communities through these projects.

While some North American museums have permitted use of historic objects in ceremonies, for UK museums, such approaches are radical. The decision to use a fragile, historic shirt in a ceremony was made by the director of the PRM, Michael O'Hanlon, in discussion with the museum's head of conservation, Heather Richardson, and the curator for the Americas collections, Laura Peers. The decision weighed the potential risk of transfer of ceremonial body paint onto the shirt during the ceremony against the potential positive effects of the ceremony on the Kainai community. The team decided to take every precaution to safeguard the shirt, but not to use the word 'damage' should paint transfer occur: such changes would be understood as part of the continuing biography of the shirt. In the end, no physical alterations occurred to the shirt in the ceremony.

If this was a ceremony of renewal for Blackfoot people, it has the potential to be so for museums as well. There was a powerful exchange of knowledge in this event about the potential meanings of objects and about how museums might conceive of objects. As Jean Davis said of the shirts, "They're artefacts in a museum, but when they come back into our community they are part of a family; someone's taking care of them, someone is treating them with a lot of love, respect." People commented that the project would not have had such powerful effects had we been looking at photographs of the shirts, or if the shirts had been in glass cases—which is how museums most frequently provide 'access' to collections. Davis responded to this issue by saying, "There's nothing better than actually having that person right beside you to hug them, instead of just looking at a picture." Museums need to acknowledge that some audiences require sensory and emotional engagements with objects. This needs to happen at the policy level and to be reflected in the very definition of museums.

The International Council of Museums (ICOM) (2007) definition says that museums "acquire, conserve, research, communicate and exhibit the tangible and intangible heritage of humanity and its environment for the purposes of education, study and enjoyment." The Declaration on the Importance and Value of Universal Museums (2004: 4) states that "[o]ver time, objects … have become part of … the heritage of the nations which house them." Neither statement acknowledges the implications of the lack of direct access to heritage items for indigenous peoples. As Classen and Howes (2006: 209) remind us, "Collecting is a form of conquest and collected artifacts are material signs of victory over their former owners." So is the nature of access to collected heritage items for indigenous groups. While Besterman's conclusion (2011: 240) that museums need to enter into debates about "trans-cultural accountability" is beginning to be reflected in literature on museum ethics (Marstine 2011; Janes and Conaty 2005), it is seldom discussed at the level of policy.

This project was a loan, after which the shirts were returned to Oxford. If making material heritage accessible is significant for healing within indigenous communities, and if this process depends on "unimpeded access" (Chambers and Blood 2009: 267), then one might see the project as a failure, and as proof that museums often pretend to engage in collaborations with source communities while retaining control over objects and power (Lynch and Alberti 2010). Perhaps we might assume that as so often happens, museum staff and indigenous participants developed only transient relationships across this project, and neither understood nor respected each other's goals (Tuhiwai Smith 1999: 28, 35).

This would, however, be imposing theory in a way that masks a more complex reality. Museums and indigenous people may choose to work with each other with eyes wide open, knowing that there are different goals involved on each side (are there 'sides'?), knowing the limitations of authority offered, and understanding the dynamics of power involved in such work. This is potentially the basis for a genuine relationship: realistic rather than idealistic, with a commit-

ment to achieving multiple goals for all participants, and understanding that not all goals will be achievable.

Blackfoot people engaged with this project in order to pursue their own goals, knowing that it involved a loan of the shirts. Their goals were not simply about having continued access to the shirts, but about renewing relationships—with heritage, within the community, and between the community and the various museums involved. This goal of renewing relationships, which is ultimately healing for indigenous people, has deep implications for museums.

Diane Hafner (2010: 257) writes of "relationships of materiality" between museums and source communities, based around mutual interests in objects. Blackfoot people have maintained a regular presence in the Pitt Rivers Museum now for a decade, and have taught many staff across museum departments, some of whom have now left to work at other institutions. They have profoundly influenced the museum's procedures in terms of care of collections and commitment to making collections accessible for indigenous communities. Every time museum staff work with the shirts, we reengage with what Blackfoot people have taught us about them, and we continue to consult with Blackfoot mentors: there are many forms of ongoing visits to maintain our relationships. Most importantly, we find that such moments of reconnection serve as a reminder that people within relationships have ongoing obligations to each other: this project did not discharge such responsibilities, but strengthened them. This is, indeed, a transformation, and renewal, of relationships, and likely to lead to other 'ceremonies of renewal' for indigenous peoples.

▪ **LAURA PEERS** is Curator (Americas), Pitt Rivers Museum and Reader in Material Anthropology, School of Anthropology and Museum Ethnography, University of Oxford

▪ NOTES

1. Laura Peers, curator (Americas), PRM; Heather Richardson, head of conservation, PRM; Alison Brown, Department of Anthropology, University of Aberdeen. There was also a project facilitation team that included staff at PRM, Glenbow, Galt, and mentors from all four Blackfoot nations. The author would like to thank everyone involved for making the Blackfoot Shirts Project possible, and also to thank anonymous readers who commented on earlier drafts of this article. Research underpinning this article was funded by the UK Arts and Humanities Research Council. Information about research materials related to this project may be obtained from the author at: laura.peers@prm.ox.ac.uk
2. I use 'Blackfoot' in this article as shorthand for 'Blackfoot and Blackfeet'. All unreferenced quotes are taken from interviews with handling session participants in 2010–2011.
3. I am grateful to Duane Mistaken Chief (personal communication, 2012), Red Crow Community College, for his linguistic and cultural explication of animacy in regard to the shirts.
4. Student to Jean Davis (Piikani), teacher, Piikani Nation High School.
5. On the psychopathology of Native American groups as the result of colonial processes, see Duran et al. (1998) and Whitbeck et al. (2004).
6. Conservation assessments in the planning phase concluded that the benefit to the shirts of protection from skin oil did not outweigh the benefit to Blackfoot people from ungloved touching. Few participants chose to wear gloves. Postworkshop assessments showed minor levels of wear on the shirts, but no obvious deposits from handling.
7. Similarly, Phillips (2003: 156) writes of the Museum of Anthropology at the University of British Columbia becoming a Northwest Coast longhouse during an opening ceremony.

8. See Classen and Howes (2006: 202): "By touching a collected object the hand of the visitor also encounters the traces of the hand of the object's creator."
9. See also Hafner's (2010: 269) experience with Australian Aboriginal people: "Such contexts [of 'reading' objects] include the sweep of their historical experience, forced removal."
10. I am grateful to Delia Cross Child for collecting responses from student participants.

▪ REFERENCES

Archibald, Robert. 1999. *A Place to Remember: Using History to Build Community.* Walnut Creek, CA: AltaMira.

Arigho, Bernie. 2008. "Getting a Handle on the Past: The Use of Objects in Reminiscence Work." Pp. 205–212 in *Touch in Museums: Policy and Practice in Object Handling,* ed. Helen Chatterjee. Oxford: Berg.

Besterman, Tristram. 2011. "Cultural Equity in the Sustainable Museum." Pp. 239–255 in *The Routledge Companion to Museum Ethics,* ed. Janet Marstine. London: Routledge.

Bille, Mikkel, Frida Hastrup, and Tim Flohr Sorensen, eds. 2010. *An Anthropology of Absence: Materializations of Transcendence and Loss.* New York: Springer.

Boast, Robin. 2011. "Neocolonial Collaboration: Museum as Contact Zone Revisited." *Museum Anthropology* 34 (1): 56–70.

Bolton, Lissant, Nicholas Thomas, Elizabeth Bonshek, Julie Adams, and Ben Burt, eds. Forthcoming. *Melanesia: Art and Encounter.* London: British Museum Press.

Brown, Alison Kay. 2000. "Object Encounters: Perspectives on Collecting Expeditions to Canada." DPhil. thesis, University of Oxford.

Brown, Alison Kay, Laura Peers, and members of the Kainai Nation. 2006. *Pictures Bring Us Messages/ Sinaakssiiksi aohtsimaahpihkookiyaawa: Photographs and Histories From the Kainai Nation.* Toronto: University of Toronto Press.

Butler, Beverley. 2011. "Heritage as Pharmakon and the Muses as Deconstruction: Problematizing Curative Museologies and Heritage Healing." Pp. 354–371 in *The Thing About Museums: Objects and Experience, Representation and Contestation,* eds. Sandra Dudley, Amy Jane Barnes, Jennifer Binnie, Julia Petrov, Jennifer Walklate. London: Routledge.

Candlin, Fiona. 2008. "Museums, Modernity and the Class Politics of Touching Objects." Pp. 9–20 in *Touch in Museums: Policy and Practice in Object Handling,* ed. Helen Chatterjee. Oxford: Berg.

Chambers, Cynthia, and Narcisse J. Blood. 2009. "Love They Neighbor: Repatriating Precarious Blackfoot Sites." *International Journal of Canadian Studies/Revue internationale d'études canadiennes* 39–40: 253–279.

Chandler, Michael, and Christopher Lalonde. 2008. "Cultural Continuity as a Moderator of Suicide Risk Among Canada's First Nations." Pp. 221–248 in *Healing Traditions: The Mental Health of Aboriginal Peoples in Canada,* ed. Laurence J. Kirmayer and Gail G. Valaskaskis. Vancouver: University of British Columbia Press.

Chatterjee, Helen, ed. 2008. *Touch in Museum: Policy and Practice in Object Handling.* Oxford: Berg.

Chatterjee, Helen, Sonjel Vreeland, Guy Noble. 2009. "Museopathy: Exploring the Healing Potential of Handling Museum Objects." *Museum and Society* 7: 164–177.

Classen, Constance. 2005. *The Book of Touch.* Oxford: Berg.

Classen, Constance, and David Howes. 2006. "The Museum as Sensescape: Western Sensibilities and Indigenous Artifacts." Pp.199–222 in *Sensible Objects: Colonialism, Museums and Material Culture,* eds. Elizabeth Edwards, Chris Gosden, Ruth Phillips. Oxford: Berg.

Clifford, James. 1997. "Museums as Contact Zones." Pp. 188–219 in *Routes: Travel and Translation in the Late 20th Century.* Cambridge, MA: Harvard University Press.

Connerton, Paul. 2011. *The Spirit of Mourning: History, Memory and the Body.* Cambridge: Cambridge University Press.

Conaty, Gerald. 2008. "The Effects of Repatriation on the Relationship Between the Glenbow Museum and the Blackfoot People." *Museum Management and Curatorship* 23 (3): 245–259.

Conaty, Gerald, and Clifford Crane Bear. 1998. "History, Connections, and Cultural Renewal." Pp. 63–74 in *Powerful Images: Portrayals of Native America,* ed. S. Boehme. Seattle: University of Washington Press.

Declaration on the Importance and Value of Universal Museums. 2004 (orig. 2002). Published in *ICOM News* 1: 4.

Dudley, Sandra. 2009. "Museum Materialities: Objects, Sense and Feeling." Pp. 1–17 in *Museum Materialities: Objects, Engagements, and Interpretations,* ed. S. Dudley. London: Routledge.

Duran, Eduardo, Bonnie Duran, Maria Yellow Horse Brave Heart, Susan Yellow Horse-Davis. 1998. "Healing the American Indian Soul Wound." Pp. 341–354 in *International Handbook of Multigenerational Legacies of Trauma,* ed. Yael Danieli. New York: Plenum Press.

Edwards, Elizabeth. 2006. "Photographs and the Sound of History." *Visual Anthropology Review* 21 (1–2): 27–46.

Edwards, Elizabeth. 2010. "Photographs and History: Emotion and Materiality." Pp. 21–38 in *Museum Materialities: Objects, Engagements, and Interpretations,* ed. Sandra Dudley. London: Routledge.

Edwards, Elizabeth, Chris Gosden, Ruth Phillips, eds. 2006. *Sensible Objects: Colonialism, Museums and Material Culture.* Oxford: Berg.

Fowles, Severin. 2010. "People without Things." Pp. 23–44 in *An Anthropology of Absence: Materializations of Transcendence and Loss,* eds. Mikkel Bille, Frida Hastrup, and Tim Flohr Sorensen. New York: Springer.

Gandhi, Leela. 1998. *Postcolonial Theory: A Critical Introduction.* St. Leonards, Australia: Allen & Unwin.

Hafner, Diane. 2010. "Viewing the Past through Ethnographic Collections: Indigenous People and the Materiality of Objects and Images." *Museum History Journal* 3: 257–280.

Hallam, Elizabeth, and Jenny Hockey. 2001. *Death, Memory and Material Culture.* Oxford: Berg.

Harris, Oliver, and Tim Flohr Sorensen. 2010. "Rethinking Emotion and Material Culture." *Archaeological Dialogues* 17 (2): 145–163.

Herle, Anita. 2003. "Objects, Agency and Museums: Continuing Dialogues Between the Torres Striat and Cambridge." Pp. 194–207 in *Museums and Source Communities: A Routledge Reader,* ed. Laura Peers and Alison Kay Brown. London: Routledge.

Hill, Jonathan. 1992. "Contested Pasts and the Practice of Anthropology." *American Anthropologist* 94: 809–815.

Howes, David. 2003. *Sensual Relations: Engaging the Senses in Culture and Social Theory.* Ann Arbor: University of Michigan Press.

ICOM (International Council of Museums), 2007. 'Museum definition.' http://icom.museum/who-we-are/the-vision/museum-definition.html (accessed 29 October 2012).

Janes, Robert, and Gerald Conaty, eds. 2005. *Looking Reality in the Eye: Museums and Social Responsibility.* Calgary: University of Calgary Press.

Knowles, Chantal. 2008. "Object Journeys: Outreach Work Between National Museums Scotland and the Tlicho." Pp. 37–56 in *Material Histories: Proceedings of a Workshop Held At Marischal Museum, University of Aberdeen, 26–27 April 2007,* ed. A. Brown. Aberdeen, Scotland: Marischal Museum, University of Aberdeen.

Krmpotich, Cara, and Laura Peers, eds. Forthcoming. *"This is Our Life": Haida People, Collections and International Museums.* Vancouver: University of British Columbia Press.

Lincoln, Amber, with John Goodwin, Pearl Goodwin, Faye Ongtowasruk, Ron Senungetuk, Barbara Weyiouanna. 2010. *Living with Old Things: Inupiaq Stories, Bering Strait Histories.* National Parks Service. http://www.nps.gov/akso/beringia/beringia/library/Living-with-old-things.pdf (accessed 29 October 2012).

Lokensgard, Kenneth H. 2010. *Blackfoot Religion and the Consequences of Cultural Commoditization.* Burlington, VT: Ashgate.

Lyons, Claire. 2002. "Objects and Identities: Claiming and Reclaiming the Past." Pp. 116–140 in *Claiming the Stones/Naming the Bones: Cultural Property and the Negotiation of National and Ethnic Identity,* ed. Elazar Barkan and Ronald Bush. Los Angeles: Getty Research Institute.

Lynch, Bernadette. 2011. "Collaboration, Contestation, and Creative Conflict: On the Efficacy of Museum/Community Partnerships." Pp. 146–163 in *The Routledge Companion to Museum Ethics,* ed. Janet Marstine. London: Routledge.

Lynch, Bernadette, and Samuel Alberti. 2010. "Legacies of Prejudice: Racism, Co-production and Radical Trust in the Museum." *Museum Management and Curatorship* 25 (1): 13–35.

Marstine, Janet, ed. 2011. *The Routledge Companion to Museum Ethics.* London: Routledge.

Miller, Daniel, and Fiona Parrott. 2009. "Loss and Material Culture in South London." *Journal of the Royal Anthropological Institute* 15: 502–519.

Parkin, David. 1999. "Mementoes as Transitional Objects in Human Displacement." *Journal of Material Culture* 4: 303–320.

Peers, Laura, and Alison Brown, eds. 2003. *Museums and Source Communities: A Routledge Reader.* London: Routledge.

Pettipas, Katherine. 1994. *Severing the Ties that Bind: Government Repression of Indigenous Religious Ceremonies on the Prairies.* Winnipeg: University of Manitoba Press.

Phillips, Ruth. 2002. "A Proper Place for Art or the Proper Arts of Place? Native North American Objects and the Hierarchies of Art, Craft and Souvenir." Pp. 45–72 in *On Aboriginal Representation in the Gallery,* ed. Lynda Jessup and Shannon Bagg. Hull: Canadian Museum of Civilization.

Phillips, Ruth. 2003. "Community Collaboration in Exhibitions: Toward a Dialogic Paradigm." Pp. 155–170 in *Museums and Source Communities: A Routledge Reader,* ed. Laura Peers and Alison K. Brown. London: Routledge.

Rosenzweig, Roy, and David Thelen. 1998. *The Presence of the Past: Popular Uses of History in American Life.* New York: Columbia University Press.

Royal Commission on Aboriginal Peoples. n.d. http://www.aadnc-aandc.gc.ca/eng/1100100014597#chp3 (accessed 29 October 2012).

Runia, Eelco. 2006. "Presence." *History and Theory* 45 (1): 1–29.

Sandell, Richard. 2007. *Museums, Prejudice and the Reframing of Difference.* London: Routledge.

Saunderson, Helen. 2011. "'Do Not Touch': A Discussion on the Problems of a Limited Sensory Experience with Objects in a Gallery or Museum Context." Pp. 159–170 in *The Thing about Museums: Objects and Experience, Representation and Contestation,* ed. Sandra Dudley, Amy Jane Barnes, Jennifer Binnie, Julia Petrov, Jennifer Walklate. London: Routledge.

Sennett, Richard. 2008. *The Craftsman.* London: Allen Lane.

Seremetakis, Nadia, ed. 1994. *The Senses Still: Perception and Memory as Material Culture in Modernity.* Boulder, CO: Westview Press.

Stewart, Susan. 1999. "Prologue: From the Museum of Touch." Pp. 17–36 in *Material Memories: Design and Evocation,* ed. Marius Kwint, Christopher Breward, Jeremy Aynsley. Oxford: Berg.

Tarlow, Sarah. 2012. "The Archaeology of Emotion and Affect." *Annual Review of Anthropology* 41: 169–185.

Tuhiwai Smith, L. 1999. *Decolonising Methodologies: Research and Indigenous Peoples.* London: Zed Books.

Waldram, James, ed. 2008. *Aboriginal Healing in Canada: Studies in Therapeutic Meaning and Practice.* Ottawa: Aboriginal Healing Foundation.

Whitbeck, Les, Gary W. Adams, Dan R. Hoyt, Xiojin Chen. 2004. "Conceptualizing and Measuring Historical Trauma among American Indian People." *American Journal of Community Psychology* 33: 119–130.

Zedeño, María. 2008. "Bundled Worlds: The Roles and Interactions of Complex Objects from the North American Plains." *Journal of Archaeological Method and Theory* 15: 362–378.

Cultural Collisions in Socially Engaged Artistic Practice

'Temple Swapping' and Hybridity in the Work of Theaster Gates

Janet Marstine

ABSTRACT: In this article I explore how socially engaged artistic practice draws upon hybridity as a methodological approach advancing social justice. Through the case study of Theaster Gates's *To Speculate Darkly* (2010), a project commissioned by the Chipstone Foundation of Milwaukee, Wisconsin, and shown at the Milwaukee Art Museum, I consider how socially engaged practice mobilizes continually shifting notions of postcolonial hybridity to help museums make meaningful symbolic reparations toward equality and inclusivity. The research is based on interviews I conducted with Gates and with the director and the curator of the Chipstone Foundation. The article will demonstrate that, with hybridity, artists have the potential to subvert hegemonic power structures and to inspire reconciliations between museums and communities. While such reconciliations generally involve complex processes with no clear end point, the evolving concept of hybridity is an effective vehicle to foster pluralistic institutions, cultural organizations characterized by practices built upon shared authority, reciprocity, and mutual trust. Theaster Gates refers to the methodology of hybridity as 'temple swapping', an exchange of values between seemingly unlike groups, in his case the black church and the museum, to explore their interconnections and relational sensibilities. Temple swapping, I aim to show, is a valuable metaphor through which to examine socially engaged artistic practice and its implications for museum ethics.

KEYWORDS: Chipstone Foundation, hybridity, Milwaukee Art Museum, reconciliation, social justice, socially engaged practice, Theaster Gates

Socially Engaged Artistic Practice as Reconciliation

Over the last two decades, socially engaged practice, also known as social practice, has emerged as an artistic strategy based on Nicholas Bourriaud's notion of relational aesthetics (Bourriaud 1998; Jackson 2011; Kestner 2011; Thompson 2012). Shaped by institutional critique but moving beyond the four walls of the museum to critique a broad range of political and cultural institutions, socially engaged practice offers up provocations that help us construct new, more socially just relationships. Social practice involves critical inquiry about the performing of social roles. Chris Mowles explains:

Museum Worlds: Advances in Research 1 (2013): 153–178 © Berghahn Books
doi:10.3167/armw.2013.010110

[W]e are born into a world where there is already a play going on. The play arises out of a history of social interaction and creates ways of speaking and acting which condition the way that new actors can speak and act. The way we express ourselves, indeed the very way we think about ourselves, is entirely shaped by the play that we join and the actions and speech of others. (2008)

Social practice interrupts the play to which Mowles refers and helps us to establish new relations with others based on equality; it breaks down the boundaries between museums and other institutions to imagine a more socially engaged future. Social practice encourages us to write, enact, interrogate, and revise new scripts about institutions and society, scripts that promote substantive discourse and mutual understanding. Social practice is a performative process with the potential to help museums shed elitist, proprietary modes of thinking and to inspire reconciliations between museums and communities.

The work of Chicago-based rising star Theaster Gates exemplifies art as socially engaged practice. Winner of the 2012 inaugural Vera List prize, awarded to artists who promote social justice, and currently inaugural director of arts and public life at the University of Chicago, Gates produces multimedia art that generates interest and resources toward urban regeneration. In *Chalkboard I* and *Chalkboard II* (figure 1) (2012), for instance, part of his three-day performance *SEE, SIT, SUP, SIP, SING: Holding Court* at the 2012 New York Armory Show, he collaborated with the diverse and constantly shifting crowd gathered around him; together they mapped and compared the complex, ethically fraught networks of competing economic, political, social, and artistic relationships that undergird both international art fairs and urban renewal projects. On the large wood-framed chalkboards salvaged from the now demolished Crispus Attucks Elementary School building on the south side of Chicago, Gates and his audience of curators, collectors, and various publics diagrammed the convergences that might leverage the resources of an art fair to address the problems of urban decay (Chen 2012). Like Joseph Beuys before him (Holland 2007), Gates used chalkboards to suggest a mode of drawing as discourse and a curricular model that transgresses boundaries to communicate and critique systems of power. During the conversation, Gates sat at a table he constructed from children's desks also salvaged from the Crispus Attucks Elementary School and etched with layer upon layer of children's handwriting (Russeth 2012; Jovanovic 2012).

Figure 1. Theaster Gates, Chalkboards from *Holding Court*, 2012. Armory Show performance. Courtesy of Kavi Gupta, CHICAGO | BERLIN

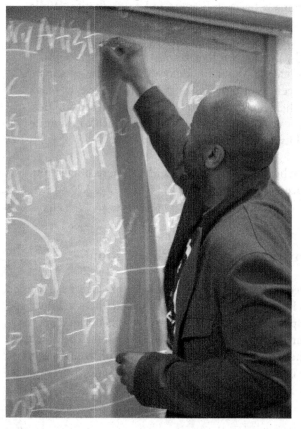

Gates adapts hybridity as a postcolonial construct to inform *Chalkboard I* and *Chalkboard II*. His performance at the Armory Show orchestrates a cultural collision between art world insiders, participants without those connections, generations of economically deprived African American schoolchildren, and the specter of Crispus Attucks, an American Revolutionary War hero of mixed-race descent and the first person killed by British soldiers during the 1770 Boston Massacre. Appropriating the revolutionary posture of Attucks, Gates refused to sell any of his works on display (the large chalkboards were priced at $40,000 each) unless the potential buyer took part in the performative process. According to Gates, this social engagement is what defines each piece and, without it, the work is not complete (Jovanovic 2012).

Mapping the web of relationships that define Gates's practice and the art world practices of buying and selling is Gates's means to analyze and reimagine those roles within the context of hybridity. It interrupts the play that Mowles describes and helps us to create new, more socially just scripts that acknowledge hybridity as a constantly evolving postmodern condition acknowledging multiple subject positions. The collaborative nature of *Chalkboard I* and *Chalkboard II*, bringing together stakeholders who are traditionally visible in art world systems with those who are too often disenfranchised, provides a mode of reconciliation between them. Gates explains in his characteristically nuanced but theoretically savvy language laced with gestures of hospitality, "I want to make space for my friends and ensure that some new friends meet old ones" (Gates 2012a).

As defined by political scientists Bashir and Kymlicka (2008), reconciliation is a framework for redressing the claims of groups historically oppressed by an environment of exclusion and for forging new pluralistic institutions characterized by shared authority and equality of opportunity to participate. I appropriate this concept of reconciliation to understand how social practice can redress exclusions and inequalities inside the museum and out. I use the term reconciliation not to suggest a facile and fixed moment of rapprochement but instead a process-driven negotiation informed by the critical sensibilities of antagonism. While it has long been acknowledged that museums are places people trust in their search for insight (Marstine 2005), it has also been demonstrated that substantive gains in co-creation, reciprocity, and shared ownership are hard won (Lynch 2011). As the work of Theaster Gates demonstrates, socially engaged artistic practice has the capacity to contribute to the development of a more participatory and just museum and society.

Hybridity as a Methodology Toward Reconciliation

In 2012, as Defne Ayas assumed the director's position at Witte de With Center for Contemporary Art in Rotterdam, she asked A. A. Bronson to compose and deliver a queer private blessing for her to mark the transition and provide direction for the future. In a secret place near the rose garden of the Vondelpark, Amsterdam, at midnight on 14 March 2012, Bronson and fellow artist Sands Murray-Wassink sat naked and cross-legged while Bronson used tarot cards and spiritually infused accoutrements to predict a course for Witte de With to prosper in the coming years.

The lone surviving member of the collaborative General Idea, who lived and made art together for twenty-five years, Bronson has worked independently as an artist, curator, publisher, and healer since his partners Felix Partz and Jorge Zontal died of AIDS in 1994. For director Ayas, the blessing was a means to induct both queer and spiritual ways of thinking into Witte de With (Ayas 2012). Within the context of Rotterdam, with its busy port, large immigrant population, and challenges of high levels of illiteracy, Bronson's blessing can be seen as a divination marking

the commencement of a social justice agenda—an organizational commitment to equality and inclusivity (Sandell and Nightingale 2012)—facilitating reconciliation between Witte de With and its diverse communities. Bronson's blessing signaled to Ayas a freedom from heteronormative and other binary structures that oppress, an openness to subversive methods directed to breach those oppressive structures and a commitment to serving diverse faith groups too often disenfranchised from museums (Reeve 2012). This move toward reconciliation is founded on an understanding of the hybridity of identity: first, that the labels we acquire—homosexual; believer; museum professional; artist; community member—are fluid, not fixed, and often collide; and second, as the case study in this article will reveal, that negotiating the hybridity of identity is at the core of redressing power relationships, both inside and outside the museum.

As a term connoting 'of mixed origin', hybridity is a contested concept. The colonial-era use of the word to castigate individuals of mixed racial heritage and to promote eugenics as a means to racial purity has made some scholars wary of its reappropriation (Werbner and Modood 1997). However, as Homi Bhabha has argued (Bhabha 1994a, 1994b, 1996), in postcolonial discourse hybridity can create a third space that problematizes boundaries and allows for multiple subject positions. He asserts that "[t]he partial, minority culture emphasizes the internal differentiations, the 'foreign bodies', in the midst of the nation—the interstices of its uneven and unequal development, which gives lie to its self-containedness" (Bhabha 1996: 57). These interstitial—or in-between spaces—have the agency to disrupt hegemonic power structures and to enable new, more socially just positions to emerge.

In social justice discourse, hybridity is but one way of engaging equality issues. Richard Sandell has acknowledged the importance of other diversity strategies, including the compensatory, the celebratory, and the pluralistic, to accommodate difference (Sandell 2005: 189–194). Hybridity, however, remains problematic for some.

In *We Have Never Been Modern* (1993), for instance, Bruno Latour declares that hybridity maintains prior differences as markers of difference within a new hybrid entity, thus perpetuating notions of us and them and the power differentials implicit in this polarity. Latour argues for a symmetry that critiques what he sees as the asymmetries embedded in hybridity. He states:

> The principle of symmetry aims not only at establishing equality—which is only the way to set the scale at zero—but at registering difference—that is, in the final analysis asymmetries—and at understanding the practical means that allow some collectives to dominate others. (Latour 1993: 107–108)

But, as Mark Elam notes, Latour's argument is problematic in that he situates himself outside the hybrid and thus does not examine his own embeddedness within it (Elam 1999: 14).

Ien Ang holds that hybridity is not a means to erase difference; it is a key component of engaging the politics of difference. Ang states:

> Hybridity is not the solution, but alerts us to the difficulty of living with differences, their ultimately irreducible resistance to complete dissolution. In other words, hybridity is a heuristic device for analysing complex entanglement. (Ang 2003: 149–150)

As a matter of social urgency and ethical responsibility, reappraising and renegotiating hybridity is an apt subject for the complex and ongoing work of reconciliation in museums. The work of Theaster Gates offers an opportunity to reappraise the notion of postmodern hybridity from a museological context.

As sociologist Jan Nederveen Pieterse explains, hybridity is not only a reflection of current realities and future aspirations, it is a powerful methodological approach from which to develop

social justice initiatives (Pieterse 2001: 238). The relational aspects of hybridity promote new modes of self-actualization based on the realities of contemporary life, rather than essentialist notions of identity, and new forms of resistance to inequalities. Acknowledging hybridity is thus a way for museums and galleries to assert individuals' cultural rights, "the right freely to participate in the cultural life of the community," as the 1946 United Nations Universal Declaration of Human Rights states and which David Anderson cites to argue for an ethically based understanding of social engagement (Anderson 2012).

Hybridity is, in fact, a key theme of efforts to facilitate reconciliation in conflict resolution. Grappling with one's complex interrelationships with others is central to forging healthy group dynamics. Theologian Nico Koopman reflects upon his experiences of the reconciliation process in South Africa:

> Through the participation in each others' lives it becomes increasingly difficult to talk about yourself as merely Coloured or South African. Participation in the lives of my black, white and Indian brothers . . . now co-defines me. I am still a Coloured but I am also more than that. I am still South African but at the same time I am more than that. . . . This 'something more' applies to all the others that I might mingle, commune, share with and with whom I live in a relationship of interdependency . . . And where this proximity and mingling, sharing and solidarity grow, there a life of reparative and healing forgiveness also takes shape. (Koopman n.d.)

As Koopman poignantly makes clear, taking stock of hybridity is a powerful reparative mechanism to creating new and more productive relationships, even among groups with a long history of imposed estrangement and segregation.

This article explores how socially engaged artistic practice draws upon the continually evolving and, I argue, still useful concept of hybridity as a methodological approach toward social justice. The article is museological in thrust, rather than art historical, as a means to address museum theory and practice. Through Gates's 2010 project *To Speculate Darkly*, commissioned by the Chipstone Foundation of Milwaukee, Wisconsin, and exhibited at the Milwaukee Art Museum, I will show how artists leverage hybridity to help museums make meaningful symbolic reparations toward equality and inclusivity. The research is based on interviews I conducted with Gates and with the director and the curator of the Chipstone Foundation. The article will demonstrate that, with hybridity, artists have the potential to subvert hegemonic power structures and to inspire what Bashir and Kymlicka call transformative justice, justice that "seeks to create a new 'we', which requires opening up new possibilities that did not exist before" (Bashir and Kymlicka 2008: 19). While such reconciliations generally involve complex processes with no clear end point, hybridity is an effective vehicle to foster pluralistic institutions, cultural organizations characterized by practices built upon shared authority, reciprocity, and mutual trust. Sometimes hybridity is a conscious strategy thoughtfully articulated in advance on the part of the commissioning institution; more often it is an inchoate agenda that evolves with the provocations of the artist as third party to the museum and its publics. But in either case, museum interventions that engage hybridity have the capacity to spark the kind of critical, self-reflective thinking essential to organizational change toward equality and social justice. Theaster Gates refers to the methodology of hybridity as 'temple swapping', a phrase he coined to signify an exchange of values between seemingly unlike groups, in his case the black church and the museum, to explore their interconnections—their relational sensibilities—and, in so doing, to create a new and powerful force for good. And as Gates exclaims, "When the museum and the temple conflate—oh boy, is that sexy" (Gates 2010).

Hybridity, Art History, and Museums

In art history scholarship overdeterminism of race is a common problem. For instance, as Darby English argues (2007), the art historical treatment of works by African American artists is commonly reductive and transparent, masking the hybrid nature of identity and preventing a complex reading of objects in relation to social, cultural, and economic factors. English characterizes this problematic treatment of African American art:

> It is almost uniformly generalized, endlessly summoned to prove its representativeness (or defend its lack of same) and contracted to show-and-tell on behalf of an abstract and unchanging 'culture of origin'. For all this, the art gains little purchase on the larger social, historical, and aesthetic formations to which it nevertheless directs itself with increasing urgency. (English 2007: 7)

English likens this essentialist approach to a system of apartheid. He holds that

> the rhetorical operations of black representational space separate from works of art elements of their informing contexts that reflect interest in issues other than race. This is how black representational space functions as a kind of tactical segregation. Probably 'segregation' has remained, until now, off our list of progressive talking points because its most ardent supporters have no reason to believe that they traffic in the kind of segregation one hollers about. Indeed for many that kind of segregation, exemplified in our time by apartheid ... enjoys a special status as that against which black representational space, for instance, provides a defense. Yet the same principle obtains whenever there exist regulatory procedures to aver something as self-sufficient, separate, intact, independent, identical to itself, in essence uncontaminated by any relation to alterity. (English 2007: 11)

English clearly implicates museums, as well as art history, in the problems of tactical segregation.

In fact, addressing postcolonial hybridity is a significant museological challenge. Simona Bodo argues that "there is a pressing need for strategies and programmes aimed at creating 'third spaces' where individuals are permitted to cross the boundaries of belonging and are offered genuine opportunities for self-representation" (Bodo 2012: 184). But, she reports, though many museums may espouse a rhetoric of defining identity through hybridity, in reality, few have managed to reframe diversity and equality issues in any substantive way in relation to fluid identity (Bodo 2012: 183).

Theaster Gates found that museums lacked such 'third spaces' as he undertook a search for artistic traditions that were meaningful to his own hybrid identity. Trained as a ceramicist, Gates came up empty in his pursuit of African and African American potters assigned both a name and a date in museum and gallery displays. He recognized the power of canonical systems in art museums that determined East Asia, ancient Greece, and contemporary California as sites of significant ceramics production (Gates 2010). These canonical systems shut out examples that did not sit within the imposed hierarchy. Gates became painfully aware that the notion of hybrid identity—specifically, that an African American could be an accomplished ceramicist—is anathema to museum systems of canonicity.

Dewdney, Dibosa, and Walsh (2012) argue that pluralism cannot be achieved in museums without engaging hybridity. In their research on diversity at Tate Britain, they recount how

> cultural diversity was rendered across the networks as a problem to be solved. Such problematisation involved an interpretation of diversity as being characterised through visual markers of racialised difference ... In this way the real work of difference becomes obscured. Differentiating between the concept of difference and racialised categorisation opens up the potential

for recognising models of power and the institutionally normalised practice which support them and thus creates the space for revision and innovation. (Dewdney et al. 2012: 121)

Hybridity, Dewdney, Dibosa, and Walsh suggest, is a radical, counterhegemonic method to re-imagine the museum through the lens of social justice and to create organizational change that manifests this vision.

Underpinning the museological concept of hybridity as a counterhegemonic method is the notion that museums have the right and responsibility to redress inequalities and advance social justice in museums and in society; museums have social impact beyond the institution itself (Nightingale and Sandell 2012: 3). Richard Sandell makes a persuasive argument that this moral agency of museums, as evidenced by a growing body of research, supports the case for activist positions (Sandell 2011: 143). As Sandell explains, activism within the museum context is an organizational commitment not to passively perpetuate hegemonic moralities, but instead to consciously combat prejudice through respectful and complex understandings of difference in representation and through fostering equality of opportunity to participate in museum experiences. Sandell asserts that "socially purposeful museums very often seek to engender support for the human rights of different communities whose lived experience of disadvantage and marginalization have often been reflected in their exclusion from, or misrepresentation, within existing museum narratives" (Sandell 2011: 131).

To be the compassionate and equitable institutions that new museum ethics imagines, institutions must be willing to accept the responsibility of activism; assuming an activist approach does not imply that the resulting agenda is reductive. Instead, activism opens up debate in the museum around social justice issues, offering opportunities for museum professionals and audiences to reexamine their own and societal assumptions as well as alternative views. Museum activism presumes that such efforts will have an impact outside the museum—that they will contribute to a more just society (Marstine 2011: 13–14). This understanding of activism is anchored in Jacques Rancière's notion of dissensus as a disruption not only of power relationships but also of the assumptions that undergird them; dissensus, Rancière holds, has the capacity to address inequalities in a way that consensus never can (Rancière 2001). Social practice artists such as Theaster Gates play a vital role in advancing activist social justice agendas, grounded in dissensus, within museums and galleries.

Hybridity and Hospitality: Theaster Gates's *To Speculate Darkly*

Hybridity Through Hospitality

Theaster Gates embeds a culture of hospitality through his projects, hospitality based on notions of hybridity as a relational methodology with the potential to foster reconciliation. This notion of hospitality has radical foundations informed by the theories of Jacques Derrida, Emmanuel Levinas, and contemporary commentators. In his *Of Hospitality* (2000), Derrida deconstructs conventional assumptions about hospitality through an ethical perspective on French colonial attitudes toward immigration; Derrida problematizes the self/other power dynamic embedded in the gesture of welcoming the 'stranger' while also opening up the conceptual possibility that unconditional hospitality—encounters between self and other in which the host accepts the 'other' on their own terms—can be imagined (Derrida 2000; O'Gorman 2006).

Dikeç et al. (2009) have extended Derrida's concept of unconditional hospitality to argue for the possibility of encounters that create new hybrid identities. They look for direction to Levinas. They assert:

What Levinas reclaims and makes central … is the very receptiveness of one person to an Other, that capacity an embodied self has to take its inspiration from what it perceives as the needs of an other self, an other body. His hospitality, we might say, proceeds from that *vertiginous moment* when one feels *bound to the other*—the moment that makes possible the ever risky tipping together of unfamiliar lives. (Dikeç et al. 2009: 6)

This reaching for unconditional hospitality has particular appeal for some institutions and artists attempting to create reconciliations with and among communities.

For instance, at the Smart Museum of Art, University of Chicago, the 2012 exhibition *Feast: Radical Hospitality in Contemporary Art* has become an impetus for introducing organizational change toward a theoretically informed and self-reflective position of hospitality (S. Smith forthcoming). The project is not just a survey of contemporary art that engages issues of food and the rituals around it, although participatory elements of the works and associated events have created an environment where community engagement thrives. It has also become a vehicle for staff to rethink their own and institutional responsibilities toward visitors as guests—thus the 'radical' adjective in the exhibition title. Staff members from all departments take turns, for instance, offering *slatko,* a Serbian jam and gesture of welcome, to visitors walking in the door in Ana Prvacki's piece *The Greeting Committee* (2011–ongoing) (figure 2). Staff and their families make the *slatko* themselves from the artist's mother's recipe (Smart Museum of Art 2012). The

Figure 2. Ana Prvacki performing *Greeting Committee* at the Smart Museum of Art for the opening of *Feast: Radical Hospitality in Contemporary Art,* 15 February 2012. Commissioned by the Smart Museum of Art for *Feast: Radical Hospitality in Contemporary Art.* Photo by: Jeremy Lawson

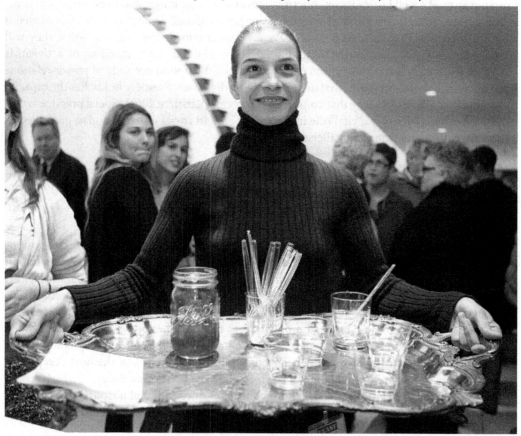

idea is that performing hospitality for the project instills new ethical understandings of hospitality as it shapes all museum activity. Chief curator Stephanie Smith explains:

> We have been thinking hard about what it means to be hospitable as an institution. We have recognised that we haven't done as well as we could so we have made hospitality an institutional priority. One of the things that the show has really helped catalyse is a wider embrace of the idea of hospitality and the set of actions that would support it on the part of a very wide range of staff. The exhibition has shifted us out of normal patterns of behaviour which we want to extend beyond mere gesture. The show has helped solidify our sense of self as an institution. (S. Smith 2012)

Key to this process is critiquing the conditional hospitality that art museums, which typically see themselves as global entities, often grant to the local and forging new hybrid relationships built on unconditional hospitality. Stephanie Smith notes of *Feast* programming:

> It's been really important that all of these projects have included aspects of the local in terms of supporting really interesting practices that are happening here in Chicago. We're thinking about knowledge exchange in and out of the museum and what it means to be a good neighbor. We're thinking about how to embrace and provide resources for a wider group of creative people who haven't necessarily been given the same advantages. (S. Smith 2012)

Thinking locally through hospitality is a key strategy of the Smart's social justice agenda toward equality and diversity.

A featured artist of *Feast,* Theaster Gates was a pivotal figure for Smith in understanding what it means to be a good neighbor. A musician and urban planner, as well as a ceramicist and installation artist, he calls himself a "cultural producer" to encapsulate these hybrid talents; Gates is well-known for performing acts of hospitality as a form of socially engaged practice.

Beginning in 2006, after years of working as a planning bureaucrat, including a stint at the Chicago Transit Authority under Valerie Jarrett, now a senior advisor to President Barack Obama, Gates bought up derelict housing in Dorchester, a deprived area in the south side of Chicago, not far from the University of Chicago. There he has created a home, studio, artist-in-residence accommodations, music venue, movie theater, and archives with material gathered from shuttered stores and the old art history glass lantern slide collection from the University of Chicago. What is now known as the Dorchester Project (figure 3), an institution in itself, employs a neighborhood crew as its workforce. Gates exclaims, "It's about knowing your neighbors and using whatever cultural capital you have to make the things around you better" (quoted in Wolff 2010: 22). Gates recycles raw materials from the building sites into art, which he then sells, reinvesting the proceeds back into Dorchester. The Dorchester Project has been so successful that it has spawned similar projects in other failing Midwestern cities. Its success is built upon a model of hospitality that holds profound implications for museums.

Gates's Dorchester Project has become a meeting ground for diverse groups to discuss issues of urgency over soul food suppers. These suppers, or what Gates calls "plate convergences" (Viveros-Faune 2012: 71), are a means not only to exchange ideas but, in the process, to actively perpetuate the formation of hybrid identities through gestures of hospitality. Gates explains, "That invitation to eat allows for people to cross racial lines and geographic lines that they normally don't cross. And I'm excited about that. There is room and reason to traverse" (quoted in Huang 2009).

Gates's approach rejects the power imbalance between host and guest in conditional hospitality, moving instead toward an unconditional or 'radical' hospitality that binds parties together (Gates 2012d). Francesca Wilmott comments:

Figure 3. Theaster Gates in front of Dorchester Projects, Chicago, 2012. Photo by: Sara Pooley

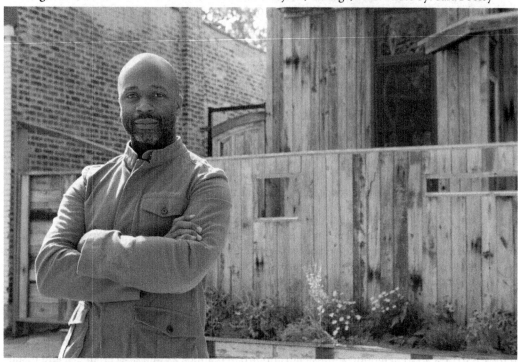

> All too often, community engagement produces an imbalanced relationship and an artist or an institution sees itself as aiding a deprived community. However, Gates freshly appraises the idea of community engagement, elevating it beyond victimization and making it part of a two-way relationship. (Wilmott 2011)

For the exhibition of *Feast,* Gates constructed *Soul Food Starter Kit* (2012), a wooden cabinet that he filled with Japanese-style ceramics he produced in collaboration with three Japanese potters. Describing this as a "mash-up" or cultural collision of ideas, Gates remarks that *Soul Food Starter Kit* allows people to explore "acts of generosity and the history of that generosity via food" (Gates 2012e). For the programming of *Feast,* Gates brought groups of twenty museum visitors, chosen by lottery, to his home for one of four dinners with selected artists and activists from his grassroots community network (figure 4). Difficult but important conversations about urban failings and the possibilities for urban rejuvenation were facilitated by the rituals of eating and by the Black Monks of Mississippi, Gates's innovative musical ensemble fusing jazz, gospel, and Buddhist chanting (Gates 2012d). For Gates, hybridity proffered through radical hospitality brings greater and deeper hybridity or a boundedness among individuals and groups.

To Speculate Darkly: Theaster Gates and Dave the Potter, commissioned by the Chipstone Foundation of Milwaukee, Wisconsin, demonstrates the potential for transformative justice that Gates's radical hospitality offers. By orchestrating a 'mash-up' or cultural collision of race and class in the Milwaukee Art Museum and its environs, *To Speculate Darkly* offers a glimpse of what unconditional hospitality might look like as a condition of hybridity or boundedness of one party to another. *To Speculate Darkly* is a complex performance of reconciliation that helped a museum and its long disenfranchised communities come together in a significant and impactful way. It was Gates's first major museum project. It shows how Gates adapts elements from institutional critique to create socially engaged practice toward reconciliation.

Figure 4. Theaster Gates, *The Art of Soul* dinner, Dorchester Project, 11 March 2012. Commissioned by the Smart Museum of Art for *Feast: Radical Hospitality in Contemporary Art.* Photo by: Sara Pooley

He understood that his work as an urban planner would help him to critique the institutional systems of museums. Gates explains:

> I was trained as a bureaucrat. After studying urban planning I actually worked for a city administration. The gift of that is that you understand that things are built in systems and structures, and the better you understand the system and structure the better you can manipulate the system and structure. (Gates 2012c)

Gates notes that he has learned many lessons from artist Fred Wilson's interventions (Gates 2012c). Emblematic of his connection to Wilson is the window at the Dorchester Project, salvaged from a museum and which reads backward "Museum Hours 9 to 5" (Cromidas 2011). Moreover, through juxtapositions and through negotiating the tensions between fact and fiction, Gates's explorations of hybrid identity build upon the precedents of Wilson's installations, such as *An Invisible Life: A View into the World of a 120-Year Old Man* (Capp Street Project, 1993), which evokes the persona of fictional gay mixed-race Baldwin Antinous Stein (Marstine forthcoming). Yet Gates's interest in looking beyond the frame of the museum to its dynamic with other kinds of institutions and his socially engaged, performative mode of creating reconciliations indicate that he is very much ensconced in social practice.

Gates says his approach to reconciliation is shaped by his experiences as a graduate student in South Africa, where he witnessed the restorative justice process led by the Truth and Reconciliation Commission:

> The best part of the reconciliation project had to do with listening. What I think felt transformative was that a person could be asked a question, answer the question, and people sit there listening, shocked, humiliated, horrified. When one listens to truth, boy it don't always sound good. (Gates 2012c)

While in Cape Town and Johannesburg, Gates absorbed the processes of cosmopolitanism taking shape that acknowledged cultural hybridity. In his projects for museums, Gates thinks of himself as a "curator of new institutional engagements" (quoted in Warner 2009) based on cultural hybridity.

The institutional engagement Gates curated for Chipstone began with an estrangement. The Chipstone Foundation, established in 1965 by Stanley and Polly Stone, boasts among the top collections of early American decorative arts. Pieces of the collection sit in the suburban house where the Stone family lived. But Chipstone also shares gallery space with the Milwaukee Art Museum (MAM) downtown, known for its sleek 2001 Santiago Calatrava pavilion shaped like a bird in flight (figure 5). The structure contains a movable sunshade that opens to a wingspan of 217 feet during the day, folding over the pavilion at night and in bad weather. Situated on the shore of Lake Michigan, the building is monumental, isolated and far from public transportation. A long stark bridge functions ironically to separate the museum from the city center, rather than unite them.

Jonathan Prown, Chipstone's director, has tried to create an environment that challenges the isolation of the MAM building. He prioritizes museological innovation that, he argues, is essential to the display of decorative arts, which is too often exhibited in a chronological narrative or as context for 'fine arts' and thus engaging primarily with specialists (Jonathan Prown 2012). Prown is the son of Jules Prown, pioneer of American material culture studies at Yale University; the elder Prown developed what is known as the Prownian method of interrogating objects, an approach that encourages letting go of prior assumptions and forming an intimate bond with the object as the researcher describes, deduces, speculates, and then finally places the object in historical context (Jules Prown 2002). At Chipstone, Jonathan Prown leverages his father's method to reveal the full sculptural essence of decorative arts. He also commissions artists to

Figure 5. Milwaukee Art Museum, Wisconsin, 2002. Photo credit: Timothy Hursley

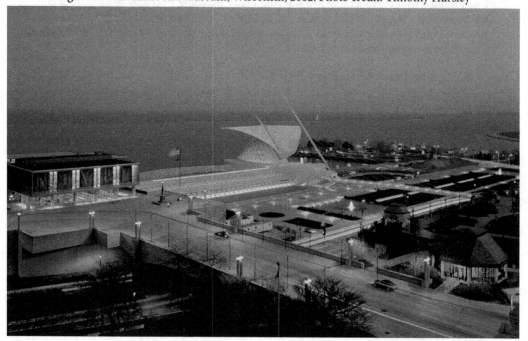

help create new connections and understandings between the artifacts and their diverse publics. Emerging from this is a notion of self-interrogation about all that they do.

Ethan Lasser, curator at Chipstone from 2007 to 2012 and now associate curator of American art at Harvard University Art Museums, was trained at Yale in the Prownian method. When Jonathan Prown gave him carte blanche to commission artists to help reinterpret the collections, Lasser proceeded to identify artists that could mine the materiality of the collections in ways that would facilitate social engagement. Lasser himself is interested in curating as socially engaged practice.

The city of Milwaukee, in America's industrial 'rust belt', offered particular challenges and opportunities to an artist and curator committed to critical practice. The population of Milwaukee's center and northwest are 50 to 100 percent African American. Center-city Milwaukee has been devastated by generations of deprivation and is bolstered by its black churches. The populations of the suburbs are between 2.5 to 10 percent African American, and the surrounding counties are between 0 and 2.5 percent African American (Lubin and Jenkins 2011). A working class that has endured years of layoffs dominates the outskirts. Most prominent is Kohler Company, a porcelain manufacturer best known for its plumbing products, where workers went on strike in 2010 for wage and pension concerns.

When in early 2010 Chipstone received a long-term loan of an 1858 impressive stoneware vessel made by the Edgefield, South Carolina, potter and enslaved individual known as Dave the Potter or Dave Drake (figure 6), they commissioned Theaster Gates to interpret the work in a way that would resonate with these diverse audiences. Dave had worked at a pottery factory belonging to his 'master', Lewis Miles. Between 1834 and 1862, Dave produced over one hundred pots for storing rations that show both physical strength and artistic vision (Goldberg and Witkowski 2006; Lasser 2010: 53). Despite the dearth of surviving material culture created by or belonging to American slaves, a group of ceramics by Dave remains extant. Even more astonishing is that Dave signed and dated many of these pots and inscribed short verses upon them. The piece on long-term loan to the Chipstone is inscribed with the couplet, "When you fill this jar with pork or Beef, Scot will be there to get a peace. Dave" (figure 7).

Other pots by Dave reveal a similar use of couplets that challenge laws and cultural codes intended to keep slaves voiceless. These verses include: "Dave belongs to Mr Miles / Wher the Oven Bakes and the Pot Biles"; "I made this Jar all for Cash / Though its called Lucre Trash"; and "I—made this Jar all of cross / If you don't repent, you will be lost."

Figure 6. Dave Drake, Storage Jar, Lewis Miles Pottery, 1858. Alkaline-glazed stoneware. H 25 5/8". Courtesy Arthur Goldberg. Photo Credit: Gavin Ashworth Private Collection on loan to the Chipstone Foundation. Originally published in Ceramics in America, 2006. *Beneath his Magic Touch. The Dated Vessels of the African-American Slave Potter Dave* by Arthur F. Goldberg and James P. Witkowski

Figure 7. Dave Drake, Storage Jar, Lewis Miles Pottery, 1858. Alkaline-glazed stoneware. H 25 5/8"
(detail). Courtesy Arthur Goldberg. Photo Credit: Gavin Ashworth
Private Collection on loan to the Chipstone Foundation
Originally published in Ceramics in America, 2006. *Beneath his Magic Touch. The Dated Vessels of the*
African-American Slave Potter Dave by Arthur F. Goldberg and James P. Witkowski

Together, the couplets transgress boundaries between the powerful and powerless in a way that
continues to resonate today.

Lasser commissioned Gates to do a project around the Dave vessel because he imagined that
Gates "could make that pot sing" (Lasser 2012b). Given his personal interest in African and
African American ceramicists, however, Gates knew that he would do much more than that.
From the start, the project was defined as a performative conjoining of Gates and Dave—using
the past to address present concerns, not unlike the conjoining of Gates and Crispus Attucks
two years later for the New York Armory Show. What Lasser hadn't envisaged is that this process
would take artist and curator out of their comfort zones on a journey to conjoin the segregated
communities of Milwaukee through the intersections between Dave's pot and their own lives.
Gates recounts:

> Chipstone in the past had a sense that contemporary artists were a tool to … talk about old
> things. I tried to set a task that was much greater than that. What I provided was a way to
> open up the pot so that it became a conversation about the value of labor and craft produc-
> tion and the history of slave economies. I asked how it could expand our sense of humanity,
> not just sympathy with history. What worked really well about Chipstone is that they admit-
> ted from the beginning that they were entering new territory. (Gates 2012c)

The Milwaukee Art Museum was more cautious. Chipstone has to clear its MAM-based projects
with the MAM exhibition committee and board of trustees. Usually this is a perfunctory process
but, in this case, as Prown reports, though the MAM wasn't hostile, they did want to sit down
and talk through the potential implications of the project. Prown recounts:

> They were aware of the potential reception of the project and its being political in a way that
> the Museum typically wasn't. Gates' engagement of race and class issues and the curatorial
> approach we took there were pretty far removed from their normative practice. This show
> tested conventional museum sensibilities. And Theaster loves being the provocateur. (Jona-
> than Prown 2012)

The MAM eventually did give its approval, but did not fully buy in to the project across depart-
ments to the extent that Gates had hoped (Gates 2012c).

Nonetheless, almost 150 years after the end of slavery in the United States, Gates came to
reify Dave's voice. Gates had studied ceramics in Japan, where he learned traditional techniques

and aesthetics but felt like an anomaly. He was moved to find models that reflected his own experiences. When he encountered Dave the Potter he felt a special kinship; he found Dave's technical skills heroic and his poems musical; and gradually Gates began to embody Dave.

Gates approached the vessel, the museum, and the communities of Milwaukee by modeling his brand of radical hospitality. Through his own interpretation of hybridity, what Gates calls 'temple swapping', Gates mined the potential of Dave for reconciliation. Viveros-Faune declares:

> He would, in the guise of an artist-curator-activist, serve different kinds of communities as an artistic 'bridge'. Of the many bridges Gates has laid over the years, few prove as nervy or emblematic as those he has spanned between the black church and the contemporary museum. (Viveros-Faune 2012: 68)

Gates's temple swapping proved quite a challenge to the Chipstone and the Milwaukee Art Museum.

Gates and Lasser began by meeting with communities all over Milwaukee. These talks helped them to conceive a three-month exhibition, two years of programming, and a long-term installation of the pot all built on the concept of unconditional or radical hospitality. Resistant to the exhibition machine that museums can become, Gates insisted on building into the project sustained investment in engagement, institutional self-reflection, and possibilities for organizational change.

The project sent Lasser to the black churches of Milwaukee to recruit a choir. Lasser recounts, "We bypassed the venues I knew best. Gates wanted to hit the kind of ground that curators rarely cover" (Lasser 2010: 55). It also sent Gates to Kohler Manufacturing for a three-month residency to learn about modes of workers' ceramic production (figure 8). Lasser explains:

Figure 8. Theaster Gates Jr. working in the Kohler Pottery during his Arts/Industry residency, January 3-March 27, 2010. Photo: Courtesy of the John Michael Kohler Arts Center

The factory had rendered these men anonymous, but the artist saw beyond the veil of the factory system. For him, the minds and hands behind the production of small machine parts and clay molds were as creative as the soaring voices of Mt. Zion [Baptist Church]. (Lasser 2010: 56)

The project also sent members of both the black and white communities to the Milwaukee Art Museum. Prown observes, "The object became a conversation in which we found ourselves doing less talking and more listening" (Jonathan Prown 2012). Gates made public these processes of reconciliation through the exhibition and programming, which, in their own right, advance the reconciliation process between museum and community.

Gates hoped to inspire self-reflective thinking toward unconditional hospitality at the Milwaukee Art Museum; he imagined the MAM rethinking what it might mean to play 'host' to underserved communities in ways that move beyond fulfilling inclusion statistics required by funders. And while he recognized the difficulties of such a transformation, he believed that the relevance of the project for all kinds of communities could persuade the MAM of its importance:

Radical Hospitality is simply having intentionality about the way in which traditional constructs of invitation and generosity are shared. In the case of the Milwaukee Art Museum, their engagement with the Black Community of Milwaukee was rather low as was their initial interest and continued interest in my work. It was clear to me that their engagement at all is, like many museums, political, and leads to resources for other programming and departments by leveraging their said commitment to underserved communities. The work I tried to tease out with Chipstone was work that would allow for some direct engagement with many different communities, including the amazing work force at Kohler Manufacturing Corporation. The work actually didn't feel radical at all; it seemed quite reasonable that people from lots of different economic and social strata should see a body of work about an enslaved potter from the middle 1800's who has become famous 170 years later by working his ass off against the odds. Sounds like many people's American story. (Gates 2012b)

As a gestural performance of this hospitality, Gates required that the Milwaukee Art Museum give out free memberships to the choir that Lasser recruited. Gates asserted:

We can do good things even though we don't believe in them and that is a fine start; those 200 memberships for the cost of printing a paper card show it doesn't cost anything to brown your museum. To extend an invitation is actually quite a free gesture. (Gates 2012c)

Gates's choreography of such gestures reflects his belief that self-conscious acts of conditional hospitality have the transformative potential to lead eventually to unconditional hospitality.

To Speculate Darkly *As Radical Hospitality*

The exhibition itself was intimate and sonorous; poetry and song were Gates's tools to make hybrid the creative forces of Milwaukee's churches, factories, and museums. The title, *To Speculate Darkly,* aptly captures Gates's approach. For Gates, the verb 'speculate' was key to the project because connecting to Dave, or almost any enslaved individual, involves postulating, as documentation is thin. But, as Gates sees it, the fiction he created around Dave is truer than the nonfiction account published by a descendent of Dave's slave master, which is laced with self-justifying rhetoric (Todd 2009).

The word 'darkly' refers both to forgotten African American histories and to the difficult work of mining the past for insights to present adversities. Gates asserts, "If I sing Dave's name loud enough and repeatedly enough, people won't forget it. I am leveraging that big white space and

loading it with something that is so fucking absolutely unapologetically black" (Gates 2012c). Gates thus facilitates radical hospitality at the Milwaukee Art Museum.

In the galleries, a long narrow hallway leads to Dave's storage jar (figure 9). Gates blanketed the hallway ceiling with glass lantern slides from his collection, representing the canon of ceramics. This canon is Gates's revision of the one he was taught, as it leads to Dave's pot and makes a connection that the younger Gates had yearned for to African American ceramics production.

Dave's storage jar is the centerpiece of a gallery containing a range of works by Gates that respond to the pot and to lingering questions of authenticity, identity, and hybridity. This includes several ink drawings that attest to Gates's training in Japan. For instance, in *Untitled (Bitch, I Made this Pot)* (figure 10), quick calligraphic style, asymmetry, and use of empty space are countered by defiant stenciled phrases that defy any doubts that an African American man today could craft vases inspired by Japanese tradition or that an enslaved individual of the American South could have crafted the impressive storage jar and the poetry inscribed upon it. Gates's ironic signature, "product," on the lower right of the drawing speaks to the question of branding and its impact in objectification—the branding of artists, consumer culture, and slaves.

A seemingly elegant vase of Gates's own making, juxtaposed to Dave's pot, further interrogates authenticity, identity, and hybridity. Titled *The Apostle*, it bears witness to Dave's work. Made of composite gold on plaster, *The Apostle* is a cast of a clay original. Gates remarks, "It was important for me to use all of the other minor materials associated with clay production to make the work itself" (Gates 2012b). The vase is etched in gold leaf with lines inspired by Dave's couplets and echoing their subversive character. It reads, "A plaster cast Makes money fast," and underneath, "Signature Here."

In the final gallery, Gates brings together groups that represent the segregated populations of Milwaukee (figure 11). On the right is a video of the gospel choir Lasser recruited performing

Figure 9. Installation view of the exhibition Theaster Gates, Milwaukee Art Museum, Wisconsin (16 April–1 August 2010), curated by Ethan Lasser at the Chipstone Foundation. Photo credit: John R. Glembin

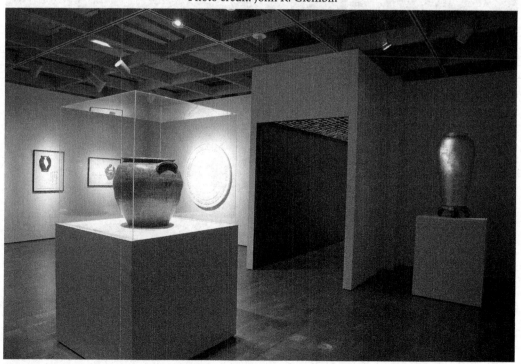

Figure 10. Theaster Gates, *Untitled (Bitch, I Made this Pot)*, 2010. Ink on paper. 24 2 x 30".
Courtesy of Kavi Gupta, CHICAGO/BERLIN

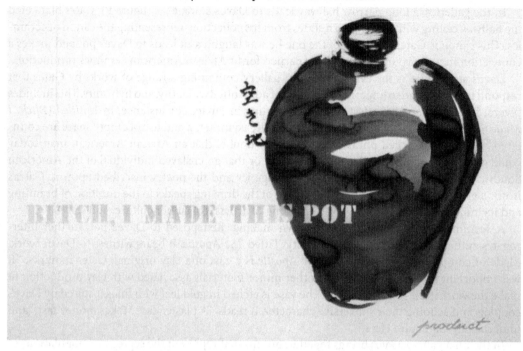

Figure 11. Installation view of the exhibition Theaster Gates, Milwaukee Art Museum, Wisconsin
(16 April–1 August 2010), curated by Ethan Lasser at the Chipstone Foundation.
Photo credit: John R. Glembin

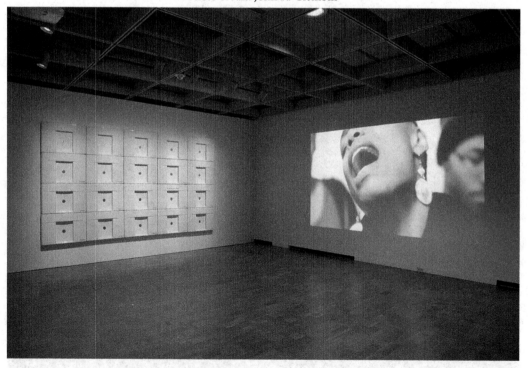

Figure 12. Theaster Gates, *Whyte Painting* (*NGGRWR0003*), 2010. Porcelian, composite gold, wood. 26" x 32" x 5". Courtesy of Kavi Gupta, CHICAGO/BERLIN

hymns Gates wrote with lyrics inspired by Dave's couplet. On the left is a wall of Kohler sinks Gates wired for sound. The voices of the choir pour out from the drain holes of the ceramic speakers, each of which Gates labels with racially explosive digital product codes, for instance

Whyte Painting (NGGRWR0003) (figure 12). In a sketch of the speakers Gates drew while at Kohler, he signed both his name and the name of the Kohler worker who helped him, Mitch Klarkowski. The drawing, titled *Dave Amplified,* indicates the words of one of the hymns (figure 13): "These speakers are made for thumping," it reads. The term thumping refers to the sound that preachers make when they pound the pulpit for emphasis. Gates metaphorically pounds the pulpit in the museum—inducing temple swapping as transformational justice.

The hymns speak to the disempowerment of the white laborers of Kohler, to the inhumanity of enslavement and the injustices that it perpetuates for generations. Song

Figure 13. Work produced as part of Theaster Gates Jr.'s Arts/Industry residency, January 3–March 27, 2010. Photo: Courtesy of the John Michael Kohler Arts Center

speaks to the hybridity of Dave and Gates, the black and the white communities. The gallery becomes a site for reconciliation, which provoked Lasser to ask, "How had I ignored the enslaved hands in the production of objects? And what else was I ignoring that could help reconcile museums and communities?" (Lasser 2012b).

The opening night of the exhibition made Gates's radical hospitality explicit. The two-hundred-member gospel choir performed live in the atrium of the MAM, singing a libretto by Dave and Gates. "These speakers were made for thumping," they sang (Chipstone Foundation 2010). And as they walked across the bridge of the museum in a processional, led by Gates, to signal the opening of the exhibition (figure 14), it was clear that something had changed. Lasser asserts:

Figure 14. Opening event for the exhibition *Theaster Gates* Milwaukee Art Museum, Wisconsin (16 April–1 August 2010), curated by Ethan Lasser at the Chipstone Foundation

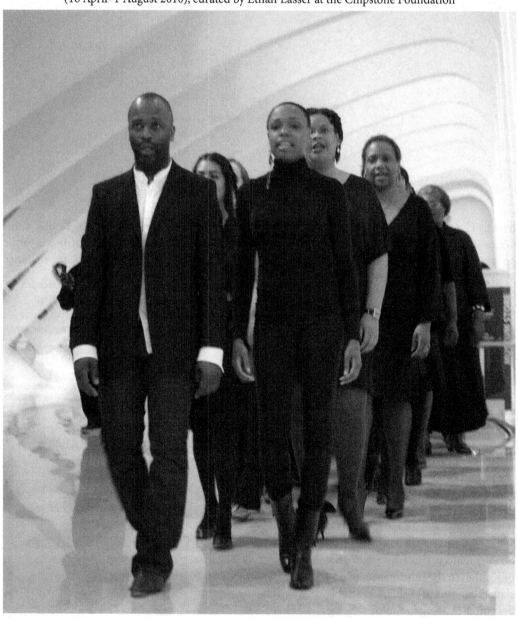

He showed me the value of 'thinking locally'. We are trained to be part of this international academic community and for him it was all about the assets like the black church that were at your doorstep and how they might inform a historical reading of an object. Those are two things that I have really taken with me—thinking about your responsibilities to your community but also what it can offer you. He made a lot of things plain both about my thinking and about museums' thinking that we wouldn't have seen on our own and that are often hard to take. (Lasser 2012b)

This new boundedness between the Chipstone and its communities shows the efficacy of Gates's radical hospitality.

Two years of poetry workshops in the schools and community centers of Milwaukee analyzing Dave's couplets and asking participants to write and inscribe their own verse on clay tablets extended the process of reconciliation (Lasser 2012a). Anticipating the programming and organizational change, Gates warned, "I am going to give you this gift and then you guys have to see it through" (Gates 2012c).

Today at the Chipstone Foundation in the Milwaukee Art Museum, Dave's pot takes center stage (figure 15). Writing on the walls to the left and right of the vessel spells out Dave's couplet. Blue script above the vessel projects thousands of couplets written by Milwaukeeans in response to Dave's poetry. Visitors can add their own with the tablet computer in front of the pot. The technology makes visible the ongoing process of reconciliation between Chipstone and its diverse communities and among these communities themselves. Symbolic transformative justice occurs through the fusion of texts by Dave, Gates, and Milwaukee's diverse communities.

The case study of *To Speculate Darkly* offers important lessons for understanding radical hospitality; through Gates's project, Chipstone enacted unconditional hospitality as a means of fostering hybridity or relational boundedness toward reconciliation. Wisconsin artist Dan Wang remarks:

Figure 15. Installation view from *The Dave Project,* organized by the Chipstone Foundation in Collaboration with the Milwaukee Art Museum, August 2010-ongoing. Photo credit: John R. Glembin

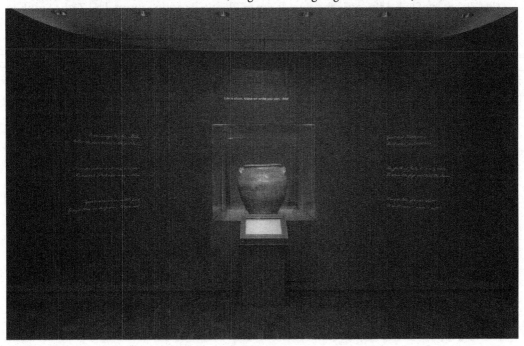

> With this project, the Chipstone Foundation announces to the world that it understands its
> place in a history of cultural dominance and now decline, and that its continued significance
> will be fostered, ironically, through its own deconstruction and critique. Courageous, but also
> the only option. (Wang 2010: 64)

And though the Milwaukee Art Museum proceeded tentatively with the project, audience
research shows that *To Speculate Darkly* drew more African American visitors (23 percent) than
other exhibitions and events (9 percent) (Milwaukee Art Museum 2010: 7). Many visitors com-
mented that it offered a much-needed corrective to hegemonic museum narratives. One, for
instance, expressed hope that the project could be a model of successful diversity initiatives for
other museums:

> On a recent visit to the Art Institute in Chicago, I was bothered by the art and history not rep-
> resented; while I noticed most of the patrons were of European descent viewing European-
> inspired art, the gallery attendants/workers were nearly all working-class African Americans.
> I did not see art at the Art Institute that represented these workers. It was a large disconnect
> that bothered me so much, I left. *To Speculate Darkly* is a meaningful and timely piece. I hope
> to see it in other major art museums. (Milwaukee Art Museum 2010: 9–10)

As Gates notes, the MAM benefited despite their initial fears. Gates also recognizes the ideo-
logical challenges the project brought to the MAM: "The thing that I want to do, it has to be so
resonant that they are willing to tolerate the tensions that will rub up. If we can get through this
open-heart surgery we'll all be better" (Gates 2012c).

In the end Gates understands the urgency of hybridity because he is asserting his personal
hybrid identity as he negotiates the distinct codes of the many different contexts in which he
operates. Gates resists being a chameleon despite conflicting expectations upon him. "It is like
having an all-weather coat for sun, rain and snow," he says. "I feel like I am finally speaking
one language. I am constantly code-shifting but at the core, the message is the same" (Gates
2012b).

This embrace of hybridity over the singularity of identity is aptly captured by Zadie Smith in
a 2009 essay, "Speaking in Tongues":

> Black reality has diversified. It's black people who talk like me, and black people who talk
> like L'il Wayne. It's black conservatives and black liberals, black sportsmen and black lawyers,
> black computer technicians and black ballet dancers and black truck drivers and black presi-
> dents. We're all black, and we all love to be black, and we all sing from our own hymn sheet.
> We're all surely black people, but we may be finally approaching a point of human history
> where you can't talk up or down to us anymore, but only *to* us. *He's talking down to white peo-
> ple*—how curious it sounds the other way round! In order to say such a thing one would have
> to think collectively of white people, as a people of one mind who speak with one voice—a
> thought experiment in which we have no practice. But it's worth trying. It's only when you
> play the record backward that you hear the secret message. (Z. Smith 2009)

Through temple swapping, Theaster Gates plays the record backward.

Conclusion

This article argues that hybridity is a dynamic methodological approach useful to museums and
galleries committed to equality, social justice, and cultural rights. Dewdney et al. (2012) argue
for such an approach:

It is practically possible to avoid the assimilationist closure (multicultural normalisation) and intrinsic failure that comes with the moral and reforming museum, just as much as it is possible to avoid the reproduction of cultural elitism which comes with attempts to shore up aesthetic modernism. (Dewdney et al. 2012: 121)

As Gates's approach shows, hybridity has tactical and strategic relevance for facilitating reconciliation between museums and communities. Moreover, Gates's notion of hybridity as 'temple swapping' is a testament to the value of reengaging and reappraising influential theoretical concepts as they continue to evolve.

To Speculate Darkly demonstrates that artists have a significant role to play in creating reconciliation through shifting postcolonial notions of hybridity. Such work may be difficult, but it is central to the project of ethics as social justice in museums. Additionally, in its fusion of Dave's pot with contemporary multimedia art, *To Speculate Darkly* offers up new understandings of both within a social justice framework. Gates's project instrumentalizes the museum to highlight the intrinsic value of objects to diverse and hybrid communities. It supports the development of activist museums, as defined by Sandell, "that do not simply reflect and reinforce the consensus but actively seek to build public and political support for more progressive human rights values" (Sandell 2012: 212). The Chipstone Foundation is clearly invested in practice that can be understood in these terms.

Hybridity as a construct to grapple with diversity will not fade from view anytime soon. The immediacy of the challenge is captured by the phenomenon of superhybridity, a term recently brought to light and probed by art critic Jörg Heiser in the international arts periodical *Frieze* (Heiser 2010; Heiser et al. 2010). In contrast to Homi Bhabha's 1990s mobilizing of hybridity to emphasize multiple subject positions within a postcolonial political framework, Heiser proposes superhybridity as a means to negotiate twenty-first century artistic diversity through digitality and through a generation of young people whose lived experience is hybridity and who ask what comes next (Heiser et al. 2010). As Heiser asserts, superhybridity emerges from

the Internet (that a new generation of artists has grown up with) and the antagonistic, ravenous dynamism of globalized capitalism but also … people's desire to macerate the limits of oppressive traditions, censorship, xenophobia and perception itself.… [Superhybridity] has moved beyond the point where it's about a fixed set of cultural genealogies and instead has turned into a kind of computational aggregate of multiple influences and sources. (Heiser 2010)

Understanding the shifting dynamics of hybridity through the cultural collisions of Theaster Gates's socially engaged practice seems all the more relevant with superhybridity in our midst.

▪ JANET MARSTINE is lecturer and program director of art museum and gallery studies in the School of Museum Studies at the University of Leicester. Her research focuses on artists and museum ethics. Marstine is editor of *The Routledge Companion to Museum Ethics: Redefining Ethics for the Twenty-First-Century Museum* (Routledge, 2011) and coeditor of *New Directions in Museum Ethics* (Routledge, 2012). She is currently completing a study on artists' interventions in museums, *Critical Practice: Artists, Museums, Ethics* (Routledge, 2013). She is principle investigator for an AHRC networking grant, with partners the Museums Association and the Interdisciplinary Ethics Applied, University of Leeds, on embedding the new ethics in the museum sector.

▪ **ACKNOWLEDGMENTS**

I am grateful for the generosity of Define Ayas, Theaster Gates, Ethan Lasser, Jonathan Prown, Stephanie Smith, and the Chipstone Foundation. Thanks also for the support of the College of Arts, Humanities and Law Development Fund.

▪ **REFERENCES**

Anderson, David. 2012. "Creativity, Learning and Cultural Rights." Pp. 216–226 in *Museums, Equality and Social Justice,* ed. Richard Sandell and Eithne Nightingale. Museum Meanings. London: Routledge.

Ang, Ien. 2003. "Together-in-difference: Beyond Diaspora, into Hybridity." *Asian Studies Review* 27 (2): 141–154.

Ayas, Defne. 2012. Interview with the author. 22 May.

Bashir, Bashir, and Will Kymlicka. 2008. "Introduction: Struggles for Inclusion and Reconciliation in Modern Democracies." Pp. 1–24 in *The Politics of Reconciliation in Multicultural Societies,* ed. Will Kymlicka and Bashir Bashir. Oxford: Oxford University Press.

Bhabha, Homi K. 1994a. "Frontlines/Borderposts." Pp. 269–272 in *Displacements: Cultural Identities in Question,* ed. Angelika Bammer. Bloomington: Indiana University Press.

Bhabha, Homi K. 1994b. *The Location of Culture.* London: Routledge.

Bhabha, Homi K. 1996. "Cultures in Between." Pp. 53–61 in *Questions of Cultural Identity,* ed. Stuart Hall and Paul Du Gay. London: Sage.

Bodo, Simona. 2012. "Museums as Intercultural Spaces." Pp. 195–215 in *Museums, Equality and Social Justice,* ed. Richard Sandell and Eithne Nightingale. Museum Meanings. London: Routledge.

Bourriaud, Nicolas. 1998. *Relational Aesthetics.* Trans. Simon Pleasance and Fronza Woods with participation of Mathieu Copeland. Paris: Les Presses du Reel.

Chen, Tom. 2012. "Video: Theaster Gates on Inserting an Inner-City Schoolroom into the Armory Show's 'Magical Atmosphere.'" *Blouin Artinfo.* 9 March. http://www.artinfo.com/news/story/762708/video-theaster-gates-on-inserting-an-inner-city-schoolroom-into-the-armory-shows-magical-atmosphere (accessed 9 December 2012).

Chipstone Foundation. 2010. "Theaster Gates: Thumping Wisconsin." http://www.artbabble.org/video/chipstone/theaster-gates-thumping-wisconsin (accessed 3 June 2012).

Cromidas, Rachel. 2011. "In Grand Crossing, a House Become a Home for Art." *New York Times.* 7 April. http://www.nytimes.com/2011/04/08/us/08cncculture.html?_r=0 (accessed 5 June 2012).

Derrida, Jacques. 2000. *Of Hospitality: Anne Dufourmantelle Invites Jacques Derrida to Respond.* Palo Alto, CA: Stanford University Press.

Dewdney, Andrew, David Dibosa, and Victoria Walsh. 2012. "Cultural Diversity: Politics, Policy and Practices. The Case of Tate Encounters." Pp. 114–124 in *Museums, Equality and Social Justice,* ed. Richard Sandell and Eithne Nightingale. Museum Meanings. London: Routledge.

Dikeç, Mustafa, Nigel Clark, and Clive Barnett. 2009. "Extending Hospitality: Giving Space, Taking Time." In *Extending Hospitality: Giving Space, Taking Time,* ed. Mustafa Dikeç, Nigel Clark, and Clive Barnett, special issue. *Paragraph* 32 (1): 1–14.

Elam, Mark. 1999. "Living Dangerously with Bruno Latour in a Hybrid World." *Theory, Culture and Society* 16 (4): 1–24.

English, Darby. 2007. *How to See a Work of Art in Total Darkness.* Cambridge, MA: MIT Press.

Gates Jr., Theaster. 2010. "Opening Night Lecture, To Speculate Darkly." Chipstone Foundation. 16 April. http://www.artbabble.org/video/chipstone/theaster-gates-opening-night-lecture-speculate-darkly (accessed 30 May 2012).

Gates Jr., Theaster. 2012a. "The Armory Show." Theaster Gates website. http://theastergates.com/section/328620_The_Armory_Show.html (accessed 6 December 2012).

Gates Jr., Theaster. 2012b. Email to the author. 25 September.

Gates Jr., Theaster. 2012c. Interview with the author. 26 April.

Gates Jr., Theaster. 2012d. "Soul Food Pavilion." Smart Museum of Art, University of Chicago. http://vimeo.com/37407879 (accessed 29 August 2012).

Gates Jr., Theaster. 2012e. "Soul Food Starter Kit." Smart Museum of Art, University of Chicago. http://vimeo.com/36719143 (accessed 29 August 2012).

Goldberg, Arthur F., and James P. Witkowski. 2006. "Beneath his Magic Touch: The Dated Vessels of the African-American Slave Potter Dave." *Ceramics in America* 6: 58–92.

Heiser, Jörg. 2010. "Pick & Mix." *Frieze Magazine* 133. http://www.frieze.com/issue/article/pick-mix/ (accessed 18 September 2012).

Heiser, Jörg, with Ronald Jones, Nina Power, Seth Price, Sukhdev Sanhu, and Hito Steyerl. 2010. "Analyze This: A Round Table Discussion on 'Super-hybridity'." *Frieze* 133 (September). http://www.frieze.com/issue/article/analyze-this/ (accessed 18 September 2012).

Holland, Allison, ed. 2007. *Joseph Beuys and Rudolf Steiner: Imagination, Inspiration, Intuition* (ex. cat., National Gallery of Victoria).

Huang, Kelly. 2009. "An Artist and a Citizen," *Art21 Blog.* 30 October. http://blog.art21.org/2009/10/30/an-artist-and-a-citizen/ (accessed 12 June 2012).

Jackson, Shannon. 2011. *Social Works: Performing Art, Supporting Publics.* London: Routledge.

Jovanovic, Rozalia. 2012. "For Theaster Gates at the Armory, There's No Sale Without Process." *GalleristNY.* 7 March. (accessed 6 December 2012).

Kestner, Grant. 2011. *The One and the Many: Contemporary Collaborative Art in a Global Context.* Durham, NC: Duke University Press.

Koopman, Nico. n.d. "Towards a Pedagogy of Hybridity, Reconciliation and Justice." Stellenbosch University weblog. http://blogs.sun.ac.za/hopefulpedagogiessu/files/2010/11/Koopman-Towards-a-pedagogy-of-hybridity-reconciliation-and-justice.pdf (accessed 20 September 2012).

Lasser, Ethan W. 2010. "Road Trips: Theaster Gates, Milwaukee and the Museum." Pp. 53–57 in *My Name Is Dave: A Hymnal,* ed. Rebecca Zorach. Milwaukee: Milwaukee Art Museum and Chipstone Foundation.

Lasser, Ethan W. 2012a. "An Unlikely Match: On the Curator's Role in the Social Work of the Museum." *Museum Management and Curatorship* 27 (3): 205–212.

Lasser, Ethan W. 2012b. Interview with the author. 25 April.

Latour, Bruno. 1993. *We Have Never Been Modern.* Cambridge, MA: Harvard University Press.

Lubin, Gus, and Christine Jenkins. 2011. "The 22 Most Segregated Cities in America." Skyscraper Page Forum. 1 April. http://forum.skyscraperpage.com/showthread.php?t=187467&page=60 (accessed 6 June 2012).

Lynch, Bernadette. 2011. "Collaboration, Contestation, and Creative Conflict: On the Efficacy of Museum/Community Partnerships." Pp. 146–163 in *The Routledge Companion to Museum Ethics: Redefining Ethics for the Twenty-First-Century Museum,* ed. Janet Marstine. London: Routledge.

Marstine, Janet. 2005. "Introduction." Pp. 1–36 in *New Museum Theory and Practice: An Introduction,* ed. Janet Marstine. Malden, MA: Blackwell.

Marstine, Janet. 2011. "The Contingent Nature of Museum Ethics." Pp. 3–25 in *The Routledge Companion to Museum Ethics: Redefining Ethics for the Twenty-First-Century Museum,* ed. Janet Marstine. London: Routledge.

Marstine, Janet. Forthcoming. *Critical Practice: Artists, Museums, Ethics.* Museum Meanings. London: Routledge.

Milwaukee Art Museum. 2010. *Final Report "To Speculate Darkly: Theaster Gates and Dave the Potter."* Internal document, Milwaukee Art Museum Archives.

Mowles, Chris. 2008. "Performance as Social Practice." *Reflexivepractice* weblog. 2 September. http://reflexivepractice.wordpress.com/2008/09/02/performance-as-social-practice/ (accessed 2 June 2012).

Nightingale, Eithne, and Richard Sandell. 2012. "Introduction." Pp. 1–9 in *Museums, Equality and Social Justice,* ed. Richard Sandell and Eithne Nightingale. Museum Meanings. London: Routledge.

O'Gorman, Kevin D. 2006. "Jacques Derrida's Philosophy of Hospitality." *Hospitality Review* 8 (4): 50–57.

Pieterse, Jan N. 2001. "Hybridity, so What? The Anti-hybridity Backlash and the Riddles of Recognition." *Theory, Culture and Society* 18 (2–3): 219–245.

Prown, J[onathan]. 2012. Interview with the author. 25 April.

Prown, J[ules]. 2002. *Art as Evidence: Writings on Art and Material Culture*. New Haven, CT: Yale University Press.

Rancière, Jacques. 2001. "Ten Thesis on Politics." *Theory & Event* 5 (3). http://www.egs.edu/faculty/jacques-ranciere/articles/ten-thesis-on-politics/ (accessed 11 December 2012).

Reeve, John. 2012. "A Question of Faith: The Museum as a Spiritual or Secular Space." Pp. 125–141 in *Museums, Equality and Social Justice*, ed. Richard Sandell and Eithne Nightingale. Museum Meanings. London: Routledge.

Russeth, Andrew. 2012. "Theaster Gates to Hold Court at the Armory Show." *GalleristNY*. 6 March. http://galleristny.com/2012/03/theaster-gates-holding-court-at-the-armory-show/ (accessed 9 December 2012).

Sandell, Richard. 2005. "Constructing and Communicating Equality: The Social Agency of Museum Space." Pp. 185–200 in *Reshaping Museum Space: Architecture, Design, Exhibitions*, ed. S. Macleod. London: Routledge.

Sandell, Richard. 2011. "On Ethics, Activism and Human Rights." Pp. 129–145 in *The Routledge Companion to Museum Ethics: Redefining Ethics for the Twenty-First-Century Museum*, ed. Janet Marstine. London: Routledge.

Sandell, Richard. 2012. "Museums and the Human Rights Frame." Pp. 195–215. *Museums, Equality and Social Justice*, ed. Richard Sandell and Eithne Nightingale. Museum Meanings. London: Routledge.

Sandell, Richard, and Eithne Nightingale, eds. 2012. *Museums, Equality and Social Justice*. Museum Meanings. London: Routledge.

Smart Museum of Art. 2012. "Ana Prvacki: The Greeting Committee." http://vimeo.com/36788036 (accessed 21 September 2012).

Smith, Stephanie. 2012. Interview with the author. 27 April.

Smith, Stephanie. Forthcoming. *Feast: Radical Hospitality in Contemporary Art* (ex. cat. Smart Museum of Art, University of Chicago).

Smith, Zadie. 2009. "Speaking in Tongues." *The New York Review of Books*. 26 February. Based on a lecture at the New York Public Library, December 2008. http://www.nybooks.com/articles/archives/2009/feb/26/speaking-in-tongues-2/?pagination=false (accessed 14 October 2012).

Thompson, Nato, ed. 2012. *Living as Form: Socially Engaged Art from 1991–2011*. New York: Creative Time Books; Cambridge, MA: MIT Press.

Todd, Leonard. 2009. *Carolina Clay: The Life and Legend of the Slave Potter Dave*. New York: W. W. Norton.

Viveros-Faune, Christian. 2012. "Theaster Gates: Anthropologist, Urbanist, Activist—The 21st-Century Artist." *Art Review* 56 (January–February): 68–71.

Wang, Dan. S. 2010. "Theaster Gates, Jr. at Chipstone: Looking, Listening, Making and Singing the Brightness of Our Common Dark Future." Pp. 59–65 in *My Name Is Dave: A Hymnal*, ed. Rebecca Zorach. Milwaukee: Milwaukee Art Museum and Chipstone Foundation.

Warner, Emily. 2009. "Interview: Theaster Gates." *Proximity Magazine* 4 (10 May). http://proximitymagazine.com/2009/05/theaster-gates-2/ (accessed 29 May 2012).

Werbner, Pnina, and Tariq Modood, eds. 1997. *Debating Cultural Hybridity: Multi-cultural Identities and the Politics of Anti-racism*. Colonial Encounters. London: Zed Books.

Wilmott, Francesca. 2011. "Creative Rebuild: Theaster Gates in Hyde Park, St Louis." *art:21 blog*. 1 August. http://blog.art21.org/2011/08/01/creative-rebuild-theaster-gates-in-hyde-park-st-louis/ (accessed 7 June 2012).

Wolff, Rachel. 2010. "Urban Outfitter: Fresh Off the Whitney Biennial, Theaster Gates Jr. Shakes up his Hometown Art Fair." *Chicago Magazine* (May): 19–22.

CONVERSATION

Museums in a Global World
A Conversation on Museums, Heritage, Nation, and Diversity in a Transnational Age

The following conversation took place during the Critical Heritage Studies conference in Gothenburg, Sweden, on 6 June 2012. The initial idea and topic was suggested by Kylie Message, the session was chaired by Conal McCarthy, and the recording was transcribed by Jennifer Walklate and edited by Conal McCarthy and Jennifer Walklate.

Chair:
Conal McCarthy, Victoria University of Wellington, New Zealand

Participants, in initial order of speech:
Rhiannon Mason, Newcastle University, UK
Christopher Whitehead, Newcastle University, UK
Jakob Ingemann Parby, PhD, Fellow, Roskilde University, Denmark; Curator, Museum of Copenhagen, Denmark
André Cicalo, Postdoctoral Researcher, desiguALdades Research Network, Freie Universität, Berlin, Germany
Philipp Schorch, Research Fellow, Cultural Heritage Centre for Asia and the Pacific (CHCAP), Deakin University, Melbourne, Australia
Leslie Witz, University of the Western Cape, South Africa
Pablo Alonso Gonzalez, PhD Candidate, University of Cambridge, UK; Researcher, University of León, Spain
Naomi Roux, PhD Candidate, Birkbeck College, University of London, UK
Eva Ambos, PhD Candidate, Cluster of Excellence, "Asia and Europe in a Global Context"/ South Asia Institute, University of Heidelberg, Germany

Respondent:
Ciraj Rassool, University of the Western Cape, South Africa

Question:
How, in an increasingly transnational and global world are the challenges of nation and diversity being squared with ideas about local and community identity? How are the tensions around these themes being articulated by museums, heritage, and cultural policy?

Museum Worlds: Advances in Research 1 (2013): 179–194 © Berghahn Books
doi:10.3167/armw.2013.010111

McCarthy:

In 2009, Ciraj and I went to a conference in Prato, Italy, called National Museums in a Transnational Age. There were people from all over the world talking about national museums, national identity, and nationalism. The very title seemed to imply that national museums were an anachronism in a transnational world and that they would naturally disappear, along with other elements of the nineteenth-century nation-state, in the face of the Internet, global trade, and multiculturalism. What struck me was that, despite the postnation thesis and the grim prognosis for the national museum, if anything, nations, national identity, and national museums were not only persisting and surviving, but in fact flourishing.

In the Pacific, there are lots of relatively new national museums, in New Zealand, Australia, Canada, New Caledonia, which are very much institutions forging a sense of national identity, both settler identity and indigenous identity. They have been referred to as 'civic laboratories' where 'experiments in culture' are carried out (Healy and Whitcomb 2006). Whether it is called postcolonial or decolonizing these nations are facing the challenges of their colonial legacy and also dealing with contemporary issues. But as Kylie Message pointed out in her book *New Museums and the Making of Culture* (Message 2006), the newness of these museums often effaces the past and the tensions and complexities of the national past are often not shown. So this is a very fruitful area of debate where there's been a lot of writing, but it seems a good time now to really take stock of where the thinking is going.

Certainly at this conference on critical heritage studies there's been a lot of discussion about new tools, new theories, and new methodologies for looking at museums and heritage, and for thinking about these kinds of issues. I've heard a lot about moving beyond representation to object-centered philosophy, Latourian sociology, and a whole range of other ideas, which may equip us to analyze these questions related to museums, globalization, and identity in more complex ways.

Mason:

I'm similarly very interested in this postnational thesis and where it has some traction and where I think it doesn't. I will just say that when I was thinking about this last night, it occurred to me that I have to start with the fact that the UK is a multinational unitary state. Great Britain is the state that is the umbrella at the top level, but underneath that we have, obviously, Scotland, Wales, Northern Ireland, and England. So really what you see when you're thinking about nation is actually a renewed interest in pursuing articulations of the nation, particularly in Scotland and Wales, which I'm more familiar with than Northern Ireland since political devolution. So 'nation' hasn't gone away in any sense; it's got stronger as a frame of reference. In the UK we've got a referendum on Scottish independence scheduled for 2014, which would be a *huge* thing for the UK in terms of reconfiguring political relationships. In the UK then I would say that the national paradigm is still strong in museums.

As for diversity and transnational identities, in thinking through these issues brought up by the migration of different populations to the UK I think you could say that this pattern has been treated as a core-plus model—we've got these nations *within* the UK and then we're going to add these others onto it. I would say that that's being reflected in museums and their approaches. For a long while what I was seeing in museums was a 'main narrative' and integrated into it were these different groups, which we identify by 'ethnicities'—the Chinese in Liverpool, the Pakistanis in London, and so on. But talking to people in city museums—and of course there's a big difference between a city museum somewhere like London, which is a world city, and a city museum perhaps in the northeast of England, where nonwhite populations are very small—you

can see parallels where they're saying this kind of core-plus, this adding on of ethnicities, leads us into what I'm coming to think of as an identity trap; that you can never satisfy. You know, you always miss out someone: the Kurdish group or the Irish trannies in Liverpool, or some community who, once they see the representation couched in a particular way, a bounded identity group, understandably feel that they have been missed out.

There seems to be a bit of dissatisfaction with that and an intent to do it in different ways and I was just thinking through a couple of these. One would be to integrate stories of different diversities throughout the narrative. For example, if you're telling a story of Liverpool you run the community stories through it and you pick certain ones that are emblematic of a significant story *but* you don't pick them all in terms of a politics of recognition. Another approach is more *issues* based, looking at issues that can be seen across communities. Another one you can see is this idea of belonging to the city. What does it mean to be a Londoner? Chris and I have been traveling a bit and I think we can see this in other museums. In Amsterdam, what does it mean to be an Amsterdamer? What about a Copenhagener, a Berliner? That kind of place-based frame of reference seems to be another strong impetus.

There are lots of pros and cons. Talking to curators in museums where these approaches have been tried, it seems that often some communities will say: 'You've missed *us* out! Where are *we*?' There is an interesting question there. Are people so used to seeing displays framed in this way that they're at a loss to read them in a new frame?

Whitehead:

What I want to talk about is a particular transnational experience: what 'nation', 'diversity', 'local communities', 'local identities' do in relation to that transnational experience of migration. I'm talking from the European Union perspective, in relation to the European Commission–funded MeLa project that Rhiannon and I are working on. Migration is obviously not a new transnational process and one of my colleagues, Iain Chambers, holds that it is actually a central experience of modernity. But I think that it's inflected in quite specific ways in contemporary discourses in relation to issues of inclusion within, and exclusion from, and movement to and through, geopolitical entities like nations, or multinational affiliations like the European Union, not to mention the bordering of entities like this.

Migrants can be seen as a heterogeneous group of people ranging from refugees to economic migrants to the transnational rich. They can be relatively invisible like the Australians in London, and they can interact very little with the host culture really—if there can ever be said to be only one host culture. The very rich and privileged and the very poor and disadvantaged can end up living in quite different kinds of gated communities and their presence can go largely unnoticed or it can cause complex tensions. So what then does migration actually *do* to the nation and to communities and localities? Obviously this can be thought of in relation both to emigration *and* immigration, which each have different problematics.

Emigration can constitute a forced displacement or a brain drain, whereas immigration can be seen on the one hand as bringing vitality, skilled labor, and new cultural capital to a locality or it can be seen by some as an alien threat to entrenched local values, a drain on the economy, and risk to monocultural and monoethnic communities. Thinking about emigration, it's rarely represented in Europe as a historical phenomenon; for example, at the Deutsches Auswandererhaus Bremerhaven or the Emigration Museum in Genoa, where there's a focus on early twentieth-century and mid-twentieth-century emigration, to the Americas for example. One of the notable findings of our MeLa research has been a lack of relationality between representations of immigrant groups in Western Europe and the 'homelands' from which they come. So in the

Netherlands and Germany there are various representations of Turkish migrant groups and experiences, but if you go to Turkish museums there is no account of Turkish emigration to Western Europe, even though there are some three million people of Turkish origin living in Germany alone.

Now with immigration, in the context of Western European museums, for example, this is a locus for very complex representations, bearing as much on the identity of the so-called receiving state as on the individual migrant whose experience is narrated—it's usually an individual who stands for the plurality of migrant experiences and also for new pluralities within society. In terms of themes we see stories of positive assimilation above all. So, for example, in the Amsterdam Museum we see stories of integration, assimilation, and adoption, adoption both of the people by the place and adoption of the place by the people. We see historicized stories of struggle where particular groups have struggled to integrate. An example is the Turkish community in Amsterdam, a historicized story that ends in the 1980s with the closing of the shipyards, where many of the Turks were guest workers. We see topics like leaving the homeland, the migration itself, the actual sense of the travel, and the new home, and these create different sorts of emphases within the actual representations. We also see the idea of the museum as a corrective or reforming instrument in the sense suggested by Tony Bennett. For example, at the immigration museum in Genoa we see videos of migrants explaining the hardships that they undergo on their way to Italy and we see curators, with whom you can have a virtual dialogue, actually reworking people's assumptions about the disadvantages of hosting migrants, such as overturning the idea that migrants take jobs away from Italians. In general, the immigrant experience is one that ruptures the fixity of the local, bringing into focus questions of diversity, tolerance, and notions of communities as groups of people who are known to each other, and with shared ideals, bringing into focus issues of hybridization and resistance to that hybridization. Migration catalyzes extreme nationalisms sometimes, but it also fuels the cosmopolitan dream. It makes local places themselves transnational, and requires a form of reflexive recognition in the museum that historicizes it in the now and grasps problematics relating to its politics and its persistence, and the mythologies that surround migration as a transnational practice.

Parby:

In my work as a museum professional and a historian I think this topic of migration and diversity we are discussing is one of the greatest challenges to European societies, particularly societies like Denmark, which has a self-image of being very homogeneous. The easy way to go is to say, 'Now we have these *added* communities', as you describe them, Rhiannon, and then we probably recognize them or try to integrate them. We construct this quite heightened and clear dichotomy between the core nation and the rest of the communities in the nation, even in the second or third generation, so that these identities are imposed upon the newcomers for quite some time. The other issue is that, rather than postnationalizing the nation or denaturalizing notions of national identity, you find that a lot of the discourse on migration actually formulates and reformulates what Danishness is—a very strong claiming of particular positions. You could argue that the experience of migration reinforces and allows the reclamation of national identity as a really bounded and clearly formed identity.

If we move from this general discussion to a more specific perspective, what can museums do about this situation? What is their role in all this? In the Danish national scene I would say that the approach of most museums has been multiculturalist; museums have strived to show newcomers that as museums they really accept them, respect them, and want to include them. Often, however, that creates the problem of Othering, because you direct specific projects to the Turkish community or to the Somali community or whatever. I think there's a lot of staging and

compartmentalization in this approach, which does not really promote integration or cohesion in society, but rather petrifies a discourse into cultural heritage. One of the ways to move beyond that is to situate and historicize national identity constructions in order to show that they are part of a distinct development. Stable national or ethnic identities (those that have always been there or are going to be there forever) do not exist. On the contrary, they are continually constructed and reconstructed through human interactions. As a historian, I operate by applying these theories of the postnational to the period *before* the nation-state, investigating how [other kinds of] transnational and cosmopolitan loyalties informed the relationship between individuals and groups in that era.

Because I work in a city museum another strategy is to look at a unit that's *not* the nation. The history of the city reveals a certain fluidity—you never have a sort of bounded, sedentary state of living, because transition and the constant influx and outflux of citizens has historically been the norm rather than the exception. It's been really helpful in my own work to think about migration and identity in this way. But obviously such an approach may have drawbacks in that perhaps you seem to dissolve ethnicities as particular identities. Even though you can criticize, and claim that 'postnational identities are better' or that that idea has greater potential in creating meaningful communities in today's societies, museums cannot altogether dismiss the individuals and groups still attached to national and ethnic affiliations. What the museum can do, however, is stimulate reflexivity about it.

Cicalo:

My research topic is about the construction of slave heritage in Brazil, so I am not talking about migrants as such, but forced migrants who have been brought into the nation. But although they were and are considered part of the nation, there has been a lack of recognition of people like the Afro-Brazilian and the indigenous community. So although there is not a problem of recognizing individuals and groups depending on whether they were migrant or not, there is a problem regarding the position that those migrants occupied in the construction of the national narrative. Now this situation is changing quite a lot through affirmative action, which is actually an effect of globalization, along with other things like multiculturalism, the World Conference against Racism in Durban in 2001, and the favorable position of UNESCO for the promotion of slave heritage. As a result, a new perspective is emerging toward slave heritage. My research is in Rio de Janeiro, where there is currently a huge debate about the building of a slave memorial and the development of an urban itinerary tracing and signposting places that are relevant to Afro-Brazilian history and culture in the port area of Rio de Janeiro, a part of the city that received millions of slaves during the trafficking period. Where previously elements of the history of slavery were completely absent in the city center, this subchapter of Brazilian history is coming out again through a social movement that is starting to organize and explore how to reconfigure the state and the nation with respect to its Afro-Brazilian identity. My ethnography of this process deals with the reconstruction of national identity not just in terms of rhetorically recognizing the nation as the historical sum of different and separate groups, but also in ways that actively confer more value to each one of these groups, questioning what place they occupy in the nation, and giving them their rightful place in the national culture as well as in society.

Schorch:

Both Christopher and André touched on two really important issues, and those are history and experience. Chris alluded to the fact that migration is not just a contemporary but a modern phenomenon, and, as we clearly see in the case of Brazil, actually a premodern phenomenon. My research sits at the intersection between globalization, museums, and meaning. Appadurai

and Breckenridge (1999) said once, "Museums are good to think with." For me they are places and spaces to understand globalization and how the actual meanings of globalization are performed and constituted. In order to do that one needs to pay attention to the fact that globalization is not a modern or contemporary invention; it is just a historical process that now gains different manifestations, especially through travel and technology. Southern Spain has always had influences from northern Africa and Islam, the Silk Route has always connected different worlds. A lot of sociological perspectives that dominate the literature don't pay sufficient attention to this longer historical context.

On that note, let us get back to the Pacific. Polynesian people migrated through the South Pacific well before any modern understanding of migration. In Australia the debate about migration relates mainly to policy and ideology after the Second World War, whereas British settlement in settler colonies is not seen as migration. It should also be remembered that nationality as a concept does not have purchase in all societies and that identity is understood in many complex ways across the world. For instance, the Maori in New Zealand have always performed multiple identities. They refer to *Hawaiki* (the homeland), to *iwi* (tribe), *whanau* (family), and different forms of identity in real-life situations. It's not so much an either/or separation, or tension, either national or local. It has been performed on a both/and level over centuries.

Museum studies as a field actually offers us tools to better understand those processes and shed light on them, and thereby create better-informed theories and policies, rather than constructing another dichotomous vocabulary or grammar of identity. The concept of place and space is very useful for my own research because, on the one hand, like any identity, it links a spatial concept to a physical place, and on the other, it always embodies a discursive space. Museums have *always* depended upon the travel of objects and of people. The objects in museums have been moved over centuries from one place to another, and if one considers the experience of the people who visit museums then there is the same shifting perspective. So although there might be a break, like in the 'New Museology', as Kylie's book points out (Message 2006), this newness covers up a historical dimension.

In that sense there's no such thing as a purely national museum or place if one considers that museums do not just embody meaning, but produce and construct it. To articulate and further this, I'm trying to work with ideas like methodological cosmopolitanism, which Ulrich Beck (2006) came up with. To achieve that distinction it is important to take into account the national or the local because you are dealing with a building, a specific place that gains meaning in those very particular settings. However, it is always linked to the discursive dynamics of an interconnected world and that has *always* been the case—it's just heightened now through travel and technology. To sum it up, the global always gains meaning in the local, and the local is always embedded in the global. Museums offer a perfect place to understand this.

Witz:

It is very interesting to listen to these discussions, but I'm not sure whether we can skirt around issues of ethnicity, identity, and diversity in the same sorts of ways in a postcolonial climate, especially when one of the major features of the apartheid state in South Africa was to reclaim diversity—you *had* to belong to an ethnic identity. One of the major aims of the postapartheid state was to do away with this notion of ethnicity and diversity in some ways, to reclaim a nation that does away with these borders. The museum sector in South Africa has flourished since the end of apartheid, but frankly I don't know why this is the case. I can see why people want to reclaim histories and all that sort of thing, but what does the museum do? Not many people visit museums. They don't make any money and don't really create jobs. So I'm still struggling

with what, as an institution, the museum *does* as opposed to a book or school or something like that—it's a very important question.

But out of nearly all of these museums, whether the older type or the newer museums, there's only one that will claim an *ethnicity*, and that is the Berlin Jewish Museum. The rest all make claims around communities or nation or some national narrative—so you have the Robben Island story, there's Freedom Park, there's District Six. It's very interesting to see the ways in which community has been claimed in those instances, more as a locality and a memory in some ways.

I'm involved in a museum called the Lwandle Migrant Labour Museum, which is about forced labor and apartheid, about people coming to Cape Town and living in hostel-type compound accommodation. Really the museum is a museum that should *not* be there. It's a sort of independent initiative of one or two people, but it is there and it's got government recognition recently. The point is: what sort of history do we put in there? I'm chair of the board of this museum and it's interesting that the narrative we employ is a narrative that relates to the historiography of the 1980s and the social history movements, you know, 'history from below'. That becomes a national story in some ways; so, crudely put, we try and find little bits that fit into the national story of migrant labor in South Africa. We create a local past out of a national past.

I want to finish with two more points in connection with this migrant labor museum. The first is tourism, which we haven't spoken much about. What imperatives are created in the tourist context of South Africa, where ethnicity is proclaimed and people come to South Africa to see 'tribes' in action? One of the major pressures on this museum was to make it a 'tribal' place, almost like a cultural village, rather than as a social history place. What do the tourists want? Do they want to see Lwandle as a form of cultural village?

The second thing is about xenophobia. The community I am talking about has a history of migrant labor, and in more recent years people from all over Africa are living in Lwandle: there are Somalis, Nigerians, people from Zimbabwe, Malawi, and elsewhere coming to live there. Now the museum has to deal with this situation. There are people who are xenophobic. They say, 'Who are these people? They should not be here.' So the museum has to somehow talk about this xenophobia and relate it to the story of a migrant labor past under apartheid that it has focused on. Yet for many residents of Lwandle there seems to be a disconnection—the present xenophobia is disconnected from the area's history of oppression through migrant labor.

Gonzalez:

My research focuses on local museums in Spain in a really peripheral, marginal area, and in Cuba I look at national stories—which in some cases overlap with Brazilian national stories. I'm going to try to frame a bigger picture, rather than just stick to my research. Basically I consider the Spanish case to be somewhat unique, because Spain is always going in different directions than the rest of Europe. I would argue the Hispanic world and the Anglo world are very different, with different traditions, ethnologies, and epistemologies.

In Spain we have this French idea of a museum, which is bureaucratic and quite different to the Anglo tradition of museum management and interpretation. Museum directors are always people from the world of culture and work within a broader framework. All of this explains why identity politics is not fundamentally important. Spain, Italy, and Greece are essentially emigrant countries, and consider themselves to be so. In the 1990s and 2000s, Spain received six to seven million immigrants, more than anywhere in the world, more even than the United States. However, there was never an identity politics associated with this phenomenon. No one ever spoke of multiculturalism, or integration, because we think of ourselves as immigrants.

So what *are* museums doing in Spain? Identity politics is professed at a traditional regional level. This is because of the new reorganization of the state after the Franco regime fell, which divided the country into regions; so we have Catalonia, the Basque region, Galicia, and so on. Some regions considered themselves to be nations within the nation, so they used museums to construct these national stories. Then there are older regions that consider themselves to be historic areas, and they also are engaged in this building of their stories through museums. But this precedent of building identity happens at all levels in Spain. We also have provinces. My province, León, has its own museum that somewhat legitimates the struggle to gain independence from the autonomous region of Castile-León.

So it is clear that everyone is trying to create a different identity without looking at what's going on in the world, which makes us quite provincial in terms of museum management, I suppose. This can be clearly seen in the local places and marginal areas where, say in the case study I presented here at the conference yesterday, there is a small village, Val de San Lorenzo, where half of the population emigrated to South America, Buenos Aires, Cuba, Mexico. But they don't talk about the immigration that comes in today, so how can they talk about emigration when they don't consider that topic to be the stuff of museums? Museums are places where beautiful objects are displayed and that's how they are mainly regarded in Spain. However, we also have quite postmodern stuff, like, you know, the Guggenheim museum in Bilbao or in Valencia, because in Spain tourism is about 15 percent of the GDP.

It seems to me that we have to consider museums within new theoretical frameworks. It is useful to talk about 'assemblages' of museums, cultural industries, cultural offers. In Barcelona, for example, there is a national history museum that counters museum narratives at the Spanish national level, but at the same time comes into an assemblage with museums from all over the world. It all comes together to create an offer to the tourist that is not only ideological, but that is also productive of businesses and many other things.

It's important to connect Spain with South America in many cases because UNESCO meetings have workshops in which people from Spain meet with people from South America, make common programs, and share experiences. In Cuba, Mexico, and other Latin American countries there is a mixture of Spanish-style museums, stemming from the local politics of the newborn states of the nineteenth century. Many people consider that nationalism began in South America. These museums, like the National Museum in Mexico City, legitimate the modern nation in the Aztec world. But this is a process of inclusion through exclusion, because in reality these communities are excluded, so what they are basing their identities on is an abstract idea of the Aztec, without really engaging with these contemporary marginalized communities. However, in South America you get a lot of projects that engage with local politics, and indigenous communities, so there is this complex relationship going on in both directions.

Roux:

Like Leslie, I work in the context of South African heritage and museums, and I would agree that perhaps we *do* have a different take on ideas of nationhood, 'multiculturalism', and diversity because of that history. An example that comes to mind from my own research is quite a small, very locally based community museum in Port Elizabeth in the Eastern Cape, called the South End Museum, which deals with a similar kind of narrative to that of the District Six Museum in Cape Town. It commemorates a neighborhood in Port Elizabeth, quite a cosmopolitan, diverse, mixed community that was ripped apart when people were separated by race into different parts of city in the 1960s under the Group Areas Act. The approach the museum's management has taken in the exhibitions has been to represent South End's diversity via a series of separate narratives and exhibitions that are culturally defined: so, for example, there's a display about the

Chinese 'community' of South End, a separate one on the Cape Malay 'community', and one on the Indian 'community'.

This is arguably problematic, because of course these all fall into the same kind of categorizations that were used by the apartheid state in order to disperse people. But the museum's management sees this approach as the best way to represent South End as a 'melting pot', or as a space where diverse cultures existed alongside each other. I think in the South African museum context, given the history of how ideas of culture and ethnicity have been used, addressing questions of 'multiculturalism' requires one to quite directly confront these complications and the baggage that comes with ideas of nationhood, ethnicity, and culture. Something that's also worth thinking about is the question of audience, which is related to the question of tourism, whether international, local, or national. That's something worth bringing into the discussion— the fact that a museum and an exhibition is addressed to someone. Is the museum addressing 'the nation', or is it addressing foreign visitors, or domestic tourists? Who is the public who is meant to be consuming this material, and what does that mean for the way that ideas about culture and ethnicity are being approached?

Ambos:

I'm an anthropologist and my research is not directly related to museums, but I study Sri Lankan healing traditions, which are put on a national stage as 'heritage'. These healing traditions were 'museumized' in the sense of being considered to be in need of revitalization and preservation, which entails a kind of freezing of these practices. I would like to pick up on what Philipp said with the intersection of different scales—the national, the global, and the local, for instance. I think it is very important we acknowledge this intersection to avoid the trap of creating new binaries or dichotomies. My research is concerned with how the translation from the local scale to the national scale works, what the shift from a local village healing ritual to a 'national heritage' means. I am looking where the ruptures occur in this process and where the translation breaks down, because this translation can never be smooth.

There's another topic that came up in several of the statements, namely, the acknowledgment that when we talk about globalization, transnationalism, and so on, we have to speak of winners *and* losers. For some groups these processes mean the opening of borders, crossing and transcending of boundaries, and increased mobility, but for others this implies confinement. The low-caste performers I study are not necessarily profiting or taking advantage of their local practices as they're elevated onto the national stage, but rather they are kind of confined in a corset of tradition, confined by notions of nationalism, of 'pure' Sinhalese Buddhist culture in the Sri Lankan context.

Another important aspect, which was mentioned by Jakob, points to the danger of abandoning the notion of ethnicity. As an anthropologist, I look at globalization from a locally anchored perspective. For people in Sri Lanka, ethnicity plays a vital role, because it is a lived reality. It is dangerous to deconstruct everything as that [reality] plays a very important role in negotiations of identity in these local contexts. And yet at the same time I want to suggest that this increased cultural exchange in the context of globalization has the paradoxical effect of increasing or enhancing the essentialization of identity, of trying to pin down identities and closing ethnic boundaries.

When I speak about heritage, that heritage is very much a normative discourse—a normative discourse in the sense that it imposes a very strict corset on a very plural and multiple articulation of reality. In the Sri Lankan context I found a shift in cultural policy from an emphasis on multiculturalism to transculturality. Transculturality in a double sense: the sense of transcending culture, that is, how a nation-state presents itself as something naturally grown, something acultural or culture neutral, something based on equal rights, democracy, and so on; and in the

second sense transculturality as an engulfing of the Other, other heritages, other cultures, by a dominant nationalist ideology. What you have in Sri Lanka, especially after the official end of the civil war in May 2009, is, for example, a redefinition of Tamil Hindu religious practices and elements as Sinhalese Buddhist heritage, or their assimilation within it. This kind of heritage politics is expressed in a museumization of cultural practices, an objectification of culture that always leads to asymmetrical power relations in which some groups become more visible and others remain invisible within the nation-state. Therefore, we have to think of heritage and museums as something *performative* that allow us to talk about contestations and dynamics, but on the other hand we also should acknowledge the *normative* aspects that cultural policy and heritage discourse bring with them.

Rassool:

This has been an absolutely fascinating discussion. Let me start with Conal's point of departure, and go back to our discussions at the Prato conference about museums in a transnational world and the possibilities of museums beyond the nation. That conference was also about the relationship between museums and historians and about the place of the discipline of history in the museum. Let me first give you my conclusion. We are living at a very interesting, complicated time in the world, characterized by such unevenness, such extraordinary change, in which we are witnessing the *end* of the museum as we know it. It's not just the end of the national museum; it's the end of the collecting museum. The authority of the museum as the collecting institution is called into question in a postcolonial world.

That argument does not arise in every society, because, as we are witnessing the end of the museum as we know it, we are still seeing the persistence of the national museum. Here, the contests over immigration and immigrant communities, and attempts to understand processes of globalization, are precisely some of the different ways in which the modern nineteenth-century museum tries to reproduce itself. All of the instruments of the modern museum through the international institutions that service the museum and heritage sector, the ethical frameworks, and definitions and committees of ICOM and so forth, all service the existing relationships within and between museums.

I'm speaking from the vantage point of being intimately involved right at the moment in the return of human remains from Austria to South Africa. In the middle of the negotiations, the key question was the authority of Austrian institutions to continue to hold these collections. Quite frankly, the deeper epistemic questions underlying these seeming transactions over individuated things are fundamental questions about the future of the museum. Because while the museum is the institution of the discipline of history, it is also the institution of a classificatory system in which the world was divided into societies of people with history and people without history. When you have postcolonial nations emerging and claiming to be nations they do that through the discipline of history and that calls into question the authority of older colonial disciplines.

Now we have many different kinds of institutions that are emerging that are calling themselves museums. In the District Six Museum in Cape Town we work with Museu do Maré in Rio de Janeiro and we've had a couple of exchanges. We participated in an IBRAM [Brazilian Museums Association] conference in Belém de Pará where we engaged in discussions about the ways in which ecomuseums, community museums, cultural centers, heritage projects, keeping places are precisely *not* about the collection. The museums are about something else, and it might be about a different way of telling a history of something. Those of us who are studying these processes examine it through engaged forms of historical practice outside the academy. Leslie

Witz and I and our colleagues have begun to refer to this as the 'practice of public history'. The other important museum forms that are emerging that might call itself 'museum' and that might call itself 'heritage' and that might call itself 'memory project' merge postconflict healing and transitional justice processes through which museums become places of historical narration. I don't know if they're postmuseums, if they are 'new museologies', or if they are museums beyond the collection. But the one thing that is becoming certain is that the future of the museum lies precisely in the source community relationship. This future lies in their transactions and in the connections between museum institutions in one society and communities and people in other societies.

Rethinking the relationship of the museum and the community is necessary because the nineteenth-century museum was not only about the nation, not only about particular modern disciplines and disciplinary institutions; it was also about the formation of citizens. So immigration and all of that are locked into the processes of citizen formation as regulation. Immigration museums tell the story of the extension of the boundaries of the citizenry, and how you come to know who you are through your national story, and who gets named as an immigrant and who does not get named as an immigrant. Really everyone's an immigrant when it comes down to it. But we are living at a time of tension. If the museum does not engage with that debate, then the museum has no future as an institution.

McCarthy:

Now we're able to open the conversation up. I'll kick off by mentioning another part of the world where these debates are echoed. Rhiannon and I were at a conference six weeks ago in Athens that was exploring how European national museums can create social cohesion within the EU: the Eunamus project. The Europeans at the conference were really struck by the fascinating presentations from Asia—which are not so well represented in museum studies. In Singapore the National Museum and Asian Civilization Museum present an idealized picture of the polyglot racialist state, with Malays and Chinese and Indians coming together in national harmony. As we learned here at this conference from the stream on China, there are nine thousand museums in the PRC now, and a new museum opens every day—the newly reopened National Museum in Beijing is now the largest museum in the world! These museums are very much about the majority Han Chinese civilization, which makes up 85 percent of the population, rather than the eighty or so minorities around the country. In northeast Asia, impressive new museums are symbols of the modern industrialized state. Taiwan, for example, where I lived for a while, boasts huge museum buildings that are obviously symbols of nationhood. But there are more people outside flying their kites on the lawn than inside.

Different parts of the world have really different situations, and scholarly perspectives have been limited to a few countries and writers have generalized about many things—settler colonies, for example. The literature on postcolonialism, nationalism, and museums often comes from places like Canada, Australia, and New Zealand, but the settler indigenous relations in new nation-states are not typical of other parts of the world. The other important thing for me, I think, which came out of our conversation, was the historical dimension mentioned by several of the people here. One of the problems with the scholarship on museums at the moment is modernity. Everyone talks about modernity, which is supposedly everywhere and nowhere, which is everything and nothing. So many things are ascribed to it and yet we can see premodern entities going right through this late modern period we are living in.

For example, in the Pacific a lot of Polynesian people think of themselves in all sorts of different kinds of ways. In nineteenth-century New Zealand, which became part of the British

Empire, settlers saw themselves as British and only later as New Zealanders, whereas a lot of Maori people saw themselves as 'brown Britains', because of the Aryanism that was a feature of the British Empire in the colonial period. At the same time they saw themselves as Maori, but in a number of ways simultaneously: there were subtribes, and increasingly tribes (itself, some argue, a colonial invention), but also a pantribal sense of indigenous nationalism, different to the kind of settler nationalism that appeared in the late twentieth century. This is a much more complex mix than is suggested by postcolonial theory today, which looks at contemporary society with its nationalism and identity politics, and tends to back-project that onto the past when those things didn't really exist.

Schorch:

To me it feels as if scholarship in general comes up with new categories like 'modern' or 'postcolonial' museums, imposing something that has been constructed in the present on a process or situation in the past. So all of a sudden we talk here at this conference about affect and emotions and so forth but it's just another intellectual abstract construction to make sense of something that has always been a unified whole. If you consider the human experience in all its complexity, people have always managed multiple identities just as we do all the time. You've got to focus on holistic complexity rather than dichotomous vocabulary.

At the same time we can definitely point out similarities: colonial migration, forced removal, in Australia there is the example of the 'Stolen Generation'. So there are always similarities and differences that allow us to communicate with the Other by creating this common sphere that is possible among human beings. Again it's not a monolithic understanding of a supposedly national framework—you have a difference within and you have the similarities between different states. What Conal said about modernity is likewise with 'hegemony', 'discourse', 'capitalism', 'state'—these categories are used as if they are self-enclosed totalities working at the bottom of society, whereas they are inherently contested terrains. Scholarship should open up the moments and processes when they are contested and really interrogate the complexity, rather than taking it as a self-evident point of departure.

Mason:

Yes—rather than looking at polarities and dichotomies, trying to see how the local and global are always interconnected shows how they are produced through the museum space. But I wanted to just pick up on this idea you were talking about Philipp, this looking back at the longer history of migration in museums, because it's exactly what they tell you, isn't it, when you go there and look at them: it's all about that, if you get past the ways it has been compartmentalized. But I *don't* think in the UK that that kind of cultural historians' understanding of the long trajectory of globalization is reflected in the way museum policy operates, because diversity is bracketed off as a post–Second World War thing, which is really problematic in the national narratives that circulate.

I started off looking at Wales, and you only have to scratch the surface of the history of South Wales, an industrialized area in the late nineteenth century, and you discover that it is full of stories of migration. But those stories were forgotten, they were pushed away in the processes of nationalism that sought to tell a unified story. Now I'm thinking about the longer history of migration that opens up the possibility of deconstructing the national narrative as it exists in Europe, and I still think there is a very important job to be done there because that isn't the way that the public discourses frame it. But on the other hand I suppose there is the problem that if you say we're all migrants, we have always been migrants, how do we do that on the one hand, but not downplay the very *different* experiences, the very structural inequalities for cer-

tain groups. I mean, look at the history of slavery—the migration that we're talking about there is radically different from what I'm talking about in an industrial area of Britain.

So I guess there are different political strategies in museums: one is about taking the core story and deconstructing that and the things that can flow from it and the possibilities it can open up for debates around citizenship and who belongs and so on; and the other is the kind of 'politics of recognition' that I think still has important things to do in certain places, because it still offers people a place to speak from and it draws attention to perhaps what is different and makes a very powerful political statement.

I'll just end by coming back to your question Leslie. You asked why are people interested in museums? What do they do that books don't do? It's tied into what I was just saying; people recognize them as an opportunity to make a move or a statement in the public sphere. In a sense, the question of *who* visits is a different part of the equation and it is very, very important. Who are migration museums for? Are they for migrants? Are they for the nonmigrant? Are they insulting for nonmigrants? Different political things are tied into these questions of the moves that are made in the public sphere in a national narrative, and these relate absolutely to these questions of who can be a citizen, who does the state acknowledge as a citizen, and do the different communities want to see themselves as citizens?

Parby:

I'd like to pick up on that one, specifically from a policy perspective. You need to realize how much political involvement and even self-censorship is at work in the museum sector, compared to, I guess, many intellectual traditions and different ways of critiquing modernity, which have really been common since the 1960s. There seems to be an apparent lack of the same critique in many museum and heritage practices, which leads to academic criticism. But what I often find is that, particularly with an issue that is so politically debated like migration, that any new initiatives are subject to a lot of political attention from the outside, but also create self-censorship among the people involved in doing them within the institutions. I think that's one of the main reasons why you often end up finding museums just reconstructing the nation in new ways and trying to pull in new groups within this unit of the national narrative.

The classification of cultures in museums is another important reason why museums have such a hard time trying to employ more relational ideas about identities or portray people and nations as constructed and negotiated. It is a complicated process to move in this direction, when a lot of the objects contained in most museums are collected and described in a way that is often closely connected to and embedded in the national narrative. It takes a lot of institutional and individual transformation to move beyond that mode of thinking.

Ambos:

Well, I'd like to comment on what Philipp said about the nation-state being contested and subverted. What I encountered in my research when I visited the homes of these performers, is that they have their own private family museums—their living rooms are backed with photos, newspaper articles, postcards, souvenirs. This material is ordered in a certain way, chronologically and in other ways. We should acknowledge what we might call these 'subaltern' articulations of the idea of the museum, of preserving something.

Cicalo:

Usually when we go to museums we think of a narrative. There is a narrative in the museum, even when the museum wants to be inclusive, a narrative about inclusion. I'm thinking maybe

the museum could be much more interesting if it was self-critical. I don't know if this is possible, but it would be a real challenge to have a museum where there is self-reflection about what this representation means and that conveys this kind of debate that we're having today, showing different opinions, different narratives.

Witz:

But I still don't understand this response to the notion of the museum as a public sphere. Why that institution? I mean a movie can do exactly that, can't it? What is the specific institutional role the museum has performed that makes it different?

Mason:

It's a truth claim . . .

Witz:

Yes, ok, it's a truth claim, but movies have also got truth claims, books have got truth claims—lots of things have got truth claims. But Ciraj has put on the table 'The End of the Museum'. I wonder if you are really talking about the destruction of that institution and its very foundational concepts of presenting facts and artifacts.

McCarthy:

You know you're doing Jakob out of a job [laughter].

Mason:

One thing that interests me is in this question about whether the museum as we have known it is moving into new territory. Could we look beyond the museum for a moment and just look at other things, like film, like television, literature, and so on, and expand our horizons a bit? Sometimes in museum studies we treat museums so independently, but of course people visit and engage with culture *across* a spectrum. The reason I think broadcasting, particularly TV, is interesting is that's it's a platform for different views, it's a *political* space. On the BBC you hear all sorts of political views that the BBC is not necessarily supporting, but there's some interesting questions there about authorship, about who is speaking, the debates you can have in a civil society, which might be interesting to play out against the museum, because I think a lot of these debates are about the voice with which the museum is speaking in a multicultural society.

Whitehead:

Moving on from the issues of the self-reflective museum, the end of the museum, and the issue of truth claims, I think one of the issues here is about the ostensible authorlessness of the traditional museum, if you like, and this is how its truth claim works in a sense. There is generally no name of the curator/writer under the label, not in the same way as there is with the director of a film or the author of a book. That authorlessness, a bit like with maps in some way, works to present a 'reality' that can't be questioned easily because there appears to be no one to question. The issue of self-reflection is a very interesting one. But then, of course, the issue is how to reconcile that with existing display technologies and existing expectations on the part of visitors about what they expect really, about the different codes of display and information delivery that we work with.

Then there's also another issue about conflict and how to frame that. If you get into a topic like migration you can historicize migration flow and hybridity in the deep past, or even in the

relatively recent but still closed past, relatively easily. But to historicize contemporary migration is difficult because it's such a matter of contention and conflict and difference of opinion. How do you actually do that? That also bears upon issues of neutrality and pluralism within the museum. Does a museum pretend to a morally neutral role? Can it continue to do so? Is that part of the end of a museum as we know it? Or does the museum have to take a position and propose a certain kind of pluralism, a certain kind of hybridization, as something to which society should aspire? What happens when you talk about admitting oppositional voices into the museum? In our project we've been looking recently at migration displays in museums in different countries where far-right political parties drop off leaflets that counteract or countermand the positive representations of immigration as a social good as seen in the museums. What do we do with those voices and how do we marshal them, how do we police that particular debate?

The last thing is the question of who museum representations are for. Is the museum the right place for a migrant to represent her- or himself, or to recognize themselves? Outside the Museum of Migration on the docks in Genoa are dozens of migrants selling goods on the pathways. The migrant community is very visible *outside* the museum rather than *within* it, so there is this disjunction between who we are speaking *about* and who we are speaking *to*. And this is also connected to this issue of the museum as a representation of globalization, as an outward gesture not as an inward one. So the museum, different from the film and the book, is a matter of international relations. It's a claiming of a geopolitical identity. What is different about the museum in this sense is its emblematism in this context.

Gonzalez:

Now I want to make some general claims about the analysis of museums and society that reflect my difficulty in this conference. I feel that our tools are already too outdated to deal with museums, because we are working within a postmodern frame in which there are really quick and internally complex assemblages and politics of things, museums, and political economy. And yet we keep on thinking as if museums are public institutions within public experiences and have a massive stake in dialogue and truth. But they are not. The museum cannot help with this, because there are always people, psychological authors, who are going to invest desire and money to push some strands forward—by that I mean nationalism, money, tourism, work, and so on.

It's still important to discuss the concepts of scale—global, regional, and local—because even my local museum in my city is connected to global flows. But I really don't think it's interesting any more to talk about, or to compare, 'national' and 'local' museums, because they are engaging in the same flows. The main thing is what they are doing specifically, in specific places. In Spain, 99 percent of museums are not national museums. Are they local museums, regional museums, or widespread museums? There's no barrier, totally the contrary. Obviously we look, first, at the national museum because it provides us with that narration we can deconstruct and criticize. But museums don't care about that, they are constructing and deconstructing something new all the time, and we are already lagging behind them. There's all these people constantly investing time, energy, identity, and money and creating symbolic capital and new identities, just as you said, Leslie.

Lastly, it's important not to split economy from culture because in our countries, the countries that have a lot of their GDP percentage in tourism, we cannot afford to create narrations, as in Britain or Sweden, that are a representational view of our identity, of making a claim. Rather, our identities are the by-product of these complex networks and assemblages. Art, tourism, and so on are our by-products, and we cannot only deal with the by-products, but must analyze what's going with that identity to be constructed. So I think our analytical tools should grow

from discourse and deconstruction to an analysis of what's going on behind and what spreads about in this 98, 99 percent that we are leaving behind.

Rassool:

As I've been listening to the second round of discussion, what comes out most powerfully is that we should stop using museum as a *noun*, and that we should start thinking about museum as a *verb*. We are living in a time of multiple, contested museumifications and museumizations, in which identities are continuing to be rendered as a museum display, through tourist gazes and the reproduction of cultural images that are limited. South Africa continues to be seen as animal and tribal as a tourist destination, which poses severe limitations on its capacity to be democratic and postracial, as if its Africanness is forever ethnic. And so the kinds of museum institutions that emerge around Cultural Villagization represent one of the contested museumifications. At the same time, some of the important processes of museumification involve taking issue, in quite an activist way, with those kinds of images and framings, in which museums become social projects of intervention about the way we understand the world. If we try to understand the processes of museumification and museumization at the center of what we are doing, understanding the knowledge transactions through which the museum project occurs, then every process of museumification involves a set of knowledge relations in which expertise is wielded, in which community knowledge is appropriated, in which authenticity is claimed. We need to really take the idea of the museum as verb in much the same way that it is better to think of *identification* as a verb as opposed to *identity*. Then we have more interesting ways of understanding the processes that are unfolding so we can continue to intervene in those processes.

Whitehead:

But is it a passive or an active verb?

[With lots of laughter, the conversation came to an end.]

▪ WEBSITES

EUNAMUS: European National Museums: Identity Politics, the Uses of the Past and the European Citizen. http://eunamus.eu. (accessed 8 October 2012)

MeLa: European Museums in an Age of Migrations. http://www.mela-project.eu/ (accessed 9 October 2012).

National Museums in a Transnational Age: A Conversation Between Historians and Museum Professionals. 1–4 November 2009. http://www.globalmovements.monash.edu.au/events/2009events.php. (accessed 10 October 2012)

▪ REFERENCES

Appadurai, Arjun., and Carol A. Breckenridge. 1999. "Museums are Good to Think With: Heritage on View in India. " Pp. 404–420 in *Representing the Nation: A Reader: Histories, Heritage and Museums*, ed. David Boswell and Jessica Evans. London: Routledge; New York: Open University.

Beck, Ulrich. 2006. *Cosmopolitan Vision*. Trans. C. Corin. Cambridge: Polity Press.

Healy, Chris, and Andrea Witcomb, eds. 2006. *South Pacific museums: Experiments in culture*. Melbourne: Monash University ePress.

Message, Kylie. 2006. *New Museums and the Making of Culture*. Oxford: Berg.

REPORTS

After the Return

Digital Repatriation and the Circulation of Indigenous Knowledge Workshop Report

Joshua A. Bell, Kimberly Christen, and Mark Turin

■ ABSTRACT: On 19 January 2012, the workshop After the Return: Digital Repatriation and the Circulation of Indigenous Knowledge was held at the Smithsonian Institution's National Museum of Natural History in Washington DC. With support from the National Science Foundation and the Smithsonian's Understanding the American Experience and Valuing World Cultures Consortia, this workshop brought together twenty-eight international participants for a debate around what happens to digital materials after they are returned to communities (however such communities are conceived, bounded, and lived). The workshop provided a unique opportunity for a critical debate about the very idea of digital return in all of its problematic manifestations, from the linguistic to the legal, as indigenous communities, archives, libraries, and museums work through the terrain of digital collaboration, return, and sharing. What follows is a report on the workshop's presentations and discussions.

■ KEYWORDS: access, collaboration, circulation, collections, digital return, knowledge, museums

On 19 January 2012, we, the authors, convened a workshop entitled After the Return: Digital Repatriation and the Circulation of Indigenous Knowledge at the Smithsonian Institution's National Museum of Natural History (NMNH) in Washington DC.[1] With support from the National Science Foundation (Grant No. 7115841) and the Smithsonian's Understanding the American Experience and Valuing World Cultures Consortia, this workshop brought together twenty-eight participants for two and half days of sustained and open debate around what happens to digital materials after they are returned to communities (however such communities are conceived, bounded, and lived).

This workshop emerged from ongoing discussions and from lessons learned from our respective fieldwork, interactions in and around museums, and digital explorations. As we explored in the workshop, it is clear that giving and receiving are rarely monodirectional or linear, and have to be thought of as reciprocal and cyclical ongoing processes (Bell 2008, 2010; Christen 2005,

Museum Worlds: Advances in Research 1 (2013): 195–203 © Berghahn Books
doi:10.3167/armw.2013.010112

2009; Turin 2007, 2011). Indigenous communities, museums, archives, and libraries, as well as individuals and family groups, are increasingly using digital materials in sophisticated and intersecting ways (e.g., Boast et al. 2007; Geismar and Mohns 2011; Salmond 2012). This use productively builds on and is in dialogue with the complex ways communities have been and continue to use visual media to assert their sovereignty, challenge the terms and nature of representation, and create new intercultural dynamics (cf. Ginsburg et al. 2002). At the same time, the institutions and scholars engaged in processes of return and 'repatriation'—whether these are digital or analog objects—continue to grapple with ever more complex notions of circulation and the ethical dilemmas and institutional barriers with which they were associated (e.g., Peers and Brown 2003; Coombe 2009; Philips 2012).

Critically engaging with these issues, the Digital Return workshop was thus born out of our collective desire to initiate a wider discussion with a diverse group of practitioners and community members who had been engaged in similar projects for many years. The workshop provided a unique opportunity to nurture further interaction, and to facilitate critical debate about the very idea of digital return in all of its problematic manifestations, from the linguistic to the legal. Digital repatriation can be a contentious term that generates reflex assumptions about the relationship between digital and material forms of cultural heritage materials. While it may be tempting to assume, at first glance, that the digital object—as a surrogate—somehow *replaces* the physical object, no standard definition, nor agreed-upon terminology, characterizes the multiple practices of collecting institutions, individuals, or local community groups surrounding the return of cultural and historical materials to indigenous communities in a digital form (Cameron and Kenderdine 2007). Digital surrogates are not always intended to replace, or be synonymous with, the physical materials that they may represent. Instead, digital (or digitized) cultural materials may also provide an alternative form of—and dynamic life for—certain physical objects. Such newly digitized and repatriated materials may be the impetus for linguistic or cultural revival, spur contention and disagreement, prompt new cultural forms or popular products, incite new collaborations, and engender new types of performances and artistic creations.

One of the most promising and dynamic sites for anthropological collaboration with indigenous communities has been in the field and practice of digital repatriation. Over the last twenty years, collecting institutions—museums, libraries, archives, and individual scholars—have heeded calls by indigenous peoples to integrate indigenous curatorial models and understandings into mainstream museum and archive practices, from cataloguing to display modes (e.g., Karp et al. 2006; Crowell et al. 2010; Christen 2011). With the growth of new digital technologies, anthropologists, museum professionals, and indigenous communities have collaborated to produce new models for the creation, circulation, and reproduction of knowledge and cultural materials. The more recent development of Web 2.0 technologies grounded in user-generated content and bottom-up exhibition and display techniques has produced a dynamic platform for sharing materials. Web-based photo-sharing platforms such as Flickr and, more recently, online publishing tools like Omeka allow people to take advantage of low-cost or no-cost technologies to create exhibits and circulate physical objects in their digital form.[2]

This newly animated digital terrain poses both possibilities and problems for indigenous peoples as they seek to manage, revive, circulate, and create new cultural heritage materials. While digital technologies allow for materials to be repatriated quickly, circulated widely, and annotated endlessly, these same technologies pose challenges to indigenous communities who wish to maintain traditional cultural protocols for the viewing, circulation, and reproduction of these new cultural materials. Many indigenous communities wish to maintain control over the circulation of certain types of knowledge and cultural materials based on their own cultural systems (Christen 2009). Digital technologies and the Internet have combined to produce both the

possibility for greater indigenous access to material collections held in collecting institutions, as well as a new set of tensions for communities who wish to control these materials and thereby limit their access and circulation. Although many museums, archives, and libraries have been quick to acknowledge indigenous knowledge models and provide digital surrogates for communities who request them, these institutions have not attempted to systematically track *how* or *if* these materials have subsequently been used, reused, altered, and reframed.

Until now, most of the research on digital repatriation has focused on the *act* of giving back; less attention has been paid to *how* these materials are *circulated* and *accessed* once they are 'home'; that is, *what* happens once digital materials are returned? This set of questions leads to others: How are these materials controlled and circulated within the community? Do they serve different purposes for local communities and other interested parties? How does the mode of access—an institutional online catalogue versus an indigenous Web portal—impact the practices of knowledge creation or revitalization? How are these newly formed cultural materials used within local social and cultural systems? Can digitally repatriated objects facilitate new knowledge creation and the revitalization of endangered languages and cultural practices simultaneously? If so, how are they mobilized within these projects? Can these projects inform international debates concerning indigenous traditional knowledge protection and the promotion of indigenous intellectual property rights? These are just some of the contentious questions that the participants of our workshop sought to address.

"If the digital is so good, why don't you keep it?"

We were privileged to have Jim Enote, the director of the A:shiwi A:wan Museum and Heritage Center at Zuni in North America, as the keynote speaker at the workshop.[3] Moving deftly from a narrative reflecting on his grandmother's humility about her global connections as an artist to the necessity of tribal control and ownership of cultural materials, Enote's keynote emphasized the generative possibilities of new media alongside the necessity of tribal involvement from the ground up. Despite his enthusiasm for the workshop, he was pointedly critical of the idea of digital repatriation, and noticeably more comfortable with the more neutral terminology of return. If digital surrogates were so good, Enote reasoned, why didn't the institutions, researchers, and scholars keep them, and return the original, nondigitized, analog object to the community instead?

Enote's welcome provocation about aspects of repatriation—what the process truly constitutes—and the responsibilities of giving and circulating knowledge stayed with us throughout our two and half days of discussions, and served as powerful inspiration for many of the presentations that followed. His address reinforced why we had organized the workshop with the notion of 'return' specifically to signal it as an umbrella under which many different forms of practices—repatriation being just one—could be clustered, each of which had specific impacts and value for different contexts. Enote's keynote address served to remind us that there are many types of return, and they are all always already embedded in the relationships and histories of the past and at the same time point to possibilities for the future. His desire to push us past the notion of repatriation as the return of digital copies underscores the need to unpack all the circulation routes of digital materials—as they become digital and move into multiple spheres of interaction.

The workshop was organized along four overlapping thematic lines, each of which was broken up by shorter presentations that focused on how the work undertaken at the Smithsonian Institution was reconnecting indigenous communities with cultural and linguistic materials through both physical and digital repatriation and return projects. The first day of the work-

shop focused on the first two themes, and the second day of the workshop focused on the other two themes.

1. *Collaborations and communications* highlighted the issue of forging the partnerships—face-to-face as well as with and through technology—that are needed to facilitate the return of cultural and linguistic materials. Collaborators addressed the challenges and successes of their joint projects and relationships. Panelists Guha Shankar (American Folklife Center, Library of Congress) and Cordelia Hooee (Librarian, Zuni Public Library); Kate Hennessy (Simon Fraser University), Mervin Joe (Inuvialuit Living History project team), and Stephen Loring (Smithsonian); and Peter Brand (Director, First Voices) and Victoria Wells (Ehattesaht community member and language activist) spoke frankly about what it takes to form and sustain such relationships, as well as what factors can impede long-lasting partnerships.

Shankar and Hooee (in absentia) presented their respective perspectives from their institutions in relation to the return of the Doris Duke Zuni Storytelling collection. They dwelled upon the necessity of tribal involvement in the process of return, but highlighted the many institutional and tribal roadblocks that can lie in the way of such projects. In particular, they emphasized the need for open channels of communication and multilevel approaches to digital return projects. Hennessey, Joe (who joined us via Skype due to a snow storm), and Loring elaborated on their collaboration to research and document the Smithsonian's MacFarlane Collection as part of the Inuvialuit Living History project (http://www.inuvialuitlivinghistory.ca/). Emerging out of the Reciprocal Research Network (RRN), the group is creating a digital 'living archive' to explore the divergent but ultimately connected histories that these materials contain and give rise to. A key aspect of the project's methodology is the way that it explicitly involves members of different generations to facilitate the construction of the digital collections and support the flow of knowledge among the project team. For their contribution, Brand and Wells discussed their working partnership using the First Voices language tool suite. With practical advice and examples of technological necessities and cultural needs, they showcased how tribal involvement leads to flourishing language programs on the ground in First Nations communities. They also demonstrated how trust, respect, and mutual recognition lie at the heart of this project, and indeed have to permeate all effective digital collaborations. For Wells, who hails from the Ehattesaht community in Canada, the terms repatriation and return were to be encouraged, as both the words themselves and the practices that they refer to convey and entail respect. She saw the political act of return as connecting to types of repatriation she had observed in her community and other First Nations aboriginal communities. All of these collaborations have been forged at the crossroads of digital technologies, national and local repatriation movements, the desire for cultural and linguistic revitalization, and the ongoing creation of culture and cultural practices within indigenous communities.

This panel was followed by presentations by Jennifer O'Neal (formerly head archivist of National Museum of American Indian and Günter Waibel (director of the Smithsonian Digitization Program). O'Neal enumerated on issues involved in the digitization and circulation of the NMAI's rich holdings. She addressed the complications that emerged when working to integrate diverse materials in George Gustav Heye's founding collection as part of making them more accessible, alongside the need to navigate their messy trajectories and legacies in relation to the expectations of indigenous communities. Waibel chronicled a collaboration between the Smithsonian Institution and the Tlingit community of southeast Alaska through new 3-D digital technologies. Describing the imaging and 3-D rendering of Tlingit sacred objects, he charted out new ways that museums can become repositories for digital renderings, which can then be reactivated as needed by tribes.

2. *Returned and received* focused on how digital materials are received when multiple stakeholders are involved. Aaron Glass (Bard College), Jane Anderson (University of Massachusetts and New York University), and Surajit Sarkar (Ambedkar University) each referred to their respective projects to probe the interaction between and within indigenous communities, nation-states, collecting institutions, and local and regional communities as they relate to the return and reception of digital materials. Each of these stakeholders interact with and have specific claims to the preservation and circulation of such cultural materials and the attendant knowledge embedded within them, and this panel of the workshop addressed the intended and unintended consequences of returning materials.

Glass elaborated on his work to connect Northwest Coast collections to communities. Specifically, he reflected on the collaborations that informed his exhibit *Objects of Exchange: Social and Material Transformation on the Late Nineteenth-Century Northwest Coast* at the Bard Graduate Center (Glass 2011) (http://www.bgc.bard.edu/gallery/gallery-at-bgc/past-exhibitions/focus-gallery-2.html), and his current project to reassemble and connect the various materials that informed Boas's 1897 monograph *The Social Organization and the Secret Societies of the Kwakiutl Indians,* which are now dispersed between different institutions, thus reanimating the various collaborations elided by Boas and the medium of a book (http://digitalreturn.wsu.edu/presentation/the-distributed-text-a-critical-digital-edition-of-franz-boass-1897-monograph/). For her part, Anderson presented aspects of her collaboration with Kim Christen. Doing so, she charted out the conceptual and practical difficulties that indigenous peoples and communities have with current intellectual property law. The presentation elaborated on their collaboration to create and distribute an innovate network of licenses and labels. These are delivered through an accessible and informative digital platform designed to address the complex intellectual property needs of indigenous peoples, communities, and collectives wishing to manage, maintain, and preserve their digital cultural heritage. The presentation raised important points in relation to how Intellectual Property regimes can be used to help protect indigenous communities in the ongoing struggle for legal, political, and social recognition within the digital domain. Broadening the geographic scope of the workshop, Sarkar gave a compelling account of six years of performances in the Catapult Arts Caravan in northeast and central India. A unique opportunity for community members to comment in public on visual and audio explorations of heritage, the Catapult Arts Caravan invites community commentaries to become part of the public spectacle. Sarkar outlined how these contexts provide critical outlets for public discourse, criticism, and reconciliation within the community. His contribution pointed to important aspects of digital return in the Global South, where differently configured indigenous and political realities affect the circulation of objects and ideas.

3. *Access and accountability* dealt with the forms of access to and relationships with digital and material objects that occur during archival processes. Aron Crowell (Smithsonian), Sue Rowley (University of British Columbia), and Robert Leopold (Smithsonian) discussed the practical matters that arise during large-scale digitization projects with indigenous communities as well as the ways in which digital technologies can bridge some circulation divides that emerge during this process. Each looked at both macro and micro levels to explore how the digital return of materials could take into account the sensibilities and cultural needs of indigenous communities while also working within and through large institutions. The presenters also described how both sides were altered through the resulting collaborations.

Crowell reflected on a decade-long series of collaborations with communities in the Alaska region that contributed to the Sharing Knowledge Project (http://alaska.si.edu/) and the linked exhibit *Living Our Cultures, Sharing our Heritage: The First Peoples of Alaska* (Crowell et al.

2010). Crowell demonstrated the effectiveness of bringing communities into conversations with collections, and addressed the challenges involved in recording, transcribing, and then presenting such knowledge to local and global audiences. Rowley gave an account of the last five years of creating and maintaining the Reciprocal Research Network (RRN). Involving nineteen institutions to date, the RRN is a unique and compelling model of intra- and interuniversity and museum collaboration with First Nations communities of Canada and, now, with other indigenous communities. Emphasizing the technical support needed across institutions, Rowley candidly detailed the long-term goals of network integration that are necessary to support larger projects. Rowley underscored an ongoing issue found throughout the workshop: digital collaborations only succeed when they are built on solid, ongoing social relations. In other words, the digital does not replace the social, but can rather help to reinforce and enable capacities that were otherwise not obtainable. Drawing on his former experience as director of the Smithsonian's National Anthropological Archive, Leopold examined the impact and complications of the return of digitized Cherokee manuscripts collected by James Mooney for the Cherokee. Taking as his starting point the gap between archival intentions and the needs of communities, Leopold examined how the dynamics of collecting play out in unusual and unexpected ways when materials are returned. Leopold provided a candid account of the different expectations and realities of such collaborations.

Following this panel, Jake Homiak, director of the Collections and Archives Program for NMNH's Department of Anthropology, reflected on the responsibilities of caring for NMNH's vast and varied collections in multiple media. He highlighted projects that are working to capitalize on the collections to engage communities more widely in the mutual production of knowledge.

4. *Circulation and transformations* looked broadly at the transformation of knowledge as a result of the circulation between communities and institutions. Lise Dobrin (University of Virginia), Gary Holton (University of Alaska Fairbanks), Haidy Geismar (New York University), and Rosemary Coombe (York University) discussed how endangered languages, cultural materials, intellectual property, and ephemera intermingle in divergent ways through the process of return. Although transformation can happen with any type of engagement, these presentations examined the particulars of return practices that presuppose complex political, social, historical, and legal situations involving the return of cultural and linguistic materials. Through their concrete case studies, these presentations addressed the process by which research findings at once resonate with local interests but may also become politically contested.

Both Dobrin and Holton reflected on techniques and opportunities in digital language documentation projects in their respective work in Papua New Guinea and Alaska. Each examined how generational shifts have transformed community attention to language. In each case, these shifts have reawakened community interest in documentary materials and the relationships drawn on and created by the respective projects. Through their reflections on their experiences, they reminded us how such collaborative work is processual, and how the continued access and transformative nature of the work is extended by the digital in various ways. Geismar provoked participants to think about how the digital is the new analogue, by which she means the horizon by which all media is understood and against which it is measured. Drawing on the notion of remediation and translation, Geismar reminded us of what it is that the digital does and does not do, and how it is inextricably connected to earlier media forms. Pulling together many of the themes discussed throughout the two days, Coombe moved from international indigenous movements to the need for larger sets of policies that could unite the work of indigenous communities while also leaving open the possibility of multipronged solutions, including a fundamental rethinking of Intellectual Property Rights in relation to digital heritage.

Collectively, these presentations, which will be brought together in a special issue for *Museum Anthropology Review,* contribute a new set of theoretical insights into the processes and practices of knowledge creation and cultural and linguistic revitalization in relation to digital materials. By emphasizing the *practices* that emerge from digital return, the workshop helped to document the many, varied ways in which digital repatriation works (or does not), while also theorizing the terrain of repatriation by documenting the day-to-day uses that grow out of its implementation. Rather than merely asking *if* such materials should be repatriated, these presentations focused on materials that have already been digitally returned in an attempt to lay bare the *types* of cultural, linguistic, and social work these objects can engage in after they are returned. If digitally returned materials have unexpected uses and create new knowledge, how do we understand the role of giving back and receiving in relation to material culture? How can we reconceptualize the ethical questions of return when digital surrogates rather than the objects themselves are at stake? The workshop offered a way in to these questions by providing specific details and historic analysis of long-term projects.

By emphasizing the applied nature of digital return, the workshop's presentations highlighted the processes of labor and partnership that are part of the digital. In that way, they undo the mystification of much digital analysis and point to the types of knowledge circulation that form a tableau of interaction. Rather than fall back on the metaphors of the superhighway, or Web 2.0 notions of user-generated content and more recent calls for a focus on 'big data', the workshop helped emphasize a digital terrain that is enmeshed with the everyday practical and oftentimes messy and contradictory fields of relation, respect, and reciprocity, which cannot be reduced to a singular metaphor. As we collectively continue to engage with types of return, we can open up the possibilities for knowledge creation by the act of entering into lasting relationships. Digital return is structured by both the digital, which allows for multiplicity, and the act of return, which builds off ethical systems of relationships.

JOSHUA A. BELL is curator of globalization and director of the Recovering Voices Initiative at the Smithsonian Institution's National Museum of Natural History. Combining ethnographic fieldwork with research in museums and archives, Dr. Bell's work examines the shifting local and global network of relationships between persons, artifacts, and the environment. While the bulk of his research has been carried out in collaboration with communities in the Purari Delta of Papua New Guinea, with Joel Kuipers at George Washington University, and a team of researchers, he is conducting a new project that examines the use, meanings, and repair of cell phones in the Washington DC metropolitan region.

MARK TURIN is a linguist and anthropologist. Before joining the South Asian Studies Council at Yale, Mark was a research associate at the Museum of Archaeology and Anthropology at the University of Cambridge. Now colocated at Cambridge and Yale, Mark directs both the World Oral Literature Project and the Digital Himalaya Project. He is the author or coauthor of four books, the editor of seven volumes, and the editor of a new series with the Cambridge-based Open Book Publishers. He is the program director of Yale's new Himalaya Initiative.

KIMBERLY CHRISTEN is an associate professor in the Department of Critical Culture, Gender and Race Studies and the director of digital projects at the Plateau Center for American Indian Studies at Washington State University. Her research focuses on the intersection of digital technologies, archival practices, cultural heritage movements, and intellectual prop-

erty rights within indigenous communities and the global commons. Dr. Christen is currently directing the Plateau Peoples' Web Portal (http://plateauportal.wsulibs.wsu.edu/), an online collaboratively curated site for Plateau cultural materials, and Mukurtu CMS (www .mukurtu.org<http://www.mukurtu.org/), a free, open-source digital archive and content management tool designed to meet the needs of indigenous communities as they manage and share their digital cultural heritage.

▪ NOTES

1. The workshop resulted in two key outputs: a website (http://digitalreturn.wsu.edu) that acts as an ongoing research network hub for cataloguing digital return projects globally and linking communities to resources, and a special issue of *Museum Anthropology Review* containing articles from a majority of the invited participants (this will be published June 2013). This workshop report is based in part on the Introduction to that special issue written by the three conveners of the workshop: Joshua A. Bell, Kimberly Christen, and Mark Turin.
2. Flickr is a photo-sharing site that allows users to upload, annotate, comment on, and provide access to their personal photos. Omeka is an exhibition platform tool that allows individuals or institutions to use template-based sets to produce their own online exhibitions.
3. A farmer, an artist, and a cultural visionary, Enote received the 2010 Council of Museum Anthropology's inaugural Michael Ames Prize for Innovative Museum Anthropology in recognition of his pioneering work over many years that has included a number of projects with digital components (e.g., Srinivasan et al. 2010). The full keynote can be found at http://digitalreturn.wsu.edu/workshop/.

▪ REFERENCES

Boast, Robin, Michael Bravo, and Ramesh Srinivasan. 2007. "Return to Babel: Emergent Diversity, Digital Resources, and Local Knowledge." *The Information Society*, 23 (5): 395–403.

Bell, Joshua A. 2008. "Promiscuous Things: Perspectives on Cultural Property Through Photographs in the Purari Delta of Papua New Guinea." *International Journal of Cultural Property* 15 (2): 123–139.

Bell, Joshua A. 2010 "Out of the Mouths of Crocodiles: Eliciting Histories with Photographs and String Figures." *History and Anthropology* 21 (4): 351–373.

Cameron, Fiona, and Sarah Kenderdine. 2007. *Theorizing Digital Cultural Heritage: A Critical Discourse.* Cambridge: MIT Press.

Christen, Kim. 2005 "Gone Digital: Aboriginal Remix in the Cultural Commons." *International Journal of Cultural Property* 12: 315–345.

Christen, Kim. 2009. *Aboriginal Business: Alliances in a Remote Australian Town.* Santa Fe, NM: School of Advanced Research Press.

Christen, Kim. 2011. "Opening Archives: Respectful Repatriation." *American Archivist* 74: 185–210.

Coombe, Rosemary J. 2009 "The Expanding Purview of Cultural Properties and their Politics." *Annual Review of Law and Social Sciences* 5: 393–412.

Crowell, Aron A., Worl, Rosita, Ongtooguk, Paul C., and Dawn D. Biddison 2010. *Living Our Cultures, Sharing Our Heritage: The First People's of Alaska.* Washington DC: Smithsonian.

Geismar, Haidy, and W. Mohns. 2011. "Database Relations: Rethinking the Database in the Vanuatu Cultural Centre and National Museum." In "The Aesthetics of Nations: Anthropological and Historical Approaches," ed. C. Pinney and N. Mookherjee. Special issue, *Journal of the Royal Anthropological Institute* NS: S133–S155.

Ginsburg, Faye, Lila Abu-Lughod, and Brian Larkin, eds. 2002. *Media Worlds: Media Worlds: Anthropology on New Terrain.* Berkeley: University of California Press.

Karp, Ivan, Kratz, Corinne A., Szwaja, Lynn and Ybarra-Frausto, Tomas ds. 2006. *Museum Frictions: Public Cultures/Global Transformations*. Durham, NC: Duke University Press.

Peers, Laura L., and Alison K. Brown, eds. 2003. *Museums and Source Communities: A Routledge Reader*. London: Routledge.

Phillips, Ruth B. 2012. *Museum Pieces: Toward the Indigenization of Canadian Museums*. Montreal: McGill-Queen's University Press.

Salmond, Amiria. 2012. "Digital Subjects, Cultural Objects: Special Issue Introduction." *Journal of Material Culture* 17 (3): 211–228.

Srinivasan, Ramesh, Boast, Robin, Becvar, Katharine and Enote, Jim 2010. "Diverse Knowledges and Contact Zones Within the Digital Museum." *Science, Technology, & Human Values* 34 (5): 735–768.

Turin, Mark. 2007. *Linguistic Diversity and the Preservation of Endangered Languages: A Case Study from Nepal*. Kathmandu: ICIMOD.

Turin, Mark. 2011. "Born Archival: The Ebb and Flow of Digital Documents from the Field." *History and Anthropology* 22 (4): 445–460.

International Seminar on Museums and the Changing Cultural Landscape, Ladakh

Conference and Project Report

Manvi Seth

The international seminar on Museums and the Changing Cultural Landscape, coordinated by Dr. Manvi Seth, was organized by the department of museology in the National Museum Institute of History of Art, Conservation and Museology in collaboration with the Ladakh Autonomous Hill Development Council (LAHDC) from 2–4 September 2012 at the Central Institute of Buddhist Studies (CIBS), Leh, Ladakh, India.

The aim of the seminar was to explore museums' potential to be platforms for documenting, representing, and communicating sociocultural change in the context of Ladakh. The seminar endeavored to encourage fellow museologists, museum professionals, and other scholars of culture and heritage studies to discuss, share, and advise on the possible forms of a museum for Ladakh. The intent was that the seminar would help initiate the process of planning a museum for Ladakh in a manner appropriate to the people and region.

Ladakh is one of the highest inhabited places on earth, with a culture that remained isolated for centuries. The heritage, natural and cultural, of the region is unique, the community is close knit, and the rich culture is ruffled by the ever-growing avalanche of tourists and the information explosion only in tourist spots and in the main city, Leh. There is a growing realization of the need to preserve cultural traditions alongside balancing the pressures of modern needs. In recent years there has been an increasing insistence in Ladakh that there should be a museum in Leh showcasing all aspects of Ladakhi culture. There are many monasteries in Ladakh that serve as museums of Buddhist religion, art, and culture; some of these monasteries have opened small museums and many others are in the process of setting up similar museums. The projected museum in Leh aspires to collect, document, and represent all aspects of a Ladakhi heritage, life, and culture in their tangible and intangible manifestations. It seeks to become a platform not merely for preserving physical collections but for connecting the younger generation with their own identity, for stimulating dialogue on the present issues concerning culture, and for providing a mechanism for understanding and channeling the future course of cultural change. It also hopes to answer questions such as: In view of fast-disappearing traditional community centers and cultural platforms, can museums fill the void of documenting and representing the past, present, and future of Ladakhi sociocultural stories and identities? How effective is the process of involving people at all levels in setting up a museum? Should not members of the community answer whether they require a museum in the first place and, if yes, what should be the form, nature, characteristics, and functions of such a museum?

Museum Worlds: Advances in Research 1 (2013): 204–205 © Berghahn Books
doi:10.3167/armw.2013.010113

The seminar was attended by international scholars, museum experts, and academicians from other parts of India and by local Ladakhi scholars. It was very encouraging for the organizers and participants to have received messages from the president of the International Council of Museums (ICOM) and from UNESCO. Julien Anfruns, director general of ICOM, told the seminar, "I salute this initiative by our Indian colleagues to reflect upon the role that museums can fulfil within communities." Francesco Bandarin, assistant director general for culture at UNESCO, provided the following message, to be read at the inauguration: "From the outset, allow me to congratulate the department of Museology of the National Museum Institute (NMI) and the Ladakh Autonomous Hill Development Council for placing emphasis on community participation and the potential of museums to serve as platforms for socio-cultural change."

Paper presentations in the seminar were on various aspects of development of a museum, such as conceptualization, building of collections, documentation, communication, community participation, and intangible cultural heritage. Ladakhi scholars spoke about the cultural history of Ladakh; the cultural similarities between Central Asia and Ladakh; the memories and knowledge outside the monasteries; the Islamic and Buddhist heritage of Ladakh; the traditions of Ladakhi people; the need to preserve the intangible heritage of Ladakh; and much more. International speakers and scholars from other parts of India deliberated on theoretical and methodological issues, such as: why visit museums?; will the museum be an active or a passive space?; who are the audiences going to be?; documentation of cultural heritage; Ladakh as a cultural and living museum; the process of conservation and reconstruction; the importance of keeping alive the link between the object and its context; the need for keeping the visitors at the heart of the museum; making the community the stakeholder; cultural mapping; and so on.[1]

The seminar was accompanied by the opening, on 1 September 2012, of a photographic exhibition, *The First Frames: In the Footsteps of Early Explorers.* The exhibition brought to the people of Ladakh some of the earliest photographs of Ladakh and Tibet. The exhibition represented the collection of photographs and fresco tracings (1947–1949) of Li Gotami from the Chhatrapati Shivaji Maharaj Vastu Sanghralaya (CSMVS), Mumbai; the photographs of the German archaeologist August Hermann Francke (1909) from the digital photographic collection of the Library of the University of Leiden; and archival photographs (1960s) of Ladakh from the photo archives of Archaeological Survey of India (ASI). The exhibition aspired to rekindle, in these fast-changing times, memories of earlier life, culture, architecture, and religion in the Western Himalayan region.

Manvi Seth, *National Museum Institute, New Delhi*

NOTE

1. Presenters included: Monisha Ahmed, T. Richard Blurton, Nawang Tsering Shakjspo, G. M. Shiekh, Sonam Gyatso Tukchu, Yutaka Hirako, Lobzang Tsewang, John Harrison, Janhwij Sharma, Nelly Rieuf, Nawang Tsering Phey, K. Mukhoupadhyay, Soumendra Mohan Patnaik, Khanchen Tsewnag Rigzin, Eithne Nightingale, Xerxes Mazda, Karen Chin Ai Ying, Abdul Ghani Shiekh, Andrew Pekarik, Jamyang Gyaltson, Rajesh Purohit, Shaguna Gahilote, Gerda de Theuns Boer, Khanpo Konchok Phandey, Khonchok Rigzen, Anamika Pathak, R. C. Agarwal, Mika Nyman, Joyoti Roy, Ven Thupstan Paldan, Rama Lakshmi, Tsering Norbo Martse, Vandana Prapanna, Poulomi Das, Tsering Sonam, Nita Sen Gupta, and Chemmet Namgail.

EXHIBIT REVIEWS

Steampunk, Bradford Industrial Museum, UK

Introduction

What do corsets, ray guns, blunderbusses, gentlemen's pocket watches, brass goggles, pith helmets, and mechanical insects have to do with science and industrial museums? In the world of steampunk, everything! In the exhibitions that I am going to discuss in this review, all of these and more feature large, showcasing an alternate world that has adherents from the Americas and Canada to the United Kingdom, from Europe to Africa, from Asia to Australasia.

Steampunk is a phenomenon that is currently going from strength to strength. Starting as a literary genre, having developed from science fiction and fantasy in the 1980s (although some suggest that it was early as the 1960s to 1970s), with the name being coined, rather in jest, by K. W. Jeter in 1987 (Jeter 2011), the steampunk aesthetic is now seen in films and has spawned a burgeoning alternative culture. Many of the books and films are set in the nineteenth century, and feature state-of-the-art steam-powered technology, Victorian clothes, dirigibles, and, in the case of author Gail Carriger's heroine, Alexia Tarrabotti (Carriger 2010), parasols and lots of tea. These all cross over into the alternative culture, but steampunks are not just about 'dressing up' in Victorian costumes. They inhabit a culture that revisions history. Their inspirations are H. G. Wells and Jules Verne. Queen Victoria is very much alive, Charles Babbage's invention is a working computer, brass, leather, and wood are the preferred materials of construction, and polite society is ensured. This is not to say that steampunks reject modern technology. On the contrary, they embrace innovation, just as their Victorian counterparts did. What they do reject is the slick sameness that epitomizes today's computers; plastic is definitely not acceptable. In the last few years, steampunk material culture has crossed over into the mainstream, with its influence seen on fashion couture (see, for example, John Galliano's 2010 collection [Popsugar Inc. 2010; Steampunk Fashion 2010]). Not surprisingly, this was a culture that museums wanted to explore.

In this review, I am going to discuss the latest steampunk exhibition in the UK, which recently closed—*Steampunk*, at Bradford Industrial Museum in Yorkshire.[1] This was the third temporary exhibition on steampunk in the UK in three years. Starting in 2009, the first major exhibition to feature steampunk art and material culture, *Steampunk*, was at the Museum of the History of Science in Oxford (referred to hereafter as Oxford).[2] This was followed in 2011 by a larger exhibition, entitled *The Greatest Steampunk Exhibition*, which was held at Kew Bridge Steam Museum in London (Kew Bridge).[3] The latest offering was at the Bradford Industrial Museum (Bradford). In talking about this exhibition, I want to examine it not only in the context of the other steampunk exhibitions, and the types of museums that are engaging with steampunks, but also what this says about the wider issues of museums working with different communities and the developing trends in the heritage sector.

Museum Worlds: Advances in Research 1 (2013): 206–240 © Berghahn Books
doi:10.3167/armw.2013.010114

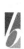

Exhibiting Steampunk

Following from the success of *Steampunk* at Oxford and *The Greatest Steampunk Exhibition* at Kew Bridge, Bradford's exhibition was a worthy successor. Put together by Wesley Perriman, creator and curator of *The Tranzient Gallery*,[4] the exhibition not only drew on the museum's collections as influences, but also placed collection items and steampunk material culture together both in the exhibition gallery and within the showcases.

While there may be concern that this juxtaposition could be confusing for visitors, especially as all the labels—what was 'real' and what was 'steampunk'—were of the same style, I felt that this blending of objects and influences worked extremely well. It facilitated a questioning of authenticity and a reappraisal of objects from the permanent collections. With the exhibitions at Oxford and Kew Bridge, the links to science, steam, and mechanical objects existed, but such blending was missing.

At Oxford, the steampunk objects had their own gallery that, though it was at the heart of the museum with other collection galleries around it, could be seen as isolated, although the objects had been influenced by the Oxford collections and the exhibition led to a complementary exhibition of items from the collection. At Kew Bridge, the steampunk objects were placed in and around the beam engines, but influences from the museum's collections were not so apparent. Bradford overcame this by juxtaposing Victorian dresses next to steampunk dresses and a blunderbuss next to a sonic ray gun. This was a strongly curated exhibition that gave steampunk a real sense of identity and placed it within a known history, while at the same time demonstrat-

Figure 1. Showcase at Bradford Industrial Museum, with collection objects and steampunk combined (Photography by the author)

ing that it was an alternative world with its own clothes, material culture, thoughts, ideas, and values.

In terms of the range of objects on display, Bradford's exhibition was closer to the exhibition at Kew Bridge. Bradford included dresses, artwork, and guns and, although the science-fiction inspired items seen at Kew Bridge were largely missing (for example, a steampunked Darth Vader—Darth Vapour and K9 from Doctor Who), there were also books, photographs, mobile cabinets of curiosity, and a 3-D steampunk silent film, *Clockwork*, by ADEPT's artists Steve Manthorp and Shanaz Gulzar,[5] for which you could borrow 3-D glasses to view. Interestingly, I had viewed this same film the previous evening at the *New Age of Discovery* (NAoD), an event held at Snibston Discovery Museum (Snibston) in Coalville, Leicestershire, which is based on the site of an old colliery.[6] Accompanied by the sound of ticking clocks, the story unfolded, a sister kept as a slave by her brother but who finds refuge in working on clocks and making mechanical objects. While the film immersed us in a steampunk and Victorian world, I was not totally convinced of its place at NAoD, as it did not obviously link to Snibston and the collections there. However, at Bradford, the film seemed to find its place, introducing as it did their interpretation of a steampunk world, and providing a suitable backdrop for the objects.

Something that is central to steampunk culture is the maxim of do-it-yourself. Not only clothes, but also computers, transport, jewelry, watches, accessories, and other material culture are either created or customized. Never mind that this might invalidate the warranty of a laptop; the aesthetic is as important as the technology and so fully working computers are clad in brass and leather to create objects that would not look out of place on a roll-top bureau in a Victorian study. So, in the showcases at Bradford, *Arachnatomatons* crawled among steampunk guns made "by appointment to H.R.H. Prince Albert" and *The Hand of Asclepius*, which featured tubules not unlike those used by the Borg in Star Trek to assimilate their victims. Beautifully wrought leather corsets demonstrated the attention to detail, and the link to the origins of museums themselves could be seen in Wesley Perriman's *Palace of Curiosities* and *The Tranzient Gallery*. In these, multifaceted objects, including a mermaid, jostled for position with sculptural books that illustrated in three dimensions the title of the book. Housed within a mobile Victorian carriage, complete with stained glass windows, these cabinets had almost too many objects in them to be able to appreciate them fully. Still, they provided a focus for what the exhibition was about—a world of reimagined objects, with links both to the Victorian age and to the museum itself.

The accompanying events have been vital to the success of these steampunk exhibitions. This is where the steampunk community really come into their own. Particularly at Oxford and Kew Bridge, regular events were organized, including fashion shows, live mannequins, and, in the case of Oxford, an accompanying exhibition of steampunk objects created by local school children. At Bradford, the museum worked closely with the steampunk community, who not only interacted with the collections, but also made objects for the exhibition (Willoughby 2011). Steampunks enjoy socializing. This could be seen at Snibston's NAoD, where regular visitors were joined by local steampunks to enjoy an evening, the finale of which was a stunning rendition of opera by Lili la Scala, who sang from the pithead gear. Then, steampunks processed from there to a walkway. Accompanied by music, images of miners, the colliery, steam engines, and mine workings were projected onto an enormous screen. Finally, steampunk Kit Cox announced the New Age of Discovery, fireworks exploded over the screen, and, to everyone's surprise (or at least most people's!), a steam train broke through the screen and charged up the track toward the museum. Events such as these make museums accessible not only to the community whose work they are showing, but also a wider museum audience. As Jim Bennett, director of the Museum of the History of Science in Oxford explained, *Steampunk* was the museum's most successful exhibition to date, bringing in a far broader range of visitors than normal (Bennett 2012),

which demonstrates the importance of engaging with different communities and the energy that results from those engagements.

The Wider Context

The relationship between museums and communities has been evolving over a number of years, but the necessity to demonstrate openness and access is one of the driving factors. Oxford showed how important engaging with a community such as steampunks was to increasing their visitor figures and thus fulfilling their access remit. They also gave over some of the curatorial power to the guest curator, Art Donovan, in developing the exhibition. This collaboration involved both parties, but Oxford retained the curatorial power to make many of the logistical and institutional decisions that a guest curator is not in a position to make. Although there may be the potential for conflict in this, both sides of the collaborative partnership have their role to play—they both need to understand the views, and the expertise, of the other partner.

So, collaboration in the production of the exhibition demonstrates inclusivity. What, though, of the resultant exhibition, how inclusive is it of a diverse audience? As the visitor figures at Oxford demonstrated, *Steampunk* was the most popular exhibition ever held at the museum. It was able to bring in not only steampunks, but also existing and new audiences. This is a crucial factor for museums; they must attract new visitors, while ensuring that they do not alienate their 'traditional' audience. *Steampunk* proved to be a charmed combination, an exhibition that drew on the permanent collections for inspiration, showcased new and exciting artworks, introduced visitors to an alternative culture, and enabled those visitors to see the companion exhibition of collection items in a new light (Bennett and Donovan 2011).

That the exhibition could do this is an indication of the burgeoning interest in the culture, and particularly the aesthetic, of steampunk. It is also a community that attracts interest from a very wide range of ages, from teenagers to people in their seventies, whether they are engaged fully in the culture or choose to admire it from afar. Moreover, it has been described as being part of the British psyche (Naylor 2011) in its focus on the Victorian era, industrial technology, and London, yet with a forward-looking adoption of modern technology. It is not only the British, however, that have succumbed to steampunk. Blogs and fan sites demonstrate the global interest in the culture. In my opinion, however, it is New Zealand steampunks who describe the ethos of the culture most effectively in their use of exhibition title: *Steampunk: Tomorrow as it Used to Be* which was held at the Forrester Gallery in Oamaru (in the South Island of New Zealand) in 2011 (Guild 2011).

With the interest in history demonstrated by so many people, combined with emphasis on reinventing science and links to science fiction, it is understandable that steampunk and the aesthetic that it portrays should be acceptable to diverse audiences, even if they are not part of the steampunk community. What of other communities, however—could they be of equal interest? This, inevitably, depends on the community. The Victoria and Albert Museum (V&A) demonstrated the interest in subcultures when they showcased *Street Style*.[7] Not only did this exhibition attract the people who lent clothes and remained part of the subcultures, but it also attracted people who had been part of those cultures and who wanted to revisit the time when they were, for example, a Goth or Teddy Boy. Nostalgia, then, is an important part of this type of community-related exhibition, as it attracts people who are, and who have been, part of the culture, but also people who remember seeing aspects of that culture and who have a nostalgia for an age, real or imagined, in which they may or may not have actively taken part at the time. Steampunk is interesting in this respect because it is a current culture, but it reimagines how

history was. People are not nostalgic for what steampunk was, but what the reenvisioned world was. There is, then, an element of wish fulfillment in the culture, and perhaps it is this that is so attractive, the hope that this time around it is possible to have the best of Victoriana, but not the worst, to avoid the racism, sexism, and inequality, and embrace the beauty of the technology and admire the craftsmanship of the objects and clothes.

Developing Trends

The work that museums have done with indigenous peoples in collaborating on the display of their cultural treasures may well have been decisive in their working more equally with communities in general. Accepting that there are many different attitudes to objects has helped museums to gain insight into a wide range of communities. Just as an artifact can be an ancestor, in the case of Māori cultural treasures (*taonga* Māori), so a historical object can form the basis for a reimagined world set in the past, but looking to the future. Unofficial heritage (for a discussion of official and unofficial heritage, see West [2010: 1]) such as this gives insight into communities and, while it can challenge the official notion of what heritage is, ultimately provides a more nuanced interpretation of modern cultures than just the official notion of what should be in a museum. Unofficial heritage provides a richness that sometimes can be missing from museums in their desire to show what they think should be on display. So, by giving up something of the curatorial power and by engaging with communities, museums gain increased audiences, fulfill their policies of access, and become more relevant to a wider range of peoples.

Being more inclusive can also be of benefit at a time when museums are facing severe funding restrictions. Although reaching out to communities can be costly in terms of personnel time and budgets in order to respond appropriately and creatively, the rewards in the form of educational activities, increased visitor numbers, and sale of associated merchandise can be worth it. This was one of the reasons why Kew Bridge approached steampunks with the idea of a collaborative exhibition. The result was an extensive display that showcased both the museum and the culture. Bradford will doubtless have gained similar benefits, although from the information available, they do not appear to have offered the same range of events that Oxford and Kew Bridge offered. Events, whether overtly educational or not, are often one of the first casualties of budget cuts. Although an important means of bringing people through the door, they simply can be too expensive in terms of staff time. Oxford and Kew Bridge were able to overcome this to a certain degree by involving steampunks in the promoting of the exhibition and the showcasing of their culture, particularly as regards fashion shows. It may well be that Bradford, working collaboratively with the same artists that worked on NAoD at Snibston, benefited in terms of visitor numbers and merchandise sales from word-of-mouth marketing within the steampunk community.

Interestingly, for a community so immersed in technology from both the nineteenth and twenty-first centuries, none of the steampunk exhibitions explored the use of digital technology to enhance the visitor experience. They remained firmly analog in their use of interpretive text panels, brochures, and catalogues. Information on the exhibitions was available through their websites, some of which was later archived, and Bradford offered further material in the form of a blog. Oxford, perhaps due to its role as a university museum, provided the most extensive postexhibition resources, with visitors able to access photographs, videos, and archived documents. Within the exhibitions themselves, however, digital technology was missing, and I think that this was a neglected opportunity for a community with such vibrant use of social media.[8] Although technology should not be used for the sake of it, it can be a means of engaging more

fully with the artists and their aims and motivations in creating their art, with the wider community, and also, of course, with the museum and its diverse collections. There are many ways an object can speak to an audience; having it relate its history (both real and imagined, in the case of steampunk), community, and heritage context in a constantly updateable form that is relevant to diverse audiences is a means both of bringing it alive and aiding in engagement.

Steampunk Futures?

What next, then, for museums and steampunks? So far we have seen mainly science and industrial museums engaging with this community, but a new museum has recently opened that challenges this. The Mechanical Art and Design (MAD) Museum in Stratford-upon-Avon opened in April 2012.[9] As well as amazing kinetic art and automata, most of which the visitor can interact with, it showcases steampunk art and design, thus reassessing how steampunk can be seen. The MAD Museum is not a science or industrial museum; instead, it is more of a commercial art gallery, with many of the objects for sale. Is the placing of steampunk among automata good, or does this risk classifying steampunk even more narrowly? I think not, and I suggest that displaying steampunk within a genre of clockwork and automata can only be good for the movement, as it may well give it longevity that it might not otherwise achieve if, or when, the fashion for steampunk abates.

There are still some links to science and industry in the other objects in the MAD Museum. By placing steampunk within this setting, the objects can span the gap between science and art; they can be both. Steampunk often defies classification, but this individualist approach is one that fits with modern society and, although steampunk looks back to the past in order to reimagine the future, it is set very much in the present, a present that its proponents are seeking to improve. Through museum engagement, we are able to see what steampunks want to achieve, how they are going about it, and ultimately gain some understanding of a dynamic and evolving culture.

Acknowledgments

Many thanks are due to Simon Atkinson for his comments and feedback on earlier drafts, and his unending patience in attending steampunk exhibitions with me.

Jeanette Atkinson
School of Museum Studies, University of Leicester

Notes

1. Bradford Industrial Museum's exhibition *Steampunk* can be seen at http://goo.gl/3TR3c (accessed 9 March 2013).
2. The Museum of the History of Science in Oxford's exhibition *Steampunk* can be seen at http://www.mhs.ox.ac.uk/exhibits/steampunk/ (accessed 9 March 2013).
3. Kew Bridge Steam Museum's exhibition *The Greatest Steampunk Exhibition* can be seen at http://goo.gl/SCTdA (accessed 9 March 2013).
4. Wesley Perriman's work can be seen at http://www.thetranzientgallery.com/ (accessed 9 March 2013).
5. ADEPT's work can be seen at http://www.soundgems.co.uk/wordpress/?page_id=19 (accessed 9 March 2013).

6. See the Snibston Discovery Museum's website at http://goo.gl/m88vE (accessed 9 March 2013).
7. The V&A's exhibition *Street Style* can be seen at http://www.vam.ac.uk/page/s/streetstyle/ (accessed 9 March 2013).
8. See, for example, forums such as Brass Goggles (http://brassgoggles.co.uk/forum/index.php) and blogs such as Silver Goggles (http://silver-goggles.blogspot.co.uk/) (accessed 9 March 2013).
9. See the MAD Museum's website at http://themadmuseum.co.uk/ (accessed 9 March 2013).

References

Bennett, Jim. 2012. Interview with the author, Museum of the History of Science, Oxford, January 2012.
Bennett, Jim, and Art Donovan. 2011. "Foreword." Pp. 18–19 in *The Art of Steampunk: Extraordinary Devices and Ingenious Contraptions from the Leading Artists of the Steampunk Movement*, Art Donovan. East Petersburg, PA: Fox Chapel Publishing.
Carriger, Gail. 2010. *Soulless: The Parasol Protectorate: Book 1*. London: Orbit.
Guild, Ben. 2011. "Street Party Marks Opening of Steampunk Exhibition." *Otago Daily Times*, 17 October. http://www.odt.co.nz/regions/north-otago/182556/street-party-marks-opening-steampunk-exhibition (accessed 2 August 2012).
Jeter, K. W. 2011. "Introduction: On Steampunk and 'Steampunk'." In *Infernal Devices*, location 36–48. Kindle. Nottingham: Angry Robot.
Naylor, John. 2011. Interview with the author, December 2011.
Popsugar Inc. 2010. "John Galliano Takes a Riding Crop to Spring 2010 Dior Couture, While Tavi's Giant Bow Grabs Some of the Attention." http://www.fashionologie.com/John-Galliano-Takes-Riding-Crop-Spring-2010-Dior-Couture-While-Tavis-Giant-Bow-Grabs-Some-Attention-7167336 (9 March 2013).
Steampunk Fashion. 2010. "Steampunk on the Runway." http://steamfashion.livejournal.com/2449102.html (9 March 2013).
West, Susie. 2010. "Introduction." Pp. 1–6 in *Understanding Heritage in Practice*, ed. Susie West. Understanding Global Heritage, volume 2. Manchester, UK: Manchester University Press in association with the Open University.
Willoughby, Dan. 2011. "Bradford Museums & Galleries Blog." http://www.bradfordmuseums.org/blog/ (accessed 2 August 2012).

———————————▪———————————

Framing India: *Paris-Delhi-Bombay* ... , Centre Pompidou, Paris

On 25 May 2011 the Centre Pompidou in Paris opened *Paris-Delhi-Bombay* ... , an exhibition of contemporary art from India. The show ran until 19 September 2011 and also included the works of seventeen French artists whose contributions to the show offered an engagement with India from their vantage point in France. Featuring such important artists from the subcontinent as Ravinder Reddy, Vivan Sundaram, Subodh Gupta, Bharti Kher, and Pushpamala N., the show was a celebration of the contemporary Indian art landscape and sought, as stated in the introductory literature, to "promote a dialogue" between France and India (*Paris-Delhi-Bombay* ... exhibition map 2011). This is not without its problems, however, as I suggest in this review. Locating the show within the larger landscape of the display of contemporary Indian art and a discussion of the exhibition's curatorial framework, I highlight how this purported two-way dialogue resulted in a one-way trajectory.

Paris-Delhi-Bombay ... presented the works of thirty Indian artists—all of whom live and work in India, rather than in the diaspora—and seventeen French artists, fourteen of whom

visited India for the first time in preparation for the show. The French artist ORLAN's piece was placed at the entrance to the show—a flag that combines French and Indian flag design, constructed of glittering sequins—and within the show the works of French artists were juxtaposed with those of Indian artists. The French artists were selected based on their presence in the contemporary French art world, rather than on any prior engagement with India. Their works accordingly seemed largely contained by the narrative constructed by the exhibition about India. The exhibition included photographic, installation, sculpture, and video works, which were arranged in concentric circle fashion around Ravinder Reddy's 2004 *Tara*, a large, gilded sculpture of an Indian woman's head. Encircling *Tara*—a sculpture in the round—were placed the introductory text panels that presented the six organizing themes of the exhibit. Because the organizers felt that to France India is "still a mystery," these themes were not intended to introduce the history of Indian art traditions or the Indian artists but instead to "set out to depict society" in India ("The Exhibition: Paris-Delhi-Bombay ..." 2011: 2).

The title itself, *Paris-Delhi-Bombay ...*, recalls the series of Pompidou exhibits from the 1970s that connected the Paris art scene with major avant-garde centers (*Paris-New York, Paris-Berlin, Paris-Moscow*). The historic relationship between the artistic and intellectual exchanges between these cities, however, is less tenuous than that between Paris and Indian cities in the sense that the earlier shows documented an artistic exchange already established. Accordingly, the dialogues created (or not created) by the past exhibitions necessarily inhabit different spaces than this most recent show. *Paris-Delhi-Bombay ...*, on the other hand, as an exhibit of both non-Western and Western art, attempts to introduce France and French artists to India, and in this recalls the infamous 1989 Pompidou show *Magiciens de la Terre*. Thomas McEvilley, reflecting on this show in his introduction to the 1996 Asia Society exhibit *Traditions/Tensions: Contemporary Art in Asia*, observed that the purpose of *Magiciens* was to open Western discourse to non-Western art, and to counter the absolute primacy of the Western tradition, an objective that notably echoes the stated purposes of *Paris-Delhi-Bombay ...* (McEvilley 1996: 57). Instead, according to McEvilley, *Magiciens* locked each tradition into itself, in effect reconstructing the boundaries that were in reality dissolving in the world. More than twenty years later, after the liberalization of the Indian market in 1991 and in a world of increasingly dissolving boundaries, the Pompidou appears to have attempted a similar exchange between Western and non-Western discourses. But much like the earlier exhibit, I suggest that the museum has continued to perform and reperform outdated and Western-centric categorizations of West and non-West.

Interestingly, as part of the show's preparation, the museum had issued a report with the aim of efficiently disseminating the sociological, religious, economic, and political information that exhibit organizers considered key to the French artists' understanding of India. This report, a sort of 'rough guide to India', was meant to introduce the French artists to the political and social climate of India—assumed (and apparently rightly so) to be unfamiliar ground. As the exhibition planning process continued, the organizers felt this same information would be instrumental to the audiences' engagement with the works and so created interpretive labels that introduced a set of themes (Kamdar 2011). These six themes—politics, urban development and the environment, religion, the domestic space, women in society, and the history of craft production—speak to "the profound changes undergone by a society in wholesale expansion" (*Paris-Delhi-Bombay ...* exhibition map 2011) and were arranged, according to Pompidou director Alain Seban and exhibition curators Sophie Duplaix and Fabrice Bousteau, in a way that could "pave the way for dialogue" and "forge long-lasting ties between [France and India]" ("The Exhibition: Paris-Delhi-Bombay ..." 2011: 2).

The exhibition's promotional literature (catalogues and guides) thus tend to begin with oft-noted statistics that frequently circulate in the Western world—that India is the world's largest

democracy, and that, after China, it is the second most populous country. From there, descriptions of rampant and immobilizing problems are presented and the viewer is to understand that the art works in the show respond to these issues. Accordingly, the political landscape in India is depicted as a democracy that is "not truly exemplary," is "extremely corrupt," and is caste-focused (*Paris-Delhi-Bombay ...* exhibition catalogue 2011: 8). The "Women in Society" theme opens by stating—in reference to the simultaneous existence of female infanticide and women in the political leadership (like former prime minister Indira Gandhi)—that "this is one of those paradoxes we cannot truly explain" (*Paris-Delhi-Bombay ...* exhibition catalogue 2011: 13). After introducing the traditional "joint family" structure in India, the guide problematizes this structure by pointing out the "nonexistent intimacy," "omnipresent abuse of mothers toward their daughters-in-law," and the unavoidable "conflicts between brothers over family inheritance" in such families (*Paris-Delhi-Bombay ...* exhibition catalogue 2011: 13). It seems that the exhibition's organizers understand India as a space of social difference and political problems first, and as an art-producing landscape second. Organized in this way, the exhibition presents the artists' works almost solely as an overdetermined response to the globalizing project of contemporary India, which is depicted as rocky and problematic. This narrow and didactic lens presents a pedantic picture of both the art and the society that produced it, and discourages more nuanced readings of the works.

Relying on these social and political themes to present contemporary Indian art—rather than structuring the exhibition around art historical narratives or on the practice of collaborative curation[1]—in effect establishes the show as an ethnographic display. *Paris-Delhi-Bombay ...* maps out a Western understanding of the landscape of the unfamiliar and then delineates the viewer's encounter with the foreign accordingly.[2] The reliance on these themes, rather than paving the way for a dialogue, performs an understanding of India via stereotypes (albeit updated for the contemporary moment) even as museum literature purports that the exhibition "clears away" the "usual clichés of contemporary Indian society" (*Paris-Delhi-Bombay ...* exhibition catalogue 2011: 16).

Instead, we see that the clichés remain plentiful. ORLAN's opening piece, the glittering combination of the French and Indian flags, is the sort of one-dimensional, colorful nod to kitsch we have come to expect in the Western exoticization and marketing of India. Philippe Ramette's sculpture of an apparently white girl climbing onto a scaffold is meant to represent the experience of women "in a country where women fight for recognition on a daily basis" ("The Exhibition: Paris-Delhi-Bombay ..." 2011, 2), but it feels simplistic, heavy-handed, and out of place. Here India, in line with an Orientalist narrative, is depicted in the exhibition's literature as a resource that French artists accessed as muse or responded to within the familiar trope of a quest for self-identity.[3] Correspondingly, India is presented as a sensory experience, encountered via "materials, textures, and colors" (*Paris-Delhi-Bombay ...* exhibition catalogue 2011: 38). Although some of the French artists appear to be engaging with the encounter in more complex and nuanced ways—Alain Bublex and Cyprien Gaillard in particular—the organizing themes, and at its core, the very concept of the 'encounter', necessarily situates even these artists' works within a more archaic, Orientalizing framework than the stated desire for dialogue suggests.

As has been noted elsewhere, the Pompidou has been late to acknowledge the current vitality of contemporary Indian art (Kamdar 2011). Within France, L'Ecole Nationale Superieure des Beaux-Arts featured *Indian Summer* in 2005, *Bombay: Maximum City* showed in Lille in 2006, Fecamp held a 2009 Indian contemporary art exhibition, and *Indian Highway IV* exhibited at the Lyon Museum of Contemporary Art earlier this year. These shows featured many of the same artists whose works appeared in the Pompidou. Moreover, several private galleries in Paris

have already been and are currently showing works by some of the same artists featured in *Paris-Delhi-Bombay* ... and others (Kamdar 2011). The Pompidou, far from 'discovering' the contemporary Indian art scene, a claim implicit in their 'introduction to India' approach, instead appears to be arriving rather late to the table.

Instead of participating in the conversations that are occurring in Paris via the concurrent displays and exhibitions of Indian art, the Pompidou has revived an outmoded and one-directional structure. The packaging of India and its art for a Western audience recalls the 1985–1986 Festival of India held in the United States. As Brian Wallis noted in his 1994 essay on those nationalist and propagandizing events, the ideological effort to package an exotic cross-cultural encounter produced a spectacularized image of a nation devoid of conflict (Wallis 1994). Although operating differently—introducing India via themes, and then encountering the works as speaking only to these curated themes—*Paris-Delhi-Bombay* ... similarly results in an ideological cultural exchange (and, indeed, reveals the 'exchange' to be heavily one way). Somewhat like the Festival of India that preceded it, *Paris-Delhi-Bombay* ... packages a product 'India'— one that, despite the dynamism of the Indian contemporary art world, acts in predictable ways. The overwhelming scale of the exhibition space and style of sensory spectacle perform an India that is chaotic and colorful, a sensory overload, one that is wrought with the social, political, and economic issues of gender and caste inequality, corruption, and extreme disparity between rich and poor, as described on the theme labels. Its use of 'Othering' themes that describe India today fit with what Nagy calls the West's desire for "hard-hitting art from India that speaks of its anxieties and traumas, psychological density and political complexity," and leaves room for little else (Nagy 2009: 36).

In furthering its project, the exhibition literature patronizingly positions contemporary Indian art against Chinese art to find that "as opposed to the Chinese, [Indian artists] have refused to copy international canons" (*Paris-Delhi-Bombay* ... exhibition catalogue 2011: 6). Indian art is praised for being sufficiently 'Indian'; China is seen as simplistically aping the West and its artistic traditions, and India, by contrast, "portray[s] the reality of the country with a certain pride" (*Paris-Delhi-Bombay* ... exhibition catalogue 2011: 17). Echoing the standard of 'purity' that the earlier *Magiciens de la Terre* outlined for the non-Western art included in this show, *Paris-Delhi-Bombay* ... values the Indian art it features for its adherence to its own canon. Paradoxically, the exhibition avoids this canon by not adequately situating it. Rather, in the manner described by Peter Nagy, the Pompidou shies away from "contextualizing Indian art with international trends" by placing it instead in the closed and ethnographically situated introductory themes (Nagy 2009: 36).

The introduction of themes through which the audience is meant to understand the art on display (and, more broadly, India) delineates the experiences of the viewer and the position of the works. This is not to say that the works do not respond in any way to the themes outlined by the Pompidou; indeed, the artists are in dialogue with political, social, and environmental issues. However, the Pompidou's organization does not allow for nuanced (or, as it sometimes feels, even positive) interpretations of the works. Accordingly, in this reading the trash worlds created and photographed by Vivan Sundaram are understood as a dire commentary on the hopeless environmental problems in India without the possibility of additional, more complex, and multifaceted references to imagined cities, a history of caste relations, or, say, a dialogue with Nek Chand's vernacular architecture project in Chandigarh.[4] In this framework there is little room for broader commentary on a capitalist-driven devaluing of social relations, propaganda, celebration, and nostalgia, or even a critique of the West.[5]

Finally, as other reviewers have noted, important diasporic artists such as Zarina Hashmi and Anish Kapoor (long-time residents of New York and London, respectively) are not only

not included in the Pompidou show but *cannot* be, due to the exhibition's territorially based confines (Kamdar 2011). Rather than seeing works by these diasporic artists as being particularly relevant to the show's stated mission of international exchange and dialogue, or at least complimentary to the discourse of exchange, the Pompidou structures the framework of the exhibition to exclude them. Problematically, the curators are quoted in the exhibition catalogue as stating that "it's important to stress that the successful Indian artists stayed on the sub-continent, or returned home if they had moved abroad for a time" (*Paris-Delhi-Bombay* ... exhibition catalogue 2011: 7). This exclusion of diasporic artists mirrors a similar exclusion inherent in the structure of the 1989 Pompidou exhibition *Magiciens de la Terre*, in which 'hybrid' works that responded to outside encounters or cultural input were rejected in favor of cultural 'purity' (McEvilley 1996: 57). *Paris-Delhi-Bombay* ... takes this exclusion in the name of closed, artistic purity one step further by effectively erasing the relevance of diasporic artists, excluding their works from the show and pointedly rejecting them in museum literature. This drive toward cultural purity on the part of the Pompidou, unfortunately, has always been a false one, and appears even more misguided and drastically irrelevant now than it did in 1989.

In *Paris-Delhi-Bombay* ..., both East and West stay, as it were, where they 'belong', physically bound by the false confines of national boundaries even as the exhibition speaks of globalization, mobility, and the ease and rapidity of cross-cultural influence. By focusing on structured themes that, ironically, purport to place India within a fluid, globalized world, by allowing no space for diasporic artists, and by making the experience territorially based and tied to the confines of the physical boundaries of the nation, the Pompidou actually denies the experience of permeability that is so much a part of the reality of the lived experience in the globalized world. The museum positions its understanding of India not as a player in a globalized world, as purported by the exhibition literature, but rather within the ghostly outlines of a colonial-era context of an ordered, codified, managed experienced of the non-Western Other. As such, it denies and excludes itself from the exchanges and dialogue between the French and Indian art worlds that is already happening not far outside its doors—no farther, in fact, than the galleries and museums across the city.

As a result of its overarching vision and interpretative structure, the show, presented as a dialogue between France and India, as equal players, about India, looks instead like 'France imagines India looking at India'. France at the Pompidou is in a conversation with itself about the Other; only one voice emerges, and this action effectively cuts off the possibility of a dialogue. Rather than existing within a contemporary reality of permeability and globalization, the exhibition instead seems to be operating within the colonial understanding of taking, holding, displaying, and interpreting Indian art. The six themes set up an authoritative (Western) voice and ethnological framework through which the audience is to understand not only Indian art but also India itself.

Tracy Buck
University of California, Los Angeles

Notes

1. For a discussion of the results of collaborative curation in the context of African art display, see Phillips (2004).
2. See Thomas McEvilley's (1996) discussion of the changing modes of curating non-Western art from the nineteenth century to today.
3. See in particular *Paris-Delhi-Bombay* ... exhibition catalogue (2011).

4. The exhibition catalogue describes Sundaram's work as a "commentary on recycling operations that echo the environmental and social problems of India" (*Paris-Delhi-Bombay ... exhibition catalogue* 2011: 21).

5. For a discussion of the works of the some of the artists featured in the exhibit, see Nath (2009).

References

Kamdar, Mira. 2011. "This Pomp at the Pomidou." *The Caravan*, 8 July. http:// www.cerium.ca (accessed 21 October 2011).

McEvilley, Thomas. 1996. "Exhibition Strategies in the Postcolonial Era." *Traditions/Tensions: Contemporary Art in Asia.* New York: Asia Society.

Nagy, Peter. 2009. "The Ballard of Cultural Relativism." Pp. 34–37 in *Chalo! India: A New Era of Indian Art.* New York: Prestel.

Nath, Deeksha. 2009. "Language of an Idealized Revolt: Sculptural Installation from the 1990s to the Present." Pp. 250–265 in *Art and Visual Culture in India, 1957–2007,* ed. Gayatri Sinha. New Delhi: Marg Publications.

Paris-Delhi-Bombay ... 2011. Exhibition catalogue. Paris: Beaux Arts Editions.

Paris-Delhi-Bombay ... 2011. Exhibition map. Paris: Centre Pompidou.

Phillips, Ruth. 2004. "Where Is 'Africa?' Re-Viewing Art and Artifact in the Age of Globlization." Pp. 758–772 in *Grasping the World: The Idea of the Museum,* ed. Donald Preziosi and Claire Farago. Aldershot, UK: Ashgate.

"The Exhibition: Paris-Delhi-Bombay ..." 2011. Exhibition guide. Paris: Centre Pompidou.

Wallis, Brian. 1994. "Selling Nations: International Exhibitions and Cultural Diplomacy." Pp. 265–281 in *Museum Culture: Histories, Discourses, Spectacles,* ed. Daniel Sherman and Irit Rogoff. London: Routledge.

———————■———————

E Tū Ake: Māori Standing Strong/Māori: leurs trésors ont une âme, Te Papa, Wellington, and Musée du quai Branly, Paris

The exhibition *Māori: leurs trésors sont une âme* opened at the Musée du quai Branly, Paris, on 4 October 2011. This exhibition was initially staged as *E Tū Ake: Māori Standing Strong* at the Museum of New Zealand Te Papa Tongarewa (Te Papa) in Wellington, New Zealand, in 2010–2011. It then travelled to France for three and a half months, before going on tour to Mexico City and Quebec.

E Tū Ake was the first Māori exhibition in a French museum created in New Zealand and developed with the input of the tribal descendants of the *taonga* (treasures). It was also the first international collaboration between these two important national museums. This partnership was not only concerned with the display of Māori *taonga*, but also coincided with the repatriation of *toi moko* (Māori preserved heads) from French institutions, a lengthy and contested repatriation process beginning with the Natural History Museum in Rouen which in 2011 returned the only *toi moko* from their collection. Since a law change in 2009, the French government has allowed institutions such as museums, hospitals, and universities to return *toi moko*, but not human remains in general, to their land of origin. This controversial event led the staff of the museum in Rouen to initiate wider discussions with Māori staff from Te Papa about the care and management of their Māori collection and, in particular, assistance with building a new permanent exhibition around their Pacific collection.

However, with the quai Branly it seems that initially the staff were not in favour of repatriating the seven *toi moko* in their collection, but they were interested in working with Te Papa on an innovative exhibition project. At first their objectives appear to have been primarily museological through collaboration with Māori curators, but over time we can see a developing awareness of the background political dimension of these topical issues. Because of the ambiguous place of human remains in French national collections and the discussions that ensued, the Musée du quai Branly wanted to take the opportunity afforded by this repatriation to work with the national museum of New Zealand and eventually reached an agreement to collaborate on this significant exhibition project.

Located halfway around the world from New Zealand, and housed in a large, new building designed by Jean Nouvelle near the Eiffel Tower in the center of the French capital, the Musée du quai Branly is famous for its spectacular exhibitions of ethnographic material displayed with a distinctive aesthetic design that has been much debated in the literature (Price 2007). Staff from Te Papa responsible for organizing the traveling show were delighted to work in a much larger space set aside in Paris than was available at Te Papa when the exhibition was originally installed there. In 2010, the design team from Paris came to Te Papa for five days to discuss the initial ideas for this exhibition, the first time French museum staff had worked directly with colleagues in New Zealand. Interestingly, differences and tensions emerged in terms of the different approaches to creating an exhibition of Māori *taonga*, which were reflected in the final installation, as seen below.

What was the exhibition made up of? It comprised 155 objects, including 118 ancestral *taonga*, the majority of which had never left the territory of Aotearoa/New Zealand. These treasures were juxtaposed with contemporary art works, photographs, and everyday material culture such as tables, towels, and other objects. The combination of modern art and customary artifacts perhaps surprised some French visitors, who were expecting the typical museological focus on native people 'as they were'. This deliberate mixture of old and new pointed to an approach now common in postsettler nations like New Zealand and Australia for displaying indigenous material culture, linking the past and the present in contrast to traditional ethnographic exhibits still common in European museums. Exhibitions like this are now commonplace in New Zealand museums, largely as a result of the first major Māori exhibition to travel overseas, *Te Māori*, which toured the United States (1984–1986) and New Zealand (1986–1987). In addition to the museum staff, a large group of Māori elders followed the exhibition to each city to participate in ceremonies and 'look after' the *taonga* on display (S.Mead 1984; McCarthy 2007).

However, it seems to me that the French public did grasp the main message from this exhibition about Māori people being alive today, and certainly understood that the objective of this exhibition was not the poetics of 'folklore' and beautiful objects but the contemporary Māori claim of self-determination (*tino rangatiratanga*) expressed in the subtitle "Māori Standing Strong." This preference for exploring contemporary social and political realities seen in the exhibition themes, the result of the involvement of the indigenous community in the professional museum sector in New Zealand since the late 1980s, may represent an important new departure for exhibiting cultures in France.

It was the Māori curators and their tribal communities, not the French staff, who made the final decisions about the display in Paris. Staff from both institutions felt that this indigenous involvement showcased innovative museum practice, thereby enhancing their international reputations for collaborative exhibition development. According to the bicultural policy at Te Papa, preservation of Māori collections is underpinned by key Māori concepts, so that Māori professionals work in partnership with the source community to develop exhibitions of *taonga*.

For the French, it was the first time that they had worked with *iwi* (tribes) on the display of their treasures.

When I saw the exhibition in Paris, I thought that one *taonga* in particular was really impressive, specifically in the context of the repatriation taking place behind the scenes. The life mask of Wiremu Te Manewha, a chief from Ngāti Raukawa (located in the lower North Island) was one of the most remarkable *taonga* within Te Papa's collections, made of plaster in the 1880s by the European artist Gottfried Lindauer. This unique *taonga* was made during the lifetime of this tribal leader, who gave his agreement to be a model for the foreign artist and allowed him to touch his head and his tattoo, despite the fact that the head is the most *tapu* (sacred) part of the body for Māori. At the end of the nineteenth century, it was unusual to see this practice of making life masks in New Zealand, particularly the creation of the cast of his face and the design of his *moko* (tattoo). This life mask is today considered one of the finest examples of *moko* made by the traditional chisel or *uhi* (Smith 2010).

This was the first time this remarkable object was displayed outside New Zealand. Museum professionals had to respect the decisions made by living descendants concerning its display and indeed all aspects of the overseas tour. In recent times the care and display of treasures in New Zealand museums demonstrates the partnership between *kaitiaki* (guardians), such as Māori curators, working with *iwi*. Moreover, the decision to display this sacred object in the first segment of the exhibition indirectly made a link for the public with the repatriation ceremony that closed the exhibition, and the return of several *toi moko* to New Zealand. However because the display of human remains is still controversial in Europe, the life mask could also be seen as inevitably satisfying the curiosity of the French public for the exotic spectacle of the Other.

The contemporary demand for control over the display and the safekeeping of *taonga* reflects one of the most important Māori political concepts today and one of the key themes in *E Tū Ake—tino rangatiratanga*—enshrined in the Treaty of Waitangi, signed in 1840 (H.Mead 2003). This Māori word, meaning absolute chieftainship/self-determination, defines power and authority over their resources and the way in which things Māori (Smith 2010) are seen and transmitted to future generations. The purpose of this exhibition, in France as well as in New Zealand, was to increase public awareness of issues such as self-determination and to demonstrate that the Māori community is still a living, thriving, and dynamic culture. Some media reports were quite negative about the show, claiming it was not representative of modern Māori culture, despite the fact that one of the objectives was to educate the public about past struggles and their effects on Māori cultural identity within the broader New Zealand society. Did the exhibition achieve its aim of changing public attitudes and stereotypes about Māori culture? After visiting this exhibition and observing the reaction of the French public, in my view many people *did* learn about Māori culture, and deepened their awareness of Māori customs and the relationship of Māori ancestors to their living descendants today. Nevertheless, although the exhibition addressed its themes from a cultural point of view, a political dimension could be perceived by different audiences.

One of the central themes of the exhibition dealt with the Māori struggle with the New Zealand government for their rights, such as the perpetuation of their language, *Te Reo Māori*, or the claims of the Waitangi Tribunal for the return of land and co-management of resources. Throughout the exhibition a case is made for the use of the native language, not so much as a desire to return to the past but its adaptation in a contemporary context. The space was divided into four sections organized around four concepts: *Tino Rangatiratanga, Kaitiakitanga, Whakapapa,* and *Mana* (Self-determination, Guardianship, Genealogy, and Spiritual Authority), which are still-current foundations for Māori contemporary cultural identity and worldviews. The point is forcefully made through text panels and labels that although the use and the application

of these concepts has changed with European contact, the underlying principles are the same. On the other hand, because the exhibition had to convey all of these four complex concepts to an audience not familiar with them, it appears that there was too much text and explanatory material and often the public got confused or overwhelmed. Despite this, I feel that visitors probably did 'get' the main point about Māori survival today, but mainly through the visual effect of the traditional and contemporary arts rather than the interpretation.

The space reserved for this exhibition at the quai Branly was located on the ground floor of the building, with the entry beside the main entrance to the museum. Moving through this generously spaced layout made for a pleasant visitor experience because it was possible to walk around some *taonga* and see the details, as in the pieces of the *waka* (canoe) on display. Moreover, it was nice to see these particular objects in front of an entire modern *waka ama* (outrigger canoe) and its paddle. It was possible for French visitors, like me, to compare these two craft, their materials, and the transmission of knowledge in the fabrication of this kind of vessel. This display was located in the middle of the largest gallery in the show, in a sense the 'heart' of the exhibition, which was devoted to the *Whakapapa* theme conveyed through the juxtaposition of maritime practices, old and new (Smith 2010). In the same area, we could see another large and dramatic exhibit, the outstanding façade of the *wharenui*, or ancestral meeting house, from Ngāti Tukorehe, named *Tokopikowhakahau* and built in 1877–1878.

In addition to the selection of objects and interpretation overseen by Te Papa staff, the quai Branly made available their considerable exhibition resources such as lighting, installation design, and interpretive materials like explanatory panels, managing to create a feeling of natural light despite the lack of direct daylight in the space. Moreover, the quai Branly undertook a lot of publicity and marketing for this event, and posters and other advertising were prominent in some of the busiest parts of Paris, such as train stations and public transport, while the museum and the Parisian metro jointly promoted the show in the streets and metro stations. A flash mob *haka* (posture dance) was even organized in one of the busiest metro stations, Saint Lazare.

Māori: leurs trésors ont une âme could not be displayed in France the same way that it was in New Zealand, mainly because of the expectations of these two institutions and their different audiences. In New Zealand, the exhibition's purpose was to declare Māori self-determination by presenting some case studies of conflicts from the past and trying to describe the evolution of the struggle with the government. On the other hand, in France the goal was principally to increase understanding about the position of the Māori community within New Zealand. The French institution did not set out to express a point of view about the political situation in New Zealand, but to present the Māori community through its art and history.

The exhibition began life as *Mauriora*, which was displayed in Japan in 2008 before being revamped for a domestic audience as *E Tū Ake: Māori Standing Strong* at Te Papa in 2010–2011. In Paris the title was changed to *Māori: leurs trésors ont une âme* (Māori: their treasures have a soul). This was part of an effort to communicate with a French audience in a clearer way and make the show more inviting for both adults and children, emphasizing the appeal and richness of the collection presented. The original title may have had more of a radical political overtone, according to French views. There was also a significant difference in the translation of the text and graphic panels and the catalogue in English and French. During a conversation with Hervé Michaud, a French man working at Te Papa as a concept developer, he said that it was "more difficult to introduce some Māori concepts to the French public because they had not heard about them before … it was a new knowledge for them."

As presented at Te Papa, the exhibition was an attempt to present complex and challenging cultural issues to the public, but in particular the younger generation of Māori, who are not as sensitive to these issues as the older generation because they do not live in the same context, politically

or socially. The loss of *tikanga* (customs) is a concern for Māori elders who are actively fighting for their rights against the *Pakeha* (European) hegemony (Walker 1990). The 1975 Māori land march and the 506-day occupation of Bastion Point (Takaparawha) were two of the main protest events dealing with land issues that the exhibition provided background information about.

In the Māori worldview, the future is informed by the past. Unlike Europeans, the past is said to lie in front to provide guidance, while the future lies behind—this perspective could help foreigners to understand the Māori view of time and their place in the world. As Rhonda Paku, senior Māori curator, told me during a conversation about the exhibition and its issues, "There is a strong continuation of practice through our heritage. Māori come from an oral culture which involves the importance of the transmission of knowledge and reflects the importance that physical objects play in achieving our understanding and interpretation of the world."

The concept of a museum, as we understand it today, is an institution that was established in New Zealand by European settlers in the nineteenth century. These days, we can see that it is evolving with the adaptation of Māori principles concerning the display and preservation of Māori collections. Through the concept of biculturalism, Māori participate in the conservation of their *taonga* in museums based on the integrity of their own knowledge (McCarthy 2011). For Māori people today, institutions such as museums can be seen as a place where *taonga* can be preserved safely along both traditional and modern guidelines. This way, what Māori call the *whare taonga*, a storehouse or 'museum', is a place where the *taonga* can be preserved according to Māori principles such as *mana* (spiritual authority) and *tapu* (sacred power), including the necessity to ritually purify people and places coming into contact with these powerful objects. It is important to understand that just as modern conservation requires such scientific practices as maintaining temperature and humidity levels in collection stores as a way of preserving the objects, so tribal owners and guardians require the observance of cultural practices based on traditional customs in order to maintain their spiritual safety, what is referred to as 'keeping the *taonga* warm'.

To conclude, although this exhibition was the first example of collaboration between these two museums from opposite parts of the world, it was a success for both despite the differences and cross-cultural ambiguities. For Te Papa, it was an opportunity to send collections to a well-known museum in France and try to educate a different public who did not previously know much about traditional or contemporary Māori culture. And for the quai Branly, the staff was able to increase their knowledge about the Māori *taonga* preserved in the quai Branly's own collections and open the door to future collaborations with Te Papa and other international museums from countries where source communities want to reconnect with their heritage. Notably, this temporary exhibition was the most visited at the museum in 2011. Another outcome was that the museum gained greater understanding about the reasons for the repatriation of human remains, in the end organizing a ceremony for the return of material on 23 January 2012, after the closing of the exhibition.

The *E Tū Ake* exhibition and the subsequent repatriation of *toi moko* has, in my view, helped to change the perspectives of French institutions about the place of human remains in museum collections and has also influenced the display and research on indigenous collections—for me, this is the way forward for museums in contemporary society. The repatriation of human remains is still a controversial issue for the French government, but this recent change of opinion suggests that museums like the quai Branly can explore important and innovative cultural exchanges with the native communities in other countries through their national museums.

Simon Jean
PhD Candidate, EHESS Paris

References

McCarthy, Conal. 2007. *Exhibiting Māori: A History of Colonial Cultures of Display*. Oxford: Berg.
McCarthy, Conal. 2011. *Museums and Māori: Heritage Professionals, Indigenous Collections, Current Practice*. Wellington: Te Papa Press.
Mead, Hirini Moko. 2003. *Tikanga Maori: Living by Maori Values*. Wellington: Huia Publishers.
Mead, Sidney Moko., ed. 1984. *Te Maori: Maori Art from New Zealand Collections*. New York: Heinemann, American Federation of Arts.
Price, Sally. 2007. *Paris Primitive: Jacques Chirac's Museum on the Quai Branly*. Chicago: Chicago University Press.
Smith, Huhana. 2010. *E Tū Ake: Maori Standing Strong*. Wellington: Museum of New Zealand Te Papa Tongarewa.
Walker, Ranginui. 1990. *Ka Whawhai tonu Matou: Struggle without End*. Auckland: Penguin Books.

∎

The New American Art Galleries, Virginia Museum of Fine Arts, Richmond

Exhibiting American Art

In the depths of the Great Recession, American art is enjoying an unprecedented boom. To be sure, Washington's Corcoran Gallery, which houses one of the great collections of nineteenth- and early twentieth-century American painting, teeters on the verge of bankruptcy.[1] But for other museums with significant American holdings, these are fat times, with millions being spent on new or renovated wings and galleries, and on high-priced acquisitions. Between 1995 and 2009, museums in Newark, Brooklyn, Chicago, Washington, Detroit, San Francisco, and Kansas City (among other places) expanded, refurbished, and reinstalled their American collections. In 2010, the Museum of Fine Arts, Boston, inaugurated a spectacular four-story glass box, designed by Norman Foster and Partners, in which to display five thousand objects under the heading *Art of the Americas*.[2] In 2011, Alice Walton's Crystal Bridges Museum of American Art, housed in an elaborate set of pavilions designed by Moishe Safdie and located in Bentonville, Arkansas, made its long-awaited debut with, as one commentator described it, "a top-tier collection" that the billionaire Walmart heiress had amassed over a period of less than ten years (Wertheimer 2011). In January 2012, New York's Metropolitan Museum of Art launched with enormous fanfare its rebuilt and greatly expanded American Wing (see Vogel 2012; Cotter 2012).

To evaluate the new American art galleries at the Virginia Museum of Fine Arts (VMFA), which opened to the public in 2010, I need to establish a range of installation possibilities—not what might be possible in theory, but the solutions museums have arrived at in practice. As we might expect, the new installations fall along a continuum from traditional to innovative. Anyone with any experience with American art museums would predict—and the prediction would not be wrong—that most of these new installations lie somewhere in the middle of the continuum. But what does it mean for an installation to be innovative or traditional? Or to put the question somewhat differently, how does an installation open new perspectives on the history of American art—or close them off?

To arrive at an answer, I want to consider first the extreme or limiting cases. Crystal Bridges is the most conservative of the new installations, a mainly chronological lineup of works of art under the rubric *Celebrating the American Spirit*. In the United States, patriotism often furnishes the principal rationale for collecting and displaying American art, but few museums are

as insistent as Crystal Bridges on equating American art with a national 'vision' or 'spirit.'[3] This emphasis accords with the views of Alice Walton's chief advisor, Professor John Wilmerding, currently chairman of the National Gallery of Art's board of trustees and an art historical traditionalist, who guided Walton in assembling a collection of paintings that Wilmerding himself unhesitatingly calls "masterpieces" (Sorensen n.d.; Rose 2011). But if Crystal Bridges is meant to be experienced as a solemn display of art historical trophies wrested at extraordinary expense from public and private collections—as so often patriotism and commodity fetishism go hand in hand—it can also be experienced in somewhat different terms. Crystal Bridges' curators have grouped eighteenth- and nineteenth-century paintings by type (portrait, landscape, genre) and have posted wall texts with information about artists and brief historical comments that in a few instances acknowledge, if only obliquely, the "difficulties," as one wall text puts it, of American history.[4] Thus in a room dedicated to Hudson River School landscape painting, a wall text points to a history of Native American resistance to white settlement: in 1862, "the year [Albert Bierstadt] painted *Indian Encampment,* insurrections among indigenous tribes over the United States government's displacement of Native peoples from ancestral lands delayed his second trip west." In sum, Crystal Bridges didactic program represents at best a minimal—one might say grudging—concession to current museological practice, in which curators employ wall texts and other means (brochures, videos, etc.) to develop a fuller sense of the historical contexts in which art was made and used, and to complicate a traditional subject-object relationship in which, as at Crystal Bridges, it is tacitly assumed that the museum's ideal visitor is white and upper class.[5]

The Brooklyn Museum's *American Identities: A New Look,* which opened in 2001, represents almost the polar opposite of *Celebrating the American Spirit.* Arnold Lehman, the museum's flamboyant director, set the terms for the project. According to the critic Anna Mecugni, "the primary mandate that [Lehman] issued to the staff was to create a visitor-friendly exhibition that could be enjoyed by anyone, even by people with no background in art history." Lehman wanted "to make sure that the reinstalled galleries conveyed cultural pluralism" (which he thought would appeal to Brooklyn's multiracial, multiethnic population), and "he requested the inclusion of more Spanish Colonial pieces, the introduction of Native American objects, and the showcase [*sic*] of works by or about African Americans" (Mecugni 2005–2006: 34–35). In response, the museum's curatorial team, led by Teresa Carbone, divided the galleries into eight chronologically defined thematic units ("From Colony to Nation," "The Civil War Era," "The Centennial Era, 1876–1900," etc.) and installed works in a wide variety of media. In addition to presenting high art—oil painting, sculpture—the curators also included decorative arts, outsider art, early silent films, and recordings of popular music.[6] Visitors accustomed to more sedate presentations may have found the tightly packed mélange bewildering, but for those with the patience for careful looking, the installation yielded new insights. Consider, for example, the museum's pairing of William Williams's nearly life-size portrait of Deborah Hall (1766) and a portrait by an anonymous eighteenth-century Peruvian painter of Doña Mariana Belsunse y Salasar. By juxtaposing two mammoth colonial portraits—one of the wife of a Philadelphia printer, the other of a member of Lima's eighteenth-century Creole aristocracy—the curators underscored not only the international dimension of colonial American portraiture, but also the ways in which portraits were used to press claims to upper-class status.[7]

Predictably, traditionalists condemned the Brooklyn Museum for, in the words of the neo-conservative critic Hilton Kramer, "pandering to lowbrow tastes. … Everything is overlabeled, overpackaged and otherwise divided into simplistic categories" (Kramer 2004).[8] Even critics who did not object to Brooklyn's mixture of fine and popular art on occasion failed to comprehend the curators' aims. Thus, in the face of massive evidence to the contrary, one reviewer

clung to the comforting idea "that the pure visual pleasure of the show demonstrates that the curators above all intended that the objects speak for themselves" (Manthorne 2001: 57). But if Brooklyn's installation demonstrated anything, it is that contrary to hoary artworld cliché, works of art do not speak for themselves but acquire meaning only in relation to other art works and to a range of other contexts—historical, social, literary, aesthetic—including the 'context' of the museum space itself.

Contextualising American Art at the VMFA

American Identities set an influential precedent.[9] What was almost unthinkable in the 1990s—for example, seeing pre–Civil War American art in relation to a brutal history of slavery and exploitation—has in many instances become commonplace. The American collection at the Virginia Museum of Fine Arts, installed in the museum's new McGlothin Wing in 2010, represents a case in point.

The VMFA's American collection comprises painting, sculpture, works on paper, and decorative arts dating from the mid-seventeenth to the mid-twentieth century.[10] The seven-gallery installation contains nothing that could readily be called low or popular art, but unlike more traditional institutions—for example, the Metropolitan Museum[11]—the museum freely mixes fine, decorative, and folk art, and even includes a period room in its sequence of galleries. The curators who planned and oversaw the installation—Elizabeth O'Leary, Susan Rawles, Sylvia Yount, and David Park Curry (who left Richmond for Baltimore in 2005)—deployed approximately 140 works following what is by now the standard chronological progression ("Colonial and Revolutionary Periods," "Early Republic and Jacksonian Eras," "Antebellum Years," etc.). But if they adhered to tradition when it came to periodization, a close look at the galleries reveals they took unusual care in making historical, thematic, and stylistic connections. Two examples will suffice.

In a gallery devoted in part to the Civil War and its aftermath, Alexander Gardner's 1862 photograph of Lincoln and General George B. McClellan at Antietam hangs next to William MacLeod's 1864 painting of *Antietam Bridge*. Gardner's photograph is a stiffly posed official portrait in which, against a background of military tents, Lincoln towers over the general and his staff. By contrast, MacLeod's painting is a seemingly bucolic landscape complete with picturesque bridge, strolling couple, picnicking tourists, and placid stream. According to a wall text, "[W]ith close to 23,000 casualties from both Union and Confederate armies, the Battle of Antietam remains the deadliest day in American military history."[12] Photograph and painting depict different aspects of the battle's aftermath. One learns that Lincoln, unhappy with McClellan's failure to pursue the retreating Confederate army after the battle ended, eventually relieved the general of his command. The bridge at Antietam was the battle's focal point, and as a wall text notes, MacLeod's painting contains the diminutive figure of a Union soldier in a Zouave uniform as well as an ambulance wagon flying a red flag—details today's viewer would likely overlook or misconstrue, but which suggest the range of meanings the painting held for the artist's contemporaries.

The pairing of Gardner's photograph and MacLeod's painting seems an obvious curatorial choice.[13] Less obvious was a decision to group together works that are thematically dissimilar but stylistically linked. A corner of gallery six ("Modern Era") features paintings and sculptures by seven early and mid-twentieth-century modernists. No work is accorded 'masterpiece' status or allowed to overwhelm the others (this is one of the great virtues of the VMFA's American installation overall), but together, they suggest ways in which US and Latin American artists adapted cubism to their artistic aims. Thus, the viewer registers how Manniere Dawson and

William H. Johnson directly imitated the style of Picasso and Braque, how the sculptors Paul Manship and Richmond Barthé domesticated cubism by turning it into Art Deco, how Diego Rivera and Oswaldo Guaysamin primitivized the style, and how the Regionalist Thomas Hart Benton used it as the basis for his distinctive folkish manner.

The grouping suggests how far the VMFA curators went to produce an inclusive history of American art. Between 2002 and 2009, the museum purchased paintings by three African American artists—Robert Duncanson, Edward M. Bannister, and Henry Ossawa Tanner—whose relatively recent 'discovery' resulted from the art historical revisionism epitomized by Brooklyn's *American Identities*.[14] The curators also relied on loans in their effort to enlarge the definition of American art. Thus, for the grouping just described, the museum borrowed works by African Americans (Barthé, Johnson) and Latin Americans (Rivera, Guaysamin).

But an enlarged sense of the history of American art is not simply a matter of adding works by minority artists or suggesting American art's global dimension via the inclusion of paintings by artists who, like Rivera and Guaysamin, were influenced by, and proved influential for, artists in the United States. American art museums have often presented redemptive histories, in which works of art could be interpreted, as at Crystal Bridges, as evidence of an American 'vision' or 'spirit', in effect obscuring or papering over unbearable historical realities. By contrast, the curators at the VMFA have opted for a version of the revisionism on view in Brooklyn—in particular, for a history of American art that encompasses the thorny and still contentious issues of slavery and racial discrimination.

One example will have to stand for many: in the gallery dedicated to art of the colonial and revolutionary period, the museum displays a portrait by an artist known as the Payne Limner, which was donated to the museum in 1953 by a Payne family descendent, and which depicts Alexander Spotswood Payne and John Robert Dandridge Payne, scions of a wealthy plantation owner, and their unnamed black nurse (figure 1). The accompanying label makes a point that

Figure 1. View of the New American art galleries at the Virginia Museum of Fine Arts, Richmond, 2012 (Photograph by the author)

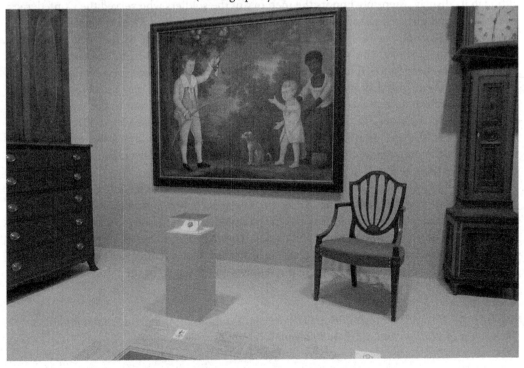

may seem obvious to some but is nonetheless necessary: despite his lack of academic training, the Payne Limner conveyed the family's privileged circumstances through setting, clothing, and the addition of the unnamed African American girl, whose legal status as a slave rendered her valuable taxable 'property'. Despite recent Revolutionary rhetoric about liberty and freedom—including the famous speech by Archer Payne's relation Patrick Henry—an economic system based on slave labor would continue in the South for another seventy-five years.

In front of the group portrait, the curators have placed a case containing one of Josiah Wedgwood's jasperware antislavery medallions, which the museum acquired in 2001. First imported to the United States by Benjamin Franklin, Wedgwood's medallions became, in the words of the wall text, "popular and persuasive political ornaments on both sides of the Atlantic. In abolitionist circles, they were variously framed, worn as pendants, and inlaid on snuff boxes." Together, painting and medallion powerfully evoke a history of oppression and resistance, a theme that is repeated elsewhere in the installation.

Coda

The VMFA is a state-funded institution located in a city that served as the capital of the Confederacy—a city that overflows with monuments, museums, and organizations dedicated to keeping alive the memory of the Lost Cause. It would be no exaggeration, then, to call the VMFA's display of American art enlightened, a reflection of the museum's determination to serve a diverse Virginia community. But as I learned, in Richmond as elsewhere, enlightenment has its limits.

While visiting the VMFA in June 2012, I was amazed to discover a group of men on the sidewalk adjoining the museum grounds waving Confederate flags at passing cars. A guard informed me that the men were protesting the museum's decision to remove a Confederate battle flag—the 'Stars and Bars'—from in front of the Pelham Chapel, a memorial to the Confederate dead that is a part of the VMFA's campus. The Confederate battle flag remains a potent symbol, and although its display ostensibly honors the memory of the soldiers who served the Confederacy, given a long and tortured history, it is also, inescapably, a signifier of white racism.

After the museum closed, I decided to pay the 'Virginia flaggers', as they call themselves, a visit. The three I spoke with—white working-class men who claimed to be descended from Confederate soldiers—proved to be an affable lot. They willingly posed for a photograph, and, when I asked them why they were urging a boycott of the museum, they said they considered the VMFA's decision to remove the flag a personal affront and an affront to the memory of the soldiers who, in the words of the flyer they handed me, "gallantly answered Virginia's call to defend her." The 'flaggers' didn't appear to be overtly racist, but it was impossible to believe they were unaware that the sight of the Stars and Bars could be painful or intimidating for those who failed to share their beliefs.

I was left contemplating a familiar dilemma. The VMFA seemed to be doing everything in its power to educate its public. That public, however, is heterogeneous, and while art museums in the United States readily attract the affluent and the educated, they are less successful when it comes to those lower down on the socioeconomic ladder (Bourdieu and Darbel 1990; Wallach 2002). This was no doubt the case with the 'flaggers'; in any event, their identity was bound up not with "the love of art," as Pierre Bourdieu might put it, but with nostalgia for the Lost Cause.

Alan Wallach
Ralph H. Wark Professor of Art and Art History and Professor of American Studies Emeritus,
The College of William and Mary, Williamsburg, Virginia

Notes

1. Having reached a point of desperation, the gallery's trustees are now formulating plans to sell their landmark building and move operations to the Washington suburbs. See David Montgomery and Jacqueline Trescott (2012).
2. See reviews by Justin Wolff (2011) and Kristina Wilson (2011).
3. When I visited Crystal Bridges on 18–19 May 2012, the two traveling exhibitions on display were called *The Hudson River School: Nature and the American Vision* and *American Encounters: Thomas Cole and the Narrative Landscape*.
4. Quotations from Crystal Bridges' wall texts recorded by the author, 16–17 May 2012.
5. Michelle Bradford (2012: 32) describes the museum's recent advertising campaign in nine Midwestern and Southern metropolitan markets as follows: "[G]eared to an upscale, better-educated audience, the ads [for the museum] appeared in the April issues of *Elle Décor, Food and Wine, Forbes, Fortune, Real Simple* and *Town & Country*."
6. See Elizabeth Hutchinson's (2003) review of *American Identities* for a fuller description of the galleries and the range of objects displayed.
7. The idea of juxtaposing these two paintings predates the opening of *American Identities* (see Mecugni 2005–2006: 56). Recently, the museum's newly acquired full-length portrait of Mrs. John Wendt, attributed to the English portrait painter Thomas Hudson, was added to the display, further demonstrating international artistic connections as well as making a point about the style of the two colonial paintings, which look awkward—although that is part of their charm—next to the suave product of an imperial metropole (see Sherry 2011).
8. Kramer's article is an attack on director Lehman's regime overall, not on *American Identities* per se, but it is suggestive of how conservatives might view the installation.
9. The controversial *The West as America* exhibition (1991), along with the rise during the 1990s of identity politics, are key aspects of the history leading up to *American Identities*. For *The West as America*, see Alan Wallach (1998).
10. For details, see the excellent scholarly catalogue published to coincide with the opening of the new American galleries (O'Leary et al. 2010).
11. Save for its period rooms, which date to the opening of the American Wing in 1924, the Metropolitan Museum displays painting and sculpture separately from furniture and other decorative arts. See the museum's website, which provides a detailed map and photographs of the galleries (http://www.metmuseum.org/collections/galleries, accessed 25 June 2012).
12. All quotations from VMFA wall texts and labels were recorded by the author, 13–14 June 2012.
13. Both painting and photograph were acquired in 2011, perhaps with the idea that they could be exhibited side by side.
14. Duncanson and Tanner have been the subjects of major retrospectives (see Ketner 1994; Marley 2011). For Bannister, see Holland (1998). The VMFA acquired Bannister's *Moonlight Marine* in 2009, apparently too late to be included in the collection catalogue (O'Leary et al., 2010).

References

Bourdieu, Pierre, and Alain Darbel. 1990. *The Love of Art: European Museums and their Public*. Trans. Caroline Beattie and Nick Merriman. Palo Alto, CA: Stanford University Press.

Bradford, Michelle. 2012. "Water Under the Bridge: Crystal Bridges Defies Critics, Wins Hearts." *Museum* 91 (4): 28–35.

Cotter, Holland. 2012. "The Met Reimagines the American Story." *New York Times*, 15 January. http://www.nytimes.com/2012/01/16/arts/design/metropolitan-museum-of-arts-new-american-wing-galleries-review.html?pagewanted=2&_r=1&hpw (accessed 16 January 2012).

Holland, Juanita Marie. 1998. "'Co-Workers in the Kingdom of Culture': Edward Mitchell Bannister and the Boston Community of African American Artists, 1848–1901." PhD diss., Columbia University.

Hutchinson, Elizabeth. 2003. "American Identities: A New Look." *CAA Reviews,* 11 April. http://www
.caareviews.org/reviews/527 (accessed 17 June 2012).

Ketner, Joseph D. 1994. *The Emergence of the African-American Artist: Robert S. Duncanson, 1821–1872.*
Columbia: University of Missouri Press.

Kramer, Hilton. 2004. "The Brooklyn Museum Gives Open House on Dumbing Down." *New York
Observer,* 17 May. http://observer.com/2004/05/the-brooklyn-museum-gives-open-house-on-
dumbing-down (accessed 25 June 2012).

Manthorne, Katherine E. 2001. "American Identities: A New Look." *Archives of American Art Journal* 41
(1–4): 55–58.

Mecugni, Anna. 2005–2006. "American Identities: The Case of the Brooklyn Museum of Art." *The Inter-
national Journal of the Humanities* 3 (11): 34–35.

Marley, Anna O., ed. 2011. *Henry Ossawa Tanner: Modern Spirit.* Berkeley: University of California
Press.

Montgomery, David, and Jacqueline Trescott. 2012. "Corcoran Gallery to test market for sale of land-
mark building." *Washington Post,* 4 June. http://www.washingtonpost.com/entertainment/
museums/corcoran-gallery-to-test-market-for-sale-of-building/2012/06/04/gJQAjHfBEV_print
.html (accessed 6 June 2012).

O'Leary, Elizabeth L., Sylvia Yount, Susan Jensen Rawles, and David Park Curry. 2010. *American Art at
the Virginia Museum of Fine Art.* Richmond: Virginia Museum of Fine Arts in association with the
University of Virginia Press.

Rose, Joel. 2011. "Wal-Mart Heiress' Show Puts a High Price On Art." National Public Radio website, 12
November. http://www.npr.org/2011/11/12/142270045/wal-mart-heiress-show-puts-a-high-price-
on-art (accessed 22 June 2012).

Sherry, Karen. 2011. "The British are Coming." The Brooklyn Museum: Community, May 12. http://
www.brooklynmuseum.org/community/blogosphere/2011/05/12/the-british-are-coming (accessed
24 June 2012).

Sorensen, Lee. n.d. "Wilmerding, John [Currie]." *Dictionary of Art Historians.* http://www.dictionaryo-
farthistorians.org/wilmerdingj.htm (accessed 24 June 2012).

Vogel, Carol. 2012. "Grand Galleries for National Treasures." *New York Times,* 6 January. http://www
.nytimes.com/2012/01/06/arts/design/metropolitan-museum-completes-american-wing-renovation
.html?pagewanted=all (accessed 7 January 2012).

Wallach, Alan. 1998. "The Battle over 'The West as America.'" Pp. 105–117 in *Exhibiting Contradiction:
Essays on the Art Museum in the United States.* Amherst: University of Massachusetts Press.

Wallach, Alan. 2002. "Class Rites in the Age of the Blockbuster." Pp. 114–128 in *High-Pop: Making Art
into Popular Entertainment,* ed. James Collins. Oxford: Blackwell.

Wertheimer, Linda. 2011. Transcript of National Public Radio's "Weekend Edition." 12 November. http://
www.npr.org/2011/11/12/142270045/wal-mart-heiress-show-puts-a-high-price-on-art (accessed 13
November 2011).

Wilson, Kristina. 2011. "Boston Museum of Fine Arts: Art of the Americas Wing." *CAA Reviews,* 25
August. http://www.caareviews.org/reviews/1691 (accessed 28 December 2011).

Wolff, Justin. 2011. "Boston Museum of Fine Arts: Art of the Americas Wing." *CAA Reviews,* 25 August.
http://www.caareviews.org/reviews/1690 (accessed 22 June 2012).

———————■———————

Scott's Last Expedition, The Natural History Museum, London

Scott's Last Expedition, at the Natural History Museum, London (20 January–2 September 2010),
marks the centenary of Robert Falcon Scott's death after reaching the South Pole and features

artifacts used by his team and scientific specimens collected during the 1910–1913 expedition. The focus on the scientific achievements of the Terra Nova expedition is evident in the comment (cited in *The Daily Telegraph*) made by the exhibition's curator, Elin Simonsson:

> [T]he legacy of the expedition … [is] incredible. Row upon row of bottles and jars and specimens—over 40,000 in total—were in the [Natural History] museum's collections, as well as numerous notebooks, sketches and volumes of analysis. Yet, we found very little about the expedition's scientific work in the biographies and books we came across. We soon realized that a big piece of the Terra Nova expedition story was missing. (Simonsson 2012)

Inevitably, however, *Scott's Last Expedition* begins with the tragic news of the death of the Polar Party, which was widely reported in the world's press in February 1913. The men had reached the South Pole on 18 January 1912, just over a month after the Norwegian Amundsen; Scott and his last two companions died on 29 March 1912. The extreme nature of the Antarctic environment—and why survival is so difficult—was captured by expedition cinematographer Herbert Ponting. His famous film footage helps to introduce visitors to Antarctica, and evocative images and film archives feature throughout the exhibition.

Although the exhibition has overtones of tragedy and loss, it is an enthralling account of life in Antarctica and how, despite the hardships endured, the men created their own community in the wooden hut at Cape Evans. This building was the main base camp, providing safe shelter for the twenty-five men who stayed there during the first winter; it survives to this day and is being restored and preserved by the Antarctic Heritage Trust. The interior of the hut is recreated for the exhibition, providing an immersive environment where images and exhibits depict everyday life and the stories of the men at work. Artifacts—including books, games, the expedition gramophone, food, clothes, letters, diaries, and scientific specimens, even a pair of seal skin overshoes and Scott's ski boots—are displayed in sections of the hut. The central feature in the building was a large table used by the crew members—officers, scientists, and lower-ranking expedition members—as a place of work and study as well as the main eating area. The table (Fig. 1) has been 'animated' for the exhibition; images projected onto its surface show the table laid for the team's last festive meal—a menu including seal soup and roast mutton—and covered with maps and scientific specimens.

Figure 1. *Scott's Last Expedition,* Natural History Museum London.
Reproduced with permission of the Natural History Museum, London.

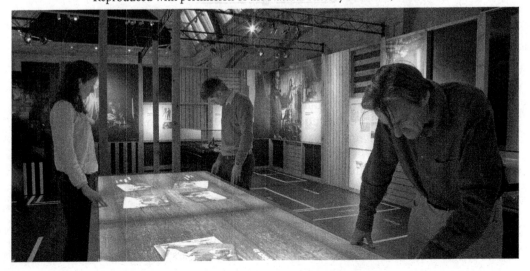

The expedition's scientific legacy is often overshadowed by the tragic events, but this exhibition stresses the contribution that was made by the scientific team to our knowledge of the geology and biology of Antarctica. Particularly significant was the fossil plant *Glossopteris indica*, which was later used to suggest Antarctica had been part of the supercontinent Gondwana. Perhaps less scientifically significant are the emperor penguin eggs collected by Adrian Edward Wilson, Henry Robertson Bowers, and Apsley Cherry-Garrard; the results of the embryo studies on the specimens were not published until 1934, when the hypothesis of penguins as an evolutionary link had been dismissed. The three men had endured 'the worst journey in the world' (the title of Cherry-Garrard's written account) to obtain them, and the eggs now represent an incredible human story, a triumph of survival in the bleakest of situations. Edward Wilson's vivid illustrations of wildlife—many which feature in his 'expedition notebook', which is displayed—have real scientific value, and many were reproduced in the reports publishing the expedition's scientific results.

The final exhibition areas examine the scientific legacy of the Terra Nova expedition, making a firm link with scientific work being carried out in Antarctica today. A cinema space shows a series of films that reflect on the expedition's lasting impact. Overall, this was a fascinating and inspirational exhibition, one that clearly affected the visitors who had left behind their comments, reflecting on the dangers, hardships, tenacity, and skill of the scientists who accompanied Scott. It admirably fulfilled the curator's goal of telling Scott's story in a new light, one of scientific endeavor and achievement.

Peter Davis
ICCHS, Newcastle University, UK

References

Simonsson, Elin. 2012. "Exhibition in Focus: Scott's Last Expedition, Natural History Museum." *The Daily Telegraph*, 27 January. http://www.telegraph.co.uk/travel/destinations/europe/uk/london/exhibition-in-focus/9043817/Exhibition-in-Focus-Scotts-Last-Expedition-Natural-History-Museum.html (accessed 28 January 2012).

──────────■──────────

Left-Wing Art, Right-Wing Art, Pure Art:
New National Art, Museum of Modern Art, Warsaw

The Museum of Modern Art (Muzeum Sztuki Nowoczesnej) in Warsaw, Poland, could itself stand as a metaphor for the uneasy modernization process of the country. Established by the Minister of Culture in 2005, until now it has not had a permanent home, and in May 2012 its director received the news that the city authorities had broken the contract with the Swiss architect Christian Kerez, winner of the 2007 competition for the museum design. Unofficially, the reason is the cuts in the city's culture budget as a result of the construction of the National Stadium for the Football Eurocup 2012.

In spite of all its adversities, the museum, provisionally located in a former furniture department store, is an outstanding example of flawed modernism practiced in the era of real socialism, and remains one of the more active cultural institutions in Warsaw. The latest show organized

on the museum premises, entitled *New National Art* (*Nowa Sztuka Naradowa*) and curated by Sebastian Cichocki and Łukasz Ronduda was aimed at challenging its own image of an elitist art institution "associated with a left-wing discourse of empowerment," as the curators put it. To the curators, it was also "an exercise in identifying the differences between left-wing critical art, confined in an elitist way to institutions and art discourse, and right-wing art that challenges the latter and puts an emphasis on achieving immediate effect." This strong polarization into left- and right-wing art reflected not only the polarization of the Polish political scene, but also the polarization of Polish society in terms of its artistic tastes. As the exhibition demonstrated, taste was supposed to be less a question of social distinction, and more of a political one. What this program tacitly assumes, however, is the existence of a common denominator for both the left and the right wing: art and, moreover, modern art, to which the museum is dedicated.

The exhibited material comprises works in different techniques and sizes, originating from very different social and political contexts, and within various registers of expression. Many of them were created after the 2010 crash of the presidential aircraft in Smolensk, and include a canvas by a professional artist; models of monuments designed to commemorate the crash victims, sent in for a public competition; some amateur drawings; and a film about the removal of the cross erected by a grassroots initiative in front of the presidential palace immediately after the crash, which became the hottest political issue of the exceptionally hot summer of 2010. There is also a selection of cover designs for the right-wing cultural review *Fronda*, as well as several comic books, mostly on patriotic subjects (patriotism understood as living up to the heroic tradition of military struggles), including one of a Polish version of superhero White Eagle (a white eagle being the national emblem of Poland). A rap music video comments on the patriotic duty of remembering WWII heroes; another video is of a show prepared by the fans of a Polish football club and performed by the audience in stands at the opening of an international game. Next to the canvas by the professional artist, hanging on the wall, is an openwork metal panel in the national colors of white and red, one of the panels used for the construction of the National Stadium. At the door visitors are greeted by a copy of the hands of the biggest statue of Christ in the world, built of concrete in the locality of Świebodzin, while in front of them a 'carpet' is spread out, made of fresh flowers for the Corpus Christi procession by the inhabitants of the village of Spycimierz.

The whole exhibition looks very pure and modern: here a piece of land art, there a piece of video art, or graphic design, here a film, there a sculpture. It is as if a museum of modern art worked as a purification machine, extracting the artistic, and separating the conceptual from the easy emotions of the crowd. In the gallery, the existential hybrid football fans performance gets dissected and brought to its supposed essence of art. This is only possible because the modern mechanism of purification into art overlooks the various complicated networks of which these works are a part. Some of them are indeed politically antimodern, sharing with the modernists their beliefs in art and its museums, but affixing the opposite sign to each declaration the modernists proclaim—the left and the right, if you wish. However, several of the works are simply nonmodern, products of the world where art cannot be pure, and never is. The flower carpet is neither left, nor right; the same with the relics of a Catholic saint represented in a photograph, a material testimony to an alleged miracle. Their hybridity seems too complex for a modern art exhibition, if modern is to be understood in its normative sense. Focused on the process of purification, the curators mixed up the antimodern works with the nonmodern works, overlooking the main difference between them.

Ewa Klekot
Instytut Etnologii i Antropologii Kulturowej, Uniwersytet Warszawski, Poland

———————————▪———————————

Focus on Strangers: Photo Albums of World War II, Stadtmuseum, Jena, Germany, 2011

Focus on Strangers: Photo Albums of World War II is based on a collaborative research project conducted by two German universities (Carl von Ossietzky Universität Oldenburg and Friedrich Schiller Universität Jena) and was conceptualized in cooperation with four German city museums in Oldenburg, Munich, Frankfurt, and Jena. While the exhibition continues a tradition of museological projects examining Germany's war history, such as the *Wehrmachtsaustellung*, which provoked fierce public debate, *Focus on Strangers* moves beyond most conventional approaches in a significant way.

The exhibition pays tribute to the recent development in which private traces of memory have become part of the public perception of history, in this case the history of World War II. Given the inevitable fact that the generation that experienced this dramatic historical event is slowly passing away, personal memories mainly live on in photo albums and their embodied stories handed on to the next generations. The photograph has, more than any other type of picture, affected the public perception of historical moments and their collective memory. Museums increasingly explore private photo albums as historical sources and *Focus on Strangers* is a particularly promising example due to its exhibitionary disclosure of the multilayered analysis of war photographs in their historical, political, and aesthetic context.

One hundred and fifty private photo albums, loaned from former *Wehrmacht* soldiers or their relatives from northern Germany as well as retrieved from museums and archives, form the basis of the exhibition. Eight thematic rooms show the construction of memories connected with World War II. Black-and-white reproductions portray the daily war routines and the ubiquitous stranger. Slide and film projections reflect the widespread aesthetic interest in new media at that time, such as color photography and amateur film. Interviews with three former soldiers offer biographical insights into the stories behind the photos, the circumstances of their being taken, and the intentions of the photographer. *Focus on Strangers* intends to present a "private pictorial history of World War II," attempting to show a "new, sharper picture of the personal experience of war" (Bopp and Starke 2009: 70–71).

In my view, the exhibition achieves this goal by *humanizing war*. At first sight, this statement might appear as an oxymoron. But despite the inhuman horrors of warfare and their technological manifestations, war as the most barbarous form of conflict itself remains a *human* concept: conducted by humans, with humans, and against humans. I recall being especially affected by a photograph with the term *Minenprobe* on its backside (figure 1). It depicts a women being used as a human landmine detector following the official military order *Minensuchgerät 42*. A seemingly innocent snapshot gains an unspeakable quality and encapsulates what, according to Daniel Libeskind (2000), "can never be exhibited . . . : humanity reduced to ashes". Other tangible examples of the trauma of war in the exhibition were photo albums with torn-out photographs; here, the traces of the absent remain visible.

By using private photographs as the principal media, *Focus on Strangers* allows the visitor to travel beyond the abstract term 'war' toward the actual *meanings* embedded in personal experience, private memory, and subjective history. The exhibition succeeds in documenting "how the war was seen, and not how it was" (Bopp and Starke 2009: 15). This seemingly paradoxical point hints at the hermeneutic complexity of the human product that is 'history'. Private war photographs embody individual spaces of memory that simultaneously construct, deconstruct,

Figure 1. A women being used as a human landmine detector, image from *Focus on Strangers: Photo Albums of World War II* in Stadtmuseum, Jena, Germany, 2011

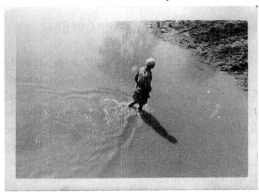

and reconstruct public perceptions and cultural memories. Every photo tells its own story, and its meaning is continuously revised through changing perspectives, contexts, and generations. The exhibition shows how the curious-ethnographic or racist view of the 'Other' contemporaneously reflects the respective sense of 'Self'. While the perception of the stranger is doubtlessly informed by war propaganda and the discourse of racist ideology, it is nevertheless impossible to consider the photos as one singular perspective on the war. The experience of the individual becomes visible in fragmented parts that make sense only in their hermeneutic relationship to the whole.

Focus on Strangers lends photos and stories to the abstract category 'war' and thus enables the visitors to confront it "as a face, not mask" (Bauman 1995: 59). The exhibition shows that Self and Other, agency and discourse, and biography and history are not dualistically opposed binaries but mutually dependent abstractions of the same process, or different sides of the same coin. By humanizing totalities such as 'people', 'history', and 'culture', the exhibition renders possible the moral and political engagement between the visitor's 'Self' and the exhibited 'Other' (Schorch 2010). The medium 'exhibition' is used to create a rich dialogue between academia and the public, contributing to the further development of the 'reflexive museum' (Schorch 2009). In my view, it is exactly the human dimension that needs to be emphasized to address human problems and find human solutions in museums and beyond.

Philipp Schorch
Alfred Deakin Research Institute, Deakin University

References

Bauman, Zygmunt. 1995. *Life in Fragments: Essays in Postmodern Morality.* Oxford: Blackwell.

Bopp, Petra, and Starke, Sandra. 2009. *Fremde im Visier—Fotoalben aus dem Zweiten Weltkrieg.* Bielefeld, Germany: Kerber Verlag.

Libeskind, Daniel. 2000. "The Libeskind Building." Jewish Museum Berlin website. http://www.jmberlin .de/main/EN/04-About-The-Museum/01-Architecture/01-libeskind-Building.php (accessed 9 April 2012).

Schorch, Philipp. 2009. "The 'Reflexive Museum'—Opening the Doors to Behind the Scenes." *Te Ara: Journal of Museums Aotearoa* 33: 1–2.

Schorch, Philipp. 2010. "Humanising Contact Zones." In *Museums and Ethnicity,* ed. O. Guntarik, 262– 287. Edinburgh: MuseumsEtc.

A Museum That Is Not: A Fanatical Narrative of What a Museum Can Be

A museum can be many things to its audience. In mainland China, museums are generously funded by the government or business tycoons, and are considered to be agents of modernity, articulating a grand narrative of Chinese arts and culture and engaging in contemporary global concerns. Such modernistic urges of national structures, however, may limit a museum's mission, purpose, scope, and method of communicating with the public. In considering these fundamental issues, the Guangdong Times Museum explores its possibilities in a temporary exhibition, *A Museum That Is Not.* The curator has invited visitors to a light-hearted and stimulating journey to subvert the conventional definition of the institution.

The journey begins with the "Museum of the Unknown," a peculiar group of daily life objects that defy rational definitions (figure 1). Floor lamps have been gathered into a magic circle to transmit secret messages of the Pythagorean tuning chart; and an industrial fan was installed onto a dining table to obscure possible dialogues at the table. The text rambles on about some of the great inventions of modern times, such as a remote-controlled helicopter for collecting whale snot, or using a roller-coaster ride to treat patients with asthma. Instead of using the objects and text to intellectualize the meaning of the exhibits, the museum blatantly states that it is not an authority, challenging its own role as a guardian of knowledge.

To further deconstruct the museum's authority, the curator has reenacted the iconic exhibition *Cubism and Abstract Art,* which was curated by Alfred Barr at the Museum of Modern Art (MoMA), New York, in 1936. The "MoMA Made in China" section of the exhibition presents a prototype of how modern art history has been constructed systematically within a white cube space. Curiously, the exhibits are highlighted as replicas made in China. Entering the gallery of fakes, in the hope of finding genuine pieces, was so haunting that visitors demanded an expla-

Figure 1. "The Museum of the Unknown" presents a peculiar group of objects that blur the boundaries of art, daily life, and science (Used with permission of the Guangdong Times Museum)

nation. The curator, however, deliberately placed fake *Cézanne*, Picasso, and Matisse works in the context of contemporary China, which elicited more questions than answers: Why were the 'works' considered to be significant in the development of modern art? How do these 'works' embody the notion of modernity, to which China passionately aspires? Where do the Chinese artists fit in all of this? And above all, why would the museum accept replicas made in China, and what does the fabrication mean in terms of China's role as the world's factory?

Regular museumgoers may be relieved when they encounter Liu Ding's *Museum and Me* in an ordinary white room with few props. Nevertheless, the sense of ease would be short-lived. The work was intended to create a private zone from public space, to show a set of letters (defined by Liu Ding as a piece of art, and as a wedding gift to his artist friends), written notes by Liu Ding and the curator about different museum experiences, and video clips of discussions about the hierarchy of the art world in contemporary China. To some extent, the exhibit is its own antagonist—viewers are expected to appreciate the language of art (in a white cube, where the language is in the forms and concepts, but here, the language is the discourse of a white cube). In any case, the sense of intimacy conveyed by the artist is compromised by the context—the 'blank' gallery space seems too stark to provide a personal touch. Again, more questions arise: Why does a white cube space alienate visitors from their individual experiences? Is the rigidity supposed to hint at the artist's aesthetic commentary? Could the gallery space have been more open and engaging?

Perhaps Wilfredo Prieto's performance installation *Mute* can shed some light on these ideas. *Mute* combines beams of disco lighting with an awkward sense of silence, to transform the exhibition space into a conceptual realm filled with uncertainties. Is this a party gone wrong? Or is it a good piece of art? How can visitors make meaning from the muteness? Prieto sets out to create a spectacular scene to engage visitors in the charms of disco lighting, but cunningly prevents people from hearing the sounds that might be joined to their own moves. Interestingly, the installation has formal qualities that empower visitors to create their own experiences through the art, and to imagine what the space could be. Not by coincidence, the work is the very last section of the exhibition. It serves as a metaphor to summarize what a museum could be—an open box that captivates the imagination of visitors, inspiring them to cocreate the meaning of art.

By touching on some of the issues that have hindered the development of museums in China, *A Museum That Is Not* invites visitors and members of the profession to consider what they want from art museums. The key question remains: as individuals, how would we like art museums to respond to our concerns, sensibilities, and aspirations for good art? The journey has barely begun, and will likely continue for some time before we can arrive at a new, acceptable meaning of the art museum.

Wing Yan Vivian Ting
Academy of Visual Arts, Hong Kong Baptist University

21st Century: Art in the First Decade, QAGOMA, Brisbane

One of the critical questions in the art world today is whether contemporary art is now truly global, and one of the most critical questions for contemporary museums is who is a museum in the twenty-first century for? (QAGOMA 2010). Both questions are implicit in the Queensland

Art Gallery/Gallery of Modern Art (QAGOMA) exhibition *21st Century: Art in the First Decade* (18 December 2010 - 26 April 2011). The exhibition was the brainchild of QAGOMA director Tony Ellwood, who introduced it as "a reflection on the polymorphous nature of the world in which we live" (Ellwood 2010).

QAGOMA had already embarked on such a reflection on the polymorphous nature of the region in which Australia lives with the *Asia-Pacific Triennial of Contemporary Art* (APT) series, launched in 1993, which has become the project for which the institution is best known and has led to one of the world's largest collections of contemporary Asian and Pacific art. *21st Century* sought to extend this concept with a reflection on what a global art might be in our times, and the project also involved a major collection building exercise, with only twenty-one works of the massive number of works on display not now part of the gallery's own collection. The exhibition also built on the extraordinary audience base QAGOMA had developed over two decades of the APT series.

The exhibition partly answered the first question posed at the beginning of this review by attempting to be truly global in scope—220 works by 140 artists from Australia, Asia, the Pacific, Africa, the Middle East, Europe, and North and South America. Most of the 40 Australian artists are indigenous. It addressed the second question by a visitor-centered approach to the

Figure 1. *21st Century: Art in the First Decade,* Queensland Art Gallery/Gallery of Modern Art, Brisbane (Image courtesy of QAGOMA)

exhibition, which included many dialogically motivated and interactive art works, extensive visitor programs with a focus on new technologies as a learning tool (smartphone interactive tours, blogs, lounges with free wi-fi and computers), a film program in the gallery's Cinémathèque, and a major emphasis on children and young people.

21st Century received an astonishing audience attendance of just over four hundred and fifty thousand (in a city and regional catchment of around two million people), even with a five-week closure when Brisbane was recovering from devastating floods. This remarkable achievement, however, drew an antagonistic, not to say hostile, response from one art historian, who entitled his review "Carnival Capers," suggesting much of the audience had been enticed by spectacle alone from their usual habitat of shopping centers; the critic complained that many visitors were dressed casually and even in shorts (and thus presumably could not respond with serious attention to art) and posed the question: "Is it possible for contemporary art to be pretentious and populist at the same time?" (Allen 2011). This was answered in a thought-

ful response about changing museum audiences by Aleema Ash, who in turn asked, "Are museums forever destined to reinforce class and cultural structures" for "people like me?" (Ash 2012).

The fact is that *21st Century* succeeded impressively in conveying both the scope and the prevailing mood of its subject and posing intellectually challenging questions for its audiences. A number of the works might indeed be termed light-hearted, such as Argentinian artist Leandro Erlich's illusional swimming pool, and a considerable number were deliberately designed to attract younger viewers. But the overwhelming theme of *21st Century* was that our world is a very serious place. Céleste Boursier-Mougenot's room, where harplike music was created by live finches landing on metal triangles, could only remind us of the fragile nature of human relationships with other life forms in this age of the anthropocene, when human actions are affecting everything on earth. Artists like Isaac Julien, William Kentridge, Ai Wei Wei, and Artur Zmijewski (whose twenty-channel video *Democracies* could not be more pertinent to our times), as well as works by African and Islamic artists, convey the mood of a world in which, as Tony Judt suggested, we are likely to find ourselves "facing a situation in which our chief task is not to imagine better worlds but rather to think how to prevent worse ones" (quoted in Buruma 2012). It is a mood precisely conveyed by Iranian-English Mitra Tabrizian's *City, London,* in which twenty-six suited men of various ethnicities stand around, unhopefully, presumably awaiting the next paroxysm of the share market. It is conveyed most acutely by the Danish group Superflex's eerily prophetic video installation *Flooded McDonalds,* depicting a McDonald's store gradually going under water, as so many buildings would go under water in the Brisbane floods and in the dreadful Tohoku tsunami.

There is a certain appropriateness in the fact that the work that could be said most unequivocally to move beyond the concerns of this world is *Soul Under the Moon* by the Japanese artist Yayoi Kusama, which provides the viewer with a most convincing sense of eternity, and a corresponding release from the twenty-first century and its anxieties. But perhaps Tony Ellwood expressed the sense of occasion best when he referred to Belgian/Swedish artist Carsten Höller's "enormous slide, commissioned for *21st Century*" as symbolizing the "leap of faith" required to "collect and engage with the art of the present … that moment when you let go and let gravity draw you down the spiralling slide, uncertain of where you will find yourself at the other end" (Ellwood 2010). We all know that feeling: it's the sense of the twenty-first century.

Caroline Turner
Senior Research Fellow, Australian National University Canberra
Glen St John Barclay
Independent Scholar

References

Allen, Christopher. 2011. "Carnival Capers." *The Australian,* review, 9 April. http://www.theaustralian .com.au/arts/carnival-capers/story-e6frg8n6-1226033122793 (accessed 12 June 2012).

Ash, Aleema. 2012. "The Contemporary Art Gallery: Equal Access for All?" *Artwrite.* http://blogs.cofa .unsw.edu.au/artwrite/?cat=4489, 19 October 2011 (accessed 17 June 2012).

Buruma, Ian. 2012. "Tony Judt: The Right Questions." *New York Review of Books* 59 (6): 28–31.

Ellwood, Tony. 2010. "Introduction." Pp. 15–16 in *21st Century: Art in the First Decade.* Edited Miranda Wallace, Brisbane: Queensland Art Gallery/Gallery of Modern Art.

Queensland Art Gallery/Gallery of Modern Art. 2010. "What Does a 21st Century Museum Look Like and Who Is it For?" http://21cblog.com/what-does-a-21st-century-art-museum-look-like-and-who-is-it-for/ (accessed 5 June 2012).

——————▪——————

James Cook and the Exploration of the Pacific, Art and Exhibition Hall of the Federal Republic of Germany, Bonn

James Cook and the Exploration of the Pacific opened at the Art and Exhibition Hall of the Federal Republic of Germany in Bonn on 28 August 2009, and then traveled to Vienna's Museum of Ethnology and then to Bern's Historisches Museum, where it closed on 13 February 2011. The three venues each had a slightly different version of the exhibition, with the version in Bonn, the subject of this review, the largest iteration, with over 550 ethnographic and natural history artifacts on display.

Entering the exhibition, visitors encountered tools of the trade. This first section was filled with the navigational equipment that James Cook and his crew used to explore the Pacific. Globes, sextants, telescopes, and maps were put on display, along with a blue Royal Navy captain's uniform similar to the one Cook wore in the well-known portrait by Nathanial Dance. Stepping further inside the exhibition, three maps of the earth covered the floor, each one detailing the route of Cook's voyages. The remainder of the exhibition was organized geographically, with artifacts from each of the countries that Cook traveled to grouped together. Three different colored lines emerging from each of the maps wound themselves around the exhibition, mirroring the route Cook took on each of the voyages—going from island to island—or, in the case of the exhibition, from section to section. For anyone having a hard time grasping the enormity of Cook's three voyages and the great expanse of ocean he traversed, following any one of the lines, or all three of them, gave you a greater appreciation of the tremendous feats Cook and his crew undertook.

Just as the lines that took visitors from section to section of the exhibition helped in understanding the great distances that the voyagers traveled, the sheer magnitude of objects on display attested to the fervor with which ethnographic and natural history artifacts were collected on the expeditions. I imagine that for the general public the exhibition was an eye opener, exposing them to areas of the world and artifacts that were largely unfamiliar to them. And for scholars who focus on the Pacific, the exhibition must have evoked similar feelings of wonderment, and encountering many of the artifacts was like seeing old friends.

While I can't possibly detail every important work in the exhibition, I would like to point out some of the many highlights on display. They include: the original Parkinson drawings of the Māori man and war canoe from the collection of the British Museum; the portrait of Sir Joseph Banks by Benjamin West, accompanied by the actual Māori cloak Banks wore in the painting, now in the collection of the Pitt Rivers Museum at Oxford; countless examples of Hawaiian featherwork; Omai's calling card; a Tongan clothing mat; Nootka masks; a Rapa Nui carved hand; a complete Tahitian mourning costume; the enormous William Hodges painting *The War Boats of the Island of Otaheite ...*; a Māori *rei puta*; and the only known Hawaiian feathered tabooing wand in the world. While the ethnographic and natural history artifacts on display were quite spectacular, I was also taken with the sample of portable soup that was included in the exhibition—a prime example of the keen attention Cook paid in maintaining the health of his crew. It is also an excellent example of the great depth of the exhibition, in that it examined the three voyages in enormous detail, right down to the soup block.

The award-winning catalogue that accompanied the exhibition is an incredible resource (Kaeppler et al. 2009). In addition to entries about each of the artifacts on display, the essays by the curator of the exhibition, Adrienne Kaeppler, as well as scholars such as Jeremy Coote,

Christain Feest, Brigitta Hauser-Schäublin, Margaret Jolly, Rüdiger Joppien, Anne Salmond, and Paul Tapsell, to name just a few, offer a wide variety of insights into Cook and his three voyages, collectively contextualizing Cook's expeditions within the scope of the age of the Enlightenment. Other essays include various native perspectives on the voyages—New Zealand Māori, Australian, and Vanuatu—as well as an essay on the death of Cook. Additional essays provided insight into some of the ships' artists, such as John Webber.

Appealing to a broad range of visitors—interested members of the public, anthropologists, art historians, and naval enthusiasts alike—the exhibition brought together both ethnographic and natural history artifacts from collections circumnavigating the globe, much like Cook himself did, an exhibitionary feat that will likely never be repeated again. The sheer magnitude of the exhibition reminds us all of the enormous impact of Cook's voyages, and to have seen this unprecedented exhibition was a once in a lifetime opportunity that I feel lucky to have had.

Jennifer Wagelie
Indiana University Art Museum, Bloomington

Reference

Kaeppler, A.L., et al. 2009. *James Cook and the Exploration of the Pacific*. London: Thames and Hudson.

───────────■───────────

Land, Sea and Sky: Contemporary Art of the Torres Strait Islands, QAGOMA, Brisbane, and *Awakening: Stories from the Torres Strait,* Queensland Museum, Brisbane

In this review, I look at two recent temporary exhibitions that focused on the Torres Strait Islands. The exhibitions are *Land, Sea and Sky: Contemporary Art of the Torres Strait Islands*, Queensland Art Gallery/Gallery of Modern Art (QAGOMA), and *Awakening: Stories from the Torres Strait*, Queensland Museum. These two exhibitions were part of a larger festival marking a celebration of Torres Strait Islander culture and history at the Cultural Center, South Bank, Brisbane, from June to October 2011. The festival was accompanied by a lavishly illustrated 320-page publication that included contributions from authors working in the disciplinary fields of archaeology, anthropology, art, and history.

The Queensland Museum's *Awakening* exhibition set out to "reconnect the spirit between people and their objects" (according to the exhibition mission statement). Situated on the museum's main floor level, visitors entered the exhibition space through a large, woven, trellislike structure that acted as a boundary into an inner space arranged around what appeared to be an archipelago of individual display areas. Each 'island' focused on one aspect of Torres Strait Island culture, denoted by anthropological categories such as place, women, food, and change. The exhibition included a number of artifacts collected by the British anthropologist A. C. Haddon during the 1898 Torres Strait expedition and loaned by the University of Cambridge.

The exhibition narrated a story of Torres Strait Island culture through a series of historical and contemporary artifacts collected by the Queensland Museum over the past 130 years. Voices of Torres Strait Islanders were presenced through sound recordings that echoed in the exhibition space and the words of prominent islanders presented on text panels (in English and local vernacular). The exhibition addressed the impacts of Christianity and the pearling

industry on the region, both of which have had a lasting influence on the social, religious, and economic make-up of the archipelago. The final 'island' featured the documentary film *Cracks in the Mask*. While the exhibition mission emphasized reconnection, this film was unsettling, as it concentrated on a Torres Strait Islander's journey of discovery to European museums to find his 'lost' cultural heritage.

If *Awakening* introduced the hope of revival, *Land, Sea and Sky* left no doubt of the vibrancy of contemporary art in the region. It featured the work of over forty contemporary artists from the Torres Strait Islands—including well-known artists such as Dennis Nona and Alick Tipoti— and included major commissions of new artworks as well as loans from private and public collections. Occupying the entire upper gallery, visitors were greeted by a colourful arrangement of buoys suspended from the ceiling. The installation *Family Tree* by Brisbane-based artist Kevin O'Brien took its inspiration from the buoys that hang from almond trees, bringing to life the maritime culture of the Torres Strait Islands through an abstract network of lines and points, much like a family tree. O'Brien's remarkable work was a fitting centerpiece, as not only did it express connections, but it also provided the pivotal meeting space for pathways off to the main exhibition spaces. One of these connecting spaces was covered by a fifty-meter mural by the acclaimed artist Alick Tipoti, commissioned for the exhibition. The mural depicted the creation of the Milky Way by a shovelnose shark.

The main gallery featured a range of contemporary artists working in a range of media, including print. Wall-mounted dance machines and *dhari* headdresses arranged in animated fashion on the white gallery walls immediately evoked connections to performance spaces on the islands. The open floorspaces combined with curvilinear walls to map out the shape of a turtle, an important cultural and religious symbol to Torres Strait Islanders.

Another space focused on baskets and fiberwork and resembled much more a conventional anthropological installation. The baskets were suspended in an eye-catching array, appearing like traps as they hung in space. The exhibition also featured a series of short films made by Torres Strait Islanders and photographs documenting a diaspora community living in Melbourne.

While the two exhibitions were impressive in their scope and design, a highlight was the program of dance performances by Torres Straight Island cultural groups over the festival's opening weekend in July. These performances were not only incredibly popular, but they also served to emphasize the nature of culture in the Torres Strait Islands as performative and ongoing.

Both exhibitions should be applauded for their attempts to relocate the Torres Strait Islands in the emerging cultural metropolis of Brisbane. This is especially important given that for the majority of the Australian population, the Torres Strait Islands remains largely unknown. Queensland Museum and QAGOMA curators worked closely with Torres Strait Islanders in the establishment of the two exhibitions, both with communities on the islands and in Brisbane. One would hope, given the strength and diversity of the collections in Queensland museums and the presence of a thriving Torres Straight Islander community in Brisbane, that a permanent gallery dedicated to the Torres Strait Islands will soon be established.

Graeme Were
Convenor of Museum Studies Postgraduate Program, University of Queensland

BOOK REVIEWS

Museums, Equality and Social Justice
Edited by Richard Sandell and Eithne
Nightingale
London: Routledge, 2012

In North America, the rise and development
of critical museology can be traced through
a trilogy of edited volumes, *Exhibiting Cul-
tures* (Karp and Lavine 1991), *Museums and
Communities* (Karp et al. 1992), and *Museum
Frictions* (Karp et al. 2006). When the first
volume appeared in 1990, I was beginning
graduate work in museum anthropology, hav-
ing worked in the disability rights movement.
Sitting in the university library cafeteria with
a fellow politically aware graduate student en-
gaged in gay rights and postcolonial theory, I
was surprised when he avoided contact with
a developmentally disabled man who cleared
our table. The man with the disability was in-
visible to the graduate student; had the for-
mer represented a racial or sexual minority, I
was sure there would have at least been a nod
of recognition. This scene has stayed with me
because it revealed how minority and human
rights are hierarchically organized, with dis-
ability issues near the bottom of the pack
(Kallen 1989).

Exhibiting Cultures was a pivotal volume,
articulating a critical vocabulary that served
my ethnographic museum fieldwork in To-
ronto and South Africa. I did not question the
absence of disability (and sexuality and gen-
der) issues in the volume. Its weaving together
of literary and philosophical theoretical tools
with the politics of ethnic and racial exclu-
sion, as well as bourgeois social control, was

exemplary. A new edited volume, *Museums,
Equality and Social Justice,* adds new layers of
complexity to the trilogy mentioned above by
situating disability, gender, and sexuality is-
sues alongside race, ethnicity, and indigeneity,
under the rubric of equity and human rights.

Museums, Equality and Social Justice in-
cludes twenty-one chapters, a number of them
addressing disability, gender, and sexuality is-
sues in museums. But the volume is not or-
ganized according to different categories of
exclusion. As a result, multiple forms of di-
versity and difference are evoked, includ-
ing religion (Reeve), economic marginality
(Younge, Varutti), illiteracy (Kamel and Ger-
bich), and social marginality (Baldino). Given
ethnographic museums' historical complicity
with colonialism, empire, and the production
and circulation of racial stereotypes, critical
museology has produced a robust literature
on decolonizing museums.[1] It is refreshing for
a North American reader to see these founda-
tional issues placed in a new and broader con-
text in *Museums, Equality and Social Justice.*

Museums, Equality and Social Justice is
the product of the 2010 conference Margins
to the Core? Exploring the Shifting Roles
and Increasing Significance of Diversity and
Equality in Contemporary Museum and
Heritage Policy and Practice, held at the Vic-
toria and Albert (V&A) Museum in London.
Eithne Nightingale, coeditor of *Museums,
Equality and Social Justice,* is head of equal-
ity and diversity at the V&A, a rare proactive
position in the museum world. The V&A is
highlighted in the volume, along with other
UK institutions including the Tate Modern,

Museum Worlds: Advances in Research 1 (2013): 241–252 © Berghahn Books
doi:10.3167/armw.2013.010115

the Horniman, National Museums Liverpool, the Gallery of Modern Art in Glasgow, and the National Portrait Gallery. One appreciates the unique context in the UK, where government policy (Race Relations Act, 2000, and the Equality Act of 2010) has had a positive impact on publicly funded museums. The private funding context of the United States is also addressed (Nightingale and Mahal), as are sites such as the Museum of Australian Democracy (Message), the Marib Museum Project in Yemen (Kamel and Gerbich), and museums in Italy (Bodo) and Taiwan (Varutti). The International Coalition for Sites of Conscience is not discussed, an omission that is unfortunate, since its mandate is social justice oriented.[2]

The volume is organized into three parts. Part 1, "Margins to the Core," assesses organizational change in museums, warning about the dangers of superficial transformation. Part 2, "Connecting/Competing Equalities," argues that museums should address multiple domains of inequality and exclusion, but also be sensitive to local needs and contexts. Part 3, "The Good Society," is the most diffuse of the set. It assesses how museums respond to "claims to cultural access" and more "equitable forms of representation by diverse communities" (6). It includes one overview chapter on social media (Wong), but given the importance of the subject, I would have liked to see more. Given that part 1 focuses on transforming museums from within, part 3 could have usefully addressed the agency of communities, audiences, and visitors in pushing museums to embrace equity issues and expand their narratives.

The premise of *Museums, Equality and Social Justice* is that museums can and should foster progressive social change. The volume seeks to harness this potential by examining in detail its many facets. It builds upon the momentum of coeditor Richard Sandell's impressive publications with Routledge, as editor of *Museums Society and Inequality* (2002), author of *Museums, Prejudice and the Reframing of Difference* (2007), and coeditor of

Re-Presenting Disability, Activism and Agency in the Museum (2010, with J. Dodd and R. Garland Thompson). In the 2002 volume, Sandell outlined individual, community, and societal benefits of inclusive museum representations. Exhibitions, he argued, should assert their agency and authority and present positive images of society's increasing pluralism. A decade later, *Museums, Equality and Social Justice* expands the scope of inquiry to include topics such as organizational change, equity and human rights statutes and policies, and new social media. The museum, as a total institution, is under scrutiny.

There is a consensus in part 1 that equality and diversity considerations must take place across museums to be meaningful. This includes staffing, collecting policies, physical access to collections, mission statements, collections research, curatorial authority, and marketing. Testimonies about institutional change reveal considerable variation in trajectories. David Fleming describes the need for "heroic" (and possibly dictatorial) leadership as the director of National Museums Liverpool, which includes the new International Slavery Museum. Conversely, the Horniman Museum has diversified its audience in a "policy lite" environment (Nightingale and Mahal). While contributors appreciate the instrumental power of progressive policies, none want museums to become too bureaucratic or to inscribe essentialist notions of identity. Museum transformation involves the art of politics, with its attendant banality (Karp and Kratz forthcoming). But individuals also make a difference, as Elaine Heumann Gurian (2009) has attested. Reductive pitfalls to be avoided include: assuming that people with disabilities are only concerned with physical access (Smith et al.); assuming that minority groups are only concerned with 'their' history (Mears and Modest); and tokenism (Younge). To this I would add: when will museums begin to properly compensate the free labor provided by community consultation and advisory committees, as it does professional consultants?

While equity policies are useful, they do not resolve complex decisions that curators confront as they expand their narratives and audiences. Glasgow's Gallery of Modern Art 2009 exhibition *Sh[OUT]* addressed lesbian, gay, bisexual, transgender, and intersex rights. As described by Sandell, the exhibit's development involved internal disagreements. Stakeholders decided to take a pride-oriented approach, as opposed to stressing victimhood and marginality. But debate occurred around the use of two Robert Mapplethorpe images of sadomasochistic sexual acts. Some feared the images would reinscribe a sense of difference and deviancy, overshadowing more assimilated aspects of the communities. Others felt that displaying photos that prompted a censorship lawsuit in the United States twenty years earlier was a powerful statement about progress. These kinds of tensions between celebratory displays and difficult issues are familiar to conventional, establishment museums. Curatorial decisions are typically made based on community consultation, collections, a notion of 'balance' and multivocality, institutional contexts, funding possibilities, and public expectations. In this sense, curating is an act of negotiation and calculation.

In her chapter on interculturalism in Italian museums, Simona Boda critiques a common establishment museum practice of targeting a minority community by exhibiting 'their' history or culture. While this approach may help to redress the under- or misrepresentation of a particular community, it risks essentializing and exoticizing 'otherness'. Visible difference is affirmed and celebrated as contributing to the cultural richness of the city or nation. Underexplored by this curatorial strategy is a sense of intercultural exchanges and tensions between communities. Boda supports an alternative curatorial approach that addresses issues that cross communities, such as slavery. Helen Mears and Wayne Modest echo these concerns about the limitations of well-intended community programming: "rarely are participants given the opportunity to challenge the dominant narratives of the museum and

museum work with 'cultural groups,' outside of programming activities—to consider collecting policies, marketing schemes, mission statements, for example—is even rarer" (300). The authors ask how museums can avoid "reductive parallels" (307) that assume a stable relationship between "target communities" and their collections.[3] They recommend curatorial strategies and institutional policies that both promote inclusion and question received notions of difference. The Horniman's multivocal and interdisciplinary "African Worlds" gallery illustrates this approach. Its curatorial and advisory team was drawn from Africa, the Caribbean, and the UK, including London's African diasporic community. But it speaks to a broader audience than this, challenging long-standing stereotypes of Africa as exotic and other.

Curatorial debates about traditions of displaying 'difference' are a mainstay of critical museology. However, the intensification of global mobility and pluralism has made these issues more pressing and relevant to disaporic communities' everyday lives. Drawing on human rights literature, Sandell discusses how museums can deal with potential conflicts between global human rights norms and local communities. Social movements are familiar with these challenges, such as when local notions of gender identity conflict with universal ideals of gender equity. Sandell calls for museums to promote cosmopolitan ideals of equity. It would be interesting to hear a countervoice—a critic or museum practitioner—who advocates a relativist position. Indeed, a multivocal exhibition about the politics and meanings of wearing a veil would be a challenging test case in exhibiting a controversial rights-oriented subject. It would need to engage with competing agendas and its end result would be shaped heavily by its conditions of production and location.

Social justice and human rights projects (museological and otherwise) may consciously avoid conflict and controversy. In 2009, the British Library Museum mounted *Sacred*, an exhibition about Islam, Judaism,

and Christianity. Due to its high profile and funding prospects, the curatorial focus was on shared heritage as opposed to points of conflict (Reeve). Arguably, the latter project would be more historically engaged. But the path chosen was perhaps more inclusive by promoting goodwill and understanding. Similarly, the Marib Museum being developed in Yemen will avoid taboo and sensitive subjects such as gender equity and recent political events. But it will make special efforts to make women visitors feel comfortable and welcome, despite their high illiteracy rate and the fact that they will probably be 'led' by a male family member through the museum (Kamel and Gerbich). This situation is all the more complex given that the museum's design is outsourced to Europeans—who are themselves concerned about enacting a neocolonial enterprise—and that the museum is meant to address local and international (tourist) audiences.

The question of how museums can deal with resistance from the general public and visitors is little addressed in this volume. In an age of visitor participation enhanced by social media, what should museums do if visitors articulate ignorant, racist, or homophobic comments? Should these be censored, condemned, or openly debated? Social media allows visitors to engage in debate anonymously, which may enable polarized rather than productive exchange (289). In contrast, museums are public and social spaces—at their best they are intimate "safe spaces for unsafe ideas"[4] Yet, histories of exhibition controversies reveal the way in which museums can be 'attacked' or undermined by media, government, and citizens, particularly when authoritative institutions are perceived to be taking a stand on sensitive, politically loaded issues. Nongovernmental organizations and other activist groups regularly engage in public debates, and Sandell believes that museums should emulate this.

Analysis of museums that resist progressive social change, in relation to exhibitions or other aspects of institutional life, would be a useful addition to *Museums, Equality and Social Justice*. Under what conditions do mu-

seums choose not to address equity in their institutional culture and exhibits? When and why are visionary leaders suppressed?[5] There are many possible scenarios, including tensions between the corporate culture of a board and its staff, between curators and educators, and between museum professionals and community needs, and a political will to control museums and their messages.

As I write this review, Canada's majority conservative government has announced that it will transform the Canadian Museum of Civilization into a Canadian Museum of History. Many academics and museum practitioners, myself included, are suspicious, though I support the teaching of public history in Canada (Eisner 2012, LeBlanc 2012). The problem is political manipulation, heightened by the approach of Canada's one hundred and fiftieth birthday in 2017. This government has shown a proclivity for military history, the monarchy, and patriotism in the symbolic realm, while resisting progressive social policies on the national and world stage. These kinds of shifts in museums call for careful evaluation, as change is often marked by inconsistencies and contradictions, whether conscious or not. Presently, a seemingly democratic public consultation process is occurring under the banner "My History Museum … Be Part of Its Creation!" Yet, the public has no sense of how input will be regarded; nor is there space to debate the fundamental institutional change. There is a lack of accountability and transparency about power. What is the point of public consultations if power lies with the government-appointed board of directors?

A recurring theme in *Museums, Equality and Social Justice* is the limitations of partial or superficial change. As Gary Younge writes: "Any push for diversity that refuses to challenge that power structure is really not worthy of the name. We don't need institutions that look different and behave the same. To create them is to mistake 'equal opportunities' for 'photo opportunities'" (109). Too often, communities are 'dropped' once an exhibition is done, and progressive, curatorial

interventions are temporary and ephemeral. Certain aspects of diversity prove more palatable than others. In Taiwan, museums have begun to represent indigenous and ethnic groups in order to assert cultural autonomy from China (Varutti). But life conditions related to unemployment, AIDS, prostitution, and poverty are ignored. Transforming museums demands vigilance, consistent effort, and a commitment to listen to collaborators' needs and desires. For instance, depicting poverty and other forms of vulnerability is highly sensitive and demands collaboration and dialogue. In Taiwan, the representation of indigenous and ethnic cultures has occurred without these elements.[6]

In theory, museum transformations should touch everyone, the powerful and marginalized, and the majority who lie in complicated ways between those poles. It is unfair if only the marginalized are engaged in the work of transformation. On the everyday invisibility of power, Younge notes, "Nobody ever asks: 'when did you first realize you were straight?' Or 'how do you balance fatherhood and work?'" (109). Exhibitions that cut across different communities and equality issues may be able to foster relational senses of identity. This is pertinent in the context of an increasingly fluid and globalized world (Nightingale and Mahal). Testimony from prominent curators in the United States reveals how each institution has a unique history and baggage to address; yet, a common thread is the sense that there is a need to both transform mainstream museums and build up specific community museums. With the development of monumental museums linked to specific communities (National Museum of the American Indian and the National Museum of African American History and Culture, to open in 2015), the lines between the two will blur in increasingly productive ways.

An interview with conceptual and installation artist Fred Wilson, as well as Janet Marstine's reflections on his museum interventions, are highlights in the volume. While the book, as a whole, shows the dauntingly huge scope of equity issues in museums, Fred Wilson's work is a reminder of the power of individual acts of curatorial creativity. Wilson has been able to enter conservative environments, such as the Maryland Historical Society in Baltimore, and work with collections and displays to raise critical questions about race, exclusion, and inequity. Marstine (100) characterizes Wilson's work as a form of "compassionate institutional critique" that can transform museum ethics. Listening to Fred Wilson, one senses his ability to connect with differently positioned actors in the museum world, displaying interpersonal skills that create trust and goodwill, as opposed to guilt or defensiveness. Wilson's dialogues and research surely create a safe context for his provocative work. He frames difficult issues and domains of potential competition positively: "A lot of museum education departments are doing really interesting things with marginalized communities. I think the future of embedding diversity is to further integrate what museum educators are doing with curatorial conversations" (39). Similarly, he notes that after decades of agitation and education, more museum staff appreciate how they can benefit from equity measures, "not only financially, but intellectually" (38).

Wilson is gifted at teaching people to see and think differently. His memorable statement, "It takes a village to raise a museum" (Wilson 2010), is unusual considering how artists' individuality and agency are so valued in the West. Assessing the impact of Wilson's work has produced a rich field of criticism (see Globus 2011). In the context of *Museums, Equality and Social Justice*, it stands as an antidote to the abstract world of policy, taking us back to real objects, people, and feelings. Etymologically, to curate means to care for. Historically, we have thought of this in relation to caring for objects and collections. *Museums, Equality and Social Justice* reminds the profession of the importance of caring for (and about) people.

Shelley Ruth Butler
Lecturer, McGill Institute for the Study of Canada

Notes

1. See literature on museums and settler societies (e.g., Simpson 1996; Peers and Brown 2003).
2. See International Coalition for Sites of Conscience: http://www.sitesofconscience.org/ (accessed 7 December 2012).
3. See also the chapter by Andrew Dewdney and colleagues.
4. Reeve (137) attributes this quote to Richard West of the National Museum of American Indian. Fred Wilson (2010) attributes it to Elaine Heumann Gurian.
5. Inclusive and intellectually adventurous directors of the National Museum of Australia and Te Papa, the National Museum of New Zealand, were removed by government (Gurian 2009).
6. As I write, controversy is brewing at the not-yet-opened Canadian Museum of Human Rights. There is an exodus of staff whose critical vision are being undermined by a government-sponsored board of directors who want "positive stories." (N.A. 2012)

References

Eisner, Candice 2012 "The End of the Museum of Civilization" CAUT/ ACPPU Bulletin. Vol 59 (9). http://www.cautbulletin.ca/en_article .asp?ArticleID=3547 (accessed 7 December 2012).

Globus, Doro, ed. 2011. *Fred Wilson: A Critical Reader.* London: Ridinghouse.

Gurian, Elaine Heumann. 2009. "Wanting To Be Third On Your Block." Michagan Museum Association Talk.

Kallen, Evelyn. 1989. *Label Me Human: Minority Rights of Stigmatized Canadians.* Toronto: University of Toronto Press.

Karp, Ivan, and Steven Lavine, eds. 1991. *Exhibiting Cultures: The Poetics and Politics of Museum Display.* Washington DC: Smithsonian Institution Press.

Karp, Ivan, Christine Mullen Kreamer and Steven Lavine, eds. 1992. *Museums and Communities: The Politics of Public Culture.* Washington DC: Smithsonian Institution Press.

Karp, Ivan, Corinne Kratz, Lynn Szwzja and Tomás Ybarra-Frausto, eds. 2006. *Museum Frictions: Public Cultures/ Global Transformations.* Durham, NC: Duke University Press.

Karp, Ivan, and Corinne Kratz. Forthcoming. "The Interrogative Museum." In *Translating Knowledge: Global Perspectives on Museum and Community,* ed. Ray Silverman. London: Routledge.

LeBlanc, Daniel 2012 "Ottawa's effort to rebrand museum met with criticism." *Globe and Mail,* 16 October.

N.A. 2012. Human Rights museum staff leave amid interference allegations. http://www .cbc.ca/news/arts/story/2012/11/30/mb-human-rights-museum-staff-quit-winnipeg .html (accessed 19 March, 2012).

Peers, Laura, and Alison K. Brown, eds. 2003. *Museums and Source Communities: A Routledge Reader.* London: Routledge.

Sandell, Richard. 2007. *Museums, Prejudice and the Reframing of Difference.* London: Routledge.

Sandell, Richard, ed. 2002. *Museums, Society, Inequality.* London: Routledge.

Sandell, Richard, Jocelyn Dodd and Rosemarie Garland-Thompson, eds. 2010. *Re-Presenting Disability: Activism and Agency in the Museum.* London: Routledge.

Simpson, Moira. 1996. *Making Representations: Museums in the Post-Colonial Era.* London: Routledge.

Wilson, Fred. 2010. "A Change of Heart: Fred Wilson's Impact on Museums." Sackler Conference for Arts Education. Sackler Centre for Arts Education. London: Victoria and Albert Museum.

Website

International Coalition for Sites of Conscience. http://www.sitesofconscience.org/ (accessed 7 December 2012).

Museum Pieces: Towards the Indigenization of Canadian Museums
Ruth B. Phillips
Montreal: McGill-Queen's University Press, 2011

Despite the ever-expanding literature on museums today, it is still rare to find books that deal with museums within a national context over a lengthy period of time, especially stud-

ies from inside as well as outside the institutions under examination. This is one such book, a clear and readable account of thirty years working in and on Canadian museums. Formerly director of the University of British Columbia Museum of Anthropology and now Canada Research Chair in Modern Culture at Carleton University in Toronto, Ruth B. Phillips is one of the finest and most prolific writers on art, museums, indigenous peoples, and related issues in the world today. Canada's museum history is extraordinary, and although it has many parallels with other settler colonies like Australia and New Zealand, and strong influences from south of the border, there are distinctive local traits and conditions that have produced a remarkable degree of participation with indigenous/First Nations peoples. "Canada's collaborative models of museum practice," writes Phillips, "have arisen as organically from its history as the canoe or the snowmobile" (3). However, this is far from a narrow or nationalistic account of Canada, as the "indigenisation" of its museums from the 1980s to the present is charted by a writer who has worked on Africa as well as the Americas, moving easily between art history and anthropology and, crucially, the university and the museum, with stints working as a curator and director as well as an academic.

Titled *Museum Pieces*, the book is an indispensable collection of Phillips's writing on museums, a 'greatest hits' album but one carefully edited with a thoughtful preface and introductions to each section. They range from chapters on Expo 67 to *The Spirit Sings* in the 1980s, a section on "re-disciplining" the museum in the 1990s, through to more recent articles on contemporary art, the digital (r)evolution, and indigenous art in mainstream art galleries in "the second museum age." Many of the pieces are classics, such as "How Museums Marginalise: Naming Domains of Inclusion and Exclusion" from 1992, while others represent different areas of Phillips's work; "The Global Travels of a Mi'kmaq Coat" shows us the native visual and mate-

rial culture studies for which she has become famous, while part 3 contains chapters on "indigenising exhibitions," for example, the exhibition comparing the re-presentation of native North America at the Canadian Museum of Civilization and National Museum of the American Indian, which demonstrates why Phillips is regarded as one of the best scholars working in this area. She makes a case for case studies in museum studies, arguing that they have the potential for providing "historical perspective *and* a site for theoretical analysis *and* models of innovative practices" (21) As a teaching methodology and pedagogy this has the appeal of opening out into museum training and "inoculating" students against the unrealistic and individualized models from the academy, instead preparing them for the negotiation and compromise required in the pluralist world of the museum, especially with native and tribal peoples. All in all, the case studies presented in the book, writes Phillips, "evidence the ways in which contestation, mediation and resolution in the museum have followed models of process similar to those that unfold in Canadian society more broadly" (10).

As an analysis of museums and/in society, Phillips's work as brought together in this book is exemplary, showing as it does the "history of contestation, innovation and change" but also how these are linked to macro and micro processes of "decolonisation, inclusivity and reform" in the wider society (4). Museums were one of the public forums for a nation exploring its own identity, made up of two founding nations and a liberal multiculturalism. To a degree, the four decades of developments charted here reflect the author's own biography and professional career, from the Task Force on Museums in the 1980s to leading the international art history body CIHA (Comité International d'Histoire de l'Art) in the 2000s. I found it really inspiring that she was able to maintain her reading, thinking, and writing throughout a busy career and constantly reflect on her work, giving conference papers and publishing articles

as well as producing scholarly monographs alongside the exhibitions, collections, and websites she was involved with. The equation Phillips proposes for research is a good model for academics, students, and professionals to aspire to: "history + theory + practice = critical museology" (16).

I thoroughly enjoyed reading this book, and devoured some chapters in a few sessions while browsing through others. It functions as a history of Canadian museums, an autoethnography of a life in museums, and a meditation on key contemporary issues. The book is elegantly designed, with plenty of color images and extensive notes, bibliography, and index. I would recommend it to anyone intersted in the several fields it covers, but especially those interested in museums as key public institutions of their time.

Conal McCarthy

Extra/Ordinary: Craft and Contemporary Art
Edited by Maria Elena Buszek
Durham, NC: Duke University Press, 2011

Craft/Art—Art\Craft
The oscillating conversation between art and craft, their distinct historical nuances as exemplified in the writings of John Ruskin and William Morris, and the exciting cross-pollination between artists and craftspeople reached a notable crescendo in 2011. From a material culture perspective, a brief discussion of two exhibitions will frame the importance of an anthology edited by Maria Elena Buszek entitled *Extra/Ordinary: Craft and Contemporary Art*.[1]

In London in 2011, two key exhibitions in their own 'crafted' way rested at opposite ends of the curatorial spectrum. While different in possibility, both exhibitions displayed materials and objects in such a way that opened up a space to contextually and conceptually unpack notions of value and process making under the nomenclature of craft and art. At the Victoria and Albert Museum, *The Power*

of Making, curated by Daniel Charny, featured a diverse range of works such as Hannah Perner-Wilson's *Tilt-Sensitive Quilt* (2010), which captures a body's movement under the covers, as well as a remarkable installation of the 'dry-stone wall' technique from the Cornwall region of England created in 2007. The catalogue accompanying this exhibit is also a dense presentation of the historical and theoretical lens that inevitably informs a broader understanding of 'making'. On the other end of the exhibition spectrum sat Grayson Perry's self-curated show at the British Museum entitled *The Tomb of the Unknown Craftsman*. Here, Perry situated his own works, such as *The Rosetta Vase* (2011), next to accessioned objects that he has extracted from the vast collections of the British Museum to create a multilayered narrative of a fictive character and emerging god called Alan Measles. Both of these exhibitions invited an engagement with a diverse range of objects, materials, and making, and most notably, both Perry and Charny used the exhibition as a modality to frame how 'craft', 'craftsmanship', and 'art' are taken up today. In a didactic panel in *The Tomb of the Unknown Craftsman*, Perry notes that "[c]raftsmanship is often equated to precision but I think there is a lot more to it. I feel it is more important to have a long and sympathetic relationship with materials." This particular focus on the significance of materials was evident in both exhibitions, but its importance is taken to new depths in a textual contact zone within the anthology *Extra/Ordinary: Craft and Contemporary Art*.

In the introduction, "Extra/Ordinary: The Ordinary Made Extra/Ordinary," Maria Elena Buszek acknowledges how contributors from Betsy Greer to Louise Mazanti "pay homage to the traditions that contemporary craft reference" (13) and that their contribution as part of this anthology succinctly illuminates the "boundary-crossing potential" (12) that tends to emerge through a discussion of media and materials, as well as process and making. This so-called boundary-crossing potential is most notably translated through the organization

of the book into four thematic sections: "Redefining Craft: New Theory"; "Craft Show: In the Realm of 'Fine Arts'"; "Craftivism"; and "New Functions, New Frontiers."

"Redefining Craft: New Theory" is framed by the work of M. Anna Fariello, Dennis Stevens, Louise Mazanti, and Paula Owen. The thread that ties these four essays together is a consideration of the Studio Arts movement and its agents (read: makers). M. Anna Fariello argues for what she calls "the craft-art continuum," where Studio Craft allows for a discussion of the maker, economic affects, and the material object, which results in a clarification of the 'function' of an object beyond its physical (tangible) existence to suggest that meaning rests in its intangible quality. Taking up the thread of the collective that emerges from Studio Craft, Dennis Stevens exhaustively looks at the role(s) of online "communities of practice" that often reflect the material goals of Gen-X and Gen-Y, as well as the rise of DIY phenomenon. In the final two contributions to this section, Louise Mazanti and Paula Owen independently focus on the use of language in relation to craft. Mazanti proposes that "super object" be applied as a "metaphor for the role craft objects play in contemporary society" (62), whereas Owen uses an active approach of investigating process through Nicholas Bourriaud's ideas of "transivity," whereby she takes the tangible craft object into an aesthetic space.

"Craft Show: In the Realm of 'Fine Arts'" follows closely the discussion of aesthetics, with the authors in this section using contemporary examples of installations and exhibitions to exemplify the boundary-crossing potential that this anthology sets out to illuminate. Together the four essays present how craft and art merge within the exhibition space by looking at varied mediums and materials from quilts to wallpaper, book making, and ceramics. Karin E. Patters begins by taking up a rather art historical narrative of how quilts garnered agency as works of art in the gallery by using the example of Jonathan Holstein and Gail van der Hoof's exhibition of quilts

at the Whitney Museum of American Art in New York City in 1971. From here, Elissa Auther relates Andy Warhol's wallpaper works to the historical importance of the Decorative Arts movement, while Betty Bright shows the rise in book artists who, as makers, "[demonstrate] a shift in the meaning of craft in the choice of the book as an artistic vehicle" (135). This section closes with Jo Dahn's critical look at defining contemporary conceptual ceramics and in doing so shows how conceptual frameworks and the "physicality of the creative process" allow notions of dematerialization to be explored by ceramists (169).

From the public gallery to public protest, the concept of "Craftivism" has become one of the more heavily trafficked terms today. This section relates this anthology to other publications such as *Neo-Craft: Modernity and the Crafts* (2007), and reminds the reader how important Glenn Adamson's *The Craft Reader* (2010) is to numerous audiences. Betsy Greer's candid narrative of the term 'craftivism', its genesis, and its application today is a brilliant essay and it sets the stage well for Kirsty Robertson's dense summation of how she applies craftivism within a Canadian context. In her own way, Robertson 'owns' the term in a manner in which Greer hopes it will be applied. The application of craftivism takes on a different ownership of meaning when Anthea Black and Nicole Burisch refreshingly look at craft in relation to curatorial practices and an engagement with publics. They suggest that "[b]oth craftivism and contemporary curatorial practices critique the mainstream economies that govern their respective disciplines" (215). Finally, Janis Jefferies dissects a series of exhibitions to look specifically at materials and craft-based processes.

"New Functions, New Frontiers" is the final summation of the boundary-crossing potential noted by Buszek, made manifest in this section through Lacy Jane Robert's contribution, where she clearly makes a strong argument that craft discourse can (and may very well need to) employ the tactics of queer theory, in particular "disidentification" (247),

if it is to not be dismissed. Using gender models and examples (or perhaps is it engendered practice) is further teased apart as Andrew Jackson uses his ethnographic analysis of men who maintain workshops in southeast England, via the case study of a canoe builder, to address issues of amateur and professional labels in relation to a value critique of time—an essay that perhaps has a connection to Richard Florida's work on *The Rise of the Creative Class* (2004) and even Matthew B. Crawford's recent publication, *Shop Class as Soulcraft: An Inquiry in to the Value of Work* (2009). Finally, the book ends with an interview with Margaret Wertheim—science writer and crocheter—whose project, *A Field Guide to Hyperbolic Space,* was organized by the Institute for Figuring (IFF) and cofounded with her sister and cultural studies professor, Christine Wertheim. This interview readdresses many of the key ideas raised throughout the anthology, from identifying who the makers and the builders of communities are, to bringing craft, and now science, into the gallery, as well as gender, and the need to look for language to address craft within the laboratory.

As a collection of the voices of those embedded within the discourse of art and craft, *Extra/Ordinary: Craft and Contemporary Art* stands out as a strong contribution to furthering debates, breaking down misconceptions, and, as Buzeck notes, crossing boundaries to generate new knowledge. Overall, *Extra/Ordinary* reads like a series of punctuation marks, where each contribution is a statement about the discourse and captures the significance of forward thinking and the need for boundary breaking by anticipating new intersections between art and craft, and possibly science, through materials and makers.

Fiona P. McDonald
PhD Candidate, University College London

Notes

1. For other formidable commentary and reviews of this book, visit: http://www.mariabu szek.com/extraordinarybook/index.htm and http://liminalities.net/7-4/buszek-rev.html.

References

Adamson, Glenn, ed. 2010. *The Craft Reader.* London: Berg.
Arfoldy, Sandra, ed. 2007. *Neo-Craft: Modernity and the Crafts.* Halifax, Canada: Press of the Nova Scotia College of Art and Design.
Charny, Daniel, ed. 2011. *The Power of Making.* Exhibition Catalog. London: The V&A Publishing and the Crafts Council.
Crawford, Matthew B. 2009. *Shop Class as Soulcraft: An Inquiry in to the Value of Work.* New York: Penguin Books.
Florida, Richard. 2004. *The Rise of the Creative Class.* New York: Basic Books.

(Re)Staging the Art Museum
Edited by Tone Hansen
Oslo, Norway: Heine Onstad Art Center, in collaboration with Revolver Publishing, 2011
287 pages. Paperback. Available through: http://www.hok.no/restaging-the-art-museum.4940620-174448.html

The complex and weighty discourse around art museums and museums of contemporary art is informed by a diverse range of international perspectives, interests, and politics. In *(Re)Staging the Art Museum* (2011), the polyphony of voices of those embedded within the network of museum practice and politics comes to light through a series of autonomous, self-reflexive narratives in this anthology. Each chapter frames a unique experience or case study of those from within the museum or running counter to these (either real or imagined) institutions—historians, artists, curators, critics, architects, and institutional directors all have a voice that contributes to the richness of this critical conversation. In this anthology, the resonance of each narrative oscillates between extremes. First, contextualizing happenings in both the Nordic art scene and Eastern Europe enables a crucial expansion to conversations around the

dominant structures of the Western art world (read: the United States). Second, the critical act of posing questions to the reader invites their active participation within the complex system of (re)framing, (re)structuring, (re)imagining, (re)activating, and potentially (re)defining the art museum.

(Re)Staging the Art Museum emerged from a seminar in 2009 at the Henie Onstad Art Center associated with the Freedom of Expression Foundation in Oslo, Norway, as part of their MuseumNow! lecture series. In both the preface written by Karin Hellandsjø, the current director of the Henie Onstead Art Center, as well as the introduction entitled "What Is to Be (Re)Staged?" by editor Tone Hansen, this anthology contributes to the discourse of contemporary art by focusing mostly upon the function of the art museum vis-à-vis economic, curatorial, and architectural (infrastructural), as well as nationalistic and ideological, consequences of and responses to global expansion upon the art world. Admittedly, this framing can be somewhat daunting to the reader, but addressing each of the aforementioned issues was poetically achieved through a constellation of contributions that does not celebrate a single tone or focus, but rather traces out its complexity by incorporating alternative modes of representation from photo essays to specific case studies and archival narratives of activism. As a collective whole, *(Re)staging the Art Museum* reads as though Tone Hansen curated a selection of international iterations of the art museum to complement each other. Together, these chapters present no ambition to creating a perfect solution or image of how to '(re)stage' the art museum, but rather succeed at capturing the dynamism of this international conversation and involve the agency of the reader in this process.

At first read, the outset of the book felt somewhat unstable at times as neither a specific nor working definition of the art museum was formally offered to contextualize *how* the authors in the anthology were specifically approaching this conversation. While the art museum is generally quite self-explanatory in nature, a reader fresh to this material could be left feeling somewhat isolated from these texts and by default question what specifically is being applied as the working definition of an 'art museum' and what is meant by 'restaging' (beyond its performative and theatrical connotations). However, by not explicitly defining the art museum, apart from acknowledging it as a living organism (5), Hansen has undertaken a sophisticated and well-crafted approach to frame a topic by refusing to impress upon the reader its bounded understanding as an institution. Upon reflection, this approach truly liberates the reader from applying a fixed definition to a pan–art museum context. By drawing upon each chapter as a case study, the anthology as a whole fundamentally allows the reader to access distinctive dimensions of the art museum that in the end encourages one to actively establish their own imagining of how disparate institutions come to bear the categorization of 'art museum'. In the case where a reader may have not have a well-established working knowledge of art museums at all, the conceptual framework of these institutions is clearly illuminated throughout the anthology via the extant citation of key figures such as Hal Foster, Charlotte Klonk, Keith Moxey, Nikolaus Hirsch (also a contributor to the anthology), and Liam Gillick. By acknowledging the work of such individuals, the theoretical frameworks are subtly disclosed for those new to either curatorial or museum studies. This nuanced dimension entices the inquisitive reader along avenues through which to garner either new or more knowledge about specific happenings in the art museum world. One such example is how Martin Braathen carefully presents the historical importance of the First Palace in the early-1960s in London (UK) and the intricate development of the European Kunsthalle.

The dynamic design of this anthology means that it does not necessarily need to be read in a linear fashion. Each contribution stands formidably alone. In an abbreviated

overview of each contribution, the reader is first met by Maria Lind's historical summary, which captures the genesis of varied spaces from art museums to museums in general. In doing so, Lind traces out the proximity of such institutions in relation to the emergence of artist-run centers from nineteenth-century models of exhibition spaces—that in and of themselves are structural and ideological quotations of the eighteenth-century Louvre (19). The contributions by Maria Lind, Zdenka Badovinac, Piotr Pitrowski, and Jan Debbaut all independently cast a much-needed critical eye toward traditional Western art history, which favors a myopic art historical meta-narrative. Pitrowski addresses the need for the plurality of histories to be *re-presented* through the proposed modes or structure, such as a "critical museum," in relation to his discussion of the National Museum in Warsaw (82). Here, Pitrowski's contribution ties in seamlessly with both Peio Aguirre's appraisal of the role of regional art museums as international monuments in the Basque country (in particular referencing Frank Gehry's work on the Guggenheim in Bilbao and the Rioja Alavesa hotel), and the interventionist project of Nomeda & Gediminas Urbonas through the Guggenheim Visibility Study (GVS) group in Lithuania. By anchoring their presentation in the issue of regionalism, both the works of Urbonas & Urbonas and Aguirre draw the reader back to an emergent idea in the contribution by Zdenka Badovinac that calls for an appraisal of the "meta-museum" and the need for institutional self-reflexivity (48). This discussion of self-reflexivity is also evident in Jan Debbaut's narration of his own experience that emerges from what he calls the "generation of curators who [...] developed within the museum" (60). As such, Debbaut's relatively autoethnographic tale of curating sits in balance with questions posed by Nikolas Hirsch about the role of architecture in curating. Hirsch asks two critical questions about the "renegotiation" of space and practice (249) that bring to light the role of the architectural frame of the art museum. Hirsch first questions: "[T]o what extent do archi-

tectures (understood as systematic frames converted in to spatial configurations) organize exhibition and art practices in general?" (252). Second, Hirsch ponders: "[C]an buildings curate? Do they act as silent curators?" (252). This dialogic between actors and space is read by Hirsch through a Latorian lens of museums whereby issues of curatorial agency become paramount. This has a strong connection to the way Martin Braathen frames the New Museum of Contemporary art in New York, as well as how Barbara Steiner looks at the politics of display at the Museum of Contemporary Art (GfZk) in Leipzig. Moving on from this, the exhibition review by Ane Hjort Guttu and photo essay by Unnar Örn insert an invaluable visual narrative to this anthology that add a distinct critical dimension to those exhibiting within the art museum.

The only challenge with this publication is that the anthology ends rather abruptly and may have benefited from a sort of creative conclusion that would potentially frame a space of reflection for the reader, or perhaps even trace out key moments in the lecture series where sentiments between presenters overlapped in either agreement or disagreement. To this end, a conclusion to the anthology could also act as a textual platform from which to have a space to reflect upon the definition of the art museum, interpretations of the varied thoughts and questions posed by the authors, and how we can each partake in this process.

(Re)Staging the Art Museum makes for a critical insertion into the theoretical and methodological discourse of museum studies and curatorial pedagogy. As a whole, the authors do not strong-arm one position on the future of the art museum, but rather they encourage an informed reading of past acts of institutional friction and re-formation in order to understand what can happen next by using the art museum as a sort of 'laboratory' of thought in which to *think through* the varied iterations of art museums or museums of contemporary art.

Fiona P. McDonald
PhD Candidate, University College London

NOTES TO CONTRIBUTORS

The *Museum Worlds* Editorial Board invites submissions. All submitted articles should be original works and not concurrently under consideration by any other publication. Please send submissions of articles, reviews, and contributions to the editors as an email attachment (MS Word is preferred, otherwise in rich text format).

Articles should be sent to:
Sandra Dudley shd3@le.ac.uk and Kylie Message kylie.message@anu.edu.au

Exhibition reviews should be sent to:
Conal McCarthy conal.mccarthy@vuw.ac.nz

Books for review should be sent to:
Masaaki Morishita
AACSB Project Coordinator
Institutional Research Section, Office of the President
Ritsumeikan Asia Pacific University
Japan
mom66122@apu.ac.jp

Research articles and articles that critically review and position the state of a particular sub-field should normally be approximately 7,000 words (including notes and references), although longer articles may be considered, and responses approximately 1,000 words each.

- Conversations: 4,000-6,000 words.
- Review articles (books or exhibitions): 3,000 words.
- Short reviews (books or exhibitions): 800 words.
- News, Exhibitions and Conferences: up to 500 words per item.
- Teaching in Museum Studies: 3,000-5,000 words in total for section; shorter items welcome.

Articles should also include a 150-word abstract and six to eight keywords. The document must be set at the US letter or A4 paper size standard. The entire document (including the notes and references) should be double-spaced with 1-inch (2.5 cm) margins on all sides. A 12-point standard font such as Times or Times New Roman is required and should be used for all text, including headings, notes, and references. Any unusual character or diacritical mark should be flagged, as the character may not translate correctly during typesetting.

Contributors should also include a cover page which provides the title of the article, complete contact information for each author (address, phone, fax, and e-mail), biographical data of approximately 100 words for each author, and any acknowledgments. Please provide a total word count and indicate the number of tables and/or figures as included.

The *Advances in Research* style guide is based on the *Chicago Manual of Style* (*CMS*), 16th edition with some deviations based on house style preferences. Please note that the journal uses US punctuation and spelling, following *Merriam-Webster's Collegiate Dictionary* or the *American Heritage College Dictionary*.

Please consult the journal's style guide, available at www.journals.berghahnbooks.com/air-mw, for the following conventions, among others: the presentation of numbers and dates; the proper use of notes and the citing of references; the requirements for the submission of graphic materials (illustrations, maps, photographs, figures, tables).

Manuscripts that have been accepted for publication but do not conform to the *Museum Worlds* style guide may be returned to the author for amendment. Upon acceptance, authors are required to submit copyright agreements and all necessary permission letters for reprinting or modifying copyrighted materials. The author is fully responsible for obtaining all permissions and resolving any associated fees.

CPSIA information can be obtained
at www.ICGtesting.com
Printed in the USA
LVOW04s2351220218
567560LV00004B/300/P

9 780857 459558